KB155183

민주주의 씨앗뭉치

Seed Pods of Democracy

민주주의 씨앗뭉치
Seed Pods of Democracy

차례

Contents

민주주의
씨앗뭉치

장문정, 김경원, 강유미 | 민주주의 포스터 프로젝트팀

서울 도심 한복판 지하철 남영역 승강장에 서 있으면 담장 너머로 짙은 회색
건물, 남영동 대공분실이 보인다. 이 건물은 말없이 암울했던 시대의 역사를
전한다. 남영동 대공분실은 1976년 고문과 취조의 효과를 극대화하기 위해
'완벽한 고문 밀실'로 기능하도록 설계되었다. 이 밀실에서 평범한 시민들과
학생들이 간첩 혹은 빨갱이로 내몰렸으며, 공식 기록을 통해 알려진 피해자만
400여 명에 이른다. 1987년 6·10민주항쟁의 도화선이 되었던 박종철
고문치사 사건을 통해서 시민과 국가는 끔찍한 국가폭력의 실체를 마주하게
되었다.[1] 이후 남영동 대공분실은 경찰청 보안분실로 계속 사용되다가,
2005년에 들어서 경찰청인권센터로 용도가 변경되어 사용되었다. 2018년
정부는 남영동 대공분실을 민주화운동기념관으로 조성하기로 하였다.
현재 민주화운동기념사업회는 기억과 성찰, 소통과 연대, 교육의 공간,
그리고 시민이 직접 느끼고 소통하는 생명체와 같은 새로운 공간으로의
민주화운동기념관 개관(2024년 예정)을 준비하고 있다.

민주주의 포스터 프로젝트는 기념관의 이러한 변화를 지원하기 위해서 민주화 운동 및 인권에 관한 작품을 수집·보존하며, 민주인권 관련 문제를 널리 알리고 공유하고자 기획되었다. 본 프로젝트는 점점 심해지는 자본화·양극화의 세계 속에서 계속 반복되는 국가폭력·반민주주의·인권 침해에 저항한 사건과 이슈를 살펴보고, 민주주의와 인권에 관한 실천과 담론을 최대화할 수 있는 시각언어는 무엇인지 포스터라는 형식을 통해 탐구하고자 했다. '지금, 여기'의 목소리를 대변하는 디자이너들, 영향력 있는 언론매체의 사회문화적 이슈를 그리는 일러스트레이터들, 국가폭력의 현장에서 활동해 온 작가들, 다국적·다중적 정체성에 관한 이야기를 전하는 작가들 등, 다양한 배경과 각기 다른 작업 방식을 가진 작가들이 흔쾌히 참여해 주었다. 각 작가들은 두 점의 신작 포스터를 병치하거나 서로 연결하여 민주주의 체제, 민주주의의 핵심 가치, 국가폭력 및 인권 관련 사건들을 역사적 시공간 안에서 살펴보고 확장하여 세계 민주주의의 현재와 문제점을 들여다보게 해주었다. 그리고 존엄, 공감, 기억, 비평, 대화, 경계, 회복, 미래, 지속, 연대와 같은 눈에 보이지 않는 가치들을 역동적인 시각언어로 해석해 주었다. 민주주의의 현재와 미래에 대한 질문을 던지고, 민주화 과정에서 희생된 사람들을 깊이 애도하고, 사회적·역사적 약자들의 고통에 공감하며, 연대의 힘과 중요성을 표현한 포스터와 그 이야기를 소개한다.

민주: 끊임없는 질문

2022년 세계민주주의의 날, UN 사무총장 안토니오 구테흐스(António Guterres)는 " … 전 세계 민주주의는 후퇴하고 있고, 시민 공간은 축소되고 있습니다. 또한 불신이 팽배하고 허위정보가 난무하며, 양극화로 인해 민주주의 제도가 훼손되고 있습니다."[2]라는 메시지를 전했다. 이 장에서는 세계 여러 나라의 정치적 역사와 실상을 알아보고, 이상적인 통치체제였던

1 남영동 대공분실에 대한 기록은 다음의 기사를 참조하였다. 해당 링크에서는 남영동 대공분실 건물 내부 곳곳을 360도 카메라로 촬영한 영상도 함께 볼 수 있다. 「천재가 설계한 완벽한 '고문밀실' 남영동 대공분실」, 『한국일보』, 2020년 6월 10일 자. https://interactive.hankookilbo.com/v/namyoungdong

민주주의는 왜 후퇴하고 있는지 그 원인에 대한 작가들의 끊임없는 질문과 생각을 전한다.

　일상의실천, 조나단 반브룩, 크리스 버넷, 카로 악포키에르는 국가폭력, 대화의 부재, 무책임한 권력, 양극화, 선거제도의 의미와 변하지 않는 낡은 현실정치 등의 문제를 시각화한다. 일상의실천은 국가의 권력이 민중에게 있음을 뜻하는 민주주의의 어원적 의미를 살펴 보고, 근현대 한국사에서 민중의 권력을 억압했던 국가폭력의 현실을 드러낸다. 〈民×KRATOS〉와 〈DEMOS×主〉는 '억압받은 민중'을 옛 남영동 대공분실의 좁은 창으로, '저항으로 쟁취한 권력'을 깨트린 벽으로 형상화하여 민중과 권력의 관계를 되짚어 본다. 조나단 반브룩은 〈분단이 아닌 대화〉에서 남한과 북한은 서로 다른 정치 체제, 정전, 분단을 넘어설 수 있을까라는 질문을 던진다. 한반도를 넘어 세계에서 발생하는 정치적 문제들은 단절이 아닌 대화로 접근해야 하며, 정의로운 민주주의 사회를 위해서 반드시 책임 있는 권력이 전제되어야 함을 강조한다. 크리스 버넷의 작품은 2021년 1월 6일, 2020년 미국 대선 결과에 불복한 트럼프 당시 대통령 지지자들이 무력으로 미국 국회의사당에 진입한 초유의 사태를 배경으로 한다. 그 원인으로 미국 사회 내 분열과 양극화의 심각성을 지적하고, 평화적·통합적·미래적 정치를 향한 방법을 찾을 것을 요구한다. 나이지리아에서 출생하여 현재 독일을 기반으로 활동하고 있는 카로 악포키에르는 두 인물이 나누는 문답식 대화를 그린다. 최근 나이지리아에서 있었던 선거를 배경으로 한 이 대화는 서구 신자유주의 국가에서 제도적인 해결책으로 제시되는 민주주의의 이상에 대한 비판과 함께 선택과 표현의 자유라는 민주주의의 가치를 되묻는다.

　크리스티나 다우라, 가스 워커, 빅토리아 치혼, 루카 손치니는 반민주적 정치를 비판하면서 민주주의 역사와 기억, 그리고 인권의 관계를 살펴본다. 크리스티나 다우라의 연작에서는 발언의 자유가 없는 민중을 상징하는 '죽은 말'과 민중의 현실을 보지 못하는 정치 지도자의 시선을 묘사함으로써 인권이 부재한 독재사회를 고발한다. 남아프리카공화국 디자이너 가스 워커의 〈뒤집힌 민주주의〉는 거꾸로 그린 인체 해부도에 폭력과 돈을 통해 권력을 행사하는 여러 국가 지도자들의 이름을 연결하여 전 세계 민주주의의 위기를 그린다. 그의 또 다른 작업 〈아만들라!〉는 똑바로 높이 들어 올린

주먹을 통해 아파르트헤이트 정책 종식을 위해 남아프리카공화국의
시민들이 보여준 힘을 상기시키며, 민주주의와 인권 수호의 여정을
지속하고자 하는 신호를 보낸다. 빅토리아 치혼은 반민주적 정치 범죄와
민주주의를 지키기 위한 시민들의 투쟁을 병치하여 그린다. 두 포스터는
하나의 시각적 연결고리를 가지면서 과거 정권과 정치 정당이 저지른 범죄를
'기억'하고, 반민주 세력으로부터 민주주의를 '수호'해야 한다고 주장한다.
비슷한 맥락에서 루카 손치니의 〈메모크라시〉는 민주주의 수호를 위해
투쟁하다 떠난 이들을 기억하고 기념한다. 사람 지문 모양처럼 놓여진
수많은 희생자들의 무덤 앞에서 묵념하는 인간을 그림으로써, 민주주의
역사에 대한 기억 형성의 중요성과 인류학적인 태도의 필요성을 전한다.

인도에 기반을 둔 디자인 & 피플과 태국의 디자이너 프라챠
수비라논트는 인도와 태국의 민주주의를 되짚어 보고, 문제적인 정치 현실을
변화시킬 힘은 민중에게 있음을 전한다. 디자인 & 피플의 〈민주주의를
위한 제 교향곡〉은 잘못된 통치를 일삼는 정치인들이 간디 모자를 착용한
채 그에 담긴 뜻을 훼손하고 있음을 날카롭게 비판하고, 〈민주주의에는
토대가 필요하다〉는 민중의 참여가 민주주의를 밀고 당기며 변화를
일으킬 수 있음을 강조한다. 태국 디자이너 프라챠 수비라논트는 〈우리의
토양에 뿌리 내린 민주주의〉에서 태국의 땅에 민주주의의 뿌리가 있음을
부정하는 옛 사상이 정치적 발전을 저해하고 있는 현실을 그린다. 거대한
뿌리가 있음에도 불구하고 싹을 틔우지 못하는 나무 이미지를 통해
성장을 멈춘 태국 민주주의를 표현한다. 반면 〈나의 거리 풍경 #1〉에서는
직접 찍은 죽어가고 있거나 죽은 두꺼비의 사진을 통해 태국 사회에서
살아남기 위해 숨죽이는 사람들의 태도를 적나라하게 보여준다. 이 두
작업은 우리가 보고 있는 것은 지표면에 납작하게 붙어 있는 두꺼비와 같은
현실일지라도 민주주의를 꽃피울 수 있는 것은 결국 민중의 힘임을 말한다.

2 안토니오 구테흐스, 「2022 세계민주주의의 날 메시지」, 2022년 9월 15일. 영어 원문은
https://ukraine.un.org/en/199351-secretary-general-message-international-day-democracy,
한글 번역문은 https://www.kdemo.or.kr/notification/news/page/1/post/522 참조. 매년 9월 15일은
UN에서 지정한 세계민주주의의 날이다. 본 글이 작성된 이후 발표된 2023년 세계민주주의의 날 기념 UN
사무총장 메시지에서는 "민주주의를 위협하는 것들을 인식"하고 현재와 미래의 민주주의를 수호하기 위해
"다음 세대의 역량 강화"에 주목해야 함을 이야기했다.

영토 점령, 종교, 이념의 갈등에 따른 분쟁과 국가 간의 무력 전쟁이
일어나는 시공간에서는 국가폭력, 정치 범죄, 전쟁 범죄, 인권침해와 같은
여러 반민주적 상황과 피해가 일어나며 이는 세계 민주주의를 훼손시킨다.
크리스 리(이정민), 카테리나 코롤레프체바, 미콜라 코발렌코는 전 지구적·전
인류적 해결 과제인 식민지 지배와 전쟁의 폭력에 대한 이야기를 전한다.
크리스 리(이정민)는 북아메리카와 유럽의 대륙을 오가며, 식민화된
장소로서의 공공장소를 살펴본다. 오늘날까지 공공장소에 남아있는 식민성을
보여주는 여러 가지 문화적·지리적·시각적 표지들을 검토함으로써 영토를
둘러싼 갈등, 약탈, 추방, 폭력 등을 설명한다. 이를 통해 작가는 공간의
탈식민화를 통한 지역 민주주의와 인권의 회복을 암시한다. 한편 2022년
러시아가 우크라이나를 침공하면서 시작된 전쟁은 흔들리고 있는 현
세계의 정치적 균열을 극명하게 드러냈다. 우크라이나 디자이너 카테리나
코롤레프체바는 전쟁을 반대하는 '전쟁 포스터'(War Posters) 연작을 통해
우크라이나에 대한 전 세계의 지원을 촉구한 바 있다.[3] 카테리나의 〈네버?〉는
소비에트 연방과 러시아가 우크라이나에 대해 저지른 범죄의 날짜를
나열하며 우리가 알아야 하는 진실과 기억해야 하는 역사를 강조한다. 한편
〈어게인〉의 "2022-202?"라는 문구에 붙은 물음표는 이 반복되는 역사
속 현재 진행 중인 전쟁의 끝이 어디인지를 묻는다. 우크라이나 문자와
언어가 가진 정체성과 타이포그래피에 주목해 온 코롤레프체바는 이번
작업에서 읽기에 다소 불편하고 어려운 느낌을 주는 글꼴로 고통스러운
주제를 더 부각하고, 연결된 타이포그래피를 통해 이 역사의 타임라인이
중단 없이 계속되고 있음을 보여주고자 했다. 슬로바키아에 거주하고
있는 우크라이나 작가 미콜라 코발렌코는 매일 전쟁에 반대하는 포스터를
제작하고 NFT 형태로 판매해 우크라이나를 지원해 왔지만,[4] 이 연작을
영원히 중단할 수 있기를 간절히 바라고 있다. 정치와 정권이 무참히
박탈하는 인권, 그에 맞서 싸우는 작지만 강한 힘을 그린 코발렌코의
〈미사일〉과 〈강압〉은 가장 단순한 형태로 강력한 메시지를 전한다.
　　전쟁으로 인한 환경파괴는 물론이거니와 지구 온난화로 인한 이상기온,
물과 식량 부족 등의 문제는 지구상의 모든 생명과 사회적 약자의 인권을

위태롭게 한다. 파괴된 지구 생태계의 균형을 맞추고, 생명이 숨 쉴 수 있는 환경을 회복하기 위해서, 민주주의의 지체 없는 대처와 실천이 필요하다. 환경문제와 디자인을 연구하는 베른하르트 렝거는 생태파괴(ecocide)가 심각한 환경 범죄라는 것을 알리며, 나아가 생명 존중과 기후 환경 회복을 위한 법과 제도를 마련하는데 총력을 기울여야 한다는 메시지를 전한다.

인권: 모든 사람의 이야기

2023년 여름, 민주화운동기념관으로 재조성 공사가 한창인 옛 남영동 대공분실을 방문했다. 과거 독재 정권 당시 국가폭력이 자행되었던 이 건물 내벽에는 1948년 선포된 '세계 인권 선언'의 여러 문구들이 남아있었다. '모든 사람은'으로 시작하는 선언 문구들을 읽으며, 인권을 박탈당했던 희생자들과 국가폭력을 집행한 가해자들의 흔적이 남아있는 이 공간에서 '모든 사람'이 맺는 관계를 생각해 본다. 이 장에서는 민주주의와 인권의 상호 보완적인 관계, 민주주의와 인권의 핵심 가치인 자유와 평등에 대해서 구체적인 이야기를 나눈다.

먼저 안마노, 디스 애인트 로클론(찰리 워터하우스, 클라이브 러셀), 하이 온 타입, 마크 고잉은 민주주의의 핵심 가치인 평등 사상에 대한 작가들의 통찰을 보여준다. 안마노의 〈모두〉는 '모두'의 생명, 자유, 행복을 추구할 권리를 강조하고, 여기에 병치되는 〈모심〉은 동학운동 사상에 담긴 '모두 섬김'의 의미를 되새긴다. 작가는 '모두'와 '모심'이라는 민주주의의 근본을 자신만의 유기적인 타이포그래피로 간결하게 표현한다. 디스 애인트 로큰롤(찰리 워터하우스, 클라이브 러셀)은 민주주의가 태동했던 시대에 그려진

3　"더 이상 정치가 아니라 우리의 현실입니다. 당신은 침묵하고 냉담할 수 없습니다. … 이러한 메시지가 공유되고 행동으로 이어지면 디자이너는 진실과 자유라는 이름으로 변화를 만들 수 있습니다." Katerina Korolevtseva, "'You can't be silent': how designers are rallying in Ukraine," *Design Week*, March 1, 2022. https://www.designweek.co.uk/issues/28-february-5-march-2022/ukraine-graphic-design/

4　NFT 거래 플랫폼인 오픈 씨(OpenSea)에서는 미콜라 코발렌코가 러시아의 우크라이나 침공 이후 120일 동안 제작한 포스터 120개를 NFT 이미지로 제공하고 있다. 취합된 판매금의 80%는 EUR 계정으로 전환되어 우크라이나 지원 자금으로 할당된다. https://opensea.io/collection/block-war-with-art

〈모나리자〉, 합의에 따른 의사결정과 같은 급진적 민주주의를 실천한 해적들을 상징하는 졸리 로저(Jolly Roger, 해적기) 이미지를 통해 민주주의의 주체인 '모든 사람'을 새롭게 정의한다. 작가는 '모든 사람'은 해적이자 예술가'라는 흥미로운 접근을 통해 새로운 형태의 민주주의를 고안해 내는 창의적이면서 급진적인 정치적 주체를 상상한다. 하이 온 타입은 왼쪽과 오른쪽의 두 지면, 흑과 백이 공존하는 타이포그래피적 경험을 통해 '모든 사람'의 관계를 추상적으로 시각화한다. 영어 단어 'left'에 담긴 '왼쪽'과 '남는다', 'right'에 담긴 '오른쪽', '권리', '옳다'라는 다중적 의미를 써서 "WHO'S LEFT WHEN THERE IS NO HUMAN RIGHT"(인권이 없을 때 누가 남는가), "WHO'S RIGHT WHEN THERE IS NO HUMAN LEFT"(남은 사람이 없을 때 누가 옳은가)라는 철학적 물음을 던진다. 이는 '인권 없이 남겨진 사람들이 있다면 과연 누가 옳다고 할 수 있는가'라는 깨달음을 준다. 마크 고잉의 〈겹친 선들의 언어 체계(내가 생각하는 바를 또한 그대가 생각할 터)〉는 붉은색과 푸른색을 띤 암호와 같은 다양한 획들로 이루어진 추상으로서, 보는 이의 적극적 관찰과 획들이 작동하는 시스템에 대한 이해를 필요로 한다. 작가는 서로 다른 방향에 놓인 획들이 만나는 접점에 주목할 때, 모든 획이 모두가 각자의 모습대로 평등하게 존재할 수 있음을 표현한다.

모든 사람은 평등하지만, 모든 사람의 인종, 국적, 종교, 성 정체성, 사회적 신분, 정치적 견해는 다르다. 모든 사람이 서로 다름을 인정하지 않을 때 이는 종종 배제, 소외, 혐오, 차별로 이어지고 모두의 평등한 관계는 깨진다. 엘리엇 스톡스, 에런 니에, 굿퀘스천(우유니, 신선아), 이경민(플락플락)은 소수자 인권, 자아 정체성, 레즈비언과 퀴어의 사회적 위상과 권리 등의 이야기를 대화의 중심에 두고, 서로 다름의 소중함을 전한다. 엘리엇 스톡스의 〈나를 보라, 우리를 보라〉와 〈탁자에〉에서 작가는 소수자의 가시성과 발언의 자유가 보장되는 공동체 사회를 희망한다. 캘리그래피와 콜라주로 만든 촉각적/감각적 인간 형상들은 존재의 다양성과 소수자 인권을 그려낸다. 에런 니에는 디자이너가 사회 문제에 참여해야 한다는 신념을 갖고, 자신의 작업을 통해 디자인과 미학에 대한 인식의 틀을 뒤흔들고자 시도하는 디자이너다. 〈자기 해석〉과 〈자기 정체성〉은 자신의 신체에 대해 스스로 해석할 권리, 성별 고정관념에 반대할 권리를 말하며 개인의 자아 정체성의 가치를 이야기한다.

굿퀘스천(우유니, 신선아)은 〈레즈비언이 민주주의를 완성한다〉에서 성소수자 역시 정치적 주체임을 표명하고, 여성 혐오와 동성애 혐오라는 이중 차별을 당하는 레즈비언의 목소리를 전한다. 사각형의 그리드 안에 퍼즐처럼 배치된 미완성의 이미지들이 하나로 합쳐질 때 그 이미지가 완성된다. 작가는 레즈비언이 주변부에 머물지 않는 평등한 사회를 만드는 것이 민주주의를 완성하는 방법이라 말한다. 이경민(플락플락)은 지속적으로 퀴어의 목소리를 시각 메시지로 전환하는 작업을 하는 디자이너다. 작가는 성소수자를 서로 연결해 주고 정보를 공유하게 해주었던 퀴어 관련 연속간행물에 주목하고 1994년부터 2000년대 중반까지 한국에서 발행된 퀴어 연속 간행물 48종의 뒤표지, 제목, 발행 연도, 발행처 정보를 기록하여 변방에 있던 퀴어 출판문화를 기록의 중심에 놓는다. 〈이것은 뒤표지라능…〉에서는 주로 책의 앞표지를 기록하는 출판계의 관행을 따르지 않고, 퀴어 간행물의 뒤표지를 나열함으로써 퀴어 공동체의 이면을 보여준다. 〈Adobe 명조 Std, M, 12pt, 14.4pt〉는 비전문적인 방식으로 제작되고 유통되었던 그 간행물들의 서지 정보를 전문화된 디자인 프로그램의 기본값으로 다시 기록한다.

다름을 인정하지 않는 사회는 구조적 차별과 폭력을 낳는다. 근래 한국에서 벌어지는 여성 혐오는 오프라인을 넘어 온라인 공간에서 치열한 논쟁을 일으켰고, 언론과 정치는 젠더 갈등 자체만을 부각하여 여성 혐오를 확대하고 재생산함으로써 여성을 대상으로 한 구조적 차별을 은폐하고 있다. 신인아, 권민호, 이지원(아키타입), 박새한, 게릴라 걸즈는 한국 민주화 운동의 역사화 과정에서 경시되어 온 여성의 활동, 페미사이드(femicide) 범죄, 성차별의 현실을 다루며, 맹목적 혐오의 폭력성과 집단 및 사회 내 구조적 차별의 심각성을 알린다. 신인아는 여성 디자이너가 일을 더 오래 잘할 수 있는 방법을 이야기하는 모임인 페미니스트 디자이너 소셜 클럽(Feminist Designer Social Club, FDSC)의 운영자이며, 글쓰기와 디자인을 통해 사회적 목소리를 내는 디자이너이다. 한국 민주화 운동의 역사화 과정에서 여성과 소수자의 역할이 제대로 살펴지지 않았다는 점에 주목하고 그들의 목소리를 이어보려는 행위로서의 디자인을 실천하기 위해, 여성주의 행사의 걸개 디자인 레터링을 소환해 '누구의 민주주의', '평생 평등 언제?'를 질문한다. 비슷한 맥락에서 권민호의 〈줍지 못한

조개〉와 〈민주화와 인권회복을 위하여〉는 한국 민주화 운동의 역사 속에서 운동의 주체였음에도 불구하고 타자가 되어야만 했던 여성의 존재를 흑백의 콜라주로 재현하며, 여성 인권과 여성 해방을 미완으로 남겨둔 진보 민주주의 이데올로기의 모순을 지적한다. 이지원(아키타입)은 한국과 전 세계 페미사이드의 현황을 수치화한 기록을 시각 메시지로 전환한다. 한국은 정부의 공식 집계가 없는 상태이고, 전 세계의 현황은 페미사이드 범죄 관리 체계를 갖춘 국가들에 국한한 통계이기에 이 숫자를 넘어서는 현실은 더 참담할 수 있음을 이야기한다. 박새한은 〈떠나보낸 이들을 기억하며〉와 〈함께 걸으며〉에서 살해된 여성 희생자들의 영혼을 추모하고 소환하며, 희생자에 대한 충분한 애도와 기억이 연대를 위한 조건이라고 말한다. 1985년 미국에서 결성된 이래 현재까지 젠더와 인종에 대한 편견을 폭로해 온 익명의 예술가·활동가 그룹 게릴라 걸스는 〈페미니즘이 빠지면 민주주의가 아니다!〉에서 "페미니즘은 모든 젠더를 위한 권리를 성취하고자 하는 투쟁"[5]이라고 말하며, 민주주의와 페미니즘의 관계성을 강조한다. 작가는 한국 사회의 높은 교육 및 경제 수준과는 비교되는 낮은 성평등 현실을 통계적으로 제시함으로써, 성차별이야말로 한국뿐만 아니라 미국 등 발전된 민주주의 국가에서도 발견되는 공통적인 문제임을 상기시킨다.

안타깝게도 전 세계 성평등 현실 역시 역행하고 있다. 여성의 권리를 보장하기는커녕 이미 확립된 제도적·법적 보호 장치마저 뒤집는 지경에 이르렀다. 애니나 테게프, 로시 루즈베하니, 멜린다 베크, 레이븐은 아프가니스탄, 이란, 미국, 미얀마 등 세계 각지에서 벌어지고 있는 여성에 대한 구조적 억압을 고발하고, 여성들의 멈추지 않는 저항과 미래에 대한 희망을 그린다. 애니나 테케프는 아프가니스탄 여성의 인권과 부르카의 상징적 의미를 살펴보며, 탈레반에 의해 압박과 침해를 받고 있는 현실 및 자유를 향해 발언하는 투쟁을 그린다. 2022년 9월 이란에서 히잡을 제대로 쓰지 않았다는 이유로 경찰에 체포된 지 사흘 만에 숨진 지나 마흐사 아미니(Jina Mahsa Amini)의 비석에는 "당신은 죽지 않았습니다. 당신의 이름은 상징이 될 것입니다."라는 글귀가 새겨졌다. 이후 히잡을 불태우고 머리카락을 자르며 '여성, 생명, 자유'를 외치는 시위가 이란 전역을 넘어 전 세계적인 지지와 연대로 이어졌다. 영국에서 활동하고 있는 이란

출생의 로시 루즈베하니는 일러스트레이션을 통해 이란 여성들의 저항을 지지하는 메시지를 분명하게 전달하며, 미래에 대한 희망 또한 잃지 않고 있다는 자신의 목소리를 더한다.[6] 멜린다 베크는 여성의 신체를 억압하는 사회적·문화적·법적 시스템에 주목한다. 작가는 〈나의 몸 나의 목소리〉에서 이란 여성 지나 마흐사 아미니의 허망한 죽음을 애도하면서, 머리칼을 자르며 자유를 외치는 여성의 모습을 그린다. 같은 맥락에서 〈나의 몸 나의 선택〉은 2022년 6월 미국 대법원이 뒤집은 여성의 임신중지권리[7]에 대한 분노와 투쟁을 불꽃과 같은 붉은 머리칼의 은유로 극대화한다. 2021년 2월 미얀마 군부의 쿠데타에 비폭력으로 저항한 시민불복종운동(Civil Disobedience Movement, CDM)은 2년이 지난 지금도 계속되고 있다. 레이븐은 미얀마의 농작물과 가정을 돌보며 평생을 보냈던 여성들, 국가를 위해 봉사했던 여성들, 그리고 이제는 목숨을 걸고 싸우는 여성들에게 곧 평화와 희망이 오길 바란다고 말한다. 레이븐의 작업 속 환한 미소를 띤 여성의 모습은 저항을 멈추지 않는 미얀마 민중의 아름답고 강인한 힘을 전한다.

한국 전국장애인차별철폐연대는 지난 2021년 12월부터 서울의 여러 지하철역에서 수십 차례에 걸쳐 장애인 이동권 보장 시위를 해왔다. 일각에서는 시민들의 출퇴근에 불편을 준다는 이유로 장애인과 시민의 경계를 가르고, 정치권은 이동권 문제 해결은커녕 시민과 시민 사이의 갈등만을 부풀린 무능함을 보여주고 있다. 이재영(6699프레스)과 윤예지는 이러한 한국 사회에서 장애인과 노동자가 겪는 차별과 불평등이 모든 사람의 문제임을 지적한다. 이재영(6699프레스)은 〈장애인, 시민, 나〉에서 사회가 모든 시민에게 완전한 평등을 제공하고 있는지를 묻고, 장애인 이동권 보장을

5 작가와의 대화, 2023년 6월 13일.

6 "나는 우리 국민들의 용기와 힘에 경외감을 느끼고 그들이 자랑스럽습니다. 화가 나고 슬프고 두렵지만 희망적이기도 합니다." Dom Carter, "Roshi Rouzbehani on saving the world with art, empowering women, and developing her own visual language," *Creative Boom*, October 24, 2022. https://www.creativeboom.com/inspiration/roshi-rouzbehani/

7 2022년 미국 대법원은 임신 6개월까지 낙태를 연방 차원에서 합법화한 '로 대 웨이드' 판결을 폐기하고 낙태권 존폐에 관한 결정 권한을 주(州)로 넘겼다. 2023년 11월 7일 오하이오주에서 낙태 권리를 주 헌법에 명기하는 개헌안이 통과됨으로써, '로 대 웨이드' 판결 폐기 이후 낙태권 보장을 결정한 7번째 주로 기록됐다. 최근 이러한 미국 내 낙태 허용 움직임은 미국 대선의 주된 쟁점인 낙태 이슈를 놓고 긴 싸움이 지속될 것을 예상하게 한다.

위한 노력을 촉구한다. 〈모든 차별에 반대한다〉에서는 기울어진 글자 '차별'
위에 수평으로 글자 '평등'을 배열하여 차별금지법과 같은 사회적 제도를
통해 기울어진 차별을 바로 세우고 평등한 사회가 실현되어야 함을 말한다.
윤예지는 최근 한국 사회에서 일어난 전국장애인차별철폐연대 시위, 제빵
공장 노동자 사망 사고, 화물연대 시위 등의 사건을 배경으로 한 작업 〈장애인을
거꾸러뜨리며〉와 〈노동자를 거꾸러뜨리며〉에서 장애인이 어디든 이동할
수 있는 권리, 인간적인 환경에서 노동할 권리, 모든 사람의 존엄을 그린다.

　　자신의 신념과 실질적 생존을 위해 국경을 넘는 사람들은 고용, 의료,
안전, 식량, 굶주림 등의 문제에 부딪힌다. 이들은 '보호받을 자격'이
있는지를 심사받고, 쫓겨나고, 거부당하는 고통을 겪으며 난민이 되거나
난민과 같은 불안정한 삶을 살게 된다.[8] 엘머 소사, 루이스 마존, 프란체스카
산나, 다이애나 에자이타, 루카 손치니는 국경의 의미, 이동의 자유와 평등,
난민화의 현실 등을 그리며 경계에 선 사람들에 대한 존중 혹은 인도적인
지원을 요청한다. 멕시코 디자이너 엘머 소사는 〈국경은 없다〉에서 난민과
이민자들의 당연한 권리인 '이동의 자유'를 다루며, 〈평등〉에서는 모두에게
동등한 생명을 부여하는 심장의 이미지로 '우리는 모두 같음'을 이야기한다.
기후 변화, 전쟁, 분쟁, 폭력으로 인해서 전 세계의 난민 위기는 점점 증가하고
있다. 루이스 마존은 흔들리는 빛과 수많은 점으로 세계의 난민화를 점묘한다.
그가 그려낸 〈조용한 물결〉과 〈로스트 인 림보〉는 입체적 윤곽선이 사라진
불안정한 몸들의 형상, 선명하지만 비현실적인 수평선과의 대조를 통해서
난민화된 삶과 존재의 죽음을 포착한다. 프란체스카 산나는 이탈리아 난민
수용소에서 만난 두 소녀의 이야기와 유럽의 여러 난민들과의 인터뷰를
바탕으로 한 그림책 『긴 여행』(The Journey)을 쓰고 그린 작가이다. 전쟁으로
인한 난민화의 고통스러운 여정을 난민 소녀의 시점으로 그린 이 책에서
자유롭게 날아가는 새는 새로운 보금자리를 찾아 안전한 삶을 시작할
수 있으리라는 희망을 상징한다. 〈안전한 집을 가질 권리…〉와 〈…는
인권이다〉는 새장에 갇혔던 다양한 종류의 새들이 새장 밖으로 자유롭게
날아가는 모습을 그리며, 모두가 안전한 삶에서 자유를 누릴 권리를
이야기한다. 중앙아프리카의 문학과 예술을 사랑하는 다이애나 에자이타는
평화롭게 살기 위한 조건에 주목한다. 작가는 〈이동〉에서 삼원색의 형상들이

만들어 내는 다양한 중첩을 통하여 모두가 자유롭게 공간을 이동할 수 있는 권리를, 〈존재〉에서는 모든 형상들이 서로에게 전경(foreground)이면서 동시에 배경(background)이 되도록 연결함으로써 모두의 삶이 존중받을 권리를 표현한다. 2022년 전 세계 난민 인구의 70%가 심각한 식량 불안정의 영향을 받는 국가 또는 지역에 거주했다고 한다. 특히 전쟁이나 분쟁지역에서 사람들이 겪는 굶주림의 고통은 그들이 난민화되는 원인이기도 하다.[9] 루카 손치니의 〈식량 위기〉는 아프리카 동부에 거주하는 사람들에게 필요한 '식량에 접근할 수 있는 권리'와 그 권리에 대한 존중을 이야기한다.

씨앗뭉치: 공감과 연대

『저항의 예술: 포스터로 읽는 100여 년 저항과 투쟁의 역사』에 실린 국제앰네스티의 후기에는 "오늘날 우리가 가진 소중한 자유는 수백 년에 걸친 투쟁과 저항을 통해 얻은 것이다. … 이는 표현의 자유와 긴밀하게 연결되어 있다. … 1961년 국제앰네스티 운동이 시작된 이래 앰네스티 각국 지부에서는 다양한 포스터를 제작해왔고 억압에 맞서 어떻게 싸워왔는지 증명해왔다."[10]고 적혀있다. 민주주의와 인권을 진전시키기 위해서 다수를 위해 하나가 되어 투쟁하며, 하나를 위해 다수가 연대하는 인류애적·공생적 접근이 필요하다. 이 장에서는 저항, 자유, 열린 공감과 연대를 위한 방법 등에 관한 작가들의 생각과 표현을 이어간다.

파흐미 레자, 일레인 로페즈, 일레인 L. 시멘트(박용훈, 양효정)는 말레이시아, 쿠바, 중국, 한국에서 있었던 자유를 위한 저항, 다수를 위한 투쟁 이야기를 전한다. 말레이시아의 파흐미 레자는 한국 민주화 운동의 저항 정신을 존중하고, 수년 전 광주를 방문했을 때 보았던 목판화 작업을

8 2018년 예멘 난민들이 제주도에 왔을 때 국내에서 난민 혐오 여론이 고조되며 '가짜 난민'이라는 말이 떠돌았다. 김기남 외, 『난민, 난민화되는 삶』(서울: 갈무리, 2020)은 당시 한국 사회의 모습을 계기로 하여 시작된 책이다.

9 Charles E. Owubah, "The Refugee Crisis is a Hunger Crisis," *Fair Planet*, July 7, 2023. https://www.fairplanet.org/op-ed/the-refugee-crisis-is-a-hunger-crisis/

10 조 리폰, 『저항의 예술: 포스터로 읽는 100여 년 저항과 투쟁의 역사』, 김경애 옮김, 국제앰네스티 협력 기획(서울: 한겨레엔, 2022), 171.

기억하며 이번 작업을 진행했다. 〈경찰은 가혹 행위를 중단하라〉는 경찰의
폭력과 책임자 처벌 부재의 문제를 지적하며, 이에 맞서 싸울 것을 촉구한다.
〈민주주의의 편에 서라〉는 미얀마에서 군부 쿠데타에 대한 반대와 민주화를
위한 연대의 표시로 등장한 세 손가락 경례(소설/영화 〈헝거 게임〉에서 영감을
받은 저항의 상징) 이미지를 통해 자유를 위해 싸우는 이들의 용기에 힘을
보탠다. 쿠바계 미국인인 일레인 로페즈는 1960년대 쿠바의 공산정권에
반대하여 정치범으로 수감되었던 할아버지를 기억하며 이 프로젝트에
임했다. 〈파트리아 이 비다(조국 그리고 삶)〉는 국민을 억압하는 쿠바 정부를
비판하고, 자유를 열망하는 반정부 시위에 주목한다. 작가는 철자 수가 다른
두 단어(Patria, Vida)의 폭을 같게 함으로써, '국가'와 국민의 자유로운 '삶'
사이의 균형을 표현하고, 그 말의 힘을 반복적으로 증폭시킨다. 〈다마스 데
블랑코(흰옷을 입은 여성들)〉는 쿠바에서 수감 혹은 실종된 반체제 인사들의
아내와 가족들이 모여 2003년에 결성한 인권 단체에 관한 이야기다.
작가는 이 작품에서 평등, 박애, 자유를 상징하는 붉은 정삼각형과 인권
단체의 지도자인 베르타 솔레르(Berta Soler)의 모습을 겹침으로써 흰옷을
입은 여성들이 펼쳐 온 반정부 평화운동의 역사와 의미를 전한다. 중국에서
태어나 미국에서 활동하고 있는 일러스트레이터 일레인 L은 섬세한 선,
부드러운 색, 독특한 질감의 작업을 통해 사회적 문제를 예리하게 비판한다.
〈시위자들 (1989)〉은 1989년 천안문 광장 시위 당시 학생들이 세운 민주의
여신상 앞에서 개혁과 자유를 외치는 젊은 시위자들의 모습을 천안문 이후
세대의 시각으로 다시 기념한다. 동일한 구도의 〈시위자들 (2022)〉은 2022년
코로나19 봉쇄 조치로 인해 사상자가 발생한 화재 사건 이후 빈 종이를
들고 언론의 자유를 외치고 있는 시위자들의 용기를 기린다. 이번 작업에서
작가는 섬세한 빛을 사용해 시위자들의 사실적인 얼굴 특징을 의도적으로
감추거나 흐릿하게 하는 예술적 방법을 시도했다. 시멘트(박용훈, 양효정)는
1987년 한국의 민주화 운동 당시 경찰과 시위대가 대치한 모습을 찍은 두
장의 보도 사진을 뒤틀린 형상으로 재구성한다. 다양한 각도로 변형된 사진과
모션 그래픽을 통해 '힘'의 양면성, 지배권력과 저항의 힘을 표현한다.
　　저항은 거부할 자유, 표현할 자유, 참여할 자유, 참여에 대한 비밀을
보장받을 자유, 발언할 자유를 향해 간다. 국지은, 오사와 유다이, 문상현,

골든 코스모스(도리스 프라이고파스, 다니엘 돌즈)는 인류애적 태도에 기초한
자유를 얻기 위해서 진정한 화해의 조건, 당연하게 여기는 인권에 대한
감사, 공동의 가치에 부합하는 기술 윤리, 발언의 힘에 대해 이야기한다.
국지은은 2022년 12월 대한민국 정부가 공표한 '2023년 신년 특별사면 복권
실시'에 관한 보도자료를 바탕으로 한국 사회에서 파괴된 화해의 문법을
재구성한다. 불투명한 회색의 지면과 텅 빈 그리드는 사과하지 않았던
국가폭력의 가해자들에게 정부가 베풀어 온 '사면'의 의미를 다시 생각하게
한다. 진정한 과거 청산을 위한 가해자들의 진심 어린 반성과 사과의 필요성을
전한다. 오사와 유다이는 〈우리는 인권에 감사를 표합니다〉를 통해 평등하고
공정한 사회가 완성되기를 희망하며, 인권의 중요성을 자각할 수 있도록
인권에 감사를 전하는 입체적 인간을 그린다. '구글 개인정보처리방침'을
배경으로 삼는 문상현의 〈도덕적 행위자로서 기술〉은 중립적이지 않은
기술에 관한 깊은 윤리적 담론 형성을 제안한다. 공동의 가치, 노력, 합의 없이
기술을 발전시키고 그 사용을 계속한다면 인간의 소통은 감시 통제당하며,
세계는 억압과 차별을 자동화하는 사회가 될 것이라고 경고한다. 골든
코스모스(도리스 프라이고파스, 다니엘 돌즈)는 의사 표현의 자유의 중요성과
발언의 위력을 전한다. '말풍선' 이미지를 활용하여 발언의 자유가 전체주의의
표적이 되기도 하고, 총보다 강하기도 하다는 것을 상징적으로 표현한다.

사회의 규모가 크고 복잡해질수록 자유와 평등의 사각지대는 넓어지고,
자본주의가 민주적 절차에 영향을 미칠수록 사회 개혁은 멀어진다. 나와 다른
이들의 인권을 지키고, 사회 개혁으로 나아가기 위해서 연대가 필요하다.
사키 호와 세바스티안 큐리의 작업은 권력과 공포를 무력화하는 공감과
연대의 힘을 그린다. 사키 호는 〈존재하는 권력〉과 〈존재하는 공포〉에서
'권력을 관통하는 연대의 힘'과 '공포를 무너뜨리는 취약함의 역설적인
힘'이라는 메시지를 타이포그래피의 구성과 대비를 통해 효과적으로
전달한다. 글자 'POWERS'(권력)는 'In Solidarity We Fight'(우리는
연대하여 싸운다)라는 문구로 가득 채워지며, 글자 'FEARS'(공포)는 'With
Vulnerability We Fight'(우리는 취약함으로 싸운다)라는 문구와 함께 무너진다.
2019년 홍콩 시위에서는 배우 이소룡(Bruce Lee)이 생전에 남긴 어록 "물은
흘러갈 수 있고, 파괴할 수도 있다. 물이 되어라. 친구여."가 구호가 되어

울려 퍼졌다. 사키 호의 작업은 이러한 '익명의 집단이 형성하는 새로운
정체성, 그 단결성과 유동성의 힘'"을 떠올리게 한다. 세바스티안 큐리의
〈여기에서 시작하다〉와 〈우리는 함께 가기 때문에 먼 길을 간다〉는 인간의
마음과 힘을 표현하는 강력한 도구이자 형식인 '손'의 언어와 상징을
통해서 지속적 민주주의를 위한 조건으로 공감과 연대를 말한다.

　　스튜디오 하프-보틀, 킴 알브레히트, 스튜디오 헤잔느 달 벨로,
장문정은 열린 공감과 연대로 나아가기 위해 시도해 볼 여러 가지 방법을
고민한다. 민주주의 사회를 지탱하기 위한 지속적인 노력과 행동, 정확한
정보와 다차원적 질문을 통한 민주주의 발전 정도 분석, 직접적·참여적
방식을 통한 시민의 의견 수집, 그리고 민주주의 역사의 재맥락화 등이다.
스튜디오 하프-보틀은 최근 서울에서 일어난 마포출판문화진흥센터
운영 파행을 막고자 모인 협의회에 참여했던 작가의 경험을 기록함으로써
민주적 소통, 절차, 집행의 현실을 보여준다. 민주인권과 사회운동에서
소소해 보이지만 반드시 필요한 일을 감당하는 사람들의 노동을 기념할
것을 제안하고, 사회운동과 일상적 업무 사이의 균형 및 우선순위에 대한
갈등을 공유한다. 킴 알브레히트는 스웨덴의 민주주의 다양성 연구소(V-
Dem)로부터 발췌한 민주주의 관련 질문을 바탕으로 국가별 민주주의 발전
추이를 비교하고, 복잡한 민주주의의 의미를 살펴본다. 많은 국가들을
대상으로 추적한 여성의 정치적 역량 강화와 정치적 부패 정도, 이동의
자유와 학문적 자유 정도의 추이 변화를 그래프로 보여준다. 그 결과로서
민주주의의 불안정하고 불균형한 발전을 보여주는 동시에 민주주의
지표들이 서로 연관되어 있음을 밝힌다. 스튜디오 헤잔느 달 벨로의 〈시민이
먼저, 디자이너는 그다음〉은 민주주의와 디자인의 관계를 고민한다.
작가는 한 사회의 시민으로서 책임이 우선한다는 것을 간결하지만 단호한
타이포그래피로 선언한다. 또한 각 개인에게 "인권과 관련하여, 첫 번째는
무엇이며, 두 번째는 무엇인가"라는 질문을 던짐으로써, 참여적 디자인과
민주적 소통을 유도한다. 마지막으로 장문정은 1960-1970년대 뉴욕 도시
환경 운동에서 사용했던 '씨앗폭탄(Seed Bombs)'에서 영감을 받아, 당시
미국의 시민권 운동에 쓰였던 슬로건을 소환하여 〈민주주의 씨앗폭탄〉을
만든다. 미국 전역의 지역사회와 세계의 연대를 실천한 '블랙 라이브스

매터'(Black Lives Matter)와 '아시아·태평양계 미국인에 대한 혐오 중단'(Stop AAPI Hate)의 목소리도 함께 담았다. 작가는 씨앗 뭉치에서 초록의 생명들이 터져 나오듯이, '사람'과 '시민'을 살리는 초록빛 민주주의를 상상한다.

새로운 시민 공간의 창출

본 출판물에는 앞서 소개한 참여 작가들의 포스터 이미지와 그들이 직접 쓴 작품 설명을 함께 수록하였다. 이를 통해서 작가들이 고민했던 민주주의와 인권에 관한 생각, 태도, 그리고 접근 방식을 구체적으로 이해하는 데 도움이 되길 바라며, 무엇보다도 말로는 설명할 수 없었던 작가들의 진정성과 시각언어로서 포스터의 힘이 전해지기를 기대한다. 또한 필자 네 명의 원고를 수록하여 '민주화 및 인권 운동에서 폭력의 문제를 어떻게 재현할 것인지', '국가폭력의 역사를 시각적으로 기념한다는 것은 어떤 의미를 가지며, 그 시각 표현의 가능성과 한계는 무엇인지', '지금의 시각문화/디자인 액티비즘의 현장은 어디에 있고, 어떤 미래를 구상하고 있는지', '디자인은 민주주의를 위해 무엇을 할 수 있을지' 등을 다시 짚어보고자 했다.

정근식은 「폭력과 이를 넘어서는 정의에 관하여」라는 글을 통해 탈식민지, 탈전쟁, 탈권위주의 시기에 정의를 실현하는 과정에서 우리가 직면했던 폭력의 유형과 성격을 어떻게 개념화하고 이론화할 것인지, 나아가 폭력과 인권의 문제를 어떻게 시각화할 것인지를 생각해 본다. 그는 정의의 실현은 예술적 상상력을 필요로 하는 문화적 프로젝트이기도 하다고 말하며, 다양하게 분화된 인권의 현대적 쟁점들을 예리하게 포착할 수 있는 눈을 예술가의 감수성에서 찾을 수 있다고 한다.[12] 김상규는 2019년 민주인권기념관 기획전 《잠금해제》의 큐레이터로 남영동 대공분실을 기억하고 기념하되 "아픈 역사를 간직한 곳이 과거의 흔적으로만 남지

11 Vivienne Chow, "The powerful images of Hong Kong's protests," *BBC Culture*, December 12, 2019. https://www.bbc.com/culture/article/20191211-the-powerful-images-of-hong-kongs-protests

12 정근식, 「양심수에서 공동체적 연대로: 민주화운동기 인권 이미지의 전환」, 『인권연구』 3권 2호(2020): 29. 본 논문에서 정근식은 인권의 시각적 이미지는 강력한 사회적 영향력을 갖는다고 피력한다.

않도록, 이미 끝난 어떤 사건처럼 잊히지 않도록 끊임없는 대화가 이어질 수 있기를 바라며"[13] 전시를 기획했다고 쓴 바 있다. 「국가폭력의 역사에 대한 시각적 기념, 그 가능성과 한계」에서도 김상규는 시각적 기념에서 누구를 위한 기억인가, 무엇을 기억할 것인가를 고려해야 함을 언급하며, 기념의 목적은 살아있는 기억, 사회적 기억의 활성화에 있어야 한다고 강조한다. 게이코 세이는 「군부와 청소년 행동주의: 태국의 경우」에서 2023년 5월 태국 총선에서 전진당(Move Forward Party)이 거둔 승리의 결정적 요인으로 제트(Z) 세대 청소년들의 신선한 행동주의를 꼽는다. 그리고 19번의 쿠데타를 거친 나라인 태국에서 앞으로 펼쳐질 시나리오는 누구도 예상할 수 없지만, 그 길고 험난한 길에서 그래픽 디자인 활동가들이 내적 부름에 답한 반응은 중요한 기록이 될 것이라고 말한다.[14] 에치오 만치니는 「프로젝트 중심 민주주의: 민주주의 실험을 위한 디자인」에서 2017년 3월 디자인 공동체를 향해 민주주의를 위한 행동을 촉구했던 공개서한[15]에서부터 시작해 참여적 민주주의의 새로운 형태로 '프로젝트 중심 민주주의 시나리오'를 제안하며, 사회혁신을 위한 디자인의 역할을 강조한다.

필자들의 글은 개관을 앞둔 민주화운동기념관이 담아 나가야 할 '예술적 상상력, 적극적인 가공을 더한 시각적 표현, 신선한 행동주의, 참여적 민주주의 프로젝트' 등을 생각해 보게 한다. 이어서 2023년 6월 부산의 동서대학교 디자인대학 재학생들과 함께한 민주인권 디자인 워크숍의 내용을 짧게 소개하였다. 워크숍 참여자들은 각자의 마음속에 숨겨둔 민주인권의 씨앗뭉치를 꺼내놓고, 터트리고, 소통하며, 울고, 웃었다. 민주인권을 주제로 함께 동영상을 디자인하면서 익숙하지 않은 것을 적극적으로 보기, 내면의 목소리를 창의적인 디자인 행동으로 전환하기, 그리고 '시민'으로서 디자이너의 사회적 역할 생각하기 등을 배웠던 소중한 시간이었다. 시민이 공공문제에 참여하고 말할 수 있는 시공간이 점점 줄어들고 있다고 한다.[16] "널리 알려진 문제면서도 여전히 더 많은 운동과 실천이 필요할 때"[17] 포스터는 만들어진다. 이 책에 실린 포스터들이 새로운 시민 공간을 창조하고, 민주주의와 인권의 문제를 해결하는 데 도움이 되기를 바란다. 오래된 계몽이 아닌, 역동적이고 유기적인 미래로 안내할 이 책에 독자들의 해석과 목소리가 더해져서 건강하고 의미 있는 대화와 혁신으로

이어지기를 희망한다. 끝으로 민주주의와 인권이라는 쉽지 않은 주제에 대해 여러 이야기를 함께 나누고, 간결하면서도 정확한 메시지를 담아 포스터로 프로젝트에 참여해 준 참여 작가들에게 진심 어린 감사 인사를 드린다. 또한 민주화운동기념관이 연구해야 할 시각 언어에 대해 생각해 볼 수 있게 해준 필자들의 깊은 통찰과 번역자들의 노고에도 감사를 전한다. 그리고 민주주의와 인권을 생각하는 시민이 된다는 것에 대한 소중한 공부를 함께 해준 워크숍 참여 학생들과 도움을 주신 모든 이에게도 고마움을 표한다.

13 김상규, 「기획 글」, 『잠금해제』(서울: 민주화운동기념사업회, 2019), 13.

14 베를린 장벽 붕괴 20주년을 기념해 2010-2011해 독일 슈투트가르트 미술관에서 열린 전시 《동방을 재디자인한다》(Re-designing the East, 이후 그단스크, 서울, 부다페스트에서 순회전)는 헝가리, 폴란드, 체코슬로바키아, 태국, 한국, 인도의 정치적 변화, 민주화 과정, 급속한 경제 발전의 맥락 속에서 정치적 디자인의 역할을 살펴보았다. 큐레이터로 참여한 게이코 세이는 태국의 디자이너 프라챠 수비라논트의 포스터 및 캠페인 작업을 소개했으며, 출판물에 수록된 글을 통해 디자인이 전하는 역사의 해석에 대해 이야기했다. Keiko Sei, "The Moment That Made a Designer Political," *Re-Designing the East: Political Design in Asia and Europe*, eds. Iris Dressler and Hans Christ (Ostfildern: Hatje Cantz Verlag, 2012), 194-201.

15 에치오 만치니와 빅터 마골린(Victor Margolin) 교수는 2017년 3월 세계 곳곳의 디자인 커뮤니티에 민주주의의 회복을 위해 동참하고 자발적인 행사를 열어주길 요청하는 공개서한을 발송하며 '민주주의를 위해 일어서라'(Stand Up for Democracy) 운동을 시작했다. 이후 밀라노 공과대학교 디자인학과 소속 연구실 동료들은 '민주주의 디자인 플랫폼'(Democracy Design Platform)이라는 이름의 디지털 플랫폼을 제안해 이 운동 중 생겨나는 선언과 행사 정보를 수집하고 있다. 이는 지속적인 행동과 대화를 촉발시키며, 참여 민주주의에 대해 다시금 생각해보길 제안한다. Ezio Manzini and Victor Margolin, "Open Letter to the Design Community: Stand Up For Democracy," Democracy and Design Platform, March 5, 2017. http://democracy-design.designpolicy.eu/open-letter-stand-up-democracy/

16 지지 파파차리시, 『민주주의 그 너머』, 이상원 옮김(서울: 뜰Book, 2022), 106.

17 Steven Heller, "Can Posters Still Change the World?," *The Atlantic*, October 7, 2015. https://www.theatlantic.com/entertainment/archive/2015/10/can-posters-still-change-the-world/409078에서 엘리자베스 레스닉(Elizabeth Resnick)의 말 재인용.

Seed Pods of Democracy

Moon Jung Jang, Kyungwon Kim, and Yumi Kang
Democracy Poster Project Team

Standing on the platform of Namyeong subway station in the
heart of Seoul, you can look across the wall to see a dark gray
building: the Namyeong-dong Anti-Communist Investigation
Office. The structure bears silent witness to a grim era in history.
The office was designed in 1976 as a "perfect torture chamber,"
intended to maximize the effectiveness of torture and interrogation.
Ordinary citizens and students were brought there and framed
as spies or communists, with official records alone documenting
around four hundred victims. In June 1987, the South Korean
public was confronted with the horrific reality of this state violence
after Park Jong-cheol died as a result of torture, an incident that
touched off a nationwide uprising for democracy.[1] Since then, the
Namyeong-dong Anti-Communist Investigation Office was used
as the Security Division of the National Police Agency until 2005,
when it was repurposed into the Korean National Police Agency
Human Rights Center. In 2018, the government announced

the transformation of the Namyeong-dong Anti-Communist Investigation Office into the National Museum of Korean Democracy. Presently, the Korea Democracy Foundation is preparing to open the National Museum of Korean Democracy (scheduled for 2024) as a space for memory and reflection, communication and solidarity, and education, as well as a new place for citizens where they can directly feel and engage with it like a living organism.

The Democracy Poster Project was conceived to support these changes in the memorial hall by collecting and preserving artistic work related to the democratization movement and human rights, and sharing issues related to democracy and human rights to enhance broader awareness. The project uses posters as a medium to explore incidents and issues involving resistance to state abuses, anti-democratic activities, and human rights infringements—events that persist in a world of intensifying polarization and domination by corporate interests. It seeks to determine how visual language might serve to maximize the effectiveness of democracy and human rights discourse and practice. The participants in this project encompass a wide range of backgrounds and artistic approaches. They range from designers representing contemporary voices to illustrators depicting social and cultural issues related to influential media. Some of the artists work in environments where state violence is currently taking place, and others tell stories that relate to multinational, multiple identities. These creators, who readily agreed to participate, added depth and variety to the project. To enable viewers to comprehend the state and problem areas of global democracy today, these artists juxtaposed or connected two newly created posters. These posters aim to explore and expand on incidents related to systems and key values of democracy, acts of state violence, and human rights within

1 Please refer to the following article on the Namyeong-dong Anti-Communist Investigation Office. The link also provides 360-degree video taken in various places inside the Namyeong-dong Anti-Communist Investigation Office building. "The Namyeong-dong Anti-Communist Investigation Office: Designed by Geniuses as a 'Perfect Torture Chamber,'" *Hankook Ilbo*, June 10, 2020. https://interactive.hankookilbo.com/v/namyoungdong

their historical temporal and spatial contexts. They applied dynamic visual language in their interpretations of dignity, empathy, memory, critique, dialogue, boundaries, resilience, future, sustainability, and solidarity. The posters raise questions about the present and future of democracy, mourn the lives lost in the democratization process, and shed light on the suffering experienced by the vulnerable in society and throughout history. The variety and depth of stories in the posters illustrate the power and importance of solidarity.

Democracy: Persistent questions

On the International Day of Democracy in 2022, UN Secretary-General António Guterres shared a message of concern, "… Across the world, democracy is backsliding. Civic space is shrinking. Distrust and disinformation are growing. And polarization is undermining democratic institutions," he warned.[2] In this section, we examine the political histories and realities of various countries around the world. We also explore persistent questions and thoughts that artists have expressed regarding the reasons why democracy has been regressing as an ideal system of government.

Everyday Practice, the Seoul-based design studio, and designers, Jonathan Barnbrook, Chris Burnett, and Karo Akpokiere give visual expression to matters of state violence, absence of dialogue, irresponsible actions by those in power, polarization, the meaning of electoral systems, and outdated realpolitik practices that remain unchanged. Everyday Practice delves into the etymological essence of democracy as a concept where power in the state lies with the people. It presents the harsh reality of state violence that oppressed this power of the people during South Korea's modern and contemporary history. The studio's works 民×*KRATOS* and *DEMOS*×主 examine the relationship between the public and those in power. The narrow windows of the former Namyeong-dong Anti-Communist Investigation Office symbolize the oppression of the public, juxtaposed with the image of a broken wall representing

the public's assumption of power through resistance. In *Dialogue Not Division*, Jonathan Barnbrook provokes questions about whether North and South Korea can ever overcome differences in their political systems, the Armistice framework, and the division separating them. His work underscores the message that political issues arising in the world beyond the Korean Peninsula must be approached through dialogue rather than division, with the onus on those in power to uphold the principles of a just democratic society. Chris Burnett's work is based on the unprecedented events of January 6, 2021, when supporters of U.S. President Donald Trump—who refused to accept his loss of the 2020 presidential election—stormed the Capitol Building. Identifying divisions and severe polarization within U.S. society as underlying causes, it calls for a search for ways to steer politics toward peace, unity, and the future. The Nigerian-born, German-based artist Karo Akpokiere portrays a question-and-answer dialogue between two figures against the backdrop of a recent election in Nigeria. This dialogue offers a critique of the democratic ideals presented as institutional solutions in Western neoliberal states. It raises questions about the value of democracy in terms of freedom of choice and expression.

Cristina Daura, Garth Walker, Viktoria Cichoń, and Luca Soncini employ their artwork to criticize anti-democratic politics and explore the history of democracy, memories, and their relationship with human rights. Cristina Daura's series denounces dictatorial societies where human rights are absent, symbolizing this through her portrayal of a dead horse—a representation of a public stripped of freedom of expression. She provides insight into the perspective of political leaders who remain oblivious to the reality faced by

2 António Guterres, "Message for the International Day of Democracy," September 15, 2002. https://ukraine.un.org/en/199351-secretary-general-message-international-day-democracy. Every year, September 15 is International Democracy Day, as designated by the United Nations. The UN Secretary-General's message commemorating the 2023 International Day of Democracy, published after this article was written, addressed the need to "recognize the many threats" to democracy and focus on "empowering the next generation" to protect democracy today and in the future.

the public. The South African designer Garth Walker's *Democracy Upside Down* depicts a global crisis of democracy by juxtaposing an inverted anatomical diagram of the human body with the names of national leaders who wield power through violence and wealth. Another work by Walker titled *AMANDLA!* presents a firmly upraised fist reminiscent of the power shown by the South African public in bringing an end to apartheid policies. This image serves as a beacon of hope for the ongoing struggle to uphold democracy and human rights. Viktoria Cichoń contrasts images of political transgressions against democracy with images showing the public's struggle to preserve it. The two posters form a visual link, underscoring the importance of remembering the crimes committed by past regimes and political parties while safeguarding democracy from the forces that oppose it. Luca Soncini's *Memocracy* serves as a tribute to those who lost their lives battling to preserve democracy. Through the portrayal of a human figure standing in respectful silence before a fingerprint pattern of the countless victims' graves, the artist emphasizes the importance of commemorating the history of democracy and the need for an anthropological approach.

The India-based organization Design & People and the Thai designer Pracha Suveeranont reflect on democracy in their respective countries, conveying the message that the power to address problematic political realities lies with the public. Design & People's *3f Symphony for Democracy* provides a scathing critique of politicians who don the Gandhi cap, yet tarnish its significance through their routine acts of misrule. *Democracy Requires Grounding*, underscores the potential for change to be initiated by public participation, serving as a driving force propelling democracy forward. Pracha Suveeranont uses his *Democracy That Planted in Our Soil* to depict a reality where political development is hindered by an old belief that the roots of democracy do not thrive in Thailand's soil. The stunted growth of Thai democracy is represented in the image of a tree with extensive roots that struggle to break through the ground. In *My Street View #1*, he uses his own photographs of dying or dead

toads to starkly illustrate how people remain quiet to survive within Thai society. The artist conveys that while the reality we see every day may resemble the toad flattened against the Earth's surface, the public possesses the power to enable democracy to flourish.

In a temporal and spatial environment characterized by wars among states and conflicts stemming from territorial occupation and religious or philosophical differences, democracy worldwide faces threats from anti-democratic acts and forms of victimization, including state violence, political and war crimes, and human rights abuses. Chris Lee, Kateryna Korolevtseva, and Mykola Kovalenko communicate messages about colonial rule and the violence of war. Chris Lee travels between the continents of North America and Europe, examining public spaces as colonialized settings. As he explores cultural, geographic, and visual indicators demonstrating the persistence of colonialism in public settings, he describes the conflicts, pillaging, expulsion, and violence that are intertwined with territorial issues. He alludes to the potential for restoring local democracy and human rights through the decolonization of these spaces. The invasion of Ukraine by Russia in 2022 starkly revealed political divisions in our current troubled world. Expressing her opposition to this war through a series of *War Posters*, Ukrainian designer Kateryna Korolevtseva calls on the world to provide its support to her country.[3] Her work titled *NEVER?* lists the dates of crimes committed against Ukraine by the Soviet Union and Russia, emphasizing the importance of acknowledging these truths and preserving this history. The question mark in the "2022–202?" that appears in her work *AGAIN* prompts us to ask when we will see an end to recurring wars. Focusing on the identity and typography of Ukrainian script and language, Korolevtseva accentuates the painful theme in this

3 "It's not politics anymore, it's our reality. You can't be silent and be aloof. ... When these messages are shared, they lead to action and designers can make a difference in the name of truth and our freedom." Katerina Korolevtseva, "'You can't be silent': how designers are rallying in Ukraine," *Design Week*, March 1, 2022. https://www.designweek.co.uk/issues/28-february-5-march-2022/ukraine-graphic-design/

Seed Pods of Democracy

work with the use of fonts that may seem somewhat awkward or difficult to read. Through the connected typography, she shows how the timeline of history has continued uninterrupted. Mykola Kovalenko, a Ukrainian artist who currently resides in Slovakia, has tirelessly supported his homeland by creating posters opposing the war and selling them in NFT form while expressing his heartfelt desire to bring this series to an end.[4] Kovalenko's works, *Missile* and *Pressure*, depict the ruthless stripping of human rights by politicians and regimes, as well as the small but powerful forces that resist them, conveying forceful messages through the simplest of forms.

In addition to the environmental devastation associated with war, unusual weather patterns stemming from global warming, along with shortages of water and food, endanger all life on the planet, particularly the human rights of socially vulnerable individuals. Restoring the ravaged balance of the Earth's ecosystem and sustaining an environment where life can persist will require swift democratic action and practice. Sharing the message that "ecocide" is a grave crime against the environment, the design researcher Bernhard Lenger emphasizes that we must devote ourselves to creating laws and institutions that promote respect for life and climate health.

Human rights: Everyone's story

In the summer of 2023, we paid a visit to the former Namyeong-dong Anti-Communist Investigation Office, where construction efforts to transform it into the National Museum of Korean Democracy were underway. On the walls of this building, which had witnessed acts of state violence during South Korea's dictatorship, several passages from the "Universal Declaration of Human Rights," published in 1948, were still visible. Reading the phrases of this declaration, which begins with the word "everyone," we contemplated the relationships that "everyone" forms within a space that still bears the scars of victims whose human rights were stripped from them and of perpetrators who committed acts of state violence. This section shares stories related to

the interconnected relationship between democracy and human rights, emphasizing freedom and equality as core values intrinsic to both.

An Mano, This Ain't Rock'n'Roll (Charlie Waterhouse and Clive Russell), High on Type, and Mark Gowing are artists who share their insights about equality as a core value of democracy. *Modu* by An Mano emphasizes the right of everyone (*modu* in Korean) to pursue life, liberty, and happiness. *Mosim* considers the concept of "serving" everyone, as reflected in the philosophy of the Donghak Peasant Revolution. Through his own organic typography, the artist succinctly represents "everyone" and "serving" as fundamental aspects of democracy. This Ain't Rock'n'Roll (Charlie Waterhouse and Clive Russell) defines "everyone"—the subjects of democracy—through image of the *Mona Lisa*. This iconic work originated in the era when democracy was only just emerging. It also incorporates the Jolly Roger, a symbol associated with pirates who practiced radical forms of democracy, including consensus-based decision-making. By equating "everyone" with pirates and artists, the members envision creative, radical political subjects who devise a new form of democracy. The collective called High on Type visualizes the relationships of "everyone" in abstract terms through a typographical experience involving coexisting left and right pages and black and white colors. Reflecting the multiple meanings contained in the English words "left" (which can mean a direction or something left behind) and "right" (which can also mean a direction, a prerogative, or correctness), the artists pose philosophical questions, such as "Who's left when there is no human right?" and "Who's right when there is no human left?" Their work encourages viewer awareness as they ask the question, "Who can be said to be right (correct) when people are left without human rights?" Mark Gowing's *Language System of Overlapping Lines* (*And what I assume you shall assume*) is an abstract

4 OpenSea, an NFT trading platform, is providing NFT images of 120 posters created by Mykola Kovalenko in the 120 days following Russia's invasion of Ukraine. 80% of the collected funds will be converted into EUR accounts and allocated to support Ukraine. https://opensea.io/collection/block-war-with-art

work consisting of code-like lines in red and blue. It demands active observation from the viewer and an understanding of the system through which the lines operate. Gowing expresses how all of the lines—which point in different directions—can coexist equally as themselves when we focus on the points where they converge.

All people are equal, yet we possess differences in ethnicity, nationality, religion, sexual identity, social status, and political opinions. Failure to recognize these differences often leads to exclusion, alienation, hatred, discrimination, and the breakdown of equality. Artists Elliot Stokes, Aaron Nieh, Good Question (Yuni Ooh and Sun-ah Shin), and Kyungmin Lee (flagflag) center their dialogues on matters of minority human rights, self-identity, and the social status and rights of lesbian and queer individuals, conveying a message about the value of diversity. In *See Me, See Us* and *At the Table*, Elliot Stokes expresses his hope for a community-based society where minority visibility and the freedom to voice one's opinion are guaranteed. Created with calligraphy and collage techniques, his human forms are tactile and stimulating to the senses, symbolizing the diversity of individuals and the importance of minority human rights. Aaron Nieh believes that designers should be engaged with social issues. In his work, he disrupts cognitive frameworks that relate to design and aesthetics. Commenting on the value of the individual's self-identity, his pieces *Self-Interpretation* and *Self-Identity* assert the individual's right to interpret their own body and challenge fixed notions of gender. Good Question, a duo consisting of Yuni Ooh and Sun-ah Shin, uses the work *Lesbians Perfect Democracy* to underscore that members of sexual minorities are also political subjects. They amplify the voices of lesbians as people who face twofold discrimination in the forms of misogyny and homophobia. Incomplete images are arranged like puzzle pieces within a rectangular grid; the image is completed when those pieces are joined together. The artists are communicating the point that democracy is "completed" when we create an equal society where lesbians are not relegated to the margins. Kyungmin Lee (flagflag) is a designer whose work has transformed queer voices into

visual messages. Focusing on queer serials that connected LGBTQ individuals together and allowed them to share information, Lee documents the back covers, titles, and publication dates and places of forty-eight queer-related serials published in South Korea between 1994 and the mid-2000s. This effort moves queer publication culture from the margins to the center of archival practices. With *This Being the Back Cover ...* , he defies the conventional practice in the publishing world, which typically records only the front covers of books. By arranging images of the back covers of queer publications, he unveils hidden aspects of queer communities. In *Adobe Myungjo Std, M, 12pt, 14.4pt*, he uses fundamental values in a specialized design application to re-archive bibliographic information for publications that were produced and circulated at the time through non-specialized means.

Societies that fail to acknowledge differences often give rise to structural discrimination and violence. Recent examples of misogynistic acts in South Korea have spawned fierce debates both offline and online. However, the media and politicians tend to conceal structural discrimination against women by framing it solely as "gender-based conflict," a perspective that exacerbates and perpetuates misogyny. Shin In-ah, Minho Kwon, Jiwon Lee (archetypes), Saehan Parc, and Guerrilla Girls shed light on aspects of female activism overlooked in the historical narrative of the South Korean democratic movement. They also address femicidal crimes and the realities of gender discrimination. In the process, they raise awareness of the brutality of blind hatred and the seriousness of structural discrimination within groups and societies. Shin In-ah operates the Feminist Designer Social Club (FDSC), an organization that discusses ways for female designers to sustain their outstanding work over the long term. As a designer, she uses her writing and design to share social messages. Focusing on the fact that the contributions of women and minorities have often been overlooked in the historical narrative of the South Korean democratization movement, she uses design as a means of keeping their voices alive. She draws upon the lettering from hanging painting designs at

feminist events as she asks "Whose democracy?" and "Equality for life, when?" *The Unpicked Shell* and *For Democratization and Restoration of Human Rights* by Minho Kwon use black-and-white collages to represent women who were relegated to the status of "others" despite being active participants in the history of South Korea's democracy movement. The work comments on the contradictions within progressive democratic ideology, which leaves women's human rights and women's liberation as unfinished tasks. Jiwon Lee (archetypes) transforms quantitative data about femicide occurring in South Korea and throughout the world into visual messages. Given the absence of official figures from the South Korean government and limited global statistics on femicidal crimes, Lee suggests that the reality beyond these statistics may be more grim. In *Remembering the Lost* and *Walking Together*, Saehan Parc honors and invokes the souls of female murder victims, emphasizing that adequate mourning and remembrance of the deceased are prerequisites for solidarity. Guerrilla Girls is a group of anonymous artists and activists founded in the United States in 1985. They have worked to expose prejudice based on gender and ethnicity. In *It's Not Democracy Without Feminism!*, they emphasize the relationship between democracy and feminism, stressing that feminism is a battle for the rights of all genders.[5] By statistically illustrating the low degree of gender equality in South Korean society despite its high levels of education and economic development, the artists remind us that gender discrimination is a shared issue found not only in South Korea but in the United States and other advanced democracies.

In the global sense, gender equality has regressed. We have reached a point where we are not only unable to guarantee the rights of women throughout the world, but we are also witnessing the erosion and dismantling of previously established institutional and legal safeguards. Anina Takeff, Roshi Rouzbehani, Melinda Beck, and Raven condemn the structural oppressions inflicted upon women around the world in Afghanistan, Iran, the United States, and Myanmar. They also convey women's enduring resistance and messages of hope for the future. Anina Takeff explores the human

rights of women in Afghanistan and the symbolic meaning of the burqa. She depicts a reality where women face oppression and rights violations at the hands of the Taliban, as well as the struggle to speak out and achieve freedom. In September 2022, a woman named Jina Mahsa Amini was arrested by police in Iran for failing to wear her hijab properly; three days later, she was dead. Written on her gravestone are the words, "You did not die. Your name will become a symbol." Her death triggered demonstrations in which participants burned hijabs, cut their hair, and chanted "Women, life, freedom." The protests spread beyond Iran, drawing global support and solidarity. Iranian-born, UK-based illustrator Roshi Rouzbehani uses her illustrations to clearly share a message in support of resistance by Iranian women while also expressing her own enduring hope for the future.[6] Melinda Beck turns her attention to social, cultural, and legal systems that oppress women's bodies. With *My Body My Voice*, she mourns the needless death of Jina Mahsa Amini, while depicting women shearing their own hair as they cry out for freedom. *My Body My Choice* uses the metaphor of flame-red hair to amplify feelings of rage and resistance over a June 2022 U.S. Supreme Court decision that overturned women's rights to abortion.[7] In Myanmar, a Civil Disobedience Movement (CDM) emerged in February 2021 as a non-violent form of resistance against a military coup in the country. Two years later, the movement persists. Raven conveys a message of peace and hope for the women in Myanmar who spent their lives

5 Conversation with the artist, June 13, 2023.

6 "I am in awe of the bravery and strength of my people and am proud of them. At the same time, I'm angry and sad and scared but hopeful!" Dom Carter, "Roshi Rouzbehani on saving the world with art, empowering women, and developing her own visual language," *Creative Boom*, October 24, 2022. https://www.creativeboom.com/inspiration/roshi-rouzbehani/

7 In 2022, the U.S. Supreme Court overturned the *Roe v. Wade* decision, which legalized abortion up to six months of pregnancy at the federal level, and transferred the authority to decide on the preservation of abortion rights to individual states. On November 7, 2023, Ohio passed a constitutional amendment stipulating abortion rights in its state constitution, making it the 7th state to guarantee abortion rights after the repeal of *Roe v. Wade*. The recent movement to allow abortion in the United States signals that a long fight will continue over the issue, promising to be a major topic in the U.S. presidential election.

 Seed Pods of Democracy

tending crops and raising families, and women who have served the state and are now risking their lives to fight. The images of brightly smiling women in Raven's work express the beautiful and tenacious strength of ordinary people in Myanmar who continue to resist.

Since December 2021, the South Korean group Solidarity Against Disability Discrimination (SADD) has held dozens of protests in Seoul subway stations to demand guarantees for the mobility rights of disabled individuals. Some argue that this situation creates a divide between disabled individuals and the rest of the public due to the inconvenience it causes commuters. Politicians have not taken effective steps to resolve the mobility rights issue, but instead have exacerbated conflicts within the public, showcasing their incompetence. Jaeyoung Lee (6699press) and Yeji Yun indicate that in South Korean society, the discrimination and inequality that disabled individuals and workers experience are issues that affect everyone. Jaeyoung Lee (6699press) uses his work *A Person with Disability, A Citizen, Me* to question whether society offers complete equality to all citizens. He calls for greater efforts to guarantee the mobility rights of disabled individuals. In *Against All Discrimination*, he places the word "equality" horizontally over the slanting word "discrimination," showing the need for anti-discrimination laws and other social systems to rectify biases associated with discrimination and achieve a more equitable society. Yeji Yun's creations *Over the Bodies of the Immobilized* and *Over the Bodies of the Workers* draw inspiration from events in South Korean society, including the SADD demonstrations, the death of a worker at a bread factory, and protests by the Korean Public Service and Transport Workers' Union. Through these works of art, she expresses the right for disabled individuals to go where they want, to have the right to work in a humane environment, and to achieve the inherent dignity of all people.

Crossing national borders for reasons related to personal beliefs and practical survival, people encounter issues with employment, healthcare, safety, food, and hunger. Some undergo reviews to determine whether they are "entitled to protections," experiencing the

pain of rejection and expulsion, while others become refugees or lead lives characterized by instability akin to that of refugees.[8] The images of Elmer Sosa, Luis Mazón, Frenci (Francesca) Sanna, Diana Ejaita, and Luca Soncini represent themes related to meaning of borders, freedom of movement, and the process of recognizing refugees. They call for respect and humanitarian support for those standing on boundaries.

Mexican designer Elmer Sosa uses his work *NO BORDERS* to focus on freedom of movement as a natural right of refugees and migrants, while *EQUALITY* uses the image of a heart giving equal life to all, thereby expressing how we are all the same. The global refugee crisis has been intensifying due to factors including climate change, war, conflict, and violence. Luis Mazón offers pointillist portraits of refugees around the world using flickering colors and countless dots. His creations *Silent Waves* and *Lost in Limbo* capture the essence of refugee life and the death of the individual through images of unstable bodies lacking three-dimensional contours and the contrast of a clear yet unrealistic horizon. Frenci (Francesca) Sanna, the author and illustrator of *The Journey*, a picture book based on the stories of two girls she met at an Italian refugee camp and interviews with various other refugees in Europe, adopts the perspective of a refugee girl to depict the harrowing journey of people transformed into refugees by war. The book uses a freely flying bird to symbolize the hope of being able to find a new nest and to begin living a life of security. Sanna's *The Right to Have a Safe Home …* and *… Is a Human Right,* show birds escaping their cages and flying freely outside them, emphasizing the right of individuals to enjoy freedom and a safe existence. Diana Ejaita, a lover of central African literature and art, focuses on conditions conducive to living in peace. In *To Move,* she juxtaposes primary-color shapes to represent the right for all people to move

8 As the arrival of Yemeni refugees on Jeju Island in 2018 led to intensifying attitudes of anti-refugee sentiment, rumors spread about so-called "fake refugees." *Refugees and the Refugee Life* (Kim Ki-nam et al., Seoul: Galmuri, 2020) is a book inspired by aspects of South Korean society at the time.

about freely. In *To Be*, the shapes are interconnected to serve as each other's foreground and background, expressing the right of all lives to be respected. In 2022, an estimated seventy percent of the world's refugee population was said to be residing in countries or regions affected by severe food insecurity. The agony of hunger experienced by people in war-torn and strife-ridden regions is one of the factors that leads them to become refugees.[9] Luca Soncini's *Hunger* communicates a message about the right to access food for people living in eastern Africa and the importance of respecting that right.

Seed pods: Empathy and solidarity

Amnesty International's afterword in the book *The Art of Protest* states, "It took centuries of struggle and protest to achieve the precious freedoms we have today. ... It is closely bound to the right to freedom of expression. ... They [our posters] are from many countries and show how we have stood up against oppression since we were founded in 1961."[10] To make progress in the areas of democracy and human rights, we need to adopt a philanthropic and symbiotic approach, uniting in the fight for the collective and rallying many individuals together for the sake of each person. In this section, artists share their ideas and representations relating to resistance, freedom, and ways of achieving an open form of empathy and solidarity.

Fahmi Reza, Elaine Lopez, Elaine L, and cement (Yonghoon Park and Hyojung Yang) relate stories about resistance for the sake of freedom and struggles on behalf of people in Malaysia, Cuba, China, and South Korea. Malaysian graphic designer Fahmi Reza embarked on this project out of respect for the resistance spirit of the South Korean democratization movement and his memories of the woodcut art that he saw while visiting Gwangju some years back. *Stop Police Brutality* comments on issues of police violence and the failure to punish those responsible, while urging a fight against brutality. *Stand for Democracy* sends an encouraging message to those fighting for freedom in Myanmar through the image of a three-finger salute (a

symbol of resistance inspired by the book and film series *The Hunger Games*). This gesture emerged as an expression of opposition to the country's coup and as a sign of solidarity in the pursuit of democracy. Cuban American designer Elaine Lopez approached this project with memories of her grandfather, who was jailed as a political prisoner for opposing the Cuban communist regime in the 1960s. *Patria y Vida* criticizes the Cuban government for repressing its people, while focusing on anti-government demonstrations that express a yearning for freedom. By presenting two words with different numbers of letters (*patria* and *vida*) at equal widths, Lopez symbolizes the balance between the "country" and the free "lives" of its people, repeatedly amplifying the power of the words. *Damas de Blanco* concerns a human rights group formed in 2003 by wives and family members of anti-regime figures who were imprisoned or disappeared in Cuba. As she displays a red equilateral triangle (symbolizing equality, philanthropy, and liberty) with the image of human rights group leader Berta Soler, Lopez conveys the history and meaning of the anti-government movement for peace that has been waged by the "women in white." The Chinese-born, U.S.-based illustrator Elaine L expresses a sharply critical perspective on social issues through work featuring fine lines, soft colors, and distinctive textures. *Protesters* (1989) adopts a post-Tiananmen Square generation perspective as it recalls the image of young protesters demanding reforms and freedom before the *Goddess of Democracy* statue raised by students at the time of the demonstrations in 1989. Boasting the same composition, *Protesters* (*2022*) honors the courage of demonstrators who held up blank sheets of paper to call for press freedoms in the wake of a deadly fire that occurred amid a COVID-related lockdown in 2022. In this work, Elaine L experiments with an artistic approach in

9 Charles E. Owubah, "The Refugee Crisis is a Hunger Crisis," *Fair Planet*, July 7, 2023. https://www.fairplanet.org/op-ed/the-refugee-crisis-is-a-hunger-crisis/

10 Amnesty International, afterword to *The Art of Protest: A Visual History of Dissent and Resistance*, by Joanne Rippon (Bournemouth: Imagine, 2020), 171.

which she uses delicate lighting to intentionally obscure or blur the realistic facial details of the protesters. The studio cement (Yonghoon Park and Hyojung Yang) creates a distorted shape by reconfiguring two news photographs depicting confrontations between police and demonstrators during South Korea's democratization uprising in 1987. Through photographs that have been transformed into multiple angles and the use of motion graphics, the artists depict both sides of power, representing forces of control and forces of resistance.

The aims of resistance encompass various freedoms, including the freedom of objection, freedom of expression, freedom of participation, freedom of secrecy in one's participation, and freedom of speech. Jieun Guk, Yudai Osawa, Sang Mun, and Golden Cosmos (Doris Freigofas and Daniel Dolz) convey messages about the prerequisites for true reconciliation and the attainment of freedom based on philanthropic attitudes, appreciation for human rights that are all too often taken for granted, technology ethics that align with common values, and the power of speech. Jieun Guk reconstructs the ravaged language of reconciliation in South Korean society, using a December 2022 press release from the national government about its New Year's special pardons and reinstatements for the coming year. The opaque gray surface and empty grid lead the viewer to contemplate the meaning of the "pardons" granted by the administration to unapologetic perpetrators of state violence. The work underscores the importance of sincere reflection and apology from those responsible to truly put the legacy of the past to rest. Through *We Want to Give Thanks for Human Rights*, Yudai Osawa shows a three-dimensional pictogram giving thanks for human rights, symbolizing hope for the achievement of an equal and fair society, and emphasizing the importance of these rights. Based on Google's personal information handling guidelines, Sang Mun's *Tech as Moral Actor* advocates for the development of a serious ethical discourse regarding non-neutral technology. He warns of how technology is being developed without common values, efforts, or consensus, leading to a future where human communication is monitored and controlled, and

society becomes automated in oppression and discrimination. Golden Cosmos, a duo consisting of Doris Freigofas and Daniel Dolz, comment on the importance of the freedom to express our views and the power of speech. Through the use of images of speech balloons, they symbolically represent how freedom of speech has been targeted by totalitarianism, while highlighting how it is also more powerful than any gun.

As a society becomes larger and more complex, its blind spots in terms of freedom and equality also expand. The greater influence of capitalism on the democratic process leads to a increased distance from achieving social reforms. Solidarity becomes crucial in preserving not only our human rights but those of others, and for driving social change forward. The works of Saki Ho and Sebastian Curi show the power of empathy and solidarity to neutralize authority and fear. In *The Powers That Be* and *The Fears That Be*, Saki Ho uses typographic composition and contrast to effectively express messages about the power of solidarity to resist authority and the ironic potency of vulnerability in dismantling fear. She fills the word "POWERS" with text that reads "In Solidarity We Fight," while the word "FEARS" crumbles with text that reads "With Vulnerability We Fight." During demonstrations in Hong Kong in 2019, the words of the late actor Bruce Lee resounded as a slogan: "Now water can flow or it can crash. Be water, my friend." Ho's work underscores the power of new identities that can be formed by anonymous groups and the associated senses of unity and fluidity.[11] Sebastian Curi's *BEGINS HERE* and *We Go the Distance Because We Go Together* use the language and symbols of the "hand"—a powerful tool and form for expressing the human heart and strength—to comment on empathy and solidarity as requirements for the continuation of democracy.

Studio Half-bottle, Kim Albrecht, Studio Rejane Dal Bello, and

11 Vivienne Chow, "The powerful images of Hong Kong's protests," *BBC Culture*, December 12, 2019. https://www.bbc.com/culture/article/20191211-the-powerful-images-of-hong-kongs-protests

Moon Jung Jang explore approaches to proceed toward more open forms of empathy and solidarity. These include sustaining efforts and taking action to support democratic societies, assessing the progress of democracy through accurate information and diverse inquiries, engaging the public through direct and participatory methods, and recontextualizing the history of democracy. Studio Half-bottle portrays the reality of democratic communication, processes, and execution based on the artists' experiences participating in council meetings in Seoul to safeguard the creative space of the PLATFORM P publishing culture promotion center. This work sheds light on the conflicts arising from the balance and priorities between social movements and everyday responsibilities by acknowledging the contributions of people who play small but vital roles in the movements for democracy, human rights, and society. Kim Albrecht uses democracy-related questions sourced from Sweden's V-Dem Institute as a basis for comparing trends in the advancement of democracy across different countries, delving into the complex meanings of the concept. His graphs show shifting trends in various countries, including the increased political capabilities of women, the extent of political corruption, freedom of movement, and academic freedoms. These results illustrate the unstable and uneven development of democracy, while also highlighting the interconnectedness of its indicators. *Citizen First, Designer Second* by Studio Rejane Dal Bello ponders the relationship between democracy and design. Through concise yet assertive typography, the artist declares that her responsibility as a member of society takes precedence. This work embraces a participatory design approach and a democratic mode of communication, posing a question to the individual: "What is your first, what is your second—regarding Human Rights?" Lastly, Moon Jung Jang draws inspiration from the "seed bombs" used by the urban environment movement in New York City during the 1960s and 1970s: summoning slogans from the American civil rights movement she created the work *Democracy Seed-Bombs*. It includes the voices of "Black Lives

Matter" and "Stop AAPI Hate," who have practiced solidarity in communities across the United States and around the world. Like green life erupting from a bundle of seeds, the artist envisions a green form of democracy that can save both "people" and "citizens."

Creating new civic spaces

In addition to the poster images described here, this publication also includes explanations of the works written by the artists themselves. Our hope is that it can go in some way in helping readers truly understand the artist's considerations about democracy and human rights, their ideas, attitudes, and approaches—and most importantly, that it can help convey a genuineness within them that cannot be expressed in words, along with the power of posters as a visual language. Texts by four authors have also been compiled to ponder the questions, "How do we represent issues of violence in movements for democracy and human rights?" "What does it mean to visually remember a history of violence by the state, and what are the possibilities and limitations of this visual expression?" "Where is activism currently taking place in visual culture and today, and what sort of future does it envision?" and "What can design do for democracy?"

In the text titled "On Violence and Its Transcendence through Justice," Jung Keun-Sik considers how to conceptualize and theorize the nature and forms of violence. He explores how we have confronted violence while striving for justice in an era marked by the shift away from colonialism, war, and authoritarianism. Jung also discusses how to visualize issues of violence and human rights. Commenting that the realization of justice is also a cultural project that necessitates an artistic imagination, Jung suggests that artists' sensitivity can provide a perspective capable of keenly addressing contemporary human rights issues, which have become differentiated in diverse ways.[12] Kim Sang-kyu, who curated the 2019 special exhibition *Unlock* at the Democracy and Human Rights Memorial

Hall, explains that he planned the exhibition to remember and commemorate the Anti-Communist Investigation Office, with the "hope that the historically traumatic space would not remain a mere vestige of the past and that we can continue conversations about these histories without burying them in historical times."[13] In his text "Visual Commemoration of the History of State Violence: The Limits and Possibilities," Kim emphasizes that in visual commemoration, it is important to consider what is being remembered and for whose sake. He adds that the purpose of commemoration should be to energize living memory and social memory. In "Military and Youth Activism: The Case of Thailand," Keiko Sei cites the novel activism of members of Generation Z as a decisive factor behind the victory of the Move Forward Party in Thailand's general elections in May 2023. She adds that while it is impossible to predict what scenarios will unfold in Thailand—a country that has had nineteen coups d'état over its history—the response of graphic design activists to their calling will go down as an important record along that long and winding road.[14] In "Project-centered Democracies: Designing for Democratic Experimentation," Ezio Manzini uses a March 2017 open letter to the design community urging action on behalf of democracy[15] as a starting point in proposing a "project-centered democracy" scenario as a new form of participatory democracy. He emphasizes the role of design in driving social change.

As we prepare for the opening of the National Museum of Korean Democracy, the writers' texts encourage us to consider what it ought to encompass: artistic imagination, visual expression with a suitable degree of artificial input, novel forms of activism, and projects promoting participatory democracy. Also included here is a brief introduction to the activities at the Design Workshop for Democracy and Human Rights held in June 2023 with students from the design college at Dongseo University in Busan. During this workshop, participants communicated through laughter and tears as they took out and spread the seed pods of democracy and human rights that they kept hidden within themselves. Working together to design a video

on the theme of "democracy and human rights," they spent invaluable time learning to actively look at the unfamiliar, to channel inner voices into creative design action, and to contemplate the social role of the designer as a citizen. It has been observed that opportunities for citizens to engage and speak out on public issues have been waning.[16] Posters are created in cases of "issues that are widely understood, but need more action."[17] Our hope is that the posters presented in this book will contribute to the creation of new civic spaces and the resolution of democracy and human rights–related challenges. This book is meant to guide us not toward some stale version of enlightenment, but rather a dynamic and organic future. We hope that, as it combines with the interpretations and voices of its readers, it fosters robust and meaningful dialogue and change. Finally, we would like to offer our sincerest thanks to the artists for sharing their diverse perspectives on the broad themes of "democracy" and "human rights" and for presenting posters that capture their messages in concise yet

12 Jung Keun-Sik, "From a Prisoner of Conscience to Communal Solidarity: The Transition of Human Rights Image in the Period of Democratic Movement," *Journal of Human Rights Studies* 3, no. 2 (2020): 29. In this paper, Jung states that visual images of human rights have a powerful influence on society.

13 Kim Sang-kyu, "Curator's Statement," *Unlock* (Seoul: Korea Democracy Foundation, 2019), 12.

14 The exhibition *Re-designing the East*, held at the Württembergischer Kunstverein Stuttgart in 2010–2011 (later traveling to Gdańsk, Seoul, and Budapest) to commemorate the 20th anniversary of the fall of the Berlin Wall, examines the role of political design in the context of political change, democratization processes, and rapid economic development in Hungary, Poland, Czechoslovakia, Thailand, Korea, and India. Keiko Sei, who participated as a curator, introduced the poster and campaign work of Thai designer Pracha Suveeranont, discussing the interpretation of history as told by design in an article included in the publication. Keiko Sei, "The Moment That Made a Designer Political," *Re-Designing the East: Political Design in Asia* and *Europe*, eds. Iris Dressler and Hans Christ (Ostfildern: Hatje Cantz Verlag, 2012), 194-201.

15 In March 2017, Professors Ezio Manzini and Victor Margolin sent an open letter to the global design community asking them to participate in the restoration of democracy and hold voluntary events. This became the beginning of the "Stand Up for Democracy" movement. Since then, their colleagues at Polytechnic University of Milan's Department of Design proposed a digital "Democracy Design Platform" to collect information on statements and events arising during this movement. This has sparked ongoing action and dialogue, suggesting that we rethink participatory democracy. Ezio Manzini and Victor Margolin, "Open Letter to the Design Community: Stand Up For Democracy," Democracy and Design Platform, March 5, 2017. http://democracy-design.designpolicy.eu/open-letter-stand-up-democracy/

16 Zizi Papacharissi, *After Democracy*, trans. Lee Sang-won (Seoul: Tteul Book, 2022), 106.

17 Quote from Elizabeth Resnick in Steven Heller, "Can Posters Still Change the World?," *The Atlantic*, October 7, 2015. https://www.theatlantic.com/entertainment/archive/2015/10/can-posters-still-change-the-world/409078

precise ways. We also wish to express our appreciation to the writers for their profound insights—which offer food for thought about visual language for the National Museum of Korean Democracy— and to the translators for all their hard work. In addition, we want to convey our gratitude to the students who participated in the design workshop, and to all the other contributors who shared their invaluable learning experiences on how to be good citizens.

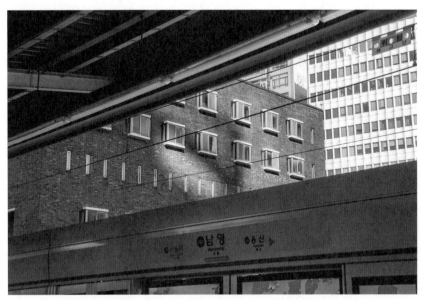

남영역 너머로 보이는 남영동대공분실(현 민주화운동기념관). 가까이 들리는 열차 소리는 피해자들로 하여금 고향이나 부모님을 떠올리게 하면서 마음을 흔드는 묘한 효과를 발휘했다고 한다. (사진: 진효숙)

The Namyeong-dong Anti-Communist Investigation Office (current the National Museum of Korean Democracy) seen beyond Namyeong Subway Station in Seoul. It is said that the sounds of trains passing nearby had the strange effect of shaking the hearts of the victims, reminding them of their hometowns and parents. (Photo: Chin Hyosook)

특수조사실 내부의 주황색 타일. 피해자들의 증언에 따르면 백열등 불빛에 비친 주황색 타일이 피로 물든 것 같은 느낌에 전율했다고 한다. (사진: 정택용)

Orange tiles inside the special investigation room. According to the testimony of victims, they shivered because they felt as if the illuminated orange tiles were stained with blood. (Photo: Chung Taekyong)

1층 쪽문에서부터 5층 조사실까지 계단참 없이 바로 이어진 나선형 계단. 눈이 가려지고
포박된 채 끌려온 피해자들은 방향과 높이조차 인지하지 못한 채 극대화된 공포감을 느꼈다.
(사진: 정택용)

A spiral staircase leading directly from the side door on the first floor to the
investigation rooms on the fifth floor without landings. The victims, who were
dragged in bound and blindfolded, unable to even recognize where or how far up
they were being taken, felt a heightened sense of fear. (Photo: Chung Taekyong)

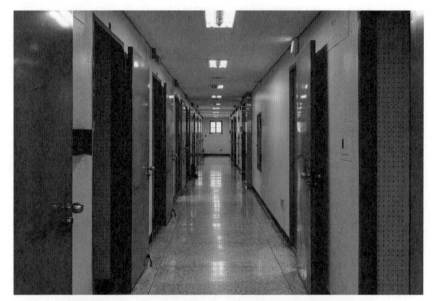

5층 조사실의 엇갈리게 배치된 출입문. 문이 열려도 피해자들은 보이는 것 없이 복도에 새어 나오는 비명만을 들을 수 있었다. (사진: 서영걸)

The staggered entrance doors of the investigation rooms on the 5th floor. Even when the door was opened, the victims saw nothing and could only hear screams from the hallway. (Photo: Suh Youngkul)

방음을 위해 조사실 벽면에 사용한 목재 타공판. 피해자들의 소리는 외부로 나가지 않도록 차단되었으나, 고음의 비명은 벽면을 통해 옆방으로 전달되며 끝 모를 공포를 심어주었다. (사진: 서영걸)

Perforated wooden boards used on the walls of the investigation room for soundproofing. The victims could not be heard from outside, but the high-pitched screams were transmitted through the walls to adjacent rooms, instilling endless fear. (Photo: Suh Youngkul)

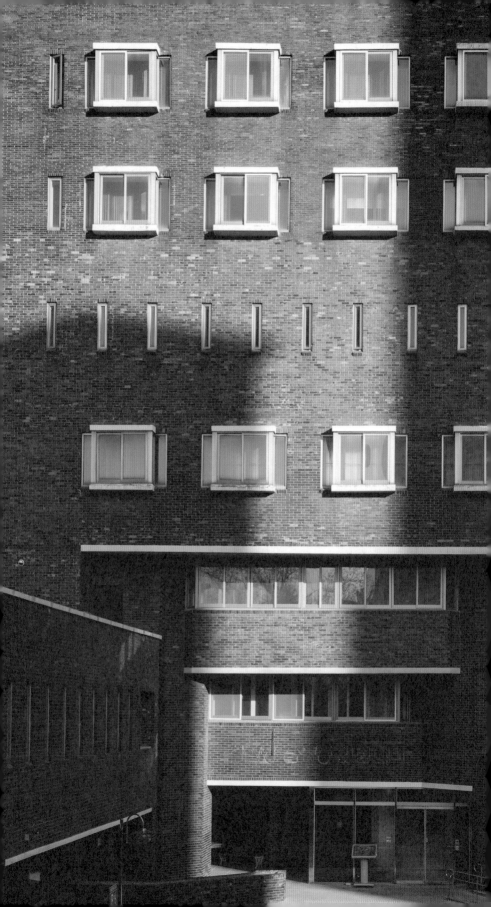

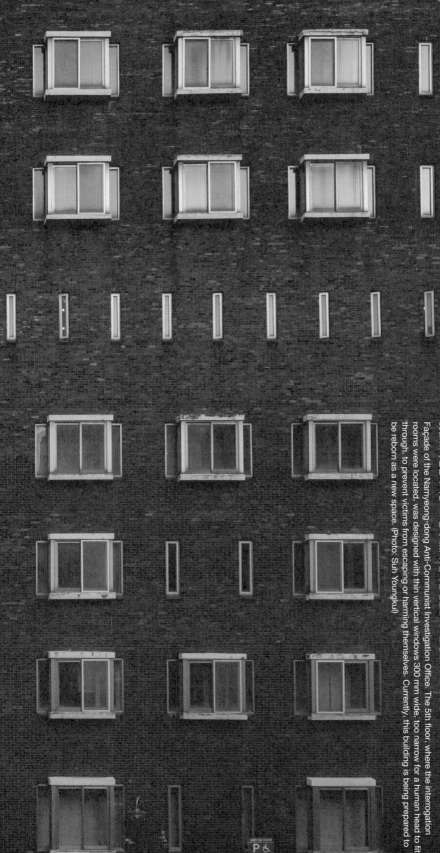

남영동대공분실 전면. 조사실이 있는 5층은 피해자들의 탈출이나 자해를 막기 위해 사람 머리가 빠져나갈 수 없는 너비인 폭 300mm의 좁은 수직창으로 설계되어있다. 현재 이 건물은 새로운 공간으로의 탄생을 위해 준비 중에 있다. (사진: 서영길)

Facade of the Namyeong-dong Anti-Communist Investigation Office. The 5th floor, where the interrogation rooms were located, was designed with thin vertical windows 300 mm wide, too narrow for a human head to fit through, to prevent victims from escaping or harming themselves. Currently, this building is being prepared to be reborn as a new space. (Photo: Suh Youngkul)

민주: 끊임없는 질문

Democracy: Persistent Questions

일상의실천

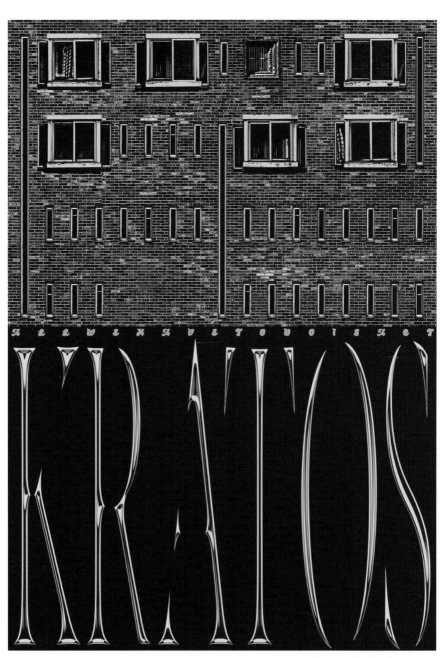

Everyday Practice

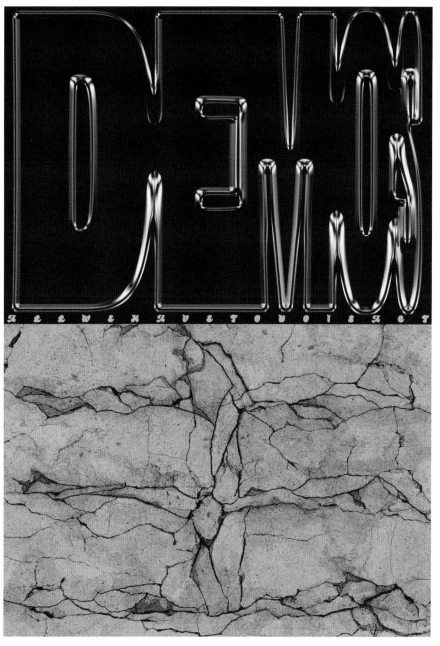

<DEMOS × 主>, 2023. | *DEMOS × 主*, 2023.

民×KRATOS · DEMOS×主 | 민주주의의 어원은 그리스어 인민(Demos)과 지배(Kratos)가 만나 이뤄진 단어로, 민중에게 국가의 권력이 있음을 표한다. 그와 별개로 민주주의를 표방한 근현대 한국사에서 민중의 권력은—냉전 이데올로기를 앞세워—폭압적인 국가폭력을 동원해 수많은 희생자를 양산해 내는 가운데 어둡고 차가운 심연에 갇혀 지내야 했다.

　　일상의실천은 민중(民)과 권력(主)을 두 개의 포스터로 나눠 이야기한다. 근현대 국가폭력 안에 갇혀 지낸 민중(民)은 건축가 김수근이 설계한 남영동 대공분실의 좁게 나열된 창문의 균일한 배치를 통해 형상화했고, 국가폭력에 저항해 새로운 시대를 맞이하게 된 민중의 권력(主)을 견고한 장벽의 균열로 형상화했다. 두 개의 포스터는 근현대 한국 사회에서 억압받은 민중과 저항으로 쟁취한 권력의 인과성을 상호 반전되는 구도로 설명한다.

民×**KRATOS** · **DEMOS**×主 | Etymologically, the word "democracy" was formed from the Greek words demos and kratos, meaning "people" and "power" respectively, suggesting that the power of the state belongs to the people. However, throughout the modern and contemporary history of what has been advocated as South Korea's democracy, the power of the people remained repressed. Using Cold War ideology as its weapon, the state pushed people power into a cold, dark abyss of state violence and tyranny.

Everyday Practice explores the ideas of "people" and "power" through two separate posters. In one, the "people," historically oppressed by state violence, are visualized through the uniform arrangement of narrow windows. The building pictured was designed in the 1970s by architect Kim Swoo Geun and is the old Namyeong-dong Anti-Communist Investigation Office, also known as the torture factory. In the other poster, the "power" of the people—that which brought about a new era in resistance to state violence—is visualized through cracks in a solid wall. Reversed in composition, the two posters demonstrate the causality between state oppression of the people and the power achieved through mass resistance.

조나단 반브룩

<말놀이 아니 대화(좌)>, 2023. | *Dialogue Not Division (left)*, 2023.

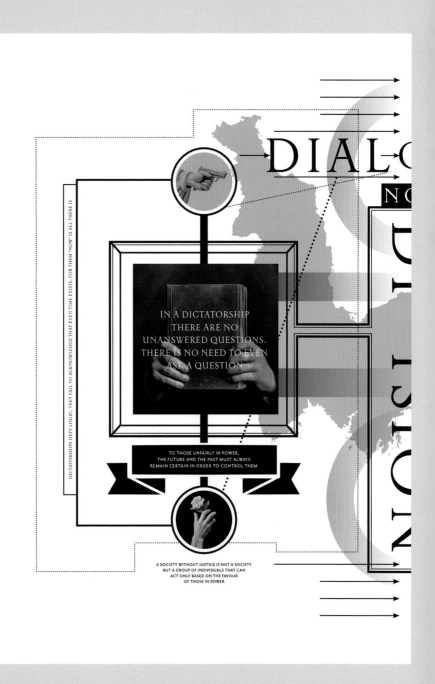

Jonathan Barnbrook

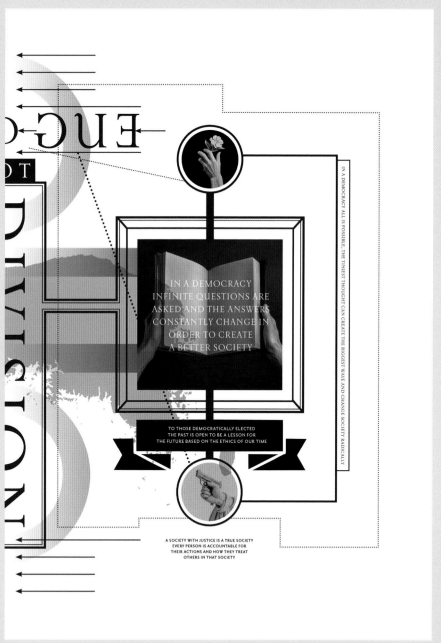

〈분단이 아닌 대화[우]〉, 2023. | *Dialogue Not Division (right),* 2023.

분단이 아닌 대화 (좌)·(우) | 〈분단이 아닌 대화〉는 나란히 있는 두 장의 포스터로 구성된 작품이다. 근접하여 놓인 두 포스터는 오늘날 세계에 만연한 다양한 민주주의의 문제에 주목한다. 그래픽 작업은 남북한의 분단으로 상징되는 인위적인 국가의 분리를 구체적으로 다루고 있지만, 그 메시지는 이들 국가를 넘어 전 세계 국가가 직면한 유사한 문제를 강조한다. 이러한 분단은 열린 대화를 통해서만 극복될 수 있다는 생각이 주요 주제로 전개된다. 포스터 속 문구는 정의로운 사회는 민주주의를 통해서만 이뤄질 수 있음을 강조한다. 민주주의에도 결함이 있다는 점을 인정하면서도 공정하고 정의로운 사회를 위해서는 책임이 중요하다는 기본 원칙을 강조해 보여준다. 이는 정부가 책임감이 부족해 국민의 요구를 해결하기보다는 권력을 가진 사람들의 이익에만 부합할 때 발생하는 문제들에 대한 인식을 일깨운다.

Dialogue Not Division (left) · (right) | *Dialogue Not Division* consists of two posters side by side. The close proximity of the posters draws attention to various democratic issues prevalent in today's world. The artwork specifically addresses the artificial separation of countries, symbolized here by the division of North and South Korea. However, the message extends beyond these nations to highlight similar challenges faced by countries globally. The central theme revolves around the idea that these divisions can only be overcome through open dialogue. The text on the posters emphasizes the importance that a just society can only be achieved through democracy. While acknowledging that democracy is not without its flaws, the artwork underscores the fundamental principle that accountability is crucial for a fair and just society. It raises awareness about the problems that arise when governments lack accountability, serving the interests of those in power rather than addressing the needs of the people.

크리스 버넷

<좌측으로 가도록>, 2023. | *To Be Left*, 2023.

Chris Burnett

〈그것은 우축인가〉, 2023. | *Is It Right*, 2023.

Democracy — Persistent Questions

좌측으로 가도록 · 그것은 우측인가 | 지난 몇 년 동안 전 세계 인류와 각국 정부는 민주주의에 닥친 다양한 문제들을 겪기 시작했다. 사람을 대표하기 위해 고안된 체제가 그토록 많은 사람들의 기본권을 보장하지 않을 수 있단 말인가? 그 결과 집단적 분노와 좌절, 폭력이 발생하고 있다.

내 고향 미국에서는 두 개의 주요 정당인 우파 공화당과 좌파 민주당이 심각한 마찰을 빚고 있다. 이들의 갈등으로 국내외 공동체에서 수많은 사회 문제가 촉발되었다. 상대편을 흠잡으려 할수록 증오와 오해만 더해질 뿐이다. 이 현상은 미디어 지형 전반에 나타나는데, 양측은 서로의 차이를 조정하고 함께 가려는 생각이 전혀 없는 것 같다. 이런 갈등은 미국 시민들 전반에 영향을 미쳐, 한 국민, 한 국가, 한 나라에 그 어느 때보다도 심각한 분열이 일어났다.

두 장의 포스터는 이 분열을 시각화하여 공화당(코끼리)과 민주당(당나귀)을 은유적으로 대변하고자 했다. 이들의 갈등이 벌어지는 장소는 우리 미국인들이 고향이라고 부르는 국회의사당 앞이며, 이러한 배경이 작품 속 아이러니를 부각시킨다. 나는 언제나 이런 질문을 던졌다. "어째서 우리는 같은 땅에 살면서 이토록 상반된 가치를 추구할 수 있을까?" 그 대답은 아직 찾지 못했지만 이 포스터들을 통해 더 많은 올바른 질문을 던지기를 촉구하고자 한다.

우리는 무엇을 믿는가? 우리는 얼마만큼의 정부를 원하는가? 우리는 누가 우리를 대표하기를 원하는가? 다음 세대를 위한 미래는 어떤 모습이겠는가? 이제 싸움을 멈춰야 한다. 그렇지 않으면 미래는 없다. 어떻게 하면 양쪽 모두를 위해 더 나은 민주주의를 만들 수 있을지, 공화당과 민주당 모두 민주주의를 똑바로 보고 물어야 한다.

To Be Left · Is It Right | Within the past few years, humans and governments around the world have started to experience a wide array of challenges with democracy. How could a system that was designed to represent the people leave so many of them without basic rights? As a result, anger, frustration, and violence are collectively on the rise.

In my home country of the US, the main two-party system has Republicans on the right and Democrats on the left at stark odds with each other. Their opposition has fueled a host of social problems in our communities both at home and abroad, and their attempts to undermine each other have only resulted in more hate and misunderstanding. It plays out across our media landscape, showing bitter rivals who seem to have no desire to reconcile their differences and come together. This fight trickles all the way down to all American citizens, who have never been so divided as a people, as a nation, as a country.

My pair of posters aims to visualize this divide, showing a metaphorical representation of the Republican Party (the elephant) and the Democratic Party (the donkey). The irony of the work will be emphasized by the setting in which these conflicts take place, both in front of the US Capitol Building—the same place my fellow Americans call home. I've always asked myself this question: "How can we live on the same soil but have such opposing values?" The answers have yet to be found, but my posters encourage us to ask more of the right questions.

What do we believe in? How much government do we want in our lives? Who do we want to represent us? And what will the future be like for the next generation? The fighting has to stop, otherwise there will be no future. It's time for Republicans and Democrats to both look democracy in the eyes and ask: how can we make this better, for both sides?

카로 악포키에르

<환상(부름)>, 2023. | *The Illusion (call)*, 2023.

Karo Akpokiere

THEN MAKE A CHOICE! THE SYSTEM ALLOWS YOU TO MAKE ONE!

BUT, AT LEAST YOU GET TO CHOOSE!

BUT, AT LEAST YOU GET TO CHOOSE!

BUT, AT LEAST YOU GET TO CHOOSE!

BUT, AT LEAST WE CAN TALK ABOUT IT

<주장(응답)>, 2023. | The Assertion (response), 2023.

환상(부름) · 주장(응답) ㅣ 포스터의 출발점은 두 사람이 선택, 좌절, 표현의 자유, 행위 주체성에 대해 나누는 가상의 대화이다.

이 대화는 음악에서 흔히 사용되는 '부름과 응답'(call and response) 의 전통에서 영감을 받았다. 첫 번째 포스터에 등장하는 인물은 시스템에 대한 점증하는 환멸을 토로하지만(부름), 두 번째 포스터의 인물은 그 시스템이 주는 혜택을 칭송한다(응답).

두 포스터를 같이 읽게끔 디자인했고, 각 포스터의 테두리는 나이지리아 국기와 독일 국기에 쓰이는 색깔로 그려져 있다. 두 인물 사이의 대화는 최근 나이지리아에서 있었던 대통령 선거 및 지방선거, 그리고 종종 맥락을 제대로 이해하지 못한 채 거드름을 피우는 서방 신자유주의적 민주주의 권위자들의 관점을 배경으로 한다. 법치가 부재하고, 인권이 무시되는 등 절차 자체에 심각한 결함이 있는 경우에조차 정치적 불안정과 경제적 침체에 대한 해결책으로 민주주의적 절차를 제시하는 것이 바로 그러한 관점이다.

이 두 포스터는 우리가 살아가는 급변하는 세상 속의 민주주의와 그 이상(理想)에 대한 비판이자 민주주의적 가치(특히 선택의 자유와 의사 표현의 자유)의 중요성에 대한 주장이다.

The Illusion (call) · The Assertion (response) | The starting point for my posters is a fictional conversation between two individuals about choice, frustrations, freedom of expression, and agency.

The conversation is inspired by the call-and-response tradition common in music. In the first poster, an individual articulates his growing disillusionment with a system (call), while the second poster features an individual who extols the benefits of the same system (response).

Designed to be read together, the posters are bordered by the colors of the Nigerian and German flags, respectively. The aforementioned conversation is set against a backdrop of the recently concluded presidential and gubernatorial elections in Nigeria and the often patronizing views of neoliberal democracy pundits in the west that mostly lack nuance. Views that present the democratic process as a cure for political instability and economic downturn even when the process is deeply flawed due to the absence of rule of law and a disregard for human rights.

Together, the two posters serve as a critique of democracy and its ideals in the fast-changing world we live in, and as an assertion of the importance of its values; specifically, the freedom to choose and the freedom to express opinions.

크리스티나 다우라

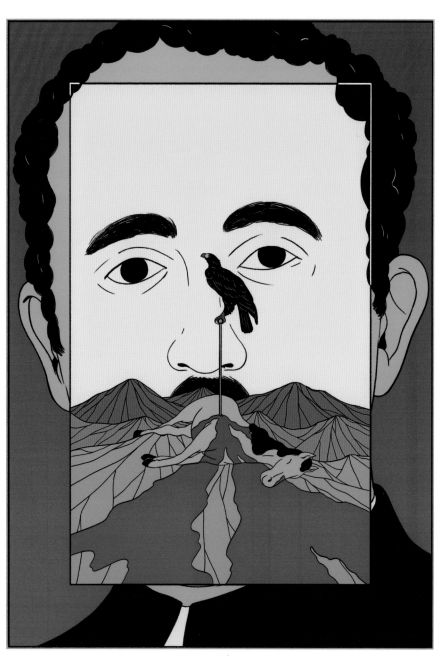

<죽은 말 1>, 2023. | *Dead Horse 1, 2023.*

Cristina Daura

〈죽은 말 2〉, 2023. | *Dead Horse 2, 2023.*

죽은 말1 | 발언 및 의사 표현의 자유는 태어날 때부터 자연스럽게 허락된 권리라고 생각할 수도 있다. 우리는 다른 사람들과 토론하고 때로는 논쟁도 한다. 우리 사회는 이런 과정을 통해 발전하며, 이를 통해 우리도 서로 존중하고 위로하고 잘못된 점은 지적하는 등 타인을 대하는 방식을 변화시킬 수 있다. 발언의 자유는 우리가 살아가면서 비판적인 관점과 한층 폭넓은 시야를 갖도록 돕는 멋진 도구가 될 수 있다. 때로는 장막을 걷어 명징한 현실을 볼 수 있게 한다. 그러나 나의 조국인 스페인에서는 적어도 36년간 발언의 자유가 제한 및 금지되었다. 오로지 한 가지 사고방식만이 강요되었다. 국민이 자유롭게 말하지 못하게 만듦으로써 한 나라, 한 집단이 말살되는 데서 받은 느낌을 묘사하고자 했다. 사람들이 각자의 방식으로 소통하지 못하게 막아 버리면, 그 나라는 절망과 슬픔으로 인해 말 그대로 서서히 죽어가고 만다. 스페인에서 발언의 자유가 없었던 36년 동안, 술집에서 술에 취해 독재자 프랑코에 대해 부적절한 발언을 하는 사람은 구속될 수도 있었고, 반정부 집단에 참여하는 사람은 사형당할 수도 있었다. 검은 독수리는 스페인을 지배했던 독재 정권을, 독수리 때문에 피를 흘리며 서서히 죽어가는 말은 국민을 상징한다.

Dead Horse 1 | The right to speak and express ideas might seem like something that we've accepted as natural since we were born. We can discuss ideas with others and sometimes argue them. With that we can move forward as a society and transform the way we act toward, respect, or comfort others and point out situations that are extremely wrong. Freedom of speech can be a beautiful tool for us to have a critical sense and to create for ourselves a bigger view of the situations we live in. It can draw back the curtain, sometimes, for us to see reality clearly. But for at least 36 years in Spain, my country, freedom of speech was restricted and prohibited. There was only one way of thinking and that was the path to follow. I decided to illustrate the feeling of killing a country, a group of people that cannot speak freely by itself. If you shut the door for people to communicate in their own way, you are slowly killing your country, by frustration, by sadness, by—literally—killing them. In Spain, for over 36 years you could be imprisoned for drunkenly shouting inappropriate words to Franco our dictator in a bar, or you could be sentenced to death for being part of an anti-regime group. The black eagle, part of the symbology of the dictatorship in Spain, is slowly killing the horse, the people, by making it bleed.

죽은 말 2 ㅣ 어째서 독재자가 집권하는 국가가 여전히 존재할 수 있으며, 심지어 그런 나라가 가장 번성한 나라 중 하나로 손꼽힐 수 있을까? 답은 간단하다. 다른 나라들이 혹할 만한 저렴한 가격으로 온갖 종류의 필수품을 생산하는 큰 기계를 만들기만 하면 된다. 자국민의 인권을 수호한다는 나라들이 슬쩍 눈을 감고는 국민의 일상생활을 통제하고, 표현의 자유를 제한하고, 역사를 왜곡하고, 민주주의를 금기시하고, 팬데믹 시기에 이동의 자유가 있는 다른 나라들과 달리 강제 봉쇄령을 내리는 국가와 계속 거래를 한다. 중국이 바로 그런 나라다. 스페인을 비롯한 많은 나라들이 중국 정부의 억압적인 통제를 알지 못한 채 중국을 존경한다. 중국은 아직도 강제 노동 수용소를 운영하고, 위구르 등 이민족을 탄압하며, 저임금 과다 노동이 만연한 국가다. 팬데믹 기간에 중국 정부는 이동의 자유를 박탈하고 사람들을 강제로 집 안에 머무르게 했다. 수많은 중국인들이 울분을 터뜨렸고 극심한 우울증에 빠졌다. 그중 일부는 정부에 반대하는 내용의 현수막을 내걸고 항의하면서 국민을 각성하려고 했다. 정부의 강압적인 코로나 봉쇄에 반대하는 내용의 현수막을 다리에 내걸고 시위를 벌였던 중국인 펑리파(彭立發)는 안타깝게도 체포되었다. 이 포스터에 그려진 말은 국민을 상징하는 동시에, 타인을 위해 '죽을' 각오를 한 사람이 지녀야 할 용기를 상징한다. 다리에 걸려 있는 현수막에는 '좋다'(好)라는 단어가 쓰여 있는데, 이는 중국 정부가 듣고 싶어 하는 말은 '좋다'는 말뿐이라고 비꼬는 의미로 최근 사이버 시위대에서 이 단어만 반복한 적이 있기 때문이다. 중국에서 표현의 자유는 여전히 신기루이며 우리는 여전히 중국에 대해 눈을 감고 있다.

Dead Horse 2 | How can a dictatorship still exist and at the same time be one of the most prosperous countries? The answer is easy: just create a big machine that can deal with and build all the necessities that other countries want for a cheap price. Countries with their own human rights will look the other way and keep doing business with a country whose people are still being controlled daily by their government, their freedom of speech restricted, their history modified, democracy prohibited, and, during a pandemic, being forced to totally shut down while the world outside moves on freely. China is that country. China is respected by many countries, including Spain, that don't recognize the total control of the Chinese government over its people. A country where they still have forced labor camps, domination of other ethnic groups like the Uyghur people, or extreme working hours with slave wages. During the pandemic, the Chinese government ordered and obligated the people living in China to stay at home, unable to move, creating frustration and extreme depression in the vast majority of people, to the point that some started to rebel and protest by hanging banners with claims against the government and urging the people of China to wake up. Peng Lifa was one of these people and decided to hang a banner over a bridge with claims to motivate people to rebel against the COVID restrictions of their country. Unfortunately, he was detained. In my piece I wanted to illustrate the horse symbolizing the people and the courage that one person has to have to stand up and "die" for the others. In the hanging banner there is the word "good," since there was a cyber-protest where people only communicated with this word as a way of making fun of the idea that it is the only word the Chinese government wants to read. Freedom of speech is still a mirage in China, and we still look the other way.

가스 워커

〈뒤집힌 민주주의〉, 2023. | Democracy Upside Down, 2023.

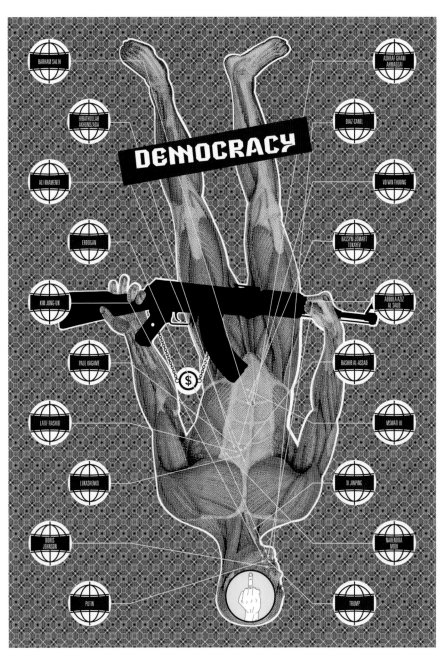

Garth Walker

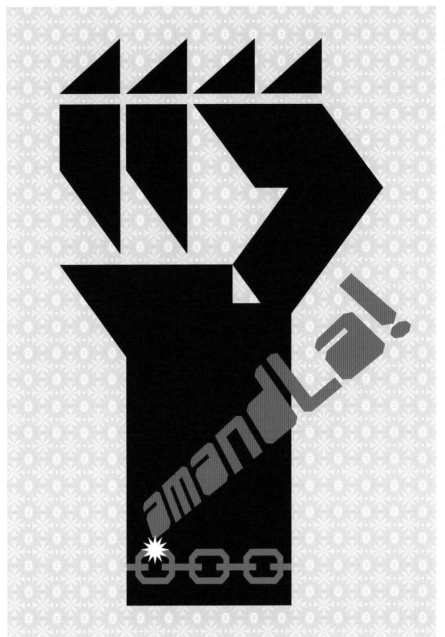

〈아만들라〉, 2023. | *AMANDLA!*, 2023.

Democracy — Persistent Questions

뒤집힌 민주주의 ㅣ 이 포스터의 제목 '뒤집힌 민주주의'는 2023년 '세계 민주주의'의 현 상태를 가리킨다. 소위 '자유롭고 민주적인' 국가를 표방하는 많은 나라들이 '독재자 또는 철인'형 지도자의 손아귀에 있거나 그런 자들이 '민주적으로 수립된 정부'의 수장으로 있다. 유권자들은 이런 지도자들의 권력을 위한 희생양이 되고 만다.

　(냉전 전후) 구세계 질서의 민주주의는 이제 위아래가 뒤집히거나 역행한다. 이에 항거하는 시도가 있었음에도 불구하고 그렇게 되었다. 특히 이 포스터에 기록된 많은 지도자들은 총이나 달러(폭력과 돈)를 이용해 권력을 잡았다.

　실제로 구글로 검색해 보면 전문가들이 비민주적이거나 근본적으로 '자유롭지 못하다'고 평가하는 국가들의 목록은 매우 길다. 이 포스터에 명시한 이름들은 해당 목록에서 무작위로 선택한 이름들일 뿐이나, 그들은 세계의 광대한 땅 대부분을 차지하고 있다.

　화살표는 단순히 그 지도자의 유형과 가장 연관성이 높은 신체 부위를 가리킨다. 입은 발언을 의미하고(트럼프를 생각해 보라) 몸통 부분은 감정이나 존재의 상태를 나타낸다(많은 지도자들은 자신이 신으로부터 통치권을 부여 받았다고 생각한다). 실제로는 어떤 신체 부위도 나라 이름과 직접적인 연관이 없다. 화살표 끝은 그저 은유에 불과하다.

Democracy Upside Down | The title for this poster refers to the current state of "global democracy" in 2023—where many supposedly "free and democratic" countries are in the grip of a "dictator" or "iron man" type of leader, or as head of a "democratically elected government." Thus is the electorate controlled as victims of their leadership.

The democracy of the old world order (pre– and post–Cold War) is now upside down or inverted—despite protestations to the contrary. Not least, many of the leaders named in the poster hold power by means of the gun or the dollar (violence and money).

A (very long) Google listing of countries regarded by experts as being undemocratic or essentially "not free" is substantial. The names used in the poster are but a random selection from said list—covering most of the global land-masses.

The arrows simply point to the body parts most associated with the type of leader shown. The mouth represents the spoken word (think Trump) whilst the torso area represents a state of emotion or being (many leaders feel they have a divine right to rule). Neither parts are actually directly associated with the name—the end point is simply a metaphor.

아만들라! | 본래의 의도는 이 포스터를 좀 더 고전적인 스타일로 디자인하는 것이었다. 나는 몇 년 전 더반의 '해방 투쟁'(더반에서 '아파르트헤이트 반대 시위'가 벌어졌던 현장들) 루트에 대한 아이덴티티와 전시 시스템을 디자인한 적이 있는데, 여기에 착안해 남아프리카공화국 디자이너로서 느끼는 인권의 의미에 대해 한층 개인적인 의견을 표현하고자 했다.

아파르트헤이트 정책하에서 남아프리카공화국의 많은 시민들(주로 흑인)이 '아만들라!'라는 용어를 사용했다. 모든 응구니 언어에서 비슷한 의미로 쓰이는 이 말은 '힘'(또는 '강함', '함께' 같은 의미) 정도로 번역할 수 있다. 꽉 쥔 주먹을 힘차게 위로 뻗는 '주먹 인사'는 '아만들라!'의 신체적인 표현으로, 1990년에 석방된 넬슨 만델라(Nelson Mandela)가 이 인사를 취하는 사진으로 인해 유명해졌다.

아파르트헤이트 당시 남아프리카공화국은 인권보호조약 서명 국가가 아니었다. 그러나 1994년 민주주의 선거 이후 남아프리카공화국 신정부가 '모든' 국민에 대한 합법적인 보호를 제공하고자 이 조약에 서명했다. 이 인권보호조약의 일부분이 현재 남아프리카공화국 헌법에 정식으로 기술되어 있다. 민주주의로의 여정은 꽉 쥔 주먹을 들어 올려 '아만들라'를 외치며 시작되었고, 남아프리카공화국의 아파르트헤이트 시절, 이는 모든 이들에게 통하는 신호였다(물론 당시 정부 내의 백인 국민당에서는 금지되었다).

이 포스터의 배경에 쓰인 패턴은 많은 남아프리카인들이 전통 방직/직물/의상에 사용하는 쉐쉐(shweshwe) 무늬로, 특히 줄루 여성들이 즐겨 만든다(더반은 남아프리카공화국에서 가장 많은 수를 차지하는 원주민 부족인 줄루족의 중심지이다).

AMANDLA! | I wanted to have this poster designed in a more classic poster style. Some years ago I designed the identity and exhibition system for Durban's "Liberation Struggle" route (sites around the city where Apartheid liberation protests had taken place). This gave me the idea to offer a more personal take on what human rights mean to me as a South African designer.

During Apartheid, many South Africans (mostly black) used the term "AMANDLA!" (similar in all Nguni languages) which translates loosely as "power" (or "strength," "together," etc.). The clenched-fist "power salute" was a physical display of "AMANDLA!"—famously shown by Nelson Mandela in a photograph when he was released from prison in 1990.

Under Apartheid, South Africa was not a signatory to the Convention on Human Rights. However, in 1994 after democratic elections, the then-new South African government signed the Convention so as to provide legal protection to all South Africans. Parts of the Convention on Human Rights are now enshrined in our constitution. This journey to democracy began with the raised clenched fist and the cry of "AMANDLA," universal to all South Africans during the Apartheid era (obviously banned by the white nationalist party in government at the time).

The pattern for this poster background is my interpretation of a classic SHWESHWE traditional textile/fabric/dress pattern work by many Black South Africans, particularly Zulu women (Durban is central to the Zulu tribe, the largest native tribe in South Africa).

빅토리아 치혼

<기억하라>, 2023. | Remember, 2023.

Viktoria Cichoń

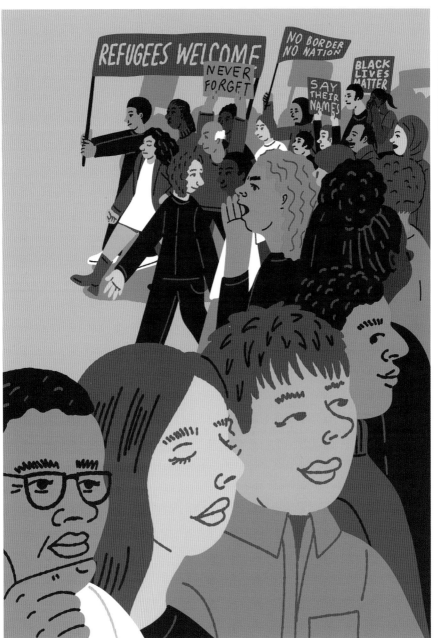

《수호하다》, 2023. | *Defend*, 2023.

Democracy — Persistent Questions

기억하라 ┃ 민주주의에서 중요한 것은 그 역사, 즉 민주주의가 어떻게, 왜 수립되었는지 기억하는 것이다. 민주주의의 중요성을 상기하는 것은 우리의 의무다. 이 포스터는 과거를 상기하고 정권과 정치 정당이 인류에 대해 공공연하게 자행한 범죄를 절대 잊지 않도록 한다.

수호하라 ┃ 두 번째 포스터는 민주주의를 위협하는 세력으로부터 어떻게 민주주의를 수호해야 하는지를 설명한다. 정치 정당들은 민주주의적 도구를 이용해 은밀하게 파시스트적 발상을 도입하려 든다. 어떤 집단이든 소외계층을 위협하는 반민주적인 발상을 정부에 퍼뜨리게 해서는 안 된다. 우리는 우리 안의 편견과 내면화된 인종차별주의에 대해 끊임없이 질문하고, 국내외 모든 사람의 평등한 삶을 위해 발전하도록 나아가야 한다.

Remember | An important thing about democracy is remembering its history: how it was established and why. It is our duty to remind ourselves of the importance of democracy. This poster serves as a reminder of past times and to never forget the crimes against humanity that were committed openly by the government and political parties.

Defend | The second poster is a depiction of how to defend democracy from those who endanger it. Political parties will introduce hidden fascist ideas with the help of democratic tools. We can never again allow a group of people to infiltrate the government with anti‑democratic ideas that harm marginalized people. We have to constantly question our own biases and internalized racism and work towards improvement to ensure equity among all humans inside and outside of the country.

〈민주주의에는 토대가 필요하다〉, 2023. | *Democracy Requires Grounding*, 2023.

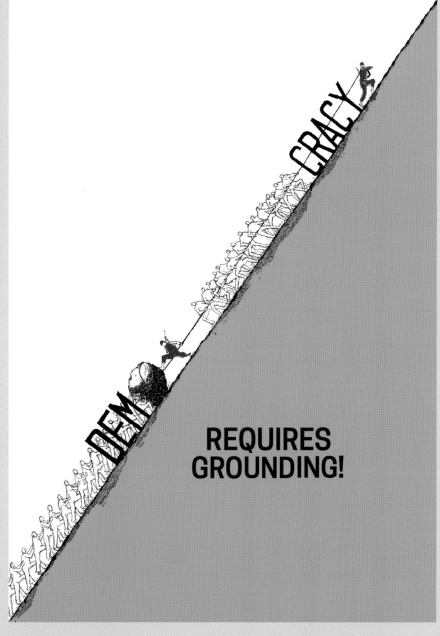

Design & People

<민주주의를 위한 अ 교향곡>, 2023. | अ Symphony for Democracy, 2023.

DISTRUST
अ विश्वास

INEQUALITY
अ समानता

HELPLESSNESS
सहायता

'अ' (ā) in Devnagri

Adding the prefix 'अ' (ā) to words in Hindi can change meaning and create antonyms, as demonstrated in the examples 'समानता' (asamaanta), 'सहायता' (asahaayta), and 'विश्वास' (avishwaas).

• 'समानता' (asamaanta) which means 'inequality' or 'disparity' is the antonym of 'समानता' (samaanta), which means equality and parity.

'सहायता' (asahaayta) means 'helplessness' and is the antonym of 'सहायता', which means 'assistance' or 'to help'.

• 'विश्वास' (avishwaas) which means 'distrust' or 'skepticism', is the antonym of 'विश्वास' (vishwaas), which means 'trust' or 'faith'.

민주주의에는 토대가 필요하다 ㅣ 이 포스터의 '줄다리기' 이미지는 민주주의의 DNA에 내포된 밀고 당기는 작용을 나타낸다. 민주주의가 국민의, 국민에 의한, 국민을 위한 것이라면 그것은 국민과 '같은' 성격을 지닌다. 모든 민주주의 국가는 다르지만 그 기본 원칙인 평등, 시민 참여, 정치적 관용, 책임, 투명성은 같다. 그러나 민주주의의 이런 원칙들은 각 나라 국민들의 해석에 따라 달라진다. 국민들 속에 존재하는 파수꾼들의 의무는 이런 원칙들이 보이지 않는 곳으로 밀려나지 않도록 하는 것이다. 이는 사법부, 입법부, 행정부 및 언론의 역할이다. 활발한 민주주의에는 언제나 오르내림이 있다. 그러나 올라간 것은 내려오기 마련이고, 내려간 것도 올라오기 마련이다. 민주주의 내에서 벌어지는 변화와 소용돌이는 소속된 시민들이 민주주의에 참여하고 있다는 사실을 뜻한다.

Democracy Requires Grounding | The image of "Tug of War" on this poster conveys the push and pull that is in the DNA of Democracy. If a Democracy is of the people, by the people, and for the people, then it will be like its people. Every Democracy is different, and yet the founding principles are the same: Equality, Citizen Participation, Political Tolerance, Accountability, and Transparency. But these are open to interpretation by the people of the Democracy; it is the duty of watchdogs among the people to ensure the principles of Democracy do not get tweaked beyond recognition. This is the role of the Judiciary, Legislature, Executive, and Media/Press. A thriving Democracy will always have ups and downs. But what goes up will come down. And vice-versa. Change and churn in a Democracy means its people are engaging with it.

민주주의를 위한 अ 교향곡 | 우리의 가치, 신념, 환경은 우리의 선택, 기대,
개인적·직업적 영역에서의 성취를 형성한다. 진정으로 평등한 사회를
조성하려면 지도자들이 자신들의 이익보다 공익을 우선으로 해야 한다. 이는
자유롭고 공정한 선거, 자유로운 언론, 사법부의 독립, 시민 자유의 수호 등
민주주의적 절차를 통해 확립될 수 있다.

이 포스터에서는 간디 모자, अ(데바나가리 문자의 첫 번째 모음), 데바나가리
문자를 복잡하게 얽어 만든 얼굴 모양 타이포그래피 등을 함께 배치했다.
간디에 의해 대중화된 카디 모자는 영국의 인도 식민 통치에 저항하는
상징이 되었다. 간디는 인도인들에게 카디 모자를 착용하여 독립운동과
함께 애국심과 연대를 표현하자고 독려했다. 이 모자는 카디 사용을
촉진하는 도구이기도 했는데, [손으로 짠 직물인] 카디는 간디가 지지하던
스와데시(자급자족) 운동에서 중요한 부분을 차지했다. 오늘날 인도에서 간디
모자는 여전히 국가적 자부심과 정치적 행동주의의 상징이다. 정치인들이나
사회운동가들은 집회나 시위에서 간디 모자를 쓰는 경우가 종종 있고
일반인들도 간디 모자를 쓰곤 한다. 힌디어에서는 접두사 'अ'를 붙이면 해당
단어의 뜻을 정반대로 바꾸어 반의어를 만들 수 있다. 예를 들어 단어 विश्वास
(신뢰, trust), समानता(평등, equality), सहायता(도움, help) 앞에 अ가 더해지면 अविश्वास
(불신, distrust), असमानता(불평등, inequality), असहायता(무력감, helplessness)이 된다.
간디 모자 아래에 이러한 데바나가리 문자를 복잡하게 얽어 만든 얼굴 모양
타이포그래피는 정치인들이 야기한 혼란, 선거에서 승리한 후 이행되지 않은
공약을 포함한 복잡한 문제들을 의미한다.

오늘날, 간디 모자가 지녔던 순수성, 인도의 독립운동이라는 상징성은
퇴색되고 있다. 정치인을 비롯한 많은 사람들은 나라를 제대로 대표하거나
통치하지도 못하면서 이 모자를 착용한다. 이는 간디 모자에 담긴 원칙에
위배된다. 말 그대로 '간디 모자 아래에 숨어' 비행을 저지르고 있다.

अ **Symphony for Democracy** | Our values, beliefs, and circumstances shape the choices we make, the expectations we hold, and our achievements in personal and professional spheres. In order to create a truly equal society, it is important that leaders prioritize the common good over their own interests. This can be ensured through democratic processes, such as free and fair elections, a free press, an independent judiciary, and the protection of civil liberties.

This poster attempts to merge and accomplish the following elements: a Gandhi cap, "अ" (first alphabet in the Devanagari script), and a typographic face created with complex threads of Devanagari. Gandhi popularized the use of the khadi cap as a symbol of resistance against British colonial rule in India. He encouraged Indians to wear it to express their patriotism and solidarity with the independence movement. The cap was also a tool to promote khadi—an important part of the swadeshi (self-reliance) movement that Gandhi championed. Today, the Gandhi cap is still used as a symbol of national pride and political activism in India. It is often worn by politicians and social activists during rallies and protests, and it is also sometimes worn by ordinary people. Adding the prefix "अ" (ā) to Hindi words can change their meaning and create antonyms. For example, when putting "अ" before words like "विश्वास (trust)," "समानता (equality)," and "सहायता (help)," they become "अविश्वास (distrust)," "असमानता (inequality)," and "असहायता (helplessness)." The term "complex thread of Devanagari typography human face" indicates a complicated problem that entails confusion and unfulfilled promises made by politicians who fail to remember them after winning elections.

The purity of the Gandhi cap (topi)—a symbol of India's independence movement—is being tainted. It is worn by politicians and other people even as they misrepresent and misrule the country, going against the principles enshrined in the Gandhi cap, literally committing misdeeds "under the guise of a Gandhi topi."

프라챠 수비라논트

<우리의 토양에 뿌리 내린 민주주의>, 2023. | Democracy That Planted in Our Soil, 2023.

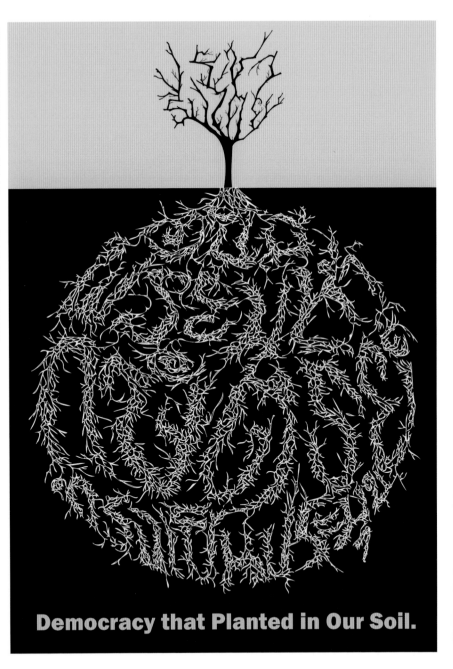

Democracy that Planted in Our Soil.

Pracha Suveeranont

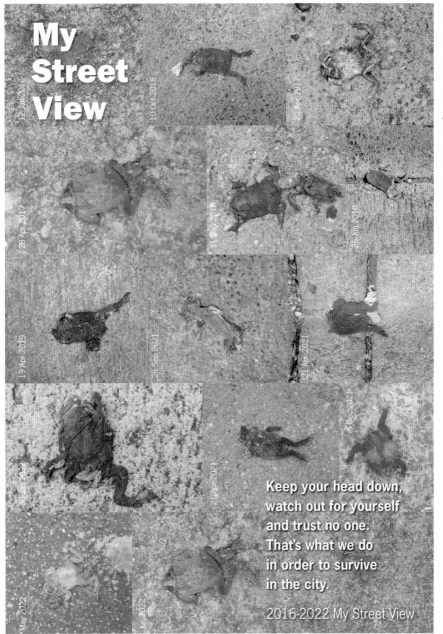

My
Street
View

Keep your head down,
watch out for yourself
and trust no one.
That's what we do
in order to survive
in the city.

2016-2022 My Street View

<나의 거리 풍경 #1>, 2023. | My Street View #1, 2023.

우리의 토양에 뿌리 내린 민주주의 ㅣ 1903년 시암 왕국의 왕 라마 5세는 찹쌀이 자라는 땅에는 보리를 심어도 소용이 없다고 말한 바 있다. 이는 민주주의가 태국의 땅에 있다는 것을 부정하는 발언이다. 그리고 1950년대에 '국왕이 국가의 수장인 민주주의'가 수립되었다. 2006년과 2014년 쿠데타로 새 국왕을 추대하는 움직임이 일었고 왕정주의는 극단으로 몰렸다. 그 이후 태국의 토양은 바뀌었고 (서구식민주주의에서 유입되기도 했던) 구체제는 붕괴했다. 그러나 옛 사상은 끈질기게 남아 있다. 의회가 승리를 거뒀지만 '태국 토양에 뿌리 내린 민주주의'는 보수 대 진보의 싸움, 왕정주의 대 국민 기본권의 싸움, 군부 대 시민 시위대의 싸움에 시달리고 있다.

나의 거리 풍경 #1 ㅣ 2016년부터 2022년까지 나는 매일 집 근처에서 죽어가고 있는 혹은 죽은 두꺼비의 사진을 찍었다. 이 사진들은 태국 사회의 증상을 나타낸다. 그들은 "머리를 숙이고, 스스로 조심하고, 아무도 믿지 말라."고 외친다. 그것은 태국 사회에서 살아남기 위해 하는 행동이기도 하다.

Democracy That Planted in Our Soil | In 1903, King Rama V of Siam said that it is no use planting barley in the soil that grows sticky rice. This was to deny that democracy belonged on our soil. In the 1950s, "democracy with a king as the head of state" was established. In 2006 and 2014, coups d'état paved the way for the new king and brought the royalist agenda to the extreme. Since then, our soil has changed, and the old system (itself a western colonial import as well) has collapsed. But the same thinking has persisted. Even though the rule of the Parliament has prevailed, the "democracy that planted in our soil" is used to continue the fight of Conservatives against Liberals, the Royalists against the People's basic rights, and the Military against the People's demonstrations.

My Street View #1 | From 2016 to 2022, I took photographs of dying and dead toads around the house every day. The pictures represent the symptoms of Thai society. It cried out: "Keep your head down; watch out for yourself and trust no one." That's what we do in order to survive in this city.

크리스 리
(이정민)

<공적 분쟁>, 2023. | *Public Dispute*, 2023.

This is a still image from a 2014 YouTube video called "Mission Playground is Not For Sale" where two groups are arguing over the use of a public soccer field in San Francisco's Mission District. The video illustrates two forms of governance: The first could be categorized as what the performance theorist Diana Taylor calls the "archival"—mediated by documental, graphical artifacts; the other category is mediated directly through what she would call a "repertoire" of performances, in this case, the performance of defeating an opponent in soccer. The conflict between the archive (document centered) and the repertoire (performatic) is an antagonism between modes of governance, each premised on different ways of remembering in common.

Chris Lee

〈정착민의 [원주민] 토지 인정—식민화된 장소로서의 공공장소〉, 2023. | A Settler's Land Acknowledgement—Public Space as Colonized Space, 2023.

크리스 리
(이정민)

공적 분쟁 ┃ 이 포스터에 쓰인 이미지는 AI로 보정한 영상 스틸컷으로, 어떤 인물이 8.5×11 인치 크기의 문서를 들고 있다. 그가 들고 있는 것은 (대부분 백인과 아시아인으로 구성된) 그의 일행이 샌프란시스코 미션 디스트릭트에 있는 공용 축구장을 저녁 7시부터 8시 사이에 독점 사용할 권한이 있다고 주장하는 문서다. 이 때문에 먼저 와서 축구장을 사용하고 있던 (대부분 원주민과 흑인 계통인) 학생들은 자리를 비워 주어야 했다.

　　여기서 우리는 거버넌스에 관한 두 가지 사고방식이 충돌하는 지점을 본다. 한쪽 편은 샌프란시스코 오락시설 및 공원에 대한 규정에 따라, 공공기관에 27달러를 지불하고 경기장을 사용할 권리를 주장한다. 다른 편에서는 축구 규칙에 따라 골을 더 많이 넣어서 이긴 팀이 경기장을 사용하게 해야 한다고 주장한다.

[포스터에 기재된 텍스트]

이 이미지는 2014년 유튜브에 게재된 <미션 운동장은 판매용이 아니다>(Mission Playground is Not For Sale)라는 영상의 스틸컷이다. 두 무리의 사람들이 샌프란시스코 미션 디스트릭트 공용 축구장 사용을 놓고 언쟁을 하고 있다. 해당 영상은 두 가지 거버넌스를 보여준다. 첫 번째는 퍼포먼스 이론가인 다이애나 테일러(Diana Taylor)가 '아카이브'라고 일컫는 범주에 속하며, 문서와 그래픽 등으로 전달된다. 또 다른 범주는 테일러가 '레퍼토리(퍼포먼스)'라고 칭한 범주를 통해 직접 전달되는데, 이 경우에는 축구에서 상대편을 패배시키는 퍼포먼스를 말한다. 아카이브(문서 중심)와 레퍼토리(퍼포먼스 위주) 간의 충돌은 서로 다른 거버넌스 간에 벌어지는 반목으로, 공통의 기억에 대해 각기 다른 전제를 갖고 있다.

Public Dispute | This poster shows an AI‑enhanced image, derived from a video still, of someone holding up a document, an 8.5" × 11" letter‑sized sheet; the holder of this piece of paper is making the claim that he and his friends (mostly white and Asian) are entitled to the exclusive use of a public soccer field in San Francisco's Mission District, between 7 and 8 pm, and that the boys who were already there (mostly Brown and Black) have to vacate the space.

We see here two modes of governance in conflict. One side believes that the space is governed by the rules of the San Francisco Recreation and Parks Department—the right to use the field is conferred by paying 27 dollars to a public agency. The other side believes that the use of the field is governed by the rules of soccer— score more points and win, and you can stay on the grass.

[Text written on the poster]

This is a still image from a 2014 YouTube video called "Mission Playground is Not For Sale" where two groups are arguing over the use of a public soccer field in San Francisco's Mission District. The video illustrates two forms of governance: The first could be categorized as what the performance theorist Diana Taylor calls the "archival"—mediated by documental, graphical artifacts; the other category is mediated directly through what she would call a "repertoire" of performances, in this case, the performance of defeating an opponent in soccer. The conflict between the archive (document centered) and the repertoire (performatic) is an antagonism between modes of governance, each premised on different ways of remembering in common.

크리스 리
(이정민)

정착민의 [원주민] 토지 인정—식민화된 장소로서의 공공장소 ㅣ 이 텍스트/이미지
에세이는 터틀 아일랜드(Turtle Island, 원주민들이 북아메리카 대륙을 부르는 명칭)의
공유지는 여전히 식민지로서 존재한다고 말한 미치 사기그 니시나벡(Michi
Saagiig Nishnaabeg, 캐나다 남부 온타리오 원주민) 학자이자 작가 리안 비타사모세이크
심슨(Leanne Betasamosake Simpson)의 경고에 대해 고찰한다. 이 에세이는 터틀
아일랜드와 유럽의 여러 지역을 넘나들며 진행되는 공간적/시각적 담화이다.
이 에세이는 종이 위에서 (패션과 격자부터 허가증과 지도에 이르기까지) 발생한
시각적 표지의 식민성, 그리고 이것이 어떻게 퍼포먼스 이론가 다이애나
테일러가 거버넌스의 '아카이브'적 형태라고 일컬을 만한 활동을 조성하는지
숙고한다.

[포스터에 기재된 텍스트]

(1-1) 트카론토의 데이비드 크롬비 공원에 원주민
드러머들이 모여 있다. 한 무리의 백인들이 그들을
괴롭힌다. 이 모든 장면이 영상에 찍혔다. 백인들 중 하나가
특히 호전적이다. 그는 기를 죽일 심산으로 어느 드러머가
떨어뜨린 핸드 드럼을 걷어찬다. 그는 드러머들이
공공장소에서 불쾌감을 주었다고 주장한다. 그들의 드럼
연주가 지루하다고 우긴다. 그는 주장한다.

(1-2) 조해너 드러커(Johanna Drucker)에 따르면,
시각화된 이미지는 그저 존재하는 것을 객관적으로,
편견 없이, 냉담하게, 수동적으로 보여주는 듯하지만,
실제로는 구름 한 점 없는 이 구형의 행성 이미지처럼
어떤 주장을 시각적 형태로 만든 것이다. 주장(claim)은
그림과 마찬가지로 약하고 부서지기 쉽다. 그러나 주장은
세상을 만들 수 있는 능력을 갖고 있다. 달리 말해 주장은
우발적이고 반박이 가능하지만 그 견고함은 결국 힘을
필요로 한다. 달리 말하면.

(1-3) 이것은 선을 그림으로써 파리 자오선을 구체화하는
시각적 흔적을 내는 행위이다. 이것은 하나의 주장이다.
이 경우, 이 선은 북극과 적도 사이의 거리를 추적한다.

(1-4) 파리 천문대에는 자오선 위치에 맞춰 헌정된 공간이
있다. 파리 천문대는 그 자체로 비문(하나의 주장)이자,

돌과 철로 이루어진 불변하는 기반으로 이 선의 유효성을
강조하는 존재이다. 최초의 미터(m)는 파리 자오선의
1/10,000,000을 1미터로 규정하면서 탄생했다. 자오선의
견고함은 논쟁의 장에서 발생한 하나의 주장을 구출하기
위해 고안된, 일종의 '신 흉내내기(God Trick)'에 근거를
두고 있다. 그것을 말 그대로 돌 위에 고정하여, 하나의
사실이 되게 한 것이다.

(2-1) 이것은 마지막으로 남아 있는 (원조) 공식 미터자 중
하나이다. 미터원기(mètre étalon)는 공식적인 사물로서
길이 측정의 관행을 결정한다. 미터는 '미터법'이라는
도량형의 기본 단위로서, 국가로서 대지 등을 행정적
관점에서 판독할 수 있게 하여 상품화가 가능하게
하는 역할을 맡는다. 미터법은 과학적 절차와 현상을
명목상 '공평'하다고 보는 관행에 의해 한층 견고해진다.
왕의 주관적 주장이 아닌 객관적인 공적 사물에 의한
결정은 대지 측정법에 대한 질문(즉 어떻게 보고
이해해야 하느냐는 질문)을 정치와 다르게 보는 방식의
논쟁으로부터 벗어나게 하는 데에 도움이 된다.

(2-2) 이 그림은 이전의 또 다른 그림과 공명한다. 혁명
이전의 왕국에서는 교회 관할령이 중복되는 상황과 귀족
영주들의 지배 때문에 평민들이 과중한 세금과 관습적
의무를 자주 부담했는데, 이 지도는 이 같은 권력 남용에

Chris Lee

A Settler's Land Acknowledgement—Public Space as Colonized Space |

This text/image essay ponders the Michi Saagiig Nishnaabeg scholar and writer Leanne Betasamosake Simpson's admonition that on Turtle Island, public land is still colonized land. It is a spatial/graphical story that traverses different areas on Turtle Island (an Indigenous name for North America) and Europe. The essay ponders the coloniality of graphic marks on paper (from rulers and grids to permits and maps) and how these facilitate what the performance theorist Diana Taylor might call "archival" forms of governance.

[Text written on the poster]

(1-1) A group of Indigenous drummers gathers in David Crombie Park in Tkaronto. A group of white men harasses them. This is all caught on video. One of the white men is especially confrontational. At one point, he kicks away a hand drum that had slipped out of a drummer's hands as he was intimidating her. He claims the drummers are disturbing the public. He claims that the drumming is monotonous. He claims.

(1-2) Johanna Drucker writes that visualizations act as if they are passively showing us what is—objective, unbiased, and disinterested—but in actuality, like this spherical cloudless planet, they are arguments made in graphical form. Claims, like drawings, are thin and fragile. Yet they are charged with a capacity to make worlds. In other words, while they are contingent and contestable, their stability ultimately requires force. In other words.

(1-3) This is a drawing of a line—a graphical mark actuating the Paris Meridian. It is an argument. And in this instance, it traces the distance between the North Pole and the Equator.

(1-4) In the Paris Observatory, there is a room aligned with and dedicated to the meridian. The Observatory is itself both the inscription—a claim—and that which reinforces its validity, in the immutable substrate of stone and iron. It was the line from which the first meter was derived—defined as 1/10,000,000th its length. The stability of this

line is premised on a kind of "God Trick," designed to evacuate a claim from a field of contestation—rendering it a matter of fact, quite literally set in stone.

(2-1) Here, the site of one of the last remaining (original) public meter sticks. As a public object, the mètre étalon (standard meter) governed the practice of measurement. It is the elemental unit of what comes to be known as the metric system. Its role, among other things, is to make things like land legible to the administrative gaze of the state and thus available to commodification. The stability of the metric system is reinforced by the nominal impartiality of scientific procedure and phenomenon. Its rendering as an impersonal public object, and not the subjective claim of a king, helps to position the question of how to measure land—which is to say, how to see and know it—outside of politics and contestation from other ways of seeing.

(2-2) This drawing is resonant with another earlier drawing: A map proposed as a modern remedy to the abuses of the ancient régime, where the overlapping jurisdictions of the church and the landed aristocracy often produced burdensome tax impositions and customary duties. The effect of rendering the land legible to the public, administrative gaze of the modern state would be that the French people would no longer be obligated to those whose titles and claims were legitimized by tradition or divine right. They would be obliged to the Republic—a demos composed of a property-owning bourgeoisie. Like the meridian,

대한 근대적인 개선책으로서 제시되었다. 근대 국가의 행정적 관점을 따라 일반인들이 지도를 볼 수 있도록 제시해, 프랑스 국민들이 전통이나 신이 부여한 권리라는 이유로 합법화된 직위와 주장에 더 이상 굴복하지 않게 하는 것이다. 그들은 공화국을, 자산을 소유한 부르주아로 구성된 민중을 섬기게 된다. 자오선과 마찬가지로 이 격자는 전통적인 국가 영토를 초월하는 합리성을 은연중에 투사하고 내재된 식민지적 욕망의 명확한 표현을 보여준다. 프랑스에서는 결국 기각되었지만 신생 국가인 미국은 이 제안이 의미하는 사상을 지지했다. 터틀 아일랜드에서 미국 몫이 된 식민지 서부 지역은 '발전'과 계몽된 관리, (식민) 질서 시행의 상징으로서 '제퍼슨 그리드(Jefferson Grid)'라고 알려진 방식(오래된 통치자의 독단적인 권력과 변칙적인 자연 지형에 저항하고 재산의 규정에 있어 대지 개념에 도전하는 형태)에 따라 조성되었다.

(3-1) 스탠딩 록 보호구역에 설치된 물의 수호자들(The Water Protectors) 캠프. 호청크(Ho-Chunk)족 학자 에인절 M. 힌조(Angel M. Hinzo)의 회상에 따르면, 본래 이 지점에서 강 하류까지의 땅은 위네바고(Winnebago)가 점유했으나 미국이 이 땅을 공공 '휴양' 지역으로 불법 지정하면서 그들의 점유권을 약탈했다. 이는 장래의 식민 지배와 석유 파이프라인 구축 등의 개발을 위한 구실에 불과했다. 정착민의 국가는 본래 복수였던 땅을 단수의 (개인 및 공공) 소유 등록지로 줄였다. 이 같은 과도한 약호화는 경찰, 군대, 자경단의 폭력을 이용한 강제적인 평준화 능력과 더불어 시공간을 장악한다.

(3-2) 이곳은 오클라호마주 아나다코 마을로, 레니 레나페(Leni Lenape)족 본부가 위치한 곳 중 하나이다. 완곡하게 말해 '인디언 이주법'의 일환으로 추방된 레니 레나페족은 레나페호킹(오늘날 뉴욕시가 있는 영토)의 원주민들이다. 그 유명한 뉴욕의 도시화는 그 자체로 약탈과 추방의 흔적이다.

(3-3) '맨하타(Manhatta)'섬은 1811년 '위원회 계획'을 기반으로 식민 통치의 행정적·상업적 관점에 용이하게 만들어졌다. 대지는 사유 재산으로서 상품화되고 그 구성적 타자인 공공 재산과 함께 보여진다. 도시 계획자들은 센트럴 파크를 디자인하여 격자 형태의 단조로움을 탈피하고자 했다. 진보적 도시화의 모범으로 찬사를 받는 센트럴 파크의 설계는 뉴욕 아프리카계 자유민들의 첫 정착지인 세네카 빌리지의 파괴를 전제로 했다. 식민지의 흉터를 분명하게 볼 수 있는 장소인 것이다.

(4-1) 터틀 아일랜드 반대편의 샌프란시스코 미션 디스트릭트, 옐라무(Yelamu)족의 땅에 있는 공용 축구장에서 충돌이 일어난다. 현지 청년들(대부분 원주민과 흑인)은 축구장을 '대여'했다고 주장하는 기술직 노동자들(대부분 백인과 아시아인)의 수상쩍은 주장에 반발한다. 노동자들은 청년들이 떠나길 바란다. 그들 중 한 사람이 샌프란시스코 오락시설 및 공원 관리 기관에서 발행한 8.5×11 인치 크기의 공원 허가증을 내민다. 청년들은 공원이 전혀 '대여'된 적이 없었다고 반박하며 해당 허가증의 적합성에 이의를 제기한다. 대신 그들은 공과 축구 규칙이라는 원칙에 따라 경기장 사용 여부를 결정하자고 주장한다. 양측 모두 선수를 7명씩 선발해 경기를 치르고, 이긴 편이 남는 것이다. 한쪽의 거버넌스는 체화된, 실제로 벌어지는 행동으로 새겨진다(inscribed). 다른 한쪽의 거버넌스는 표면상 합법적 주장임을 나타내는 문서로 공식화되는데, 이는 갈등이 일어났을 경우 공공 기관이 승인할 수 있게 고안된 것이다.

(4-2) 흑인 남성인 크리스티안 쿠퍼(Christian Cooper)는 레나페호킹 뉴욕시 센트럴 파크에서 새를 관찰하고 있다. 그는 목줄을 차지 않은 반려견과 산책 중인 백인 여성 에이미 쿠퍼(Amy Cooper)와 마주친다. 공원의 해당 구역에서는 반려견에게 목줄을 채워야 한다. C. 쿠퍼는 A. 쿠퍼에게 개 목줄을 채우라고 요청한다. 말다툼이 벌어지고 A. 쿠퍼는 911에 전화를 걸어 자신이 어느 흑인 남성에게 위협을 받고 있다고 신고한다. 경황이 없는 와중에도 A. 쿠퍼는 자신의 주장을 정당화하기 위해 정치적으로 올바른 표현을 쓰면서 자신의 인종차별적 태도를 은폐하려 했다. 위험한 쪽은 그녀 자신이 아니라 … 그녀가 국가 폭력의 대상으로 가르킨 상대방이라는 것이다.

(4-3) 이런 수사학적 폭력은 이브 터크(Eve Tuck)와 K. 웨인 양(K. Wayne Yang)이 '결백을 주장하는 정착민의 행동(settler move to innocence)'이라고 일컫는 개념과 공명한다. 이는 원주민에게는 종말에 가까웠던, 식민지적인 원주민 영토 점령에 대한 성찰 없이 식민지 죄책감을 표면적으로 면제받는 전략이다. 이런 점에서 공공장소의 물화는 결백하지 않다. 미치 사기그 니시나벡 학자이자 작가, 예술가인 리안 비타사모세이크 심슨은 공공장소조차도 재산으로서의 대지라는 식민지적 모체의 일부라는 사실을 우리에게 일깨워 준다. 공유지와 사유지는 공동으로 구성된다. 한쪽이 없으면 다른 하나도 존재하지 않는다. 각각의 대지를 구분하고 그것을 온전하게 유지하거나 강화하는 것은 터틀 아일랜드에서 이루어지는 민주주의의 적법성 주장에 대응하는 어떤 폭력이 지닌 필수적인 기능이었다.

this grid implicitly projects its rationality beyond the traditional national territory and figures as an articulation of a latent colonial desire. Although this proposal was ultimately rejected in France, what it represented found favor in the newly formed United States. What came to be known as the "Jeffersonian Grid"—a form that challenged the arbitrary power of the old rulers and the vagaries of natural geography, and competing conceptions of land in defining property—comes to the US portion of Turtle Island in the territories west of the original colonies as a symbol of "progress," enlightened governance, and the imposition of (colonial) order.

(3-1) The Water Protectors' camp at Standing Rock. The Ho-Chunk scholar Angel M. Hinzo recalls the United States' subversion of Winnebago sovereignty, downriver from this site, through the illegitimate designation of Winnebago land as public "recreational" space—a pretext for further colonial expropriation and the development, for instance, of future oil pipeline infrastructure. The settler state reduces otherwise plural land into the singular register of (private and public) property. Its overcoding is coextensive with its capacity to enforce this flattening through police, military, and vigilante violence.

(3-2) Here is the town of (A)nadarko, Oklahoma, where one of the contemporary headquarters of the Leni Lenape is located. Displaced as part of the euphemistically named "Indian Removal Act," the Leni Lenape are the original inhabitants of Lenapehoking—the territory where New York City sits today. The city's famous urbanism is itself a vestige of plunder and displacement.

(3-3) The "Commissioner's Plan" of 1811 was the basis upon which the island of Manhatta was made available to the administrative and commercial gaze of colonial governance—land commodified as private property and figured by its constitutive other—public property. City planners sought to correct the monotony of the grid by commissioning the design of Central Park. Hailed as an exemplar of progressive urbanism, Central Park was premised upon the destruction of Seneca Village—the first settlement of free Black Americans in New York City. It is visible from space as a colonial scar.

(4-1) On the other side of Turtle Island, in the Mission District of San Francisco, Yelamu land,

a public soccer field, is the site of a conflict. Local youth (mostly Brown and Black) resist the incredulous claims of a group of tech workers (mostly white and Asian) who claim that the field has been "rented." They expect the youth to leave. One of the tech workers presents a park permit, a banal 8.5" × 11" sheet issued by the authority of the San Francisco Recreation and Parks Department. The youth reject the permit's legitimacy, countering that the park has never been "rented." Instead, they insist, claims about who can and can't be on the field are governed by the principles of pick-up ball (and the rules of soccer): We have seven players, you have seven players—winner stays on. One form of governance is "inscribed" as embodied and lived practice. The other form of governance is formalized with a document, ostensibly representing a "legitimate claim," designed to be recognized as such by a public authority should a conflict arise.

(4-2) Christian Cooper, a Black man, is birdwatching in Central Park, New York City, Lenapehoking. He encounters Amy Cooper, a white woman, walking her dog without a leash in an area of the park where they are required. He asks her to leash her dog. A confrontation erupts, and she calls 9-1-1, telling the operator that she is being threatened by an African American man. Though she is beside herself, she is deliberate enough to mask her racist fear with a politically correct affectation—an attempt to protect her claim as legitimate: the person against whom she has directed the violence of the state is the menace ... and not her.

(4-3) Such rhetorical violence is resonant with what Eve Tuck and K. Wayne Yang have called a "settler move to innocence"—a set of strategies whereby one is ostensibly absolved of colonial guilt without a necessary reckoning with the quasi-apocalyptic, colonial occupation of Indigenous land. The reification of public space is not innocent in this regard. Leanne Betasamosake Simpson, a Michi Saagiig Nishnaabeg scholar, writer and artist, reminds us that even public space is part of the colonial matrix of land-as-property—public and private land are co-constitutive. One does not exist without the other. Maintaining the integrity of and enforcing the distinction between each has been the essential function of the kind of violence that subtends the claims to legitimacy of the democracies on Turtle Island.

카테리나 코롤레프체바

<네버?>, 2023. | NEVER?, 2023.

NEVER?

1917–1921: SOVIET RUSSIAN WAR AGAINST UKRAINIAN NATIONAL REPUBLIC · 1921–1923: A MASS FAMINE IN UKRAINE CARRIED OUT BY THE SOVIET RUSSIA · 1921–1941: SOVIET RUSSIAN OCCUPATION OF UKRAINE · 1932–1933: THE HOLODOMOR (TERROR-FAMINE) AND GENOCIDE CARRIED OUT BY THE SOVIET RUSSIAN REGIME IN UKRAINE · 1937–1938: THE GENERATION OF UKRAINIAN LANGUAGE INTELLIGENCE PERSECUTED AND SHOT BY THE SOVIET RUSSIAN REGIME (THE EXECUTED RENAISSANCE) · 1965–1972: THE GENERATION OF UKRAINIAN LANGUAGE INTELLIGENCE REPRESSED AND IMPRISONED BY THE SOVIET RUSSIAN REGIME (THE SIXTIERS) · 1946–1947: A MASS FAMINE IN UKRAINE CARRIED OUT BY THE SOVIET RUSSIA · 1944–1991: SOVIET RUSSIAN OCCUPATION OF UKRAINE · 2014–202?: RUSSIAN OCCUPATION OF CRIMEA AND WAR IN THE EAST OF UKRAINE

Kateryna Korolevtseva

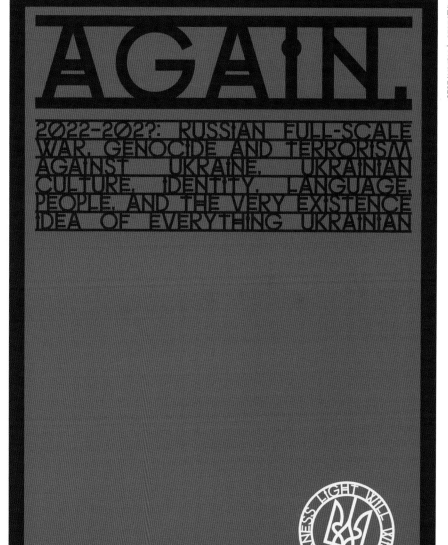

AGAIN.

2022–202?: RUSSIAN FULL-SCALE WAR, GENOCIDE AND TERRORISM AGAINST UKRAINE, UKRAINIAN CULTURE, IDENTITY, LANGUAGE, PEOPLE, AND THE VERY EXISTENCE IDEA OF EVERYTHING UKRAINIAN

LIGHT WILL WIN OVER DARKNESS

네버? | 첫 번째 포스터 〈네버?〉는 과거에 발생한 사건들을 기리는 작품이다. 물음표는 보는 이에게 우리가 진실을 외면하고 있지는 않은지, 우리가 역사를 알고 있는지 의문을 품도록 촉구한다. 구소련과 현 러시아의 프로파간다가 '형제 국가'라는 날조된 신화 뒤에 감추려고 애쓰는 역사에 주목하게 하기 위해서다. 이 포스터는 지난 세기 동안 소비에트 연방과 러시아가 우크라이나 국민들에게 저지른 주요 범죄들의 날짜를 나열한다. 우리는 이것들을 알아야 하고, 기억해야 한다.

어게인 | 두 번째 포스터 〈어게인〉은 바로 지금, 현재 일어나고 있는 사건을 기린다. 여기에는 오직 하나의 날짜만 있다. 그것은 바로 러시아가 우크라이나의 문화, 정체성, 언어, 우크라이나 국민, 우크라이나의 모든 실존적 관념을 상대로 전면전을 벌인 날짜다. 이는 내가 개인적으로 맞닥뜨린 현실로서, 나는 침략자가 시작한 전쟁은 민주주의, 인권, 자유의 가치, 국경에 대한 가장 끔찍한 유린이라는 사실을 확신한다. 전쟁은 주권 국가의 경계뿐 아니라 우리 삶의 경계까지도 침범한다. 두 포스터는 단일한 시각적 스타일을 구성하고 "네버 어게인"(Never Again)이라는 유명한 문구를 암시하여, 우크라이나뿐 아니라 전 세계에서 일어난 과거의 사건과 현재 사이에 평행선을 그린다.

NEVER? | The first poster is called "NEVER?" and is dedicated to the events that took place in the past. The question mark prompts viewers to wonder if we are turning a blind eye to the truth, whether we know the history. I want to draw attention to the history that once Soviet and now Russian propaganda tries to hide behind the synthetic myth of "fraternal nations." This poster lists the dates of the major crimes committed by the Soviet regime and Russia against the Ukrainian people in only the past century. We should know. We should remember.

AGAIN | The second poster is called "AGAIN" and is dedicated to the events that take place right now, in the present. And there is only one date. The date of the beginning of Russia's full‑scale war against Ukraine, against Ukrainian culture, identity, language, people, and the very existence of everything Ukrainian. The reality I have personally encountered. And now I am sure that war started by an invader is the most terrible violation of democracy, human rights, values of freedom, and borders. Not only the borders of the sovereign country but also the borders of our lives. Both posters together form a single visual style and refer to the famous phrase "NEVER AGAIN," thus drawing a parallel between the events of the past and the present not only in Ukraine, but also across the whole world.

미콜라 코발렌코

<미사일>, 2023. | Missile. 2023.

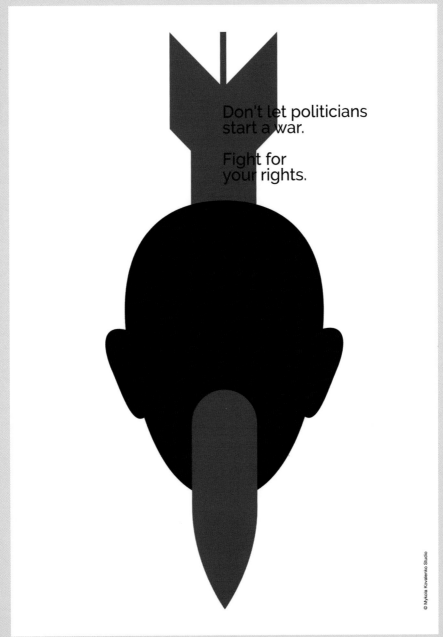

Don't let politicians
start a war.

Fight for
your rights.

Mykola Kovalenko

<검열>, 2023. | *Pressure*, 2023.

© Mykola Kovalenko Studio

Are the authorities
pushing you around?

Stand up for
your rights.

미사일 ㅣ 단순한 디자인의 이 포스터는 개인이 어떻게 돌봄과 기본 인권을 박탈당할 수 있는지를 그려 보이며, 정치와 정권이 사람들에게 미치는 지대한 영향력을 강조한다.

강압 ㅣ 추상적인 형식을 취한 이 포스터는 자유를 위해 싸우는 개인과 정부 간의 불균형한 권력 투쟁을 묘사한다. 조그만 흰색 점을 짓누르는 검은 물체의 이미지는 정권이 얼마나 손쉽게 인권을 박탈할 수 있는지를 상징한다.

Missile | With a simple design, this poster highlights the significant impact that politics and government have on people, depicting how individuals can be deprived of care and basic human rights.

Pressure | Through an abstract style, this poster depicts a disproportionate power struggle between the government and individuals fighting for freedom. A black mass covers a small white spot, representing how the government can easily take away human rights.

베른하르트 렝거

〈새로운 세상을 위한 법〉, 2023. | *A Law for a New World*, 2023.

"ecocide" means unlawful or wanton
acts committed with knowledge that
there is a substantial likelihood of
severe and either widespread or
long-term damage to the environment
being caused by those acts.

Bernhard Lenger

⟨고장난 시스템⟩, 2023. | *Broken Systems*, 2023.

새로운 세상을 위한 법 l 이 포스터는 뛰어난 변호사이자 환경운동가로서 지구를 보호하기 위해 일생을 바친 고(故) 폴리 히긴스(Polly Higgins)에게 헌정하는 작품이다. 포스터의 목적은 생태파괴(ecocide)를 유죄로 간주하는 새로운 법이 시급하게 필요하다는 사실을 일깨우는 것이다.

이 포스터는 폴리 히긴스와의 대화에서 영감을 받아 제작되었다. 렝거는 환경 보호에 전념하는 히긴스의 열정과 헌신에 감동했다. 디자이너인 렝거는 생태파괴 관련법에 대한 히긴스의 주장에 깊은 감명을 받아 인권을 주제로 하는 작업을 시작하게 되었다.

생태파괴는 인간의 활동으로 인한 광범위한 생태계 및 환경의 파괴를 가리키는 용어로, 생태파괴는 지구에 돌이킬 수 없는 해를 입히는 환경 범죄의 일종이며 인간을 비롯한 수없이 많은 종의 생존을 위협한다.

이 포스터는 국제 스톱 에코사이드(Stop Ecocide International)가 정의한 현재의 생태파괴 개념을 통합하여, 생태파괴를 인류와 지구에 대한 범죄로 인식하는 것의 중요성을 홍보한다. 생태파괴의 유죄 선고는 환경을 보호하고 지구에 닥칠 더 큰 피해를 방지하는 강력한 수단이 될 수 있다.

A Law for a New World | The poster is a tribute to the late Polly Higgins, a prominent environmental lawyer and activist who dedicated her life to advocating for the protection of the planet. The poster aims to raise awareness about the urgent need for a new law that criminalizes environmental destruction, known as ecocide.

The poster is inspired by the conversations between Polly Higgins and Bernhard Lenger, who was moved by Higgins' passion and dedication to the cause of environmental protection. Higgins' advocacy for ecocide law became the catalyst for Lenger to start working on human rights issues as a designer.

Ecocide is a term that refers to the widespread destruction of ecosystems and the environment as a result of human activities. It is a form of environmental crime that causes irreversible damage to the planet and threatens the survival of countless species, including humans.

The poster promotes the importance of recognizing ecocide as a crime against humanity and the planet, by incorporating the current definition made by the Stop Ecocide International. The criminalization of ecocide can serve as a powerful tool to protect the environment and prevent further damage to the planet.

고장난 시스템 ⏐ 이 포스터는 우리 시스템을 현저하게 변화시키라는 시각적 촉구다. 포스터는 계속적인 발전을 통해 우리가 맞닥뜨린 난제에 얼마든지 대처할 수 있다는 사고방식에 도전하고 인류와 지구의 필요에 더 부합하는 사회·환경·정치적 구조에 대해 철저하게 고심해야 한다고 촉구한다. 이 디자인에서 제시하는 최소의 이상향적 비전은 야심 차면서도 성취 가능하여, 모두의 유익을 위한 시스템이 기능하는 세상, 자연이 다시 균형을 되찾은 세상을 상상하게 한다.

　　이 포스터는 개인과 공동체에게 시스템 변화를 위해 움직여야 한다고 요구한다. 우리를 둘러싼 시스템에 대해 비판적으로 사고하고 불평등과 부당함, 환경파괴를 영구적으로 고정시키는 구조에 도전하라고 촉구한다. 이는 조치를 취하고 더 나은 미래를 만들 책임이 우리에게 달려 있다는 점을 상기시킨다.

Broken Systems | This poster is a visual call for significantly changing our systems. The poster challenges the idea that incremental improvements are enough to address the challenges we face, calling for a complete reimagining of our societal, economic, and political structures to better serve the needs of humanity and the planet. A minimalistic utopian vision presented in the design is both aspirational and attainable, urging viewers to imagine a world where systems work for the benefit of all. One in which nature is back into balance.

The poster is a call to action, inspiring individuals and communities to work towards systemic change. It prompts people to think critically about the systems that surround them and to challenge the structures that perpetuate inequality, injustice, and environmental destruction. The poster serves as a reminder that it's up to us to take action and create a better future.

인권: 모든 사람의 이야기

Human Rights: Everyone's Story

안마노

<묘두>, 2023 | Modu, 2023.

An Mano

〈모심〉, 2023. | Mosim, 2023.

모두 ㅣ 민주인권은 우리 모두의 권리이다. 인종, 성별, 종교, 출신 지역에 관계없이 모든 인간은 자유롭게 생명, 자유, 그리고 행복을 추구할 권리가 있다. 이 포스터는 힘차게 쓰여진 '모두'라는 두 글자를 통해 이 땅의 민주인권을 지켜내고자 했던 믿음의 뿌리를 표현하고자 한다. 그것은 바로 사람들의 힘과 우리의 목소리이다.

모심 ㅣ 민주인권의 미래를 위해 '모심'이라는 말을 제안한다. 이는 이 땅의 사람들을 모두 섬긴다는 동학운동의 뜻에서 이어져 온 말이다. 우리 모두가 서로를 아껴주고 존중할 때, 서로를 모실 때 민주주의와 자유가 가능해진다. 이를 통해 우리는 민주주의적인 가치와 역할에 대해 생각하고, 더 나은 미래를 위해 함께 노력할 수 있다.

Modu | Democracy and human rights are for all. All human beings, regardless of race, gender, religion, or place of origin, have the right to freely pursue life, liberty, and happiness. This poster features energetic strokes that read "all" or "everyone" in Korean. It seeks to visualize the conviction at the heart of those who fought to keep democracy and human rights alive in South Korea—the conviction in the power and voices of the people.

Mosim | This work suggests *mosim*, meaning "service" in Korean, as the attitude towards which democracy and human rights should advance. The word has its roots in the Donghak Peasant Revolution in the late 1890s, which was founded on the idea of serving all people of this land. Democracy and liberty are realized only when we all care for, respect, and serve one another. It is only then that we are able to reflect on the value and role of democracy and work together towards a better future.

디스 애인트 로큰롤
(찰리 워터하우스, 클라이브 러셀)

<모든 사람은 해적이다>, 2023. | *Everyone is Pirate*, 2023.

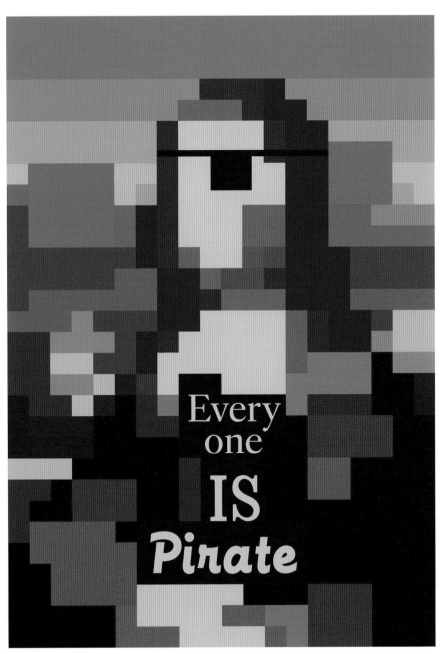

This Ain't Rock'n'Roll
(Charlie Waterhouse and Clive Russell)

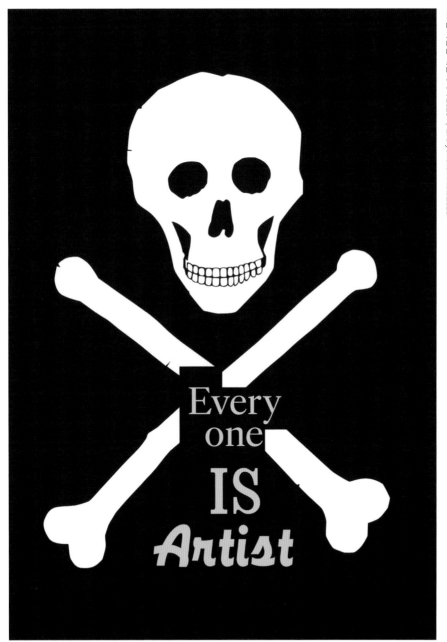

〈모든 사람은 예술가다〉, 2023. | *Everyone is Artist*, 2023.

디스 애인트 로큰롤
(찰리 워터하우스, 클라이브 러셀)

모든 사람은 해적이다 · 모든 사람은 예술가다 | 약 250년의 시간 차가 있는
〈모나리자〉와 졸리 로저(Jolly Roger, 해적기)는 오늘날까지도 많은 사람들이
알아보는 강력한 상징이다. 두 이미지가 별 연관성이 없다고 생각할 수도
있지만, 둘 사이에는 놀랍게도 많은 공통점이 있다. 〈모나리자〉는 초기
계몽주의, 즉 우리가 현대 민주주의의 태동과 연관 지어 생각하는 바로 그
시기에 그려진 작품이다. 이 시기 유럽에서는 인쇄술이 발명되고 출판물에
(라틴어가 아닌) 공용어를 사용하면서 지식 접근권이 확장되었다. 그래서
그리스의 민주주의 수행에 대한 정보가 널리 회자되었고, 왕권과 군주제에
의문을 제기하게 되었다. 신 앞에서는 모든 사람이 동등하기 때문이다.

　　졸리 로저는 이와 같은 이성의 시대에 종지부를 찍었다. 당시 유럽은
이성(그리고 신)을 구실로 삼아 세계의 광대한 지역을 식민지로 삼았다. 졸리
로저를 달고 다니던 해적들 중에는 교육을 받은 상인도 있었고, 노예 출신의
자유민도 있었다. 이들은 자신들이 유럽의 세계관에 맞지 않는다는 공통의
합의 아래 모였다. 졸리 로저는 폭력의 상징이 아니라, 추방된 자로서의
자신의 사회적 지위를 인지한 선원들이 자신의 '이미 죽은 상태'를 선언한
것이다. 많은 해적들이 급진적인 형태의 민주주의를 실천했는데, 예컨대
'합의에 따른 의사결정' 같은 관행은 오늘날의 기준에서 보아도 매우
급진적이다.

　　인류학자 고(故) 데이비드 그레이버(David Graeber)는 다음과 같은
탁월한 평을 남겼다. "해적들은 위기와 무법, 그리고 자유에 대한 극단적인
이상을 상징하면서 로맨스와 판타지 영역에 오래도록 살아남았다. 그러나
이 신화의 근저에는 사회를 움직이는 실제 해적들의 공동체, 즉 유럽 제국의
가장자리에서 자치와 대안적 사회 형성에 관해 활기차고 상상력 풍부한
실험이 이뤄졌다."

　　〈모든 사람은…〉의 메시지는 예술이 어떻게 민주적일 수 있는지를 제기한

Everyone is Pirate · Everyone is Artist | Separated by approximately 250 years, the *Mona Lisa* and the Jolly Roger are potent symbols that are still recognizable today. Although you might think there's no link, you'll be surprised to find they have a lot in common. The *Mona Lisa* was painted in the early enlightenment period—a period we associate with the birth of modern democracy. During this time, in Europe, more people had access to knowledge because of the invention of the printing press and the use of common languages in print (not Latin). This meant Greek democratic practices were widely discussed and the ideas of kingship and monarchy were questioned: Everyone is equal in the eyes of God.

The Jolly Roger marks the end of this age of reason. An end which saw Europe enslave huge areas of the world using rational thinking (and God) as an excuse. The pirates who flew the "Jolly Roger" were from diverse backgrounds. Some were educated merchants, others freed slaves. These crews were held together by a common understanding that they did not fit into this European world vision. The Jolly Roger is not a symbol of violence but a declaration of the crew being "already dead," a recognition of the crew's social status as outcasts. Many crews practiced radical forms of democracy, even by today's standards, like consensus decision-making.

In the late, great David Graeber's words: "Pirates have long lived in the realm of romance and fantasy, symbolizing risk, lawlessness, and radical visions of freedom. But at the root of this mythology were real pirate societies—vibrant, imaginative experiments in self-governance and alternative social formations at the edges of the European empire."

The message "Everyone is … " paraphrases a Joseph Beuys quote which questioned how democratic art is. He proposed that "everyone

요제프 보이스(Joseph Beuys)의 말을 옮긴 것이다. 보이스가 '모든 사람은
예술가'라고 주장한 이유는 인간의 모든 행동에는 어떤 퍼포먼스적 요소, 또는
하나의 행동을 다른 행동과 구분 짓기 위한 장식 문자와 같은 모종의 예술이
내포되어 있기 때문이다. 디스 애인트 로큰롤은 이런 면모를 민주주의의
중요한 일부로 인식하며, 민주주의에 문제를 제기하고 (17세기 해적들이 그랬듯이)
새로운 형태의 민주주의를 고안하는 능력이 더욱 중요하다고 말한다. 이런
능력이 없다면 우리는 지금 있는 곳에 그대로 머무른 채, 불공정한 세상
속에서 지구의 파괴를 향해 무모한 경주를 하다가 자멸을 초래할 것이다.

is an artist" because all human activities have some kind of art within them, some element of performance or a flourish to mark one action from another. This Ain't Rock'n'Roll recognizes this as an important part of democracy, and the ability to question democracy and invent new versions of it (like 17th-century pirates did) is even more important. Without this we are stuck where we are—in an inequitable world running headlong towards the destruction of our planet, our own extinction.

<누가 남는가?>, 2023. | Who's Left?, 2023.

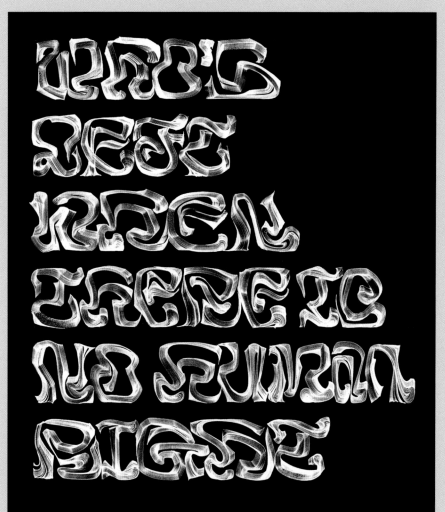

WHO'S
RIGHT
WHEN THERE
IS
NO HUMAN
LEFT

<누가 옳은가?>, 2023. | Who's Right?, 2023.

누가 남는가? ㅣ 우리는 다음과 같은 주제에 대해 이야기를 나눴다. 정의나 자유는 차치하고라도, 평등이란 정확히 무엇인가? 우리는 흑과 백이 언제나 공존하는 서체상의 원칙 안에서 경험한 혼란을 추상적으로 번역하는 방법을 고심했다. 성명을 내는 일이 우리에게 달려 있나? 질문을 던지는 일이 우리에게 달려 있나? 단어를 이리저리 바꿔 보고, 말장난을 하고, 상반된 개념끼리 바꿔 철학적 대화를 시작하고, 언어의 아름다움과 단어의 의미, 해석의 여지를 창출했다. 이제 또 다른 질문을 적어 보자.

누가 옳은가? ㅣ 영어 단어 'right'는 '권리를 부여하다, 도덕적으로 선하거나 옳다, 특정 방향(오른쪽)' 등 여러 가지로 해석될 수 있다. right의 반대말은 left로, 방향(왼쪽)과 관련된 의미 외에도 '남는다'라는 의미도 지닌다. 다소 혼란스럽게 읽히는 이 질문(Who's right?)은 훌륭한 철학적 대화를 요구한다. 인권의 테두리 바깥에 남은 사람들이 있는 상황에서, 누군들 도덕적으로 선하다 할 수 있을까?

Who's Left? | We talked about and discussed the themes. What exactly is equality? Let alone justice or freedom. We considered making abstract translations of the experienced confusion, created within the calligraphic principle where black and white always work together. Is it up to us to make a statement? Or is it up to us to ask questions? Playing with words, creating wordplay. Shifting opposites opening up philosophical conversations. The beauty of language, the meaning of words, space for interpretation. Let's write down another question.

Who's Right? | Right can be interpreted in many ways: being entitled to something, being morally good or correct, and as a sense of direction. The opposite of right is left, which apart from direction also has the meaning of leaving. The slightly disorientating question asks for a good philosophical conversation. Is there anyone who is morally good as long as there are people left out from their human rights?

마크 고잉

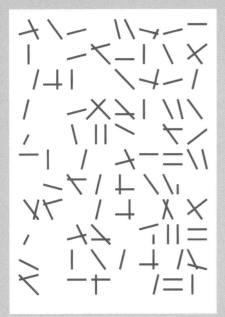

<겹친 선들의 언어 체계(내가 생각하는 바를
또한 그대가 생각할 터) #1>, 2023.
*Language System of Overlapping Lines (And
what I assume you shall assume) #1*, 2023.

<겹친 선들의 언어 체계(내가 생각하는 바를
또한 그대가 생각할 터) #2>, 2023.
*Language System of Overlapping Lines (And
what I assume you shall assume) #2*, 2023.

Mark Gowing

겹친 선들의 언어 체계(내가 생각하는 바를 또한 그대가 생각할 터) #1 · #2 | 마크 고잉의 추상적이고 기하학적인 조판들은 기존의 문자 언어를 전복해 형태와 언어의 새로운 조합을 창조한다. 이 두 작품은 시인 월트 휘트먼(Walt Whitman)의 1855년 작 〈나 자신의 노래, 1〉[나는 나 자신을 찬양한다]에 등장하는 "내가 생각하는 바를 또한 그대가 생각할 터, / 내게 속한 모든 원자는 마찬가지로 그대에게 속하므로."(And what I assume you shall assume, / For every atom belonging to me as good belongs to you.)라는 구절을 글자 형태를 해체해 하나의 조판 체계로 보여준다. 평등을 선언하는 이 글귀는 작품에 배열된 각각의 획에 반영되어 있는데, 각각의 선은 자유롭고 주체적으로 보이지만 여전히 유기적이고 리듬감 있는 체계 안에서 전체와 관계를 맺는다. 이는 마치 한 그룹의 구성원들이 하나의 민주적 공동체 안에서 독립적으로 생활하는 모습과 비슷하다. 두 작품을 서로 겹쳐 올리면 읽을 수 있는 문자 배열이 나타나는데, 이는 개개인이 모인 집단의 결속을 통해 민주주의 체계가 성취될 수 있음을 보여준다. 두 작품 속 선들은 각각 파란색과 빨간색으로 그려져 있는데, 이 두 가지 색은 정치에서 서로 대립하는 좌파와 우파를 나타낼 때 통상적으로 쓰이며, 세계 여러 나라에서 자국의 정체성을 나타내는 색으로도 자주 사용된다. 두 작품의 타이포그래피 문구들은 합의된 영어 기호 체계를 우아하게 추상화하는 개념적 개입을 형성하며, 우리가 서로 관계를 맺는 방식에 대한 직관적인 이해에 질문을 던진다. 표준 언어체계 외부에서 출발하는 고잉의 관점은 일종의 외적 관점을 제공하고 기존의 쓰기에 새로운 의미를 부여한다.

Language System of Overlapping Lines (And what I assume you shall assume) #1 · #2 | Gowing's abstracted geometric typesettings subvert the conventional written word to create new combinations of form and language. These two works employ a type system of formally deconstructed letterforms that represent a selected stanza from Walt Whitman's 1855 poem *Song of Myself, 1 [I Celebrate myself]*, in which Whitman declares that "And what I assume you shall assume, / For every atom belonging to me as good belongs to you." This statement of equality is reflected in the work's arrangement of individual strokes where each line feels free and autonomous, yet still relates to the whole in an organic and rhythmic system, like a group of people living their lives independently, yet within a democratic community. When overlaid on top of one another, the two works create a legible arrangement of the written text, exhibiting how a democratic system can be achieved through the solidarity of a group of individuals. The two works are executed in blue and red in response to the politically traditional opposing colors of left and right, and as used in a large number of national identities throughout the world. These two typographic statements together form a conceptual intervention that elegantly abstracts our agreed system of English language marks, and questions our innate understanding of how we relate to one another. Gowing's view from outside our standardized language systems provides a kind of external perspective and lends new meanings to existing writings.

〈나를 보라, 우리를 보라〉, 2023 | See Me, See Us, 2023.

Elliot Stokes

〈타자이〉, 2023. | *At the Table*, 2023.

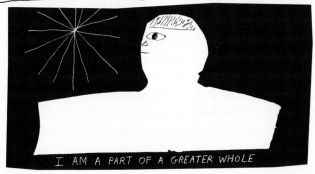

"At the Table" by Elliot Stokes

나를 보라, 우리를 보라 | 소수자 인권은 인종, 종교, 성 정체성 등이 다른 공동체의 일원을 동등하게 존중하기 위한 기본 인권으로서 존재한다. 소수자들의 정체성에 대한 동등한 인정, 보호, 존중은 소수자 인권의 주요 요소다. 이러한 권리들은 개인, 그리고 그 개인이 속한 공동체 모두에 적용된다.

〈나를 보라, 우리를 보라〉에는 소수자 가시성이라는 개념을 담았다. 포스터에는 종이 조각으로 만든 세 주인공이 등장한다. 그들은 서로 연대하면서도 동시에 각자의 정체성을 드러내면서 서 있다. 그들의 몸통을 구성하는 다양한 질감이 그것을 상징한다. 다 같이 팔을 활짝 벌려 위로 치켜든 인물들은 자신들의 존재를 굳건하게 주장하면서 집중을 요구한다. 포스터의 회화적 타이포그래피는 화면 중앙에 있는 인물들을 보완하며 테두리를 이룬다. 그 메시지는 집요하고 반복적이고 결연하여, 작품의 주제가 드러내고자 하는 정서를 극대화한다. 텍스트 안에서 번갈아 가며 쓰인 단수 대명사와 복수 대명사(Me, Us, I, We)는 개인과 공동체 사이의 이중성을 반영한다. 문자와 이미지가 함께 평등에 대한 인식을 요청한다.

See Me, See Us | Minority rights exist as fundamental human rights that act to ensure equal respect for members of different communities, by race, religion, or gender identity. Equal acknowledgment, preservation, and respect of minority identity are elemental to minority rights. These rights apply both to individuals and to the communities in which they belong.

See Me, See Us conveys this concept of minority visibility. Depicted in the poster are three protagonists, constructed with found papers. They stand in solidarity, while simultaneously carrying their individual identities—defined by the varied textures that comprise their bodies. With their arms collectively upright and expansive, the figures firmly assert their presence and command attention. The poster's painterly typography complements and frames the central figures. Its messaging is insistent, repetitive, and resolute, amplifying the thematic sentiment. Within the text, the rotation of singular and plural pronouns—Me, Us, I, and We—reflect the duality between individual and community. Together, the type and image work to invoke equality in perception.

탁자에 | 미국 최초의 여성 국회의원인 셜리 치좀(Shirley Chisholm)은 "그들이 탁자에 당신의 좌석을 마련하지 않는다면 접이식 의자를 가져오라."고 강력하게 선언했다. 그녀의 발언은 포용(inclusion)과 대표(representation)의 개념을 뚜렷하게 나타내고 있다. 치좀의 말에서 따온 〈탁자에〉는 소수자의 목소리를 묘사하는 데에 집중한다. 두 부분으로 나뉜 포스터 윗부분에는 한 무리의 인물들이 둥글게 모여 있다. 종이를 잘라 만든 이 인물들은 다양한 색상과 질감으로 이루어져 있으며 그림 아래에는 관련 문구가 있다. 맨 아래에 있는 크게 확대된 인물은 위에 있는 한 무리의 사람들과 시각적·개념적 대비를 이루면서 개인적인 관점으로 맥락을 전환한다. 이 인물은 그 아래 적힌 문구에 표현된 바와 같이 사람들 각자의 목소리를 고려하고, 전체 집단에 대한 각자의 역할을 강조한다. 서로 구별되지만 근본적으로는 연결되어 있는 이 요소들은 재현에 있어 소속, 포용, 다양성이라는 아이디어를 전달하기 위해 한 곳으로 수렴된다.

At the Table | Shirley Chisholm, the first Black United States congresswoman, powerfully declared, "If they don't give you a seat at the table, bring a folding chair." Her statement boldly embodies the concepts of inclusion and representation. Referencing Chisholm's words, *At the Table* centers on describing the minority voice. Divided into two parts, the top section of the poster depicts a collection of figures circled in assembly. Punctuated with referential text beneath, these paper-cut figures are rich in color and texture. At bottom, an expansive singular figure sits in stark juxtaposition to the group above, imparting visual and conceptual contrast, shifting the context to an individual perspective. This figure considers their individual voice and highlights their role in regards to the larger population, as expressed in the figure's caption. Distinct but fundamentally connected, the components converge to telegraph ideas of belonging, inclusion, and diversity in representation.

에런 니에

<자기 해석>, 2023. | Self-Interpretation, 2023.

Aaron Nieh

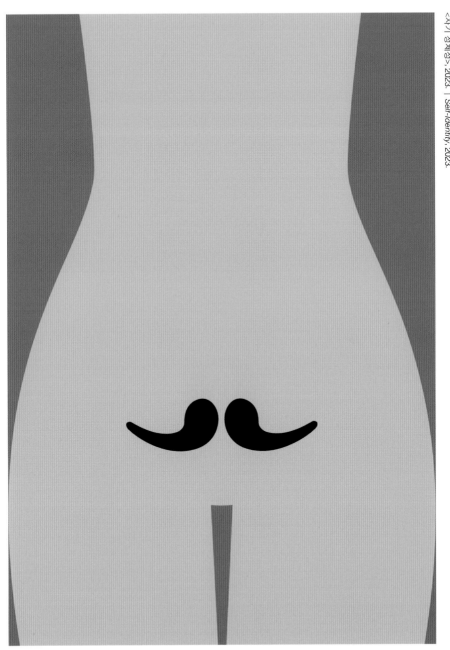

<자기 정체성>, 2023. | *Self-Identity*, 2023.

자기 해석 ┃ 다양성의 사회에서 이 세대를 살아가는 인간으로서 우리는 개인의 독립과 자기 정체성의 가치를 존중하는 법을 배워야 했다. 포용성은 피부색, 젠더, 배리어 프리(barrier-free), 일반적인 정치적 올바름을 다룰 뿐 아니라 개인이 자신의 신체에 대해 자기 해석을 할 권리 또한 독려한다.

자기 정체성 ┃ 물리적 현실이 어떠하든 간에, 어떤 모습을 하고, 어떤 옷을 입고, 어떤 색을 좋아해야 하며, 어떤 자기 젠더 정체성을 지녀야 한다는 젠더 고정관념에 반대할 권리가 있다. 진정한 인권의 기반은 타인이 가정하는 바를 억지로 만족시키지 않고 개인의 선택을 존중하는 데 있다.

Self-Interpretation | As humans living in a society of diversity in this generation, we have had to learn to respect the values of individuals' independence and self-identity. Inclusivity covers not only color, gender, and barrier-free and general political correctness, but also encourages the rights to one's self-interpretation of their bodies.

Self-Identity | Anyone has the right against gender stereotypes to determine how they look, how they dress, what color they like, and their self-identification as to sex, despite another tale being told by physical reality. True human rights are based on respect for individuals' choice without being forced to satisfy others' assumptions.

굿퀘스천

(우유니, 신선아)

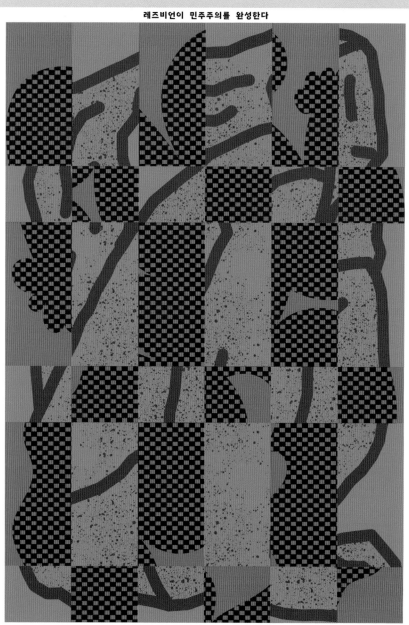

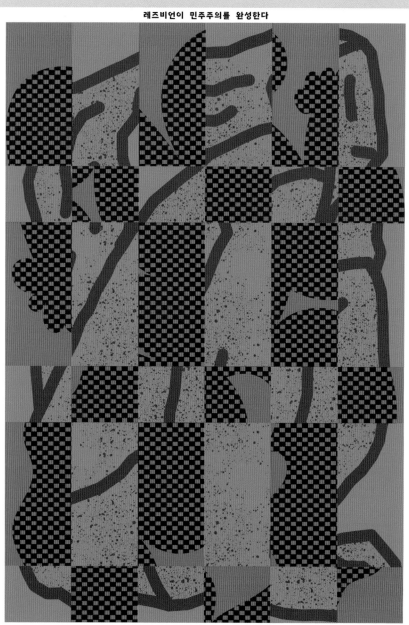

레즈비언이 민주주의를 완성한다

LESBIANS PERFECT DEMOCRACY

<레즈비언이 민주주의를 완성한다 1>, 2023. | *Lesbians Perfect Democracy 1*, 2023.

Good Question
(Yuni Ooh and Sun-ah Shin)

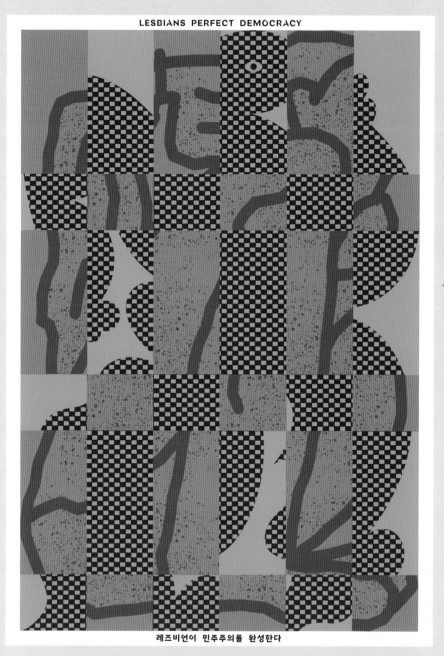

LESBIANS PERFECT DEMOCRACY

레즈비언이 민주주의를 완성한다

<레즈비언이 민주주의를 완성한다 2>, 2023. | Lesbians Perfect Democracy 2, 2023.

레즈비언이 민주주의를 완성한다 1・2 | 지금까지 기록된 민주주의는 불완전하다. 한국 민주주의 담론은 '어떤' 민주주의를 '어떻게' 할 것인가에 초점을 맞추어 왔지만 '누가' 주체인가의 문제는 괄시했다. 2022년 고등학교 도덕 과목에서는 '성평등'이, 통합사회과목에서는 '성소수자' 표현이 삭제되었다. 미소지니(misogyny)와 호모포비아(homophobia)로 중첩된 차별을 받고 있는 곳에서 레즈비언은 과연 민주주의를 경험하고 있을까?

　중심보다는 주변부로 떠밀리는 여성들, 그중에서도 남성과 성애적 관계를 맺지 않는 레즈비언은 더욱 과소 대표되고 계속 다음 차례로 밀려나 보이지 않게 된다. 이러한 레즈비언이 정치적 주체로서 지위를 가지고 사회 전면에 나올 때, 비로소 민주주의가 완전해질 수 있다.

Lesbians Perfect Democracy 1 · 2 | The current written history documenting democracy is incomplete. Discourses on democracy in South Korea have been focused on "how to" achieve "what type" of democracy, undermining the question of "who" the subjects of the democracy are. In 2022, the expressions "gender equality" and "sexual minorities" were erased from South Korea's high school ethics and social studies textbooks respectively. Is democracy being experienced by lesbians in this country, where discrimination takes the form of both misogyny and homophobia?

Women are marginalized as they are, and lesbians, for merely not engaging in sexual relationships with men, are further underrepresented and underprioritized to the point of invisibility. It is only when lesbians come to the fore of society as political subjects that democracy can be complete.

이경민
(플락플락)

<이것은 뒤표지랍니다······>, 2023. | *This Being the Back Cover ···* , 2023.

Kyungmin Lee
(flagflag)

〈Adobe 명조 Std. M, 12pt, 14.4pt〉, 2023. | Adobe Myungjo Std. M, 12pt, 14.4pt, 2023.

이경민
(플락플락)

이것은 뒤표지라능⋯ ㅣ 작업의 제목은 퀴어 연속간행물 『완전변태』 창간호
(완전변태 발행, 2008)의 뒤표지 문구에서 가져왔고, 본 작업은 퀴어 연속간행물
48종의 뒤표지 사진으로 구성됐다.

　한국에서는 1994년부터 현재까지 꾸준히 퀴어를 다루고 퀴어가 만든
연속간행물이 등장하고 있다. 이들은 (ISBN/ISSN이 등록된) 공식 출판과는
다른 목적과 방식으로 기획-집필-편집-디자인-유통됐다. 다른 목적이라
함은 성소수자에 대한 낙인이 강한 사회 속에서 서로 연결되고 싶은 열망과
간절한 정보의 공유였으며, 다른 방식이라 함은 경제적이고 '비전문적'인 자가
출판을 통한 제작과 퀴어 커뮤니티만의 네트워크를 통한 수면 아래의 비공식
유통 등을 꼽을 수 있다. 이러한 특징은 특히 한국 최초의 퀴어 연속간행물로
기록된 『초동회 소식지』가 발행된 1994년부터 가정용 인터넷이 대중화된
2000년대 중반 사이에 발행된 연속간행물에서 두드러진다. 비공식 경로로의
유통은 연속간행물의 수집과 기록에 제약을 가져오는데, 현재 한국에서 가장
많은 퀴어 기록물을 소장 중인 퀴어 아카이브 '퀴어락'에서도 연속간행물의
목록은 곳곳이 누락돼 있다. 이를 불완전한 방식으로 다시 기록해 보고자 했다.

　오늘날 출판 시장에서 책의 대표 이미지를 '앞표지'로 한정하는 관습에
질문을 하며 뒤표지를 기록했다. 해당 기간에 발행된 퀴어 연속 간행물의
뒤표지에는 업소 광고, HIV/AIDS 캠페인, 단체 사무실 정보, 낙서 등 흔히
기록의 대상으로 여겨지지 않는 다양한 흔적들이 있다.

Kyungmin Lee
(flagflag)

This Being the Back Cover … | The title of the work is derived from a quote printed on the back cover of the first issue of *Wanjeonbyeontae* (2008), a queer serial publication. The work itself is composed of images of the back covers of 48 different queer serial publications.

Serial publications for and by queer people have been consistently produced in South Korea since 1994. The ways in which these publications have been ideated, written, edited, designed, and distributed as well as their purposes, distinguished them from regular, commercial publications. Many of the publications were produced in a cost-effective way by non-professionals to be covertly and informally distributed within the queer community. The intention went beyond a mere sharing of information to also relay the common desire for connection within a society that stigmatizes sexual minorities. These aspects are prominent in queer serial publications produced between 1994, when South Korea's first-recorded queer serial publication *Chodonghoe Sosikji* was issued, and the mid-2000s, when the internet was widely distributed around homes. Distribution through informal channels limited the collection and documentation of these publications, and even Korea Queer Archive, South Korea's largest queer materials archive, has issues missing from its lists of serial publications. Lee's work seeks to document the incompleteness of the archive.

The collection of back covers questions the convention of limiting the placement of representative images to the front cover of publications. The back covers of the queer serial publications from the given period feature advertisements, HIV/AIDS campaigns, publisher information, doodles, and other elements often deemed unfit for documentation.

이경민
(플락플락)

Adobe 명조 Std, M, 12pt, 14.4pt | 작업의 제목은 어도비사의 레이아웃 디자인 프로그램 '인디자인'의 기본 문자 서식 값에서 가져왔고, 본 작업은 〈이것은 뒤표지라능…〉에 기록된 퀴어 연속간행물 48종의 제목, 발행 연도, 발행처 정보로 구성됐다.

퀴어 연속간행물들은 많은 경우 '전문' 출판인이 아닌 퀴어 커뮤니티 구성원들이 직접 '비전문'적인 방식과 과정으로 만들고 유통했다. 이는 적은 물적·인적 자원으로 구성된 퀴어 커뮤니티의 환경과 연관이 있다. 소수의 사람들 혹은 1인이 출판의 모든 과정을 도맡은 경우가 많았는데, 이때 1990년대 초반부터 국내에 도입된 워드프로세서 프로그램인 '아래아한글'이 디자인의 주요 도구로 사용되곤 했다. 이 과정에서 해당 프로그램의 기본 기능과 형식으로 만들어진 인쇄물들이 보이기도 한다. A5 혹은 A4 판형, 기본 탑재된 폰트의 사용과 도드라지는 특징이 없는 글줄 구성, 흑백 출력과 중철 제본 등이다.

본 포스터의 글들은 오늘날 출판 작업에 주로 사용하는 어도비사의 인디자인을 열었을 때 설정된 기본 문자 서식으로 쓰였다.

Kyungmin Lee
(flagflag)

Adobe Myungjo Std, M, 12pt, 14.4pt | The title of this work lists the values of the default text setting in InDesign, the Adobe layout design program. The work comprises the titles, publication dates, and publisher information of the 48 queer serial publications featured in *This Being the Back Cover … .*

Most of the early queer serial publications were produced and distributed by non‑professional publishers and members of the queer community through "unprofessional" methods and processes. This was due to limited resources such as materials and labor within the queer community. In many cases, a small number of people, if not one person, oversaw the entire publishing process. The main design tool used then was the word‑processing program Hangul Word Processor (HWP), which began to be widely used in South Korea in the early 1990s. Its default setting and format can be spotted in some of the publications. These publications are marked by A5 or A4‑size formats, the use of built‑in fonts, plain and design‑less line compositions, black‑and‑white prints, and saddle stitch binding.

The text in this poster is set in the default style provided by Adobe InDesign, the most widely used publication design tool today.

신인아

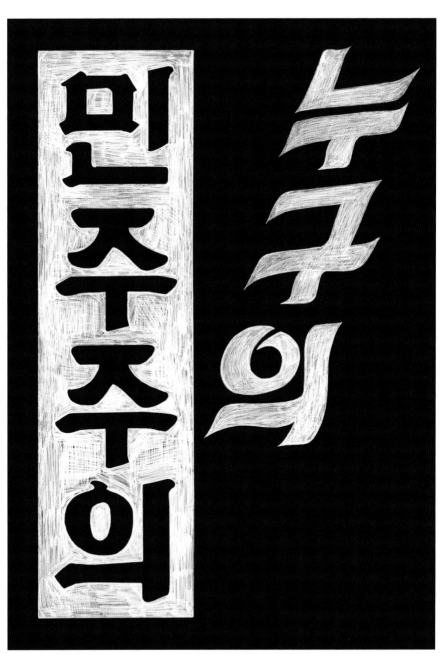

〈누구의 민주주의〉, 2023. | Whose Democracy, 2023.

Shin In-ah

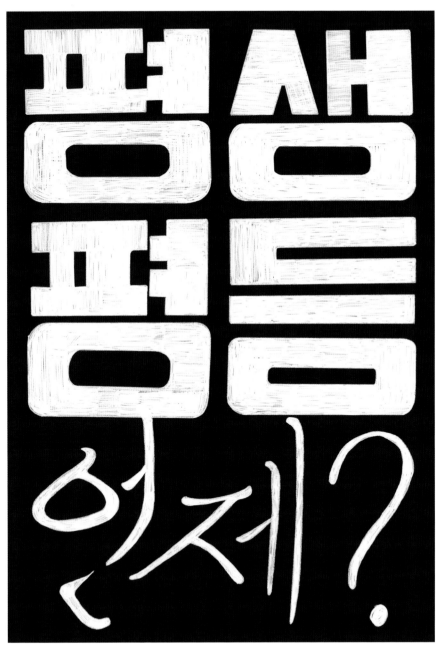

<평생평등 언제?>, 2023. | *Equality for Life, When?*, 2023.

누구의 민주주의 · 평생평등 언제? | 사회 변혁은 홀로 이룩할 수 없는 것임에도 그에 함께한 모두는 하나하나 기억되지 않는다. 민주화 운동을 이야기할 때 역시 여성과 같은 소수자들은 잊혀지거나 누락된 인물들로 간간이 소환될 뿐이다. 기억되고 기념되는 이들의 이름이 높아질수록 그 운동은 누구의 운동이었는지 되묻지 않을 수 없다. 민주주의의 앞에 '누구의'를 붙이는 건 성립되는 말일까? 그런데 그렇다고 민주주의가 오늘날 모든 사회 구성원을 위한 것이라는 명제는 참인가? 그렇다면 어째서 30-40년 전 여성들이 외쳤던 '평생 평등'이라는 구호는 아직도 '동일 노동 동일 임금'으로 메아리 치고 있는가?

다시, 기억되는 것이 이야기의 총체가 아니다. 그렇지만 누락된 이야기를 찾으려면 기억되는 이야기의 조각들을 뒤질 수밖에 없다. 여성의 의제를 다루었던 순간들의 기록을 뒤적이며 나는 걸개 디자인에 주목하게 되었다. 그곳에 여성의 목소리를 담은 특징적 타이포그래피는 일관된 스타일을 가지고 있었고 누군가(들)의 작업임이 분명했다. 이 작업들을 내 작업에 되도록 충실히 소환하고 싶었다. 삐뚤면 삐뚤어진 채로. 그 배경의 이야기까지 알고 싶으니까.

Whose Democracy · Equality for Life, When? | Change on a societal level cannot be achieved alone. However, many individuals who partake in said change go unrecognized or are not remembered. In discussions on democratic movements, minority members of society, including women, are only intermittently brought up and often forgotten or left out. As the few remembered and celebrated names earn a higher and higher status, we cannot help but ask who the actual agents of the movement were. Would it make sense to add "whose" in front of "democracy"? Furthermore, is the statement "Democracy today is for every member of society" even true? If so, then why does the slogan "Equality for Life" uttered by women some 30 to 40 years ago still ring true today, in the form of "Equal Pay for Equal Work"?

Again, this isn't necessarily about being remembered. It's an effort to reclaim the stories that have gone omitted. We must scour the pieces of the stories that we remember. Digging through the archive of events pertaining to women's issues, I came to pay attention to the banner designs. The unique typographies capturing women's voices had a coherent style and were clearly works by the same person (or people). I wanted to faithfully incorporate this into my work. If they were crooked, they were crooked for a reason. I wanted to find out, and understand everything about such works.

<줍지 못한 조개>, 2023. | The Unpicked Shell, 2023.

Minho Kwon

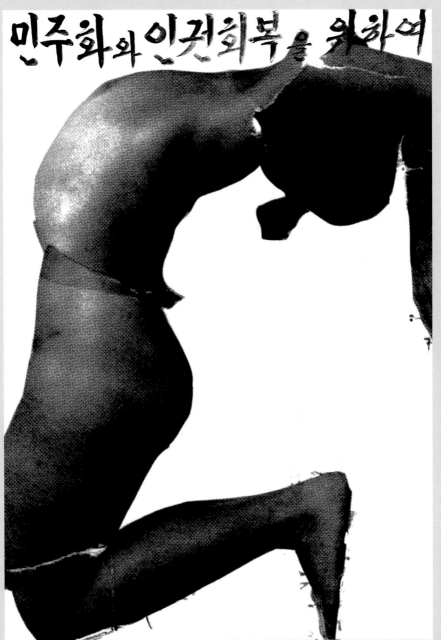

<div style="writing-mode: vertical">〈민주화와 인권회복을 위하여〉, 2023. | *For Democratization and Restoration of Human Rights*, 2023.</div>

줍지 못한 조개 | 엄마의 손을 잡고 놀이동산에 가는 길. 육교에 올라서니 건너편 큰 형, 누나들이 다니는 대학교 건물이 보였다. 하얀색 건물에 박혀 있는 검은 유리창 하나에서 검은 연기가 뿜어져 나왔다. 누군가를 타도하고 무언가를 호소하는 절박한 문구가 가득한 배너들. 그 사이에서 검은 연기를 내뿜는 하얀색 건물. 그 풍경은 숭고해 보였다. 그것의 맥락을 이해할 수 없었던 저학년 초등학생에게도 그 싸움의 숭고한 이미지는 충분히 지배적으로 드리워졌었다. 그래서였을까? 거대한 절대 악과 정의로운 싸움이라는 빛나는 대의명분은 정작 그들 안에서의 민주화와 인권을 보살피지 못하게 했다. 당내 성폭행 사건이 벌어졌을 때 한 운동권 출신 정치인이 말했던 "해일이 몰려오는데 조개를 줍고 있다."는 그들의 대의가 그들이 추구했던 가치를 가리고 있음을 드러낸다. 이 포스터는 그때 줍지 못했던 그 '조개'의 이미지를 다룬다. 당시, 투쟁의 급박한 상황을 묘사하는 회보의 뒤에 반쯤 가려진 한 여성 동지의 초상을 넣었다.

민주화와 인권회복을 위하여 | 거대하게 밀려오는 '해일'과의 거룩하고 숭고한 싸움 때문에 줍지 못했던 '조개' 이야기를 이어서 한다. 첫 번째 포스터가 그 가려진 아이덴티티에 초점을 맞췄다면 두 번째는 남성 중심의 가부장적 폭력으로 착취된 여성 구성원들에 대한 메시지를 담았다. 당시 대표적인 슬로건 중 하나인 "민주화와 인권회복을 위하여"라는 문구를 실제 사용됐던 현수막에서 가져왔다. 그 아래 뒤틀리고 왜곡된 여성의 신체를 배치했다. 무릎을 꿇고 있는 듯한 어떻게 보면 한반도의 모습을 연상시키는 듯한 형상을 포토 콜라주로 만들었다. 인체를 프레임 안에 가득 차게 배치하여 사각형의 틀 안에 마치 구겨져 끼어들어 간 듯한 느낌을 주려고 했다.

The Unpicked Shell | I was holding my mother's hand and climbing up an overpass to get to a theme park when I saw the college building. There was black smoke billowing out from one of the white building's black windows. The sight of the banners filled with desperate cries about overthrowing something against the white building emitting black smoke was sublime. Even to a low-grade elementary school student with no contextual understanding, this magnificent snapshot of the protest left a lasting impact. Perhaps it was the attraction of such a great and glowing cause—fighting a just fight against a giant and absolute evil—that blinded the activists from addressing their own democracy and human rights issues within. The phrase "picking up clam shells when a tidal wave is rushing in" was used by a former-activist politician to describe the attention on the sexual assault that occurred in his party. This phrase reveals how the sense of a "great cause" has obscured the very values that activists had initially fought for. This poster is about that "shell" that went neglected. A portrait of a female activist-student is half-obscured by the bulletin describing the urgency of the protest.

For Democratization and Restoration of Human Rights | This work continues the story of the shells that went unnoticed amid the sacred, noble fight against the "tidal wave." Whereas the first poster highlighted the identity of the obscured individual, the second conveys a message about women who have been exploited and violated within a male-dominated, patriarchal society. Under the slogan used on a banner in a previous protest, is a contorted, female body. The kneeling figure was created by collaging photographs and vaguely resembles the shape of the Korean peninsula. Furthermore, the way in which the figure is seemingly crammed into frame conjures a sense of confinement.

이지원
(아키타입)

〈분노의 게이지, 2012-2022〉, 2023 | Gauge of Anger, 2012-2022, 2023.

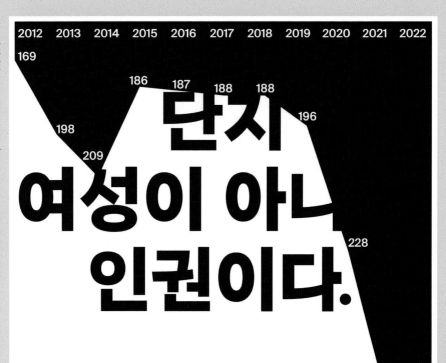

| 2012 | 2013 | 2014 | 2015 | 2016 | 2017 | 2018 | 2019 | 2020 | 2021 | 2022 |

169
198
209
186
187
188
188
196
228
260
311

단지 여성이 아니 인권이다.

Femicide is not just a crime against women, it is a violation of human rights.

Over the past 11 years, at least 2,320 women in South Korea were killed or threatened by their intimate partners. On average, one woman was killed or threatened every 1.7 days. In 2022, 311 women were killed or threatened by their intimate partners, which translates to an average of one woman being killed or threatened every 1.17 days. The number of women killed or threatened by intimate partners in the previous years were as follows: 169 in 2012, 198 in 2013, 209 in 2014, 186 in 2015, 187 in 2016, 188 in 2017, 188 in 2018, 196 in 2019, 228 in 2020, and 260 in 2021.

지난 11년간 대한민국에서 최소 2,320명의 여성이 남편이나 애인 등 친밀한 관계의 남성에 의해 살해되거나 살해 위협을 당했다. 약 1.7일에 한 명이 죽거나 죽을 위험에 처했다. 2022년에는 311명의 여성이 친밀한 관계의 남성에 의해 살해되거나 살해 위협을 당했다. 약 1.17일에 한 명이 죽거나 죽을 위험에 처했다. 2012년에는 169명, 2013년에는 198명, 2014년에는 209명, 2015년에는 186명, 2016년에는 187명, 2017년에는 188명, 2018년에도 188명, 2019년에는 196명, 2020년에는 228명, 2021년에는 260명의 여성이 친밀한 관계의 남성에 의해 살해되거나 살해 위협을 당했다.

Jiwon Lee
(archetypes)

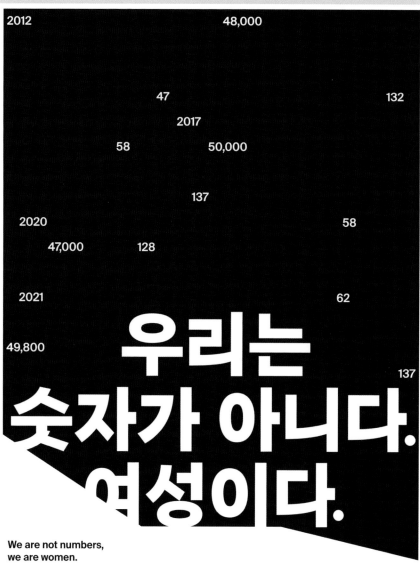

〈페미사이드, 2012-2021〉, 2023. | Femicide, 2012-2021, 2023.

2012 48,000

47 132

2017

58 50,000

137

2020 58

47,000 128

2021 62

49,800 137

우리는 숫자가 아니다. 여성이다.

**We are not numbers,
we are women.**

Globally, in 2012, an estimated 48,000 women - around 132 per day - were killed by intimate partners or other family members. About 47% of all female homicides are committed by them. In 2017, around 50,000 women, representing 58% of all female homicides - roughly 137 per day - were killed by them. In 2020, around 47,000 women, representing 58% of all female homicides - about 128 per day - were killed by them. In 2021, the percentage of female homicides committed by them increased to 62%, with roughly 49,800 women - about 137 per day - losing their lives to these crimes.

2012년에 전 세계에서 약 48,000명의 여성이 남편이나 애인 등 친밀한 관계의 남성이나 다른 가족 구성원에 의해 살해되었다. 이는 전체 여성 살해 피해자 중 약 47%에 해당한다. 하루에 약 132명이 죽었다. 2017년에는 전체 여성 살해 피해자 중 58%인 50,000명의 여성이 살해되었다. 하루에 약 137명이 죽었다. 2020년에는 전체 여성 살해 피해자 중 58%인 47,000명의 여성이 살해되었다. 하루에 약 128명이 죽었다. 2021년에는 전체 여성 살해 피해자 중 약 62%인 49,800명이 친밀한 관계의 남성이나 다른 가족 구성원에 의해 살해되었다. 하루에 약 137명의 여성이 죽었다.

이지원
(아키타입)

분노의 게이지, 2012-2022 | 지난 11년간 대한민국에서 남편이나 애인 등 친밀한 관계의 남성에게 살해되거나 살해 위협을 당한 여성은 최소 2,320명이다. 약 1.7일에 1명의 여성이 친밀한 관계의 남성에게 살해되거나 살해당할 위험에 처했다. 이는 언론에서 보도한 사건의 수를 취합한 최소한의 수치이며, 실제 피해 여성의 수는 훨씬 많을 것으로 추정한다.

2012년 유엔(UN)은 여성이라는 이유로 성인 여성이나 여아를 살해하는 범죄를 '페미사이드'로 공식 규정했다. 또한 범죄에 대한 정의와 진단, 여성 인권 정책을 수립하기 위해 '페미사이드'에 대한 감시체계를 구축해 가해자·피해자 통계를 제시하라고 권고해 왔다.

〈분노의 게이지, 2012-2022〉는 언론 보도를 통해 본 친밀한 관계의 남성 파트너에 의한 여성 살해 분석 보고서 〈분노의 게이지〉의 통계를 발췌한 것이다. 한국은 정부의 공식 집계가 없기 때문에, 민간기관인 한국여성의전화의 자료를 인용했다.

Jiwon Lee
(archetypes)

Gauge of Anger, 2012-2022 | In the past 11 years, at least 2,320 South Korean women were killed or threatened with death by intimate partners such as husbands and boyfriends. This figure suggests that a woman was killed or threatened with death every 1.7 days. However, as this only accounts for the number of cases reported by the media, the actual number of victims is estimated to be much higher.

In 2012, the UN officially defined any intentional killing of women or girls, with a gender-related motivation, as "femicide." It advised member nations to establish a femicide monitoring system and to present predator/victim statistics in the hopes of facilitating crime diagnosis and definition as well as related policies.

Gauge of Anger, 2012–2022 presents an excerpt from the report "Gauge of Anger," which analyses media-reported femicides perpetrated by intimate partners. Because the South Korean government does not provide official data, the numbers were pulled from materials released by Korea Women's Hot-Line, a private organization.

이지원
(아키타입)

페미사이드, 2012-2021 ㅣ 2021년 전 세계에서 약 49,800명의 여성이 남편이나 애인 등 친밀한 관계의 남성이나 다른 가족 구성원에 의해 살해되었다. 하루에 약 132명이 죽었다. 전체 여성 살해 피해자 중 62%에 해당하며, 이는 '페미사이드'에 의한 범죄로 추정된다. 47%를 기록한 2012년부터 약 10년간 15%가 증가했다.

〈페미사이드, 2012-2021〉은 유엔마약범죄사무소와 유엔여성기구(UN Women)에서 발표한 '성인 여성 및 여아 살해 보고서'의 통계를 종합해 전 세계 '페미사이드' 현황을 보여준다. 이 숫자들은 '페미사이드' 범죄 관리 체제를 갖춘 국가들에 국한한 통계로, 유엔은 실제 피해 여성의 수는 훨씬 많을 것이라 추정한다. 한국은 정부의 공식 집계가 없기 때문에, 국제기구 보고서에서 한국의 '페미사이드' 지표는 확인이 불가하다.

Femicide, 2012-2021 | In 2021, approximately 49,800 women around the globe were murdered by men with whom they had close relations, including husbands, boyfriends, and other family members.
This means that about 132 women were killed on a given day. This number of cases presumed to be femicides accounts for 62% of all female homicides, which is 15% higher than the 47% recorded in 2012.

Femicide, 2012–2021 shows the current status of femicides around the world, integrating statistics from the report "Gender-related killings of women and girls" by United Nations Office on Drugs and Crime (UNODC) and UN Women. The provided numbers only account for the cases confirmed in countries with a femicide monitoring system and the UN estimates the actual numbers to be much higher. The South Korean government does not provide official data; hence, South Korea's femicide index is missing from the report.

박새한

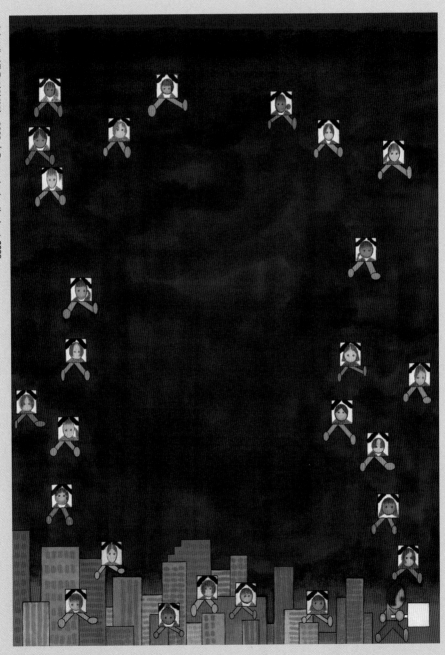

<떠나보낸 이름을 기억하며>, 2023. | Remembering the Lost, 2023.

Saehan Parc

<함께 걸으며>, 2023. | Walking Together, 2023.

Human Rights — Everyone's Story

떠나보낸 이들을 기억하며 ┃ '여성의 전화'에 따르면 대한민국에서는 매일 최소한 명의 여성이 배우자나 애인에게 살해당하거나 살해당할 위험에 처한다고한다. 이 모든 희생자들이 도시 위에 떠돌며 그들을 기억하는 이들과 함께행진하는 모습을 상상했다.

함께 걸으며 ┃ 여성 살해의 희생자들을 추모하며 여성들이 길거리로 나와정의를 요구한다. 죽은 자들은 침묵하지 않는다. 그들도 시위대에 합류하여우리와 함께 걷는다.

Remembering the Lost | At least one woman is murdered or attempted murder by her partner every day in South Korea, according to the Korea Women's Hot-Line, I imagine all those victims flying over the city and marching with those who remember them.

Walking Together | The women take to the streets together to demand justice by commemorating the victims of femicide. The deceased do not remain silent; they join the demonstrators and march with us.

게릴라 걸즈

〈페미니즘이 빠지면 민주주의가 아니다〉, 2023. | *It's Not Democracy Without Feminism!*, 2023.

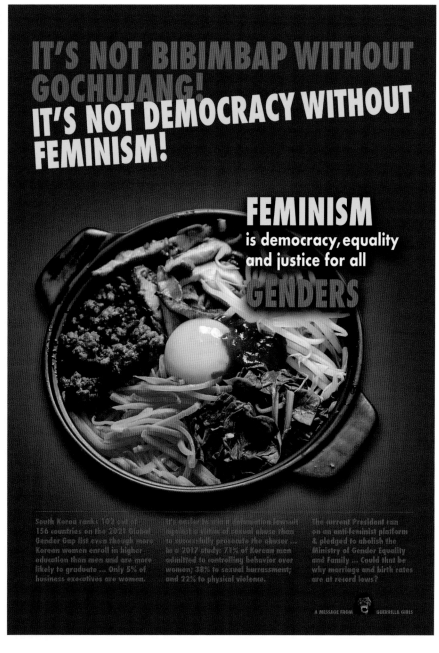

IT'S NOT BIBIMBAP WITHOUT GOCHUJANG!
IT'S NOT DEMOCRACY WITHOUT FEMINISM!

FEMINISM
is democracy, equality and justice for all
GENDERS

South Korea ranks 102 out of 156 countries on the 2021 Global Gender Gap list even though more Korean women enroll in higher education than men and are more likely to graduate ... Only 5% of business executives are women.

It's harder to win a defamation lawsuit against a victim of sexual abuse than to successfully prosecute the abuser ... In a 2017 study: 71% of Korean men admitted to controlling behavior over women; 38% to sexual harrasment; and 22% to physical violence.

The current President ran on an anti-feminist platform & pledged to abolish the Ministry of Gender Equality and Family ... Could that be why marriage and birth rates are at record lows?

A MESSAGE FROM GUERRILLA GIRLS

Guerrilla Girls

페미니즘이 빠지면 민주주의가 아니다! | 우리는 진정한 민주주의는 '모두'에게 평등한 권리, 기회, 정의를 보장해야 한다고 믿는다. 미국을 포함한 많은 민주주의 국가들이 이런 열망을 공언하고서도 그에 합당한 실천을 하지 않고 있다. 우리에게는 모든 민주주의 국가들이 불평등과 부당함을 찾아내고 이를 근절할 조치를 취함으로써 진정한 평등을 추구하고자 노력하도록 압박할 책임이 있다.

　젠더 문제는 우리 시대에 가장 중요한 인권 투쟁 중 하나이며, 페미니즘은 모든 젠더를 위한 권리를 성취하고자 하는 투쟁이다. 우리가 한국과 관련된 통계를 삽입하고 민주주의와 페미니즘을 동일시한 이유가 여기에 있다. 어느 하나가 없으면 다른 하나도 없다. 이 프로젝트는 우리에게 미국의 젠더와 페미니즘에 관해서도 유사한 포스터를 만들도록 영감을 주었다.

It's Not Democracy Without Feminism! | We believe that a true democracy must guarantee equal rights, opportunities, and justice to ALL. Many democracies, including our own, do not live up to those professed aspirations. It is up to all of us to pressure democracies everywhere to strive towards true equality by identifying inequities and injustices, then to work towards eliminating them.

　Gender is one of the most important human rights struggles of our time, and feminism is the struggle to achieve those rights for all genders. That is why we included statistics about South Korea and why we equated democracy with feminism. You can't have one without the other. This project has inspired us to make a similar poster about gender and feminism in the United States.

애니나 테케프

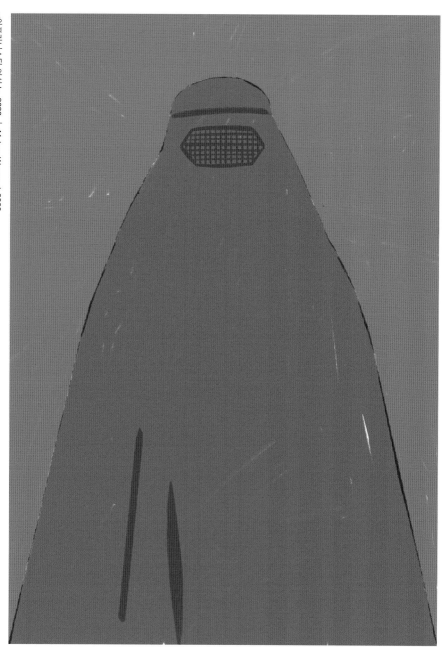

〈아프가니스탄 여성 I〉, 2023. | Afghan Woman I, 2023.

Anina Takeff

〈아프가니스탄 여성 II〉, 2023. | Afghan Woman II, 2023.

아프가니스탄 여성 ㅣ ㅣ 이 그림에서는 부르카를 묘사한다. 하지만 부르카를 입은 여성도 함께 묘사하고 있는지는 분명하지 않다. 부르카를 입은 여성은 천에 완전히 덮여 정체성이 전혀 드러나지 않는다. 부르카는 이미 여러 차례 묘사된 적이 있지만, 여전히 여성의 개성을 억압하는 가장 통렬한 상징이다. 부르카를 쓴 사람은 부르카가 주는 시각적 효과로 인해 하나의 기능으로 축소되고 만다.

이 단순한 이미지 뒤에는 탈레반 집권 이후 아프가니스탄 여성들과 소녀들이 처한 억압적인 현실이 있다. 여성들의 정체성을 억지로 은폐하는 부르카는 사실상 중등, 고등 교육이 금지된 곳에서 여성과 소녀에게 가해지는 극심한 제약을 보여준다. 게다가 여성의 의료 접근성과 이동 및 표현의 자유 같은 기본 인권까지 말살한다. 또한 정책적으로 경제 활동을 할 수 없도록 엄격한 제한을 두어 가난과 불평등을 심화시키고 있다.

이 그림은 탈레반의 정책으로 아프간 여성들과 소녀들이 당하는 수많은 권리 침해를 부각시킨다. 이 이미지를 통해 아프간 여성들과 소녀들이 겪고 있는 어려움과 자신의 권리를 되찾기 위한 분투, 더 나은 미래를 위한 투쟁을 부각시켜 세상에 충격을 던지고자 한다.

Afghan Woman I | This image depicts a burqa. Does it also depict a woman, who wears it? It is uncertain. The garment covers the woman inside so her identity cannot be ascertained with any certainty. The burqa—though depicted so many times—is still the most poignantly understandable symbol of the suppression of the female individuality. It visually reduces the human underneath it to a function.

Behind that simple image is the oppressive reality that women and girls in Afghanistan have faced since the Taliban took control. The burqa which forced them to conceal their identities speaks of the dire restrictions imposed on women and girls, who were effectively barred from pursuing secondary or higher education. This also includes denying them access to healthcare and basic rights such as freedom of movement and expression. In addition, the policies have also severely restricted their ability to earn an income, further perpetuating the cycle of poverty and inequality.

This illustration brings to light the numerous rights violations that the Taliban's policies have inflicted upon Afghan women and girls. It is meant to serve as a wake-up call to the world, highlighting the plight of Afghan women and girls and their struggle to reclaim their rights and fight for a brighter future.

아프가니스탄 여성 II | 〈아프가니스탄 여성 II〉는 〈아프가니스탄 여성 I〉과 병렬되는 동시에 대조를 이룬다. 〈아프가니스탄 여성 I〉이 억압에 대해 이야기한다면, 〈아프가니스탄 여성 II〉는 내적인 힘과 희망을 이야기한다. 부르카 아래에 무엇이 있는가? 자기 미래에 대한 자기 자신의 생각이 있는 한 개인, 한 젊은 여성이 있다. 그는 자기 주변의 세상과 탈레반 정권이 규정한 범위 너머의 세상을 배우고 싶어 한다.

이 이미지는 무수한 방해에도 불구하고 더 많은 지식을 얻고 고등 교육을 받고자 하는 아프간 여성들의 정신과 회복력을 칭송하고 기념하기 위한 그림이다. 이 포스터는 여성 교육의 중요성과 탈레반의 억압을 극복하려는 아프간 여성들의 노력을 지지할 필요성을 부각시킨다. 교육은 오래도록 아프가니스탄을 괴롭혀 온 가난과 불평등, 압제의 굴레를 끊을 도구와 기술을 여성들에게 제공하여 그들의 역량을 키운다. 이 포스터는 비밀 학교에서 교육을 받으며 그들이 마땅히 받아야 할 교육을 가로막는 장애물을 극복하는 아프간 여성들의 힘과 용기, 결의를 표현하는 희망의 메시지를 담았다. 이 그림은 아프가니스탄 여성들이 모든 역경을 딛고 그들과 공동체의 더 밝은 미래를 위해 여전히 투쟁하고 있음을 보여준다. 우리는 그들을 지지하고 격려해야 한다.

Afghan Woman II | The *Afghan Woman II* both accompanies and contrasts the other illustration, *Afghan Woman I*. Where the latter image speaks of oppression, the former speaks of inner strength and hope. For what hides underneath the burqa? It is an individual, a young woman with her own ideas for her future, with the urge to learn about the world around her and the world beyond the boundaries set for her by the Taliban regime.

This image is meant to honor and celebrate the spirit and resilience of Afghan women who, despite facing countless obstacles, continue to strive for more knowledge and higher education. The poster underscores the importance of education of women and the need to support their efforts to overcome the restrictions imposed on them by the Taliban. Education empowers them by providing the tools and skills necessary to break the cycle of poverty, inequality, and oppression that has plagued Afghanistan for far too long. This poster is meant to serve as a message of hope, reminding us of the strength, courage, and determination of Afghan women who are learning in secret schools and breaking through the barriers to attain the education they so rightfully deserve. It is a reminder that despite the odds, Afghan women continue to strive for a brighter future for themselves and their communities. It is up to us to support and empower them.

로시 루즈베하니

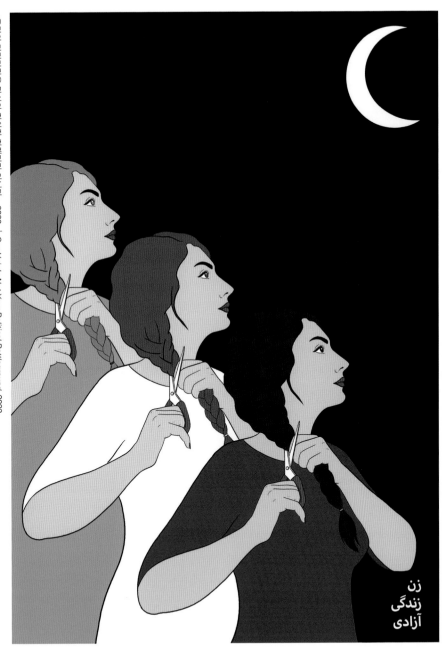

<우리의 머리카락은 당신의 정치적 전쟁터가 아닙니다>, 2023. | *Our Hair is Not Your Political Battleground*, 2023.

Roshi Rouzbehani

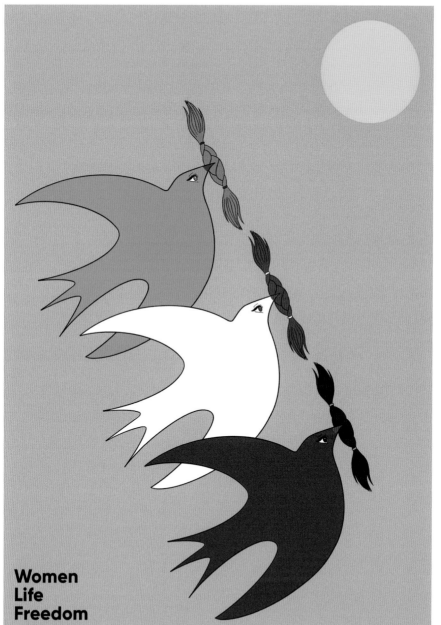

〈태양을 향해 날아오르다〉, 2023. | *Soar Towards The Sun, 2023.*

Women
Life
Freedom

우리의 머리카락은 당신의 정치적 전쟁터가 아니다 Ⅰ 2022년 9월 16일 스물두 살의 쿠르드계 이란 여성 지나 (마흐사) 아미니(Jina Mahsa Amini)가 사망했다. 히잡을 '부적절하게' 착용했다는 이유로 도덕 경찰에게 구금된 지 사흘 만의 일이었다. 지나의 죽음으로 이란과 전 세계에서 여성들의 주도로 대규모 시위가 벌어졌다. 시위에서 여성들이 머리카락을 자르는 것이 가장 상징적인 행동이 되었고 "여성, 생명, 자유"(Zan, Zendegi, Azadi)는 그들의 구호가 되었다.

이란 문화에서 머리카락을 자르는 행위는 여성들 사이에서 애도와 분노를 표출하는 관습으로 여겨져 왔다. 그러나 이제는 머리칼과 여성성의 연관성을 잘라냄으로써 자신의 몸에 대한 여성의 통제권을 의미하는 행동으로 발전했다.

이 포스터에는 다양한 연령대의 이란 여성 세 명이 등장한다. 이란 국기와 같은 색상의 옷을 입은 그녀들은 자기 머리카락을 자르고 있다. 이 여성들은 그녀들이 현재 겪고 있는 암울한 불평등과 성차별을 딛고 승리하기를 열망한다. 이들은 자신의 몸이 정치적 전쟁터가 되는 상황을 더 이상 용인하지 않으려 한다.

이 작품에서 나는 성차별로 인한 역경을 감내하는 이란 여성들의 회복력을 칭송하고 기념하고자 한다. 이란 여성들은 목소리를 높여 변화를 촉구하고 그들의 자유를 엄격하게 제한하는 장벽을 극복하고자 고군분투하고 있다. 이 용감한 이란 여성들의 싸움은 자유를 추구하는 전 세계 여성들에게 영감을 불어넣는다.

Our Hair Is Not Your Political Battleground | Jina (Mahsa) Amini, a 22-year-old Iranian Kurdish woman, died three days after being detained by Iran's morality police for wearing her hijab "improperly" on September 16, 2022. Her death led to significant demonstrations led by women in Iran and across the globe. Women cutting their hair became one of the primary symbolic gestures in the protests, and the "Zan, Zendegi, Azadi" chant (meaning "Women, Life, Freedom") became their rallying cry.

In Iranian culture, cutting off one's hair has been reported as a customary practice among women in times of mourning and anger. However, it has also developed into a representation of women's control over their bodies by severing the association between hair and femininity.

The poster I created features three Iranian women of various ages, donning the colors of the Iranian flag while cutting their hair. Their aspiration is to triumph over the darkness of injustice and gender apartheid that they are currently experiencing. These women will no longer accept their bodies being a political battleground.

In this work, I aim to honor and celebrate the resilience of Iranian women in withstanding the challenging situations they are experiencing as a result of gender-based discrimination. Iranian women are using their voices to advocate for change and striving to overcome the barriers that have strictly limited their liberty. The struggle of these courageous Iranian women serves as an inspiration for the pursuit of freedom by women all over the world.

태양을 향해 날아올라 | 이란에서 머리카락은 여성들이 주도하는 '여성, 생명, 자유' 시위에서 주요한 상징이다. 머리카락을 자르는 행위는 이란 사회에 존재하는 성차별과 제한에 대항하는 그들의 도전을 나타내기 때문이다. 머리칼을 자르는 행위는 국경을 초월해 전 세계에서 자유와 평등을 위해 투쟁하는 여성들의 강력하고 지속적인 상징이 되었다.

이 포스터에서는 이란 국기와 같은 색을 한 세 마리의 새가 태양을 향해 날아오른다. 이로써 자유와 희망, 그리고 한계를 극복하고 더 높은 곳으로 도달할 수 있는 가능성을 내포하고자 했다. 위쪽으로 날아오르는 새들은 이란 여성들(그리고 여성 전반)이 가부장적 한계를 뛰어넘어 여권 신장과 성취의 새로운 단계에 도달할 수 있다는 발상을 의미한다.

이 작품에서 세 마리의 새는 머리 타래를 물고 청명한 하늘로 날아오른다. 이 새들은 앞 포스터에 등장한 세 여성의 머리 타래를 물고, 희망차고 자유로운 미래를 상징하는 밝은 태양을 향해 날아간다. 이 이미지는 이란뿐만 아니라 전 세계적으로 더 높은 수준의 자유와 평등을 성취할 수 있는 여성의 잠재력을 나타낸 것으로도 해석될 수 있다. 새들과 그들이 물고 있는 머리 타래는 그들을 억압하던 속박에서 벗어나 경계를 넘어 더 밝고 희망찬 미래로 솟아오르는 여성들을 상징한다.

Soar Towards The Sun | Hair has taken on a prominent symbolic role in the women-led Women, Life, Freedom movement in Iran. This is because the act of cutting hair represents their defiance against the gender-based segregation and restrictions that exist within their society. The symbolic significance of hair cutting has transcended national borders and has become a potent and enduring global symbol of women's struggle for freedom and equality.

This poster portrays three birds in flight, soaring towards the sun, and depicted in the same colors as the Iranian flag. This image is intended to convey a sense of freedom, hope, and the potential to overcome limitations and achieve greater heights. The birds, with their upward trajectory, represent the idea that Iranian women (and women in general), can rise above patriarchal restrictions and reach for new levels of empowerment and fulfillment.

In this artwork, these three birds are soaring through a clear blue sky while gripping onto hair braids. The birds are carrying the hair braids of the women depicted in the previous poster towards the radiant sun, symbolizing a hopeful and liberated future. This image can be interpreted as a representation of the potential for women, not only in Iran but globally, to achieve greater levels of freedom and equality. The birds and their hair braids embody the idea of women breaking free from the constraints that have held them back, and soaring beyond the boundaries towards a brighter and more hopeful future.

멜린다 베크

<나의 몸 나의 목소리>, 2023. | My Body My Voice, 2023.

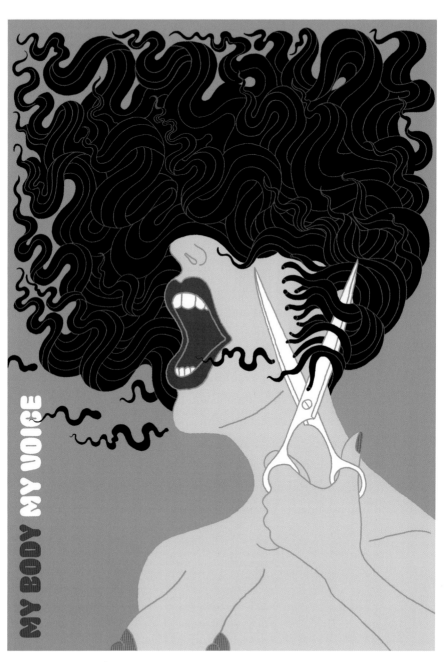

Melinda Beck

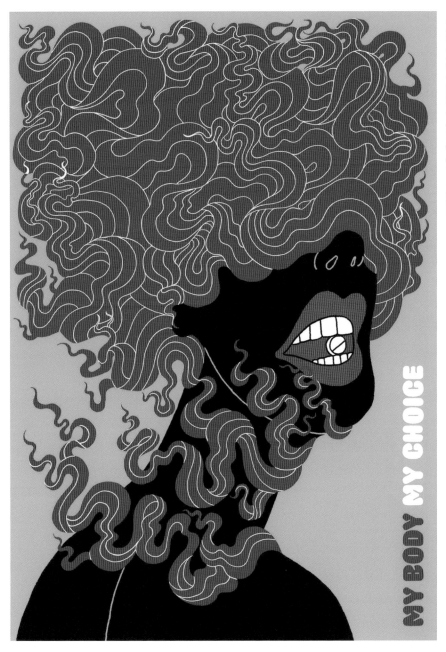

<나의 몸 나의 선택>, 2023. | My Body My Choice, 2023.

MY BODY MY CHOICE

나의 몸 나의 목소리 · 나의 몸 나의 선택 ┃ 역사적으로 정부는 여성 시민의 신체를 규제하는 법률을 제정하여 여성이 누려야 할 민주적 권리를 억압해 왔다. 여성의 의료 접근권, 옷을 입는 차림새, 사랑할 수 있는 사람, 투표권, 재산권, 남성과 동등한 법적 보호를 받을 권리는 물론이고, 심지어 자동차 운전 같은 단순한 활동까지도 제한해 왔다. 이러한 관행이 만연하는 현실을 나타내기 위해 완전히 다른 두 나라인 이란과 미국의 여성을 소재로 삼아 포스터를 제작하고자 했다.

이란은 페르시아 문화의 본고장이다. 페르시아는 예술과 과학, 시와 같은 지적 유산의 역사가 깊다. 이와 대조적으로 현 이란 정부는 1979년 팔레비 왕조 축출 이래로 독재적인 신정 체제를 유지하고 있다. '도덕경찰(Morality Police)'이라는 이름의 경찰 조직은 이란 길거리를 순찰하면서 여성들에게 엄격한 이슬람식 복장 준수를 강요한다. 2022년 히잡을 부적절하게 착용했다는 이유로 체포된 22세 여성 지나 마흐사 아미니가 구금 중 사망했다. 이 사건에 분노한 이란 여성들이 들고일어나 시위를 주도했다. 일부 여성들은 공공장소에서 히잡을 벗고 머리칼을 잘랐다. 페르시아 문학에서 머리카락을 자르는 행위는 애도와 항거를 의미한다. 포스터에서 머리카락을 히잡처럼 뒤집어쓰고 얼굴을 가린 여성을 묘사했다. 이 여성은 가위로 머리칼을 잘라 입을 드러낸다. 머리칼을 잘라낸 그는 이제 자유롭게 소리치며 목소리를 내고 있다. 또한 맨가슴을 드러낸 모습으로 그렸기 때문에 몇몇 국가에서는 이 포스터 인쇄가 금지될 수 있다. 이런 다수의 법 때문에 여성들이 마치 자신의 신체가 불법이거나 선정적이라고 여기며 수치스럽게 느끼지만, 여성들이 이런 낙인을 극복하기를 바란다.

이란과 달리 미국은 250년 역사의 젊은 다문화적 민주주의 국가다. 미국 시민으로서 우리는 민주주의 국가인 미국이 전 세계 다른 국가들에게 찬란한 희망의 봉화라고 배웠다. 그러면서 미국인들은 노예제와 억압의 역사,

My Body My Voice · My Body My Choice | Throughout history, governments have suppressed the democratic rights of their female citizens by creating laws that regulate their bodies. Laws have been created to restrict access to medical treatment, what women can wear, whom they can love, their ability to vote or own property, to have the same legal protections as men, or even the simple act of driving a car. To illustrate the pervasiveness of this practice, I chose to create posters of women from two very different countries: Iran and America.

Iran, is home to the Persian culture, which has a long history of intellectualism, the arts and sciences, and poetry. In contrast to this, the current government has been an authoritarian theocracy since the overthrow of The Shaw in 1979. A unit named the Morality Police patrols the streets of Iran and is responsible for enforcing the country's strict Islamic dress code for women. In 2022, 22-year-old Mahsa Amini was detained for improperly wearing her head scarf and died in the custody of the Morality Police. This sparked a protest led by the women of Iran. Some of the women removed their mandated head scarves and cut their hair in public. In Persian literature, cutting one's hair is an act of mourning and protest. In this poster, I depict a woman whose hair covers her face like a veil. She is using the scissors to cut away her hair and reveal her mouth. With the hair removed, she is now free to shout and let her voice be heard. I also chose to depict her bare breasts, making this poster unprintable in some countries. Many of these laws seek to make women feel ashamed of their bodies as something illegal or pornographic, and I hope to break through this stigma.

America, in contrast to Iran, is a young country with a 250-year-old multicultural democracy. As American citizens, we are taught that our country's democracy is a shining beacon of hope for other

국가주의라는 이름으로 모습을 드러내는 권위주의를 적당히 얼버무리려했다. 2022년 미연방대법원이 로 대 웨이드(Roe v. Wade) 판결을 뒤집으면서 50년간 보장돼 온 임신 중지 권리도 함께 전복되었다. 이제 미국 주 가운데 절반은 강간, 근친상간, 또는 여성의 건강 문제 등에 대한 예외 없이 임신 중지를 금지하거나 엄격하게 제한한다. 종전에는 임신 중지 시술을 위해 수백 킬로미터를 이동할 여력이 없는 많은 여성들이 거주지와 관계없이 임신 중지를 허가하는 진료 처방전을 집에서 우편으로 받을 수 있었다. 그러나 현재는 약물을 이용한 임신 중지를 금지하거나 엄격하게 규제하는 법안이 상정되고 있다. 이런 약물은 여성이 의료적 부작용이나 사망의 위험 없이 안전하게 유산할 수 있도록 돕는 데에 사용된다. 포스터에는 알약을 입에 물고 있는 여성이 그려져 있다. 이 여성은 반항적으로 관객에게 등을 돌렸고 머리카락은 불처럼 붉다.

두 포스터 모두 질문을 제기한다. 국민 절반이 자기 몸에 대한 기본권을 행사하지 못하도록 법적으로 제한하는 나라가 진정 민주주의 국가인가?

countries around the the world. This belief allows Americans to gloss over our history of slavery, oppression, and sometimes creeping authoritarianism in the name of nationalism. In 2022, the Supreme Court overturned overthrow Roe v. Wade, and with it 50 years of legal protection for abortion. Access to abortion is now banned or severely restricted in half of the states, with no exception for rape, incest, or the health of the woman. Many women, unable to afford to travel the hundreds of miles needed to obtain an abortion, have found a safe option for abortion in a medical prescription that can be mailed to their homes no matter where they live. Lawmakers are now proposing laws that would ban or severely restrict medicated abortions. These medications are also used to help women safely through miscarriage, without medical complications and death. In this poster, I show a woman with a pill clenched between her teeth. She has defiantly turned her back on the viewer, and her hair is a raging orange fire.

Both posters pose the question: Is a country truly democratic if half of its citizens are subjected to laws that restrict their basic human right of freedom over their own bodies?

레이븐

〈평화가 있기를〉, 2023. | *Let There Be PEACE*, 2023.

Raven

〈힘밍이 있기를〉, 2023. | *Let There Be HOPE*, 2023.

평화가 있기를 ㅣ 이 포스터는 여성들, 특히 미얀마의 주요 농경지에 속하는 안야 지역 여성들을 위한 작품이다. 이 지역에 사는 여러 세대의 여성들은 작물을 기르고 가족을 보살피면서 평생을 보낸다. 현재 미얀마 군대는 이 지역 촌락들에 습격, 폭격, 방화를 자행하고 있다. 안야 여성들은 그들의 땅과 사랑하는 사람들을 잃고서도 여전히 자기 삶을 살아내고 있다. 이 포스터는 그들에게 바치는 그림이다. 하루빨리 그들에게 평화가 있기를.

희망이 있기를 ㅣ 이 포스터는 여성들, 특히 한때 나라를 위해 교사, 의사, 회계사 등으로 헌신하다가 2021년 봄 혁명의 시민 불복종 운동에 참여한 여성들을 위한 포스터이다. 이들은 목숨과 경력을 걸고 일터를 떠났다. 그 중 다수가 구속되었고, 그들 모두는 생존을 위해 분투하며 여전히 두려움 속에 살고 있다. 하루빨리 그들에게 희망이 있기를.

Let There Be PEACE | This is for women, especially the women of Myanmar's Anyar regions, the country's main agricultural area. Generations of women from that area have spent their lifetimes caring for crops and their families. Now the military is raiding, bombing, and burning the villages in that region. Women there are still running for their lives, leaving their lands and loved ones. This is for them. May there be peace for them very soon.

Let There Be HOPE | This is for women, especially those women who were once in the service of the country—teachers, doctors, accountants, etc.—and who participated in the Civil Disobedience Movement of Myanmar's 2021 Spring Revolution. They left their jobs, risking their lives and their careers. Many of them were arrested, and all of them still live in fear, struggling for life. May there be hope for them very soon.

이재영

(6699프레스)

〈모든 차별에 반대한다〉, 2023. | Against All Discrimination, 2023.

Jaeyoung Lee
(6699press)

《장애인, 시민, 나》, 2023. | *A Person with Disability, A Citizen, Me, 2023.*

결국 장애
국 시 애
되 내 되 민 되 인
었 가 었 이 었 이 나
다 고 고 는

Judith Heumann

이재영
(6699프레스)

모든 차별에 반대한다 | 2023년 대한민국을 살아가는 개인은 모두 존엄하며 평등하다 말할 수 있을까. 우리 주변에 나이, 성별, 성적 지향, 장애, 직업, 국적 등의 영역에서 차별은 여전히 독립적으로 작동하며 차별 금지의 의미를 기각하고 있다. 기울고 가려진 '차별' 사회에서 수평적 '평등'이란 존재할 수 없는 것이다. 차별금지법은 가려진 '차별'이 무엇인지를 말해주는 법안이다. 기울어진 '차별'을 바로 세워 진정한 의미로서의 '평등'을 실현하고자 하기 위함이다. 차별의 경험을 개인이 극복해야 하는 조건이 아닌 사회적 구조와 구성원의 문제임을 인식하게 하는 것이 차별금지법이 제정돼야 하는 이유다. 진정한 인권로서의 평등은 '나중'으로 유예될 수 없으며, 지금 당장 차별과 혐오에 맞서고 있는 용기들을 지지하고 연대해야 한다.

Jaeyoung Lee
(6699press)

Against All Discrimination | Can we be assured that all individuals living in South Korea in 2023 are dignified and equal? Discrimination still operates independently in realms such as age, gender, sexuality, disability, occupation, and nationality, thereby proving the assumed removal of discrimination is far from being fully realized. In a society that is biased and selectively represented, horizontal equality simply cannot exist. The anti-discrimination law currently waiting to be enacted is one that defines discrimination as a way to level the playing field and realize equality in its truest sense. The law must be enacted for people to recognize that discrimination isn't an experience overcome by individuals. Rather, it is a problem arising from the very social structure and makeup of our society. Equality as a basic human right cannot be postponed; we must act now to support and provide allyship to those already brave enough to stand up to discrimination and hate.

이재영
(6699프레스)

장애인, 시민, 나 | 이동권은 시민 모두에게 주어져야 할 권리다. 장애인 이동권에 대한 본격적인 논의는 2001년 오이도역 리프트 추락 참사 이후 본격화됐다. 그러나 22년이 지난 지금, 여전히 장애인의 이동은 자유롭지 못하며 안정성을 보장 받지 못하고 있다. 역명은 존재하나 노선은 연결되지 못한, 시민으로서의 권리가 끊어지는 순간이다. 장애인 권리를 위해 투쟁해 온 주디스 휴먼(Judith Heumann)은 "나는 장애인이 되었고, 시민이 되었고, 결국 내가 되었다."고 말하며 동등한 한 사람으로서 분리될 수 없는 삶의 존엄을 발화했다. 장애인 이동권의 보장은 시민으로서 누려야 할 시민권, 교육권 등 다른 기본권과도 직결되는 '완전한 평등'을 의미한다. 국가는 장애인 이동권 보장을 위해 변화하고 노력해야 하며, 우리는 장애 운동을 넘어 더불어 사는 세상을 만들기 위해 함께 노력해야 한다.

Jaeyoung Lee
(6699press)

A Person with Disability, A Citizen, Me | The right to mobility must be equally granted to all citizens. In South Korea, an active discussion on mobility rights for people with disabilities began in 2001 in the wake of a wheelchair lift accident at Oido Station. However after 22 years, mobility for wheelchair users is still limited and its safety unguaranteed. While the subway system is advanced in South Korea, the routes are disconnected for wheelchair users due to the lack of basic facilities, which signifies a breach in their rights as citizens. Disability rights activist Judith Heumann's claim that she had become a person with a disability then a citizen before ultimately becoming herself affirms the notion that dignity cannot be separate from equality. Guaranteeing mobility for people with disabilities is a step toward "complete equality" and by extension, a step toward protecting other basic rights such as citizenship and education. The state needs to strive towards change and ensure mobility for those with disabilities. We must join forces in efforts beyond disability rights movements to create an inclusive world.

윤예지

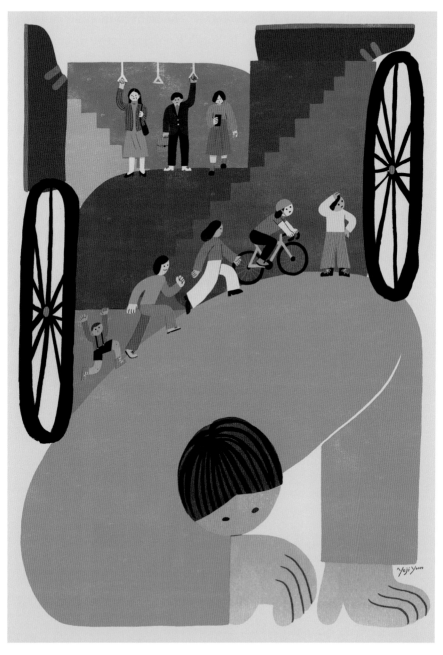

〈장애인을 가로지르며〉, 2023. | Over the Bodies of the Immobilized, 2023.

Yeji Yun

〈노동자를 거꾸러뜨리며〉, 2023. | *Over the Bodies of the Workers*, 2023.

장애인을 거꾸러뜨리며 ┃ 2023년 1월 장애인들의 '이동권 보장 선전전'을 서울교통공사가 불법시위로 규정하는 일이 있었다. 전국장애인차별철폐연대(전장연)를 중심으로 한 장애인 인권 활동가들은 모든 지하철역에 휠체어 접근이 가능하도록 엘리베이터 동선을 확보하는 것과 장애인 권리 예산 증액을 요구하기 위해 수년 동안 온몸을 건 시위를 하고 있다.

　모든 사람은 어디에든 이동할 수 있는 권리가 있다. 그 당연하고 최소한의 권리를 누리지 못하는 사람들이 있다. 그들은 투명 인간이 아니며, 존재하는 우리와 같은 사람들이다. 이것은 그들만을 위한 이야기가 아니라 우리 모두를 위한 권리 주장이다. 그들은 다른 범주의 사람들이 아니다. 비장애인도 언제든 장애인이 될 수 있다.

　사회에는 다양한 소수자들이 모여있다. 그들을 보듬어 같이 가는 사회가 처음에는 느려 보여도 더 멀리 크게 나아갈 수 있는 세상이 될 것이다.

Over the Bodies of the Immobilized | In January 2023, the Seoul Transportation Corporation declared that the mobility rights protests staged by disability activists at subway stations were "illegal." With "Jeonjangyeon" (National Coalition for Elimination of Discrimination Against Persons with Disabilities) at the center, disability activists have protested for years. Putting their bodies on the line, they demand elevators and wheelchair access to every subway station and an increase in the budget for people with disabilities and their mobility.

Everyone has the right to free movement, but there are still those being denied this fair and minimal right. These people aren't ghosts; they exist just as we do. Their demand is our demand as we do not belong to different categories—disability can affect any of us at any time.

There are many kinds of minorities in society. An inclusive society may advance slower at first, but it will reach further.

노동자를 거꾸러뜨리며 ㅣ 2022년 가을 야간 근무로 지친 제빵 공장의 20대 노동자가 샌드위치 소스 기계에 끼어 숨지는 사고가 발생한다. 열악한 작업 환경의 누적과 회사 측의 노동자들에 대한 횡포는 결국 사람을 죽였다.

2023년 어느 추운 겨울날 화물연대 사람들은 나섰다. 도로 위 누구도 죽거나 죽이지 않기 위해, 최소한의 보장 장치를 위해 목소리를 내어보지만 정부와 사회는 이들의 요구를 받아주지 않고 다시 일터로 밀쳐낸다.

누구나 인간적인 환경에서 노동할 권리가 있고, 노동조합을 만들 권리가 있다. 자본주의 사회구조는 힘없는 노동자들에게 결국 선택의 권한을 주지 않는다. 이 사회에서 돈은 사람보다 위에 있고, 그들은 멈춤 장치 없는 쳇바퀴 위를 계속 뛸 수밖에 없다. 최소한의 인권을 보장하기 위해, 건강한 사회 구조가 만들어지기 위해서는 그들의 존엄을 지켜줄 수 있는 법적 장치들이 필요하다.

Over the Bodies of the Workers | In the fall of 2022, an exhausted nightshift worker in her 20s died after her body was caught in a sauce mixing machine at a bread factory. This death was the result of a combination of accumulated fatigue from the grueling working condition and the company's despotic treatment of its workers.

On one cold day in 2023, the people of the Korea Cargo Workers Union set out on a strike in demand of minimal safety measures so that no one ever dies or commits manslaughter on the road, only to be dismissed by the government and society and forced back to work.

We are all entitled to the right to work in a humane environment and to form a workers' union, but the capitalist social structure leaves powerless workers no choice. In this society, where money trumps people, workers are chained to an endlessly moving treadmill. In order for the least of human rights to be guaranteed and for society to take a healthier structure, workers need the law to protect their dignity.

엘머 소사

<국경은 없다>, 2023. | NO BORDERS, 2023.

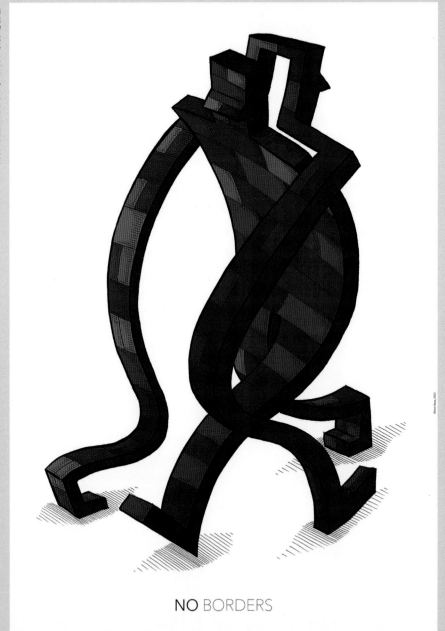

NO BORDERS

Elmer Sosa

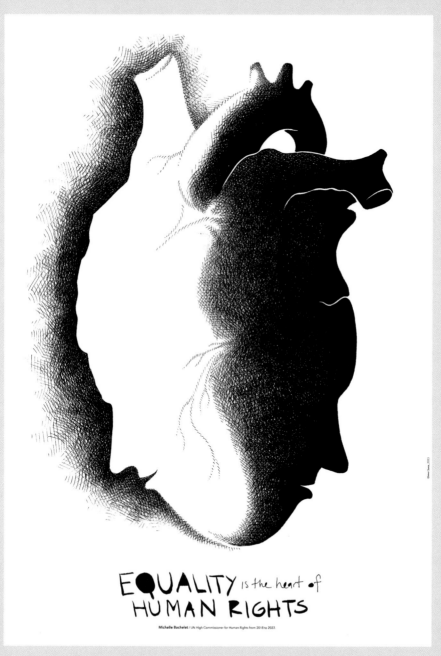

<평등>, 2023. | *EQUALITY*, 2023.

EQUALITY is the heart of HUMAN RIGHTS

Michelle Bachelet / UN High Commissioner for Human Rights from 2018 to 2022.

엘머 소사

국경은 없다 | 모든 난민 또는 이민자는 이동의 자유, 새로운 성장 가능성을 탐색할 자유, 가족을 보호할 자유, 존엄하게 살 자유를 꿈꾼다. 국경은 없다!

평등 | "평등은 인권의 심장이다." (미첼 바첼레트, 유엔 인권 고등판무관)

인종, 성별, 경제적 수준, 지적 수준, 이데올로기의 차이와 상관없이 심장은 사람에게 생명을 준다. 이 중 어떤 특성도 인간을 우월하거나 열등하게 만들지 않는다. 우리는 모두 같다.

NO BORDERS | Every refugee or immigrant dreams of having the freedom to move, to be free in search of new possibilities to grow, to protect their family and live with dignity. No borders!

EQUALITY | "Equality is the heart of Human Rights."
(Michelle Bachelet / UN High Commissioner for Human Rights)

A heart gives life to a person regardless of differences of race, sex, or economic, intellectual, or ideological level. None of these characteristics make you better or worse; we are all the same.

루이스 마존

<조용한 물결>, 2023. | Silent Waves, 2023.

Luis Mazón

〈로스트 인 림보〉, 2023. | *Lost in Limbo*, 2023.

조용한 물결 ㅣ 2014년 이래로 26,000명이 넘는 이주자 및 난민이 지중해에서 목숨을 잃었다.

로스트 인 림보 ㅣ 유엔에 따르면 세계 난민들 가운데 약 22퍼센트가 난민 캠프에서 생활한다. 이는 약 660만 명에 이르는 수치다. 그들 가운데 450만 명은 조직적으로 관리되는 캠프에 거주하고 200만 명가량은 스스로 지은 캠프에서 생활한다.

Silent Waves | Since 2014 more than 26,000 migrants and refugees have died in the Mediterranean Sea.

Lost in Limbo | According to the UN, approximately 22 percent of the world's refugee population live in refugee camps—an estimated 6.6 million people. Among them, 4.5 million reside in planned and managed camps and approximately 2 million are sheltered in self-settled camps.

프란체스카 산나

〈안전한 집을 가질 권리…〉, 2023. | *The Right to Have a Safe Home* …, 2023.

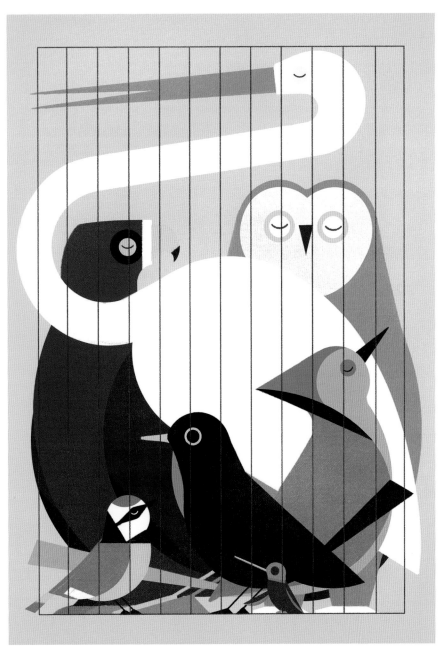

Frenci (Francesca) Sanna

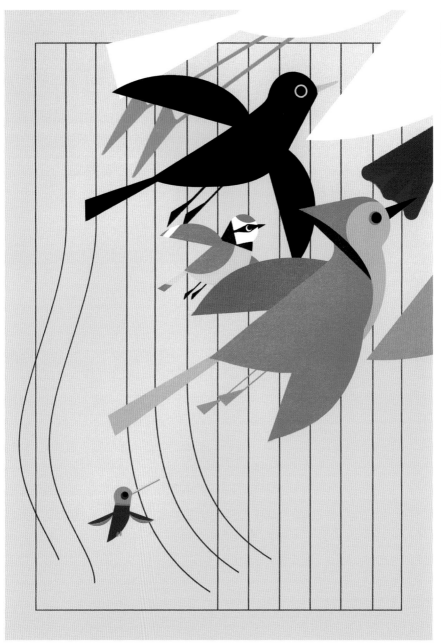

〈…는 인권이다〉, 2023. | … *Is a Human Right*, 2023.

안전한 집을 가질 권리… • …는 인권이다 | 이 두 포스터는 전과 후의 순서로
이루어져 있다. 첫 번째 포스터는 '전'의 그림이다. 색깔도, 모양도 가지각색인
여러 종류의 새들이 있다. 새들은 집이 아닌 새장에 갇혀 있어 숨쉬기도
어렵고 갑갑하다.

두 번째 포스터는 '후'의 그림이다. 새장의 철창은 장식적 요소로
사라지고, 새들은 자유롭게 풀려난다. 새들은 안전한 곳으로, 새로운 집을
찾아 날아간다. 이 두 포스터와 그 속에 나타난 이미지는 살아갈 안전한
장소를 가질 권리가 바로 인권이라는, 매우 중요한 개념을 상징한다.

The Right to Have a Safe Home ... • ... Is a Human Right | The two posters consist of a before-and-after sequence. In the first visual composition we see the "before" picture: a group of many different birds, with different colors and shapes. The birds are locked in a cage, feeling suffocated and trapped in a space that is not their home.

In the second poster we see the "after" picture of the sequence. The bars of the cage disappear into decorative elements, while the birds are set free. They fly away to find their new home, a safe place to live in. The two posters and the visuals that are represented in them are a metaphor to convey the very important concept that the right to have a safe place to live in is a human right.

다이애나 에자이타

<이동>, 2023. | *To Move*, 2023.

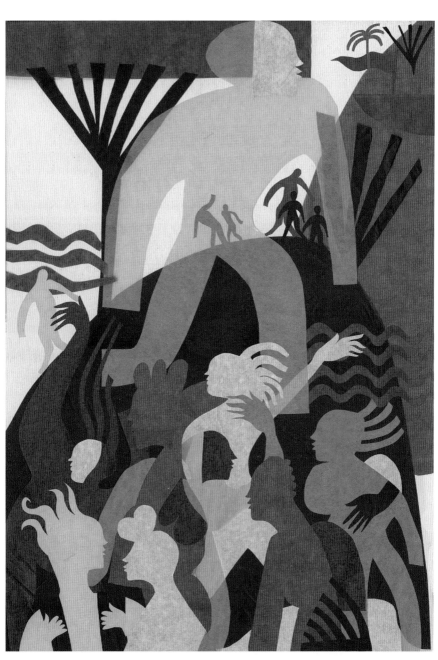

Diana Ejaita

〈존재〉, 2023. | *To Be*, 2023.

이동 ㅣ 이동, 거주 이전, 이주의 권리는 논의의 여지가 없이 누구나 태어날 때부터 가지는 권리이어야 한다.

존재 ㅣ 자신이 속한 젠더, 종교, 문화적 배경을 지니고 존재할 권리는 평화롭게 살기 위해 논의의 여지가 없이 주어지는 권리이어야 한다.

To Move | The right of movement, displacement, and migration should be an incontestable birth right.

To Be | The right to be whichever gender, religion, or cultural background we belong to, this is an incontestable right to live peacefully.

루카 손치니

<메모크라시>, 2023. | *Memocracy*, 2023.

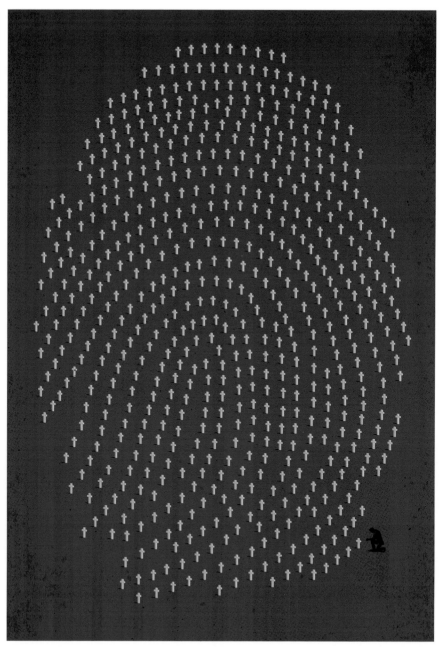

Luca Soncini

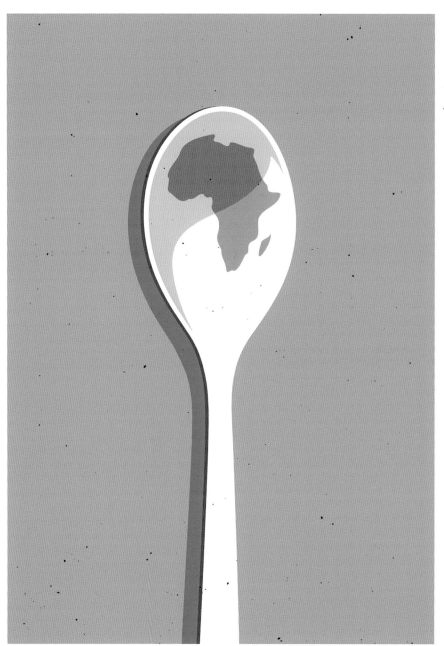

〈식량 위기〉, 2023. | *Hunger*, 2023.

메모크라시 ┃ 〈메모크라시〉는 민주주의를 위해 투쟁하다 희생된 이들을 기억하며 기념하는 포스터이다. 절대군주제, 민족주의, 포퓰리즘, 과거의 잔학 행위에 대한 부정이 증가하는 시기에는 기억 형성(memory-making)을 이해하려는 움직임이 일어나곤 한다. 기억의 문제는 언제나 개인적인 삶과 공동의 삶에서 함께 일어나는 만큼, 인상적이고 때로는 폭력적이며 파괴적인 역사적 사건들을 여러 방면에서 아우르려 할 때 강력하게 발생한다. 최근이나 먼 과거의 기억을 관리하는 데 있어 민주주의적 공동체가 겪는 어려움은 하나의 역사적 상수(常數) 같다. 기억을 형성하는 데에는 거친 노력이 수반되는데, 반드시 국가 또는 국제기관의 지지를 받는다는 법도 없고, 심지어 여러 미디어를 통해 방해를 받는 경우도 많다. 역사를 이해하고 교훈을 배우려는 노력에는 역사의 교훈과 기억에 필요한 정직성 등과 같이, 수사법과 기억의 도구화를 피하는 데에 필수적인 어떤 인류학적이고 윤리적인 태도가 필요하다. 기억 형성은 개인적이고 사회적인 뿌리를 찾아 우리 자신과 우리가 가는 방향을 더욱더 깊이 탐구하는 것을 의미한다.

Memocracy | *Memocracy* is a tribute to memory and the victims who fought in the name of Democracy. At a time when sovereignism, nationalism, populism, and disavowals of past atrocities are growing, the need to make sense of memory-making often arises. The problem of memory, as much as it accompanies personal and communal life at all times, arises strongly when memory embraces remarkable, often violent and devastating historical events in many ways. The difficulty democratic communities have in managing the memory of their recent or distant past seems to be a historical constant. The making of memory is connoted as a rude effort, not always fostered by national and international institutions, often even hindered, including through the use of various media. The effort to understand, to draw a lesson from history, requires certain anthropological and ethical attitudes that are essential to avoid the rhetoric and instrumentalization of any memory, such as the lesson of history and the honesty that memory requires. Memory-making means going to personal and social roots to discover more and more who we are and where we are going.

식량 위기 ┃ 아프리카에서 식량에 접근할 권리에 대한 존중, 혹은 비존중에 대해 이야기를 할 필요가 있다. 아프리카 동부 대부분의 지역은 지속적인 식량 위기를 겪고 있다. 가뭄, 분쟁을 비롯한 수많은 이유로 1,200만 명이 넘는 인구가 굶주린다. 동아프리카는 2011년 이래 여러 번, 가장 최근에는 2017년과 2020년에 식량 위기에 직면했다. 우기 강수량이 평균 이하를 기록하면서 가뭄을 겪었다. 흉작이 들고 기르던 가축이 죽어 일가족이 식량과 물을 찾아 고향을 떠나 여기저기 떠돌기도 하고, 운이 좋으면 국경을 넘어가는 경우도 있다. 마다가스카르가 특히 심각하지만, 아프리카 동부 전체가 매우 어려운 처지에 놓여 있다.

Hunger | There is a need to talk about respect, or rather non-respect, for the right to food in Africa. There is an ongoing food crisis in much of East Africa. Drought, conflict, and multiple reasons for instability have left more than 12 million people hungry. East Africa has been facing an alternating food crisis since 2011, including most recently in 2017 and 2020. The region is experiencing drought due to below-average rainfall during the expected rainy seasons. As crops fail and animals die, families are forced to leave their homes in search of food and water, migrating within their own country and, those who are luckier, across national borders. Significant is the case of Madagascar, but the situation in the entire eastern region of the continent is worrying.

씨앗뭉치: 공감과 연대

Seed Pods: Empathy and Solidarity

파흐미 레자

<경찰은 가혹 행위를 중단하라>, 2023. | *Stop Police Brutality*, 2023.

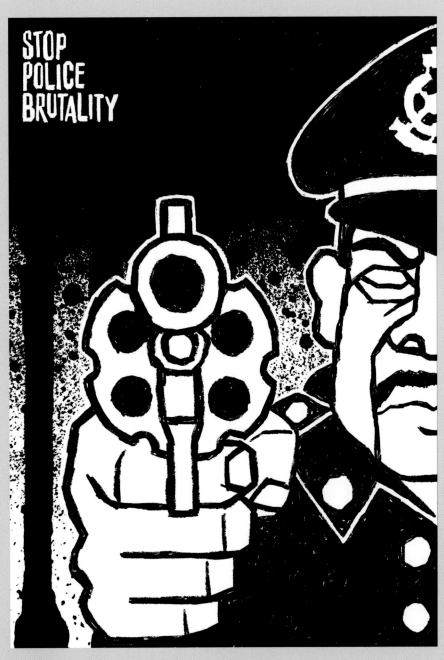

Fahmi Reza

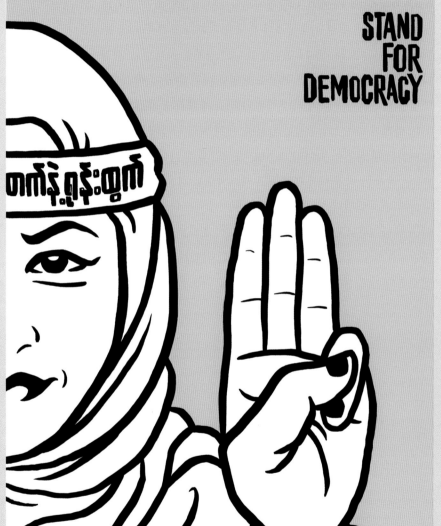

<민주주의 편에 서라>, 2023. | *Stand For Democracy*, 2023.

Seed Pods—Empathy and Solidarity

경찰은 가혹 행위를 중단하라 ㅣ 말레이시아에서 경찰의 가혹 행위는 고질적인 문제로, 매년 법 집행관의 학대와 폭력에 대한 보도가 무수히 쏟아진다. 말레이시아는 오래전부터 경찰들이 인권 침해를 자행했고, 경찰에 체포된 많은 시민들이 사망했지만 아무도 책임을 지지 않았다. 이러한 책임 결여로 형벌을 면하려는 문화가 자리 잡았고 경찰에 대한 공적 신뢰도가 하락했다. 이는 말레이시아만의 문제는 아니며, 세계 여러 나라에서 경찰의 가혹 행위와 폭력 사건이 벌어지고 있다. 미국의 블랙 라이브스 매터(Black Lives Matter) 운동이 이 문제를 조명했고 세계적으로 경찰 조직의 변화를 요구하는 담화에 불을 붙였다. 경찰의 가혹 행위는 법치를 약화하고 시민의 기본 인권을 침해하여 민주주의를 위협한다. 이 포스터에 담긴 섬뜩한 이미지는 경찰에게서 맞닥뜨릴 수도 있을 잠재적인 위험을 상기시키고 대중에게 법 집행관의 가혹 행위에 반대하도록 행동을 촉구한다.

Stop Police Brutality | Police brutality is a persistent issue in Malaysia, with numerous cases of abuse and violence by law enforcement officials being reported every year. The country has a long history of human rights violations by law enforcement, and many Malaysians have died in police custody without any officers being held accountable. This lack of accountability perpetuates a culture of impunity and undermines public trust in law enforcement. This problem is not unique to Malaysia, as police brutality and violence occur in many countries around the world. The Black Lives Matter movement in the US has shed light on this problem and sparked a global conversation about the need for systemic change in law enforcement. Police brutality undermines the rule of law and violates the basic human rights of citizens, thereby posing a threat to democracy. This poster serves as a chilling reminder of the potential danger faced by citizens at the hands of the police and as a call to action, urging the public to take a stand against the brutal actions of law enforcement officials.

민주주의 편에 서라 ㅣ 2021년 2월 미얀마에서 군부 쿠데타가 벌어지자
각계각층의 시민들이 단결하여 군사 정권에 반대하고 민주주의 회복을
요구하는 시위를 벌였다. 시민 불복종 운동의 지지를 받은 반군부
시위는 소셜미디어와 평화 시위, 집회, 파업을 통해 조직되었다. 다양한
민족적·종교적 배경을 지닌 시민들이 모여 민주주의와 인권을 요구하는
운동을 벌였고 이러한 움직임은 미얀마 전역에 반향을 일으켰다. 시위대는
영화 〈헝거 게임〉에서 저항을 상징하는 세 손가락 경례를 그들의 결속과
군부에 대한 저항의 표시로 차용했다. 이 경례는 동남아시아 민주주의를
지향하는 시위대들에게 퍼졌고 미얀마인들의 저항과 희망을 뜻하는 강력한
상징이 되었다. 군부의 폭력적인 탄압에도 불구하고 자유와 권리를 위해
투쟁하는 미얀마인들의 용기와 결의는 계속해서 세계에 감동을 주고 있다.
이 연대의 포스터는 침묵하지 않고 민주주의를 추구하는 미얀마인들을
기억하고자 한다.

Stand For Democracy | Following a military coup d'état in
Myanmar in February 2021, citizens from all walks of life united
to protest against the military junta and demand the restoration of
democracy. The anti-coup protest movement, supported by the Civil
Disobedience Movement, was organized through social media and
peaceful demonstrations, rallies, and strikes. The movement brought
together people from different ethnic and religious backgrounds, and
their demand for democracy and human rights resonated throughout
the country. The three-finger salute, a symbol of resistance inspired
by *The Hunger Games* movies, was adopted by the protesters as a
sign of solidarity and opposition to the military coup. The gesture
has been widely used in Southeast Asia by pro-democracy protest
movements and became a powerful symbol of resistance and hope
for the people of Myanmar. Despite the military's violent crackdown
on the protesters, the anti-coup movement continues to inspire the
world with their courage and determination to fight for their rights
and freedoms. This solidarity poster serves as a reminder that the
people of Myanmar will not be silenced in their pursuit of democracy.

Elaine Lopez

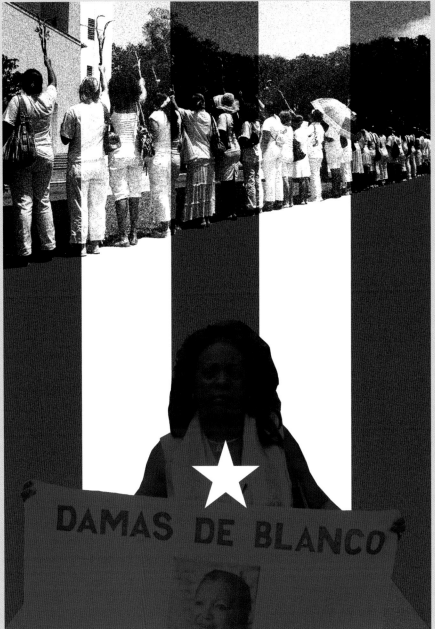

〈다마스 데 블랑코(흰옷을 입은 여성들)〉, 2023. | *Damas de Blanco*, 2023.

파트리아 이 비다(조국 그리고 삶) ❙ 스페인어 문구인 '파트리아 이 비다'(Patria y Vida)는 영어로 '홈랜드 앤드 라이프'(Homeland and Life), 즉 '조국 그리고 삶'을 뜻한다. 쿠바에서 유래한 이 문구는 정치적 변화와 현 공산주의 정부로부터의 자유를 주창하는 쿠바인들을 위한 집결 구호가 되었다. '조국 그리고 삶'은 쿠바 혁명 당시 지도자인 피델 카스트로(Fidel Castro)가 널리 퍼트린 구호인 '조국 아니면 죽음'(Patria o Muerte, 파트리아 오 무에르테)의 단어 유희이다. '조국 그리고 삶'을 사용한다는 것은 낡은 구호를 거부하고 보다 희망에 찬 쿠바의 새 미래상을 향한 열망을 시사한다.

다마스 데 블랑코(흰옷을 입은 여성들) ❙ 흰옷을 입은 여성들을 의미하는 '다마스 데 블랑코'(Damas de Blanco)는 쿠바 인권단체로, 2003년 투옥된 반체제 인사들의 아내와 친척들이 창설했다. 이 단체의 회원은 주로 여성들이며 흰옷을 입고 평화 시위에 참여해 정치범들의 석방을 요구하고 쿠바 인권 문제를 제기한다.

다마스 데 블랑코의 운동은 2003년 쿠바 정부가 75인의 언론인, 인권 운동가, 반체제 인사를 구속하고 장기 징역을 선고한 '검은 봄'에서 비롯되었다. 이 단체는 쿠바 정부의 괴롭힘, 위협, 폭력 등으로 탄압을 받았다. 그럼에도 이들은 국제적으로 인정과 지지를 받으며 평화적 운동을 지속하고 있다.

다마스 데 블랑코는 몇 차례 노벨평화상 후보에 올랐고 비폭력 운동에 헌신한 공로로 여러 상을 받았다. 쿠바의 자유, 민주주의, 인권을 위한 그들의 고군분투는 평화적 저항과 시민 참여의 중요한 본보기로 남아 있다.

Patria y Vida | "Patria y Vida" is a Spanish phrase that translates to "Homeland and Life" in English. It is a slogan that originated in Cuba and has become a rallying cry for Cubans who are advocating for political change and freedom from the country's communist government. The phrase is a play on the slogan "Patria o Muerte" ("Homeland or Death") which was popularized by former Cuban leader Fidel Castro during the Cuban Revolution. The use of "Patria y Vida" signals a rejection of the old slogan and a desire for a new, more hopeful vision for Cuba's future.

Damas de Blanco | "Damas de Blanco" refers to the Ladies in White, a Cuban human rights organization founded in 2003 by wives and relatives of jailed dissidents. The group is composed mainly of women who wear white clothing and participate in peaceful demonstrations to demand the release of political prisoners and promote human rights in Cuba.

The Damas de Blanco movement emerged during the "Black Spring" of 2003 when the Cuban government arrested and sentenced 75 journalists, human rights activists, and political dissidents to long prison terms. The organization has faced repression from the Cuban authorities, including harassment, intimidation, and physical violence. Despite this, the Damas de Blanco have continued their peaceful activism, receiving international recognition and support.

The Damas de Blanco have been nominated for the Nobel Peace Prize several times and won numerous awards for their commitment to non-violent activism. Their struggle for freedom, democracy, and human rights in Cuba remains an important example of peaceful resistance and civic engagement.

일레인 L

<시위자들(1989)>, 2023. | *Protesters* (1989), 2023.

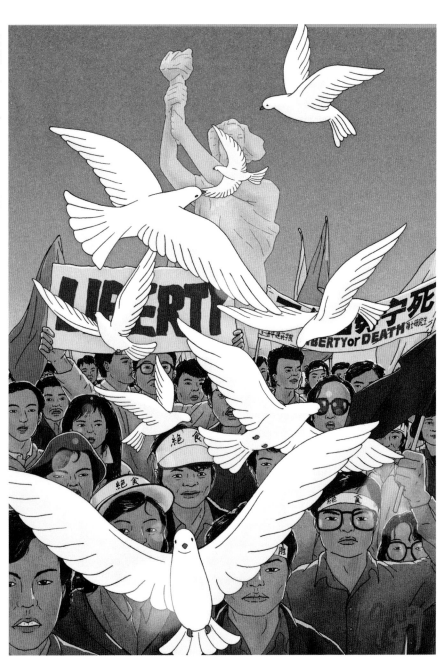

Elaine L

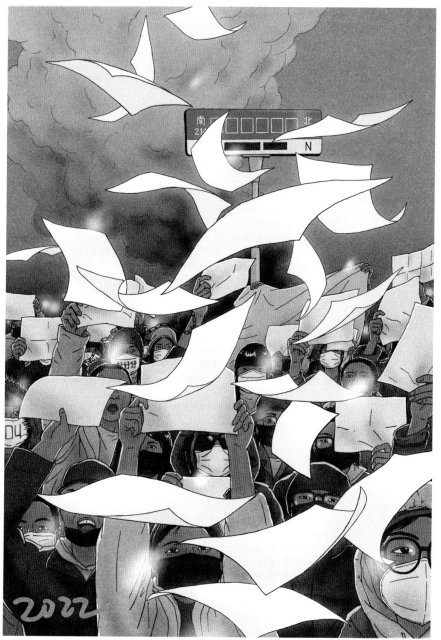

〈시위자들(2022)〉, 2023. | Protesters (2022), 2023.

Seed Pods— Empathy and Solidarity

시위자들(1989) Ｉ 1989년 봄, 베이징과 중국의 여러 주요 도시에서 이례적으로
많은 수의 학생들이 길거리로 쏟아져 나와 정치 개혁, 민주주의, 언론의
자유, 표현의 자유, 부패 척결 등을 요구하는 시위를 벌였다. 중국의 정치적
중심지인 천안문 광장 시위에 노동자, 언론인, 지식인을 비롯한 베이징
주민들이 합세했다. 학생들은 단식 투쟁을 단행했다. 예술 전공 학생들이
제작한 10m 높이의 민주의 여신상이 천안문 전면에 세워졌고, 시위 해산을
위해 투입된 군인들이 이를 철거했다. 이 포스터에서는 시위대 진압에 초점을
맞춘 서구의 관점과 달리, 천안문 시위 이후 세대의 관점에서 자유를 사랑하는
1989년의 젊은 시위대를 기념한다.

Protesters (1989) | In the spring of 1989, an unprecedented number of students in Beijing and across major cities in China went on the streets to call for political reform, demanding democracy, freedom of the press, freedom of speech, an end to corruption, etc. The demonstrations in Tian'anmen Square, China's political center, were joined by workers, journalists, intellectuals, and other residents of Beijing. Students went on hunger strikes. A 10-meter-tall statue of The Goddess of Democracy built by art students was put in front of the Tian'anmen Gate Building before its destruction in the military crackdown of the protests. Contrary to the Western focus on the crackdown, this poster celebrates the freedom-loving young demonstrators in 1989, from the perspective of a member of the post-Tian'anmen generation.

시위자들(2022) ㅣ 2022년 11월 우루무치의 한 아파트에서 발생한 끔찍한 화재 이후, 중국 전역의 주요 도시에서 젊은이들이 나섰다. 그들은 표현의 자유를 억압하는 정부에 항의하는 표시로 빈 종이를 치켜들고 가혹한 '제로코로나' 정책을 중단할 것을 요구했다. 언론의 자유 및 검열 폐지를 요구하는 목소리도 있었고, 드물게는 시진핑 주석과 공산당 통치의 종식을 요구하는 사람들도 있었다. 시위 영상을 온라인에 공유한 후 체포되어 선고를 받은 위구르 여학생을 포함하여, 시위에 참여한 수많은 시민들이 이후 구속되었다. 이 시위는 1989년 민주화 운동과 직접적인 연관은 없지만, 인터넷 검열과 극심한 봉쇄에도 불구하고 자유와 민주주의에 대한 갈망이 중국 젊은이들 사이에 지속적으로 스며든 결과였다. 이 포스터는 자유를 사랑하는 시위대의 용기를 기념하는 한편, 아직 구속 중인 시위자들의 석방을 촉구한다.

Protesters (2022) | In November 2022, following a fatal apartment building fire in Ürümqi, young people across major cities in China held up blank sheets of paper, a protest sign against the suppression of free speech, to demand an end to the draconian "Zero-COVID" policy. Other demands included press freedom and an end to censorship. In a rare case, some called for the country's top leader Xi Jinping to step down and an end to Communist Party rule. An unknown number of protesters were detained in the aftermath, including a female Uyghur student who was arrested and sentenced after merely sharing videos of the protests online. While this round of protests was not directly related to the movement in 1989, the ideas of freedom and democracy managed to infiltrate through Internet censors and continued to inspire generations of young Chinese, despite the ever stricter crackdown on dissent. This poster celebrates the bravery of these freedom-loving protesters and calls for the release of those who are still detained.

시멘트
(박용훈, 양효정)

〈힘 #1〉, 2023. | Power #1, 2023.

cement
(Yonghoon Park and Hyojung Yang)

〈힘 #2〉, 2023. | *Power #2*, 2023.

힘 #1 · #2 |

'힘'은 다양한 의미를 담고 있다.

누군가는 '힘'이 무언가를 제어하고 지배함을 의미한다고 말하며,
누군가는 '힘'이 어떤 일을 해낼 수 있는 능력을 의미한다고 말한다.

누군가는 자신의 이익을 위해 그 '힘'을 사용하며,
누군가는 불의에 저항하기 위해 그 '힘'을 사용한다.

누군가는 강한 '힘'만이 세상을 바꿀 수 있다고 생각하며,
누군가는 좋은 세상을 바라는 '힘'이 모일 때 비로소 세상이 바뀐다고
생각한다.

이 작업은 다양하게 정의되는 '힘'의 양면성을 드러내며,
민주주의를 위해 키워야 할 '힘'이 무엇인지 생각하게 한다.

 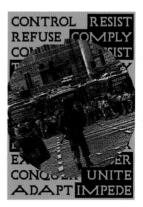

[Still photograph of moving poster]

Power #1 · #2 |

The word "power" has multiple meanings.

Some say that "power" is the ability to control and dominate something,
while others say that it is the ability to accomplish something.

Some use "power" for their own benefit,
while others use it when resisting injustice.

Some believe that strong "power" is the only thing that can change
the world,
while others believe that the collective "power" of good intentions
changes the world.

This work visualizes the duality of power, which is defined in a
various ways,
by asking viewers which "power" needs to be cultivated for the good
of democracy.

<화해 1>, 2023. | Reconciliation 1, 2023.

잘못
용서
인정하다
빌다
스스로

Jieun Guk

<훅해 2>, 2023. | *Reconciliation 2, 2023.*

화해 1 · 2 | 한국 현대사에서 국가 공권력은 이념과 정치에 무관한 이들을 희생시켰고, 연이은 독재 정권은 국민들의 인권을 무참히 탄압했다. 과거 한국 사회와 정부는 이러한 반민주적·반인권적 국가폭력의 가해자였음에도 불구하고, 관용을 베푸는 주체가 되어 '사면'을 시행했다.

현재 우리나라는 1년에 1회 이상의 사면을 꾸준히 시행하고 있으며, 2023년 올해 정부는 "화해와 포용, 폭넓은 국민 통합을 통해 과거를 청산하고 미래를 지향한다."라는 이유로 사면을 공표했다. 과거의 우리와 현재의 우리가 마주하는 '화해'는 달라졌을까.

본 작품은 한국 사회에서 파괴된 '화해'의 문법을 재구성하여, 과거로부터 답습된 '사면'의 본질적인 의미에 대해 질문한다. 배제된 사과, 용서의 기회조차 박탈된 '화해'가 이루어질 수 있는가. 국가가 말하는 '화해'는 무엇인가. '화해'의 문법은 왜, 아직도 과거 국가폭력 이후의 모습과 닮아있는가.

Reconciliation 1 · 2 | Throughout modern history, the South Korean state used its power to victimize innocent people who were not involved in any ideological or political issues. Successive authoritarian regimes ruthlessly trampled human rights. Despite having been the very perpetrator of anti‑democratic and inhumane violence in the past, the South Korean society and government have implemented amnesty as an agent of clemency.

South Korea currently pardons at least once a year, and the government's reasoning behind this year's amnesty was "to settle the past through reconciliation, magnanimity, and nationwide unity and to advance into the future." It makes us wonder, if "reconciliation" was forced in the past, is it any different today?

This work reconstructs the semantics of "reconciliation" that has been destroyed by South Korean society as a way of questioning the fundamental meaning of "amnesty" in the past. Can there be "reconciliation" without apology, without even a chance to forgive? What does "reconciliation" mean to the state, and why does this word seem to carry the same connotations that it did since the past eras of state violence?

오사와 유다이

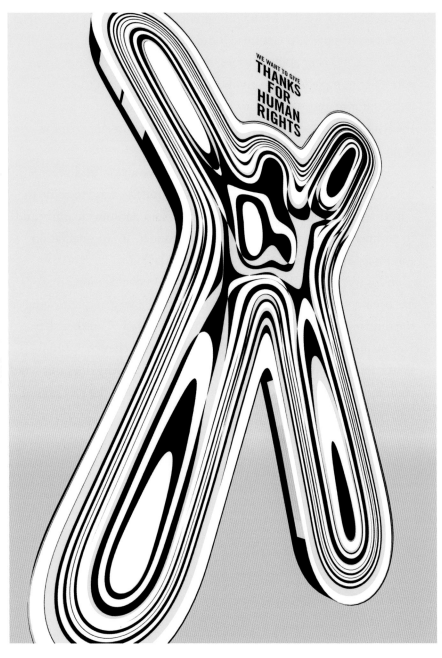

〈우리는 인권에 감사를 표합니다(앞)〉, 2023. | We Want to Give Thanks for Human Rights (Front), 2023.

WE WANT TO GIVE
THANKS
FOR
HUMAN
RIGHTS

Yudai Osawa

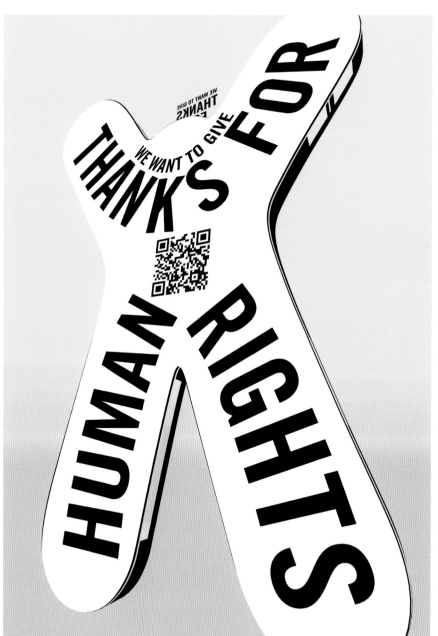

<우리는 인권에 감사를 표한다(뒤)>, 2023. | We Want to Give Thanks for Human Rights (Back), 2023.

우리는 인권에 감사를 표합니다(앞) · (뒤) | 인권은 우리가 존엄하게 살 수 있는 능력을 보호하지만, 오늘날의 세계에서 인권이 무시되는 경우가 자주 있다. 인권은 평범한 주제가 되어 당연한 것처럼 여겨져 종종 그 가치를 제대로 평가받지 못한다.

이 점을 염두에 두고 '인권 개념이 지닌 가치의 재평가'를 촉진할 아이디어를 떠올렸다. 사람들이 인권의 의의를 자각하고 생각하도록 하여 그 가치와 중요성을 인지할 수 있게 돕고자 했다.

'우리는 인권에 감사를 표합니다'라는 제목으로 두 장의 포스터를 만들었다. 이 제목은 친구에게 감사를 표하는 듯한 말투로 인권의 가치를 깨닫게 하는 친근한 기념물이다. 이 포스터에는 인간으로서 행복하게 살아가는 사람을 표현한 3D 아이콘을 디자인하고, 뒷면에는 슬로건과 함께 QR 코드를 배치했다. 아이콘 표면에 에너지의 흐름처럼 디자인한 패턴은 인간인 우리 안에서 뿜어져 나오는 힘과 능력을 나타낸다. 배경 색상은 어두운 세상을 비추는 밝은 빛을 뜻한다.

3D 아이콘 뒷면의 QR 코드를 스마트폰으로 스캔하면 연결된 웹사이트에서 360도로 회전하는 3D 모델 작품을 볼 수 있다. 포스터 이미지를 다운로드해 스마트폰 배경 화면으로 쓸 수도 있다. 이 슬로건에 동의한다면 더 많은 사람들이 이 웹사이트에 접속할 수 있도록 SNS에 공유할 수도 있다. 실제 포스터를 볼 수 없는 사람들도 이런 식으로 우리의 메시지를 보고 잘 이해할 수 있다.

우리는 2차원 포스터가 전시되는 장소에 3D 아이콘의 3차원 버전도 함께 배치할 계획이다. 우리가 디자인한 2차원, 디지털, 3차원 형태의 포스터가 더 많은 관객들을 만나, 그들이 인권과 인권의 중요성이 지닌 가치를 한층 깊이 생각하는 계기가 되길 바란다.

We Want to Give Thanks for Human Rights (Front) · (Back) |
I believe that human rights are often neglected in the world today, despite the fact that they protect our ability to live with dignity. Human rights have become so commonplace that their importance is often taken for granted and not fully appreciated.

With this in mind, I came up with the idea of promoting "a renewed appreciation for the concept of human rights." By raising awareness and encouraging people to consider the significance of human rights, we can help people recognize their value and importance.

Our approach involves creating two enlightening posters titled *WE WANT TO GIVE THANKS FOR HUMAN RIGHTS*. This title serves as a friendly reminder to appreciate human rights, just as one would express gratitude to a friend. The posters feature a 3D icon design that depicts people happily living as human beings, with a slogan and QR code on the reverse side. The aura-like design on the surface conveys the strength and power that comes from within us as human beings. The background color represents a shining light in a dark world.

By scanning the QR code on the back of the 3D icon with a smartphone, viewers can access a 360-degree rotation of the 3D model artwork on our website. They can also download an image of the poster to use as a smartphone wallpaper. If they agree with the slogan, they can share the website on social networking sites to reach more people. This way, even those who cannot see the physical poster can still view and appreciate the message.

In addition to the two-dimensional posters, we plan to display a three-dimensional version of the 3D icon at the same location where the posters will be displayed. By creating this design in two-dimensional, digital, and three-dimensional forms, we hope to reach a wide audience and encourage more people to appreciate human rights and their importance.

문상현

Sang Mun

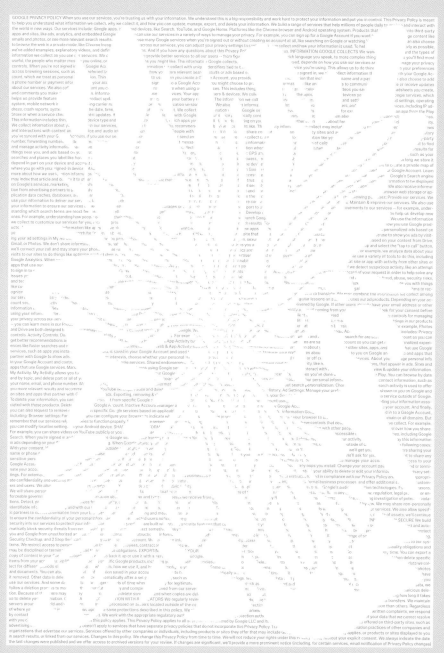

도덕적 행위자로서의 기술 A · B I

"기술 자체는 선하지도 악하지도 않지만, 중립적이지도 않다."

멜빈 크랜즈버그(Melvin Kranzberg)의 '6가지 기술의 법칙(Six Laws of Technology)'에서 인용한 이 말은 디지털 세상을 구축하는 공학자들에게 토대가 되는 말이다. 기술은 위대한 아름다움과 경이의 원천이 될 수 있으며, 타인과 우리를 연결하고, 방대한 정보에 민주적으로 접근할 수 있게 한다. 반면 기술 때문에 전례 없는 수준까지 개인의 삶을 감시하고 추적할 수도 있게 되었다. 정부와 기업은 우리의 움직임을 추적하고, 대화를 감시하고, 개인적인 습관과 선호도에 대한 방대한 데이터를 수집할 수 있다. 이러한 사생활 침해는 여론 조작, 체계적인 불평등 고착, 기관에 대한 신뢰도 손상 등 광범위한 결과를 가져올 수 있다.

이 작품은 기술의 흉측하고도 아름다운 측면과 우리의 사생활에 미치는 영향을 동등하게 보여준다. 우리는 기술이 본질적으로 중립적이라는 전제를 받아들이기보다 기술과 사회의 관계에 대한 미묘하고 윤리적인 담론에 참여하고, 공동의 가치와 열망에 적합한 기술 시스템의 발전과 적절한 사용을 지향해야 한다.

Tech as Moral Actor A · B |

"Technology is neither good nor bad; nor is it neutral."

The quote comes from Melvin Kranzberg's Six Laws of Technology, which serves as the foundation for the technologists who build our digital world. Technology can be a source of great beauty and wonder, enabling us to connect with others, and democratizing access to vast amounts of information. On the other hand, technology has enabled unprecedented levels of surveillance and monitoring of our personal lives. Governments and corporations can track our movements, monitor our conversations, and collect vast amounts of data about our personal habits and preferences. This invasion of privacy can have far-reaching consequences, including the manipulation of public opinion, the perpetuation of systemic inequalities, and the erosion of trust in institutions.

The work showcases the equally gross and beautiful side of technology and its impact on our privacy. Rather than accepting the premise that technology is inherently neutral, we must engage in a nuanced and ethical discourse about the relationship between technology and society, and work towards developing and deploying technological systems that align with our shared values and aspirations.

골든 코스모스
(도리스 프라이고파스, 다니엘 돌즈)

〈발언의 자유 1〉, 2023. | *Freedom of Speech 1,* 2023.

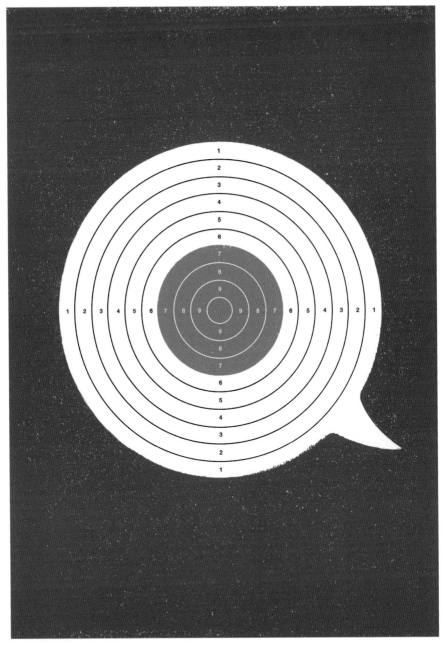

Golden Cosmos
(duo Doris Freigofas and Daniel Dolz)

<조발언의 자유 2>, 2023. | *Freedom of Speech 2*, 2023.

발언의 자유 1 ㅣ 의사 표현 및 발언의 자유는 보호받아야 할 인권 중 하나이다. 전체주의 체제에서 개인적인 의견을 표현하는 사람은 자신의 자유 또는 심지어 목숨까지도 자주 위협받는다. 이를 표현하기 위해 과녁이 된 말풍선을 택했다.

발언의 자유 2 ㅣ 말은 총알보다 강력하다. 이 사실을 설명하기 위해 말풍선 모양의 마개가 총구를 막아 무력하게 만드는 이미지를 그렸다. 폭력과 압제를 끝내는 대화의 힘을 묘사했다.

Freedom of Speech 1 | Freedom of speech and expression is a human right and needs to be protected. People who express their individual opinions in totalitarian systems often risk their freedom or even their lives. To illustrate this, we chose a speech bubble that has become a target.

Freedom of Speech 2 | Words are stronger than bullets. To illustrate this, we put a speech bubble–shaped plug down the barrel of a gun, rendering it harmless. Ending violence and suppression with dialogue.

사키 호

〈존재하는 권력〉, 2023. | *The Powers That Be*, 2023.

Saki Ho

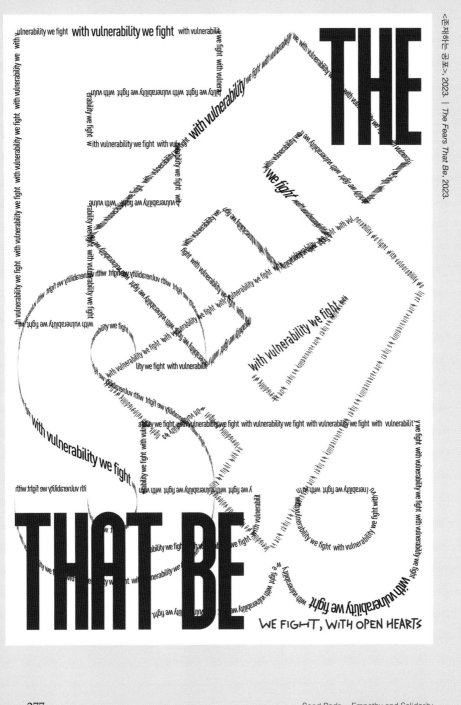

《존재하는 공포》, 2023. | *The Fears That Be*, 2023.

Seed Pods — Empathy and Solidarity

존재하는 권력 ┃ 권력은 인간 사회에서 중요한 역할을 담당하며 인권에 커다란 영향을 미친다. 권력은 행동과 결정을 통제하거나 영향을 미치는 능력이며, 정책과 규칙, 사회적 규범을 형성한다. 권력은 긍정적으로도, 부정적으로도 사용될 수 있다.

'존재하는 권력'은 한 사회에서 권력과 권위를 지닌 개인이나 기관을 일컫는 데에 사용되는 문구로 종종 '당국자' 혹은 '책임자'로 옮겨진다. 여기서 이 문구는 강요하고 방해함으로써 모두가 누려야 할 권리와 기회를 박탈하는 문제에 대해 이야기한다.

연대는 변화를 일으키고, 하나의 공동체로서 행동하고 인권 침해에 대항하는 효율적인 전략이다. 한데 모여 함께 움직임으로써 우리는 높은 장벽을 뚫는 물처럼 장애물을 극복할 수 있다.

이 작품의 타이포그래피에 나타난 구도와 대비는 하나의 메시지를 담으려 하고 있다. '존재하는 권력'이 거대하고 견고해 보일지라도 단결에 의해, 무엇보다도 인류애에 의해 침투당하고 와해될 수 있다. 이 작품은 1975년 아이즐리 브라더스(Isley Brothers)와 1989년 퍼블릭 에너미(Public Enemy)가 부른 〈권력과 싸워라〉(Fight the Power)라는 동명의 다른 노래에서 영감을 받았는데, 이 작품의 디자인은 이 노래에 쓰인 펑키한 리듬 대신 훨씬 더 미묘한 방식으로 메시지를 전달한다.

The Powers That Be | Power plays a major role in human society and definitely has a large impact on human rights. It is the ability to control or influence actions and decisions; it shapes policies, rules, and social norms. Power can be used in both positive and negative ways.

"The Powers That Be" is a phrase used to refer to the individual or institution who holds power and authority in a society; here on this piece, it addresses the forces and obstacles keeping us from the rights and opportunities that everyone deserves.

Solidarity is an effective strategy to make change, act as a community, and fight against human rights abuse. By coming together and working through coordination, we can overcome obstacles like water penetrating high walls.

The typographic compositions and contrast of this piece are trying to convey a message—even though "The Powers That Be" might look gigantic and solid, they are permeable and can be dissolved by unity, and most importantly, humanity. The concept of this piece is inspired by the 1975 song *Fight The Power* by The Isley Brothers and another song with the same title later released by Public Enemy in 1989, but instead of funkiness the design carries the message in a much more subtle manner.

존재하는 공포 ｜ 1941년 미국의 프랭클린 D. 루스벨트 대통령은 '네 가지 자유', 즉 의사 표현의 자유, 신앙의 자유, 결핍으로부터의 자유, 공포로부터의 자유를 제시했다. 당시 '공포'는 주로 전쟁과 국제적인 갈등에 관한 것으로 여겨졌다. 2023년 현재, 공포는 인권 침해, 기후 변화, 디지털 진화, 팬데믹, 다양한 전쟁 수단 등 급격한 사회·환경적 변화로부터 발생한다.

공포는 자기 회의, 자기 검열, 불신, 정치·문화적 생활로부터의 후퇴를 낳는다. 공포는 인권의 주요한 걸림돌이다. 이 작품의 제목인 '존재하는 공포'는 '존재하는 권력'의 단어 유희로, 우리 스스로가 이러한 문제에 대항하기에는 너무 하찮고 무력한 존재로 여겨질 때 느껴지는 공포에 대해 이야기한다.

공포는 피할 수 없지만, 오히려 취약해짐으로써 극복할 수 있다. 공포는 우리가 자신의 감정과 생각을 꺼내놓고 정직해질 수 있게 한다. 자기 자신을 보여주고 이해받을 수 있도록 스스로 허락한다. 관계와 이해를 쌓을 수 있게 하는 취약함은 오히려 우리에게 힘이 되어주고, 연대와 지지를 형성한다.

〈존재하는 공포〉는 〈존재하는 권력〉과 유사한 구도를 지니면서도 명암이 반전되어 있어 우리가 공포를 포용하고 그것을 해제하는 힘이 취약함과 개방성에서 나온다는 메시지를 전달한다.

The Fears That Be | In 1941, when US President Franklin D. Roosevelt proclaimed the "Four Freedoms"—Freedom of Speech, Freedom of Worship, Freedom from Want, and Freedom from Fear—"Fear" was mainly understood as war and world conflicts to be overcome. Today in 2023, fear is triggered by rapid social and environmental changes such as violation of human rights, climate change, digital evolution, pandemics, and various means of war.

Fear leads to self-doubt, self-censorship, mistrust, and withdrawal from political and cultural life. It is a major stumbling block of human rights. "The Fears That Be" in this piece is a wordplay on "The Powers That Be," addressing the fears we face when one feels so insignificant and powerless to cope with these issues.

Fear cannot be evaded but can be overcome with vulnerability. It is the ability to be open and honest about our feelings and thoughts. We allow ourselves to be seen and understood. Vulnerability is empowering because it builds connections and understanding; it leads to a sense of solidarity and forms support.

In parallel to *The Powers That Be*, *The Fears That Be* shares similar composition but a reversed visual, to deliver the message that vulnerability and openness empower us to embrace fear and disarm it.

세바스티안 큐리

<여기에서 시작한다>, 2023. | *BEGINS HERE*, 2023.

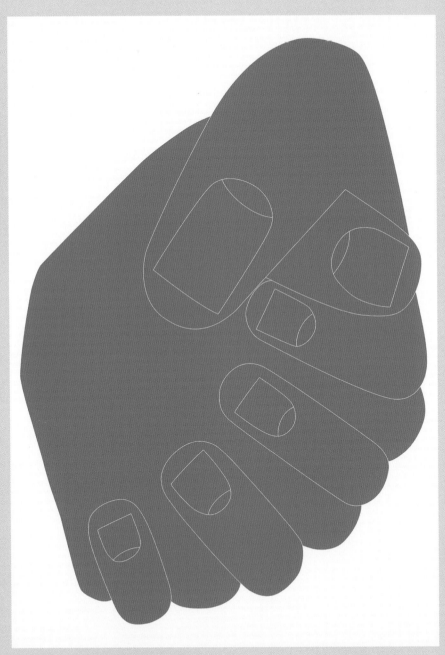

Sebastian Curi

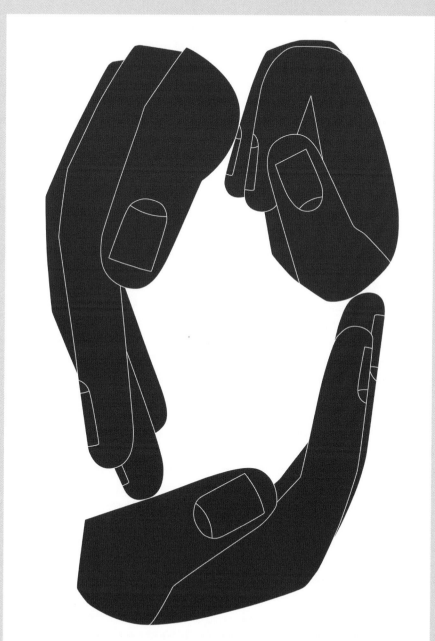

<우리는 함께 가기 때문에 먼 길을 간다>, 2023. | We Go The Distance Because We Go Together, 2023.

Seed Pods— Empathy and Solidarity

여기에서 시작하다 ㅣ 나는 타인을 이해하고 그와 정서를 공유하는 힘을 믿는다. 민주주의는 우리 모두가 함께하는 만큼 강하다. 이 맞잡은 손은 공감과 연대의 상징이다.

우리는 함께 가기 때문에 먼 길을 간다 ㅣ 단결의 중요성에 근거해 무언가를 그리고 싶었다. 과거가 없는 나라는 없으며, 어려운 상황 속에서 우리를 움직이는 것은 서로에 대한 지지라고 믿는다.

BEGINS HERE | I believe in the power of understanding and sharing feelings with one another. Democracy is as strong as all of us together. These holding hands are a symbol of empathy and solidarity.

We Go The Distance Because We Go Together | I wanted to draw something based on the importance of unity. There is no country without a past and I believe what drives us through difficult situations is the support we have with each other.

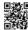

스튜디오 하프-보틀

《플랫폼P 입주사협의회의 업무 목록 리스트》, 2023. | List of Duties Performed by the Council of Tenant Companies at PLATFORM P, 2023.

플랫폼P 입주사들이 공지를 통해 처음으로 문제를 인지한 때.

13 February 2023

① 플랫폼P 입주사협의회
② 요구가 기억될 수 있도록

협의회 총회 조직

문제의식 공유 여물 주고받기. 입주사 간담회 조직. 입주사 간담회 진행. 총회 날짜 선정 및 참여 여부 조사. 협의회 회칙 초안 작성. 협의회 회칙 수정 피드백 받기. 협의회 가입자격과 회비 정하기. 총회 접근 준비. 총회 온라인 중계 준비. 총회 이전의 활동 내역 보고. 협의회 회칙 확정. 임원 선거. 단체시민 뭉치. 회원 가입 및 회비 수납 조직.

조직 유지·보수

회원 대학원 구성. 운영진 모임. 운영진 활동 팀 구성. 운영진 업무를 위임하고 구성. 운영진 업무를 문서 아카이빙 구성. 운영진 업무를 문서 양식 제작. 회비 운영 계좌 개설. 회원 대상 활동 현황 뉴스레터 발송. 활동 내용을 소개하는 언론 기사를 화환에게 공유.

마포구청 상대 대응

"구민에게 돌려줍니다" 청구를 통한 공식 민원 제기. 마포구청 문화시설팀과 연락. 마포구청 문화시설팀장과 간담회. 마포구청과의 간담회 자료 요청. 마포구청 관련 문화예술교육과와 간담회. 마포구청이 발행한 "마포출판문화진흥센터 2023년 2기 입주사 계약 연장 및 신규 모집 제한 문제" 문서 정보공개청구. 마포구청이 발행한 "마포출판문화진흥센터 관련된 불분명 사실 해명자료" 문건 대응 보도자료 작성.

언론 알림 및 대응

플랫폼P 사태 관련 초동 보도자료 배포. [기자 1] 현장취재 배포 및 인터뷰 추선. [언론사 1] 협의회 멤버 기고글 게시. [기자 2] 현장취재 보이 및 인터뷰 추선. [언론사 2] 라디오 생방송 현장 참여. [언론사 3] 라디오 생방송 인터뷰 참여. [기자 3] 전화 인터뷰 추선. [기자 4] 전화 인터뷰 추선.

서명운동 진행

[마포출판문화진흥센터를 응원하는 정상화와 출판문화 진흥을 촉구하는 공동서명] 작성과 작성. 온라인에 서명을 모을 수 있도록 제작. 서명 홍보글 제작. 서명 현황 확인 및 공지. 서명인 주소록 업데이트. 대량 이메일 뉴스레터 발송 툴 구매. 서명인 대상 활동 현황 이메일 공유.

플랫폼P 북페어 "마포 책소동"

북페어 공비림 모집. 예산안 작성. 포스터 제작 및 인쇄 제작. 소셜 홍보를 위한 디자인 시안 제작. 소셜 계정 만들기. 굿즈 제작 및 발주. 소셜 디자인 제작. 무엇보름. 서명인 대상 북페어 홍보메일 발송. 시민자료 배포. 부스 설치 및 공간 꾸미기. 뒤댓테이 사진, 부스 철거. 참가비 및 행사 준비 비용 정산. 사후보도자료 배포.

마포구 관내 홍보용 정당현수막 게시

[정당 지역조직 1, 2]와 제작 방식 및 비용 분담 합의. 현수막 문구 지정. 현수막 디자인 시안 제작. [정당 지역조직 1, 2]와 공동 게시물 사진 작업. 현수막 제작 발주. 현수막 게시 작업 참가할 멤버 모집. 거리 현수막 게시. 현수막 철거 작업 장비질 멤버 모집. 거리 현수막 12장 철거.

출판인, 출판단체와 연대

출판인 단체 목록 리스트업. 출판인 단체 대상 연대 요청 연락. 입주사협의회 위원이 참가하는 북페어 목록 정리. 북페어 현장 네트워크 통신 행렬로 제작. [단체 1] 회장과 공식 연대. [단체 2] 운영위원회와 간담회. 북페어에 마주친 [단체 3] 회장과 비공식 연대.

지역 정치인, 정당조직과 협업

지역구 마포구의원 및 정당 지역조직과 접촉. 공문 발송. 지역구 마포구의원 공동 간담회. [정당 지역조직 1]과 간담회. 마포구의회 구성원들의 진행. 마포구의원들을 통한 구정 문서공개청구. [정당 지역조직 2]와 간담회.

집회와 기자회견

집회 날짜 장소 섭외 및 집회 신고. 집회 참가 멤버 모집. 캠프 대회, 피켓 및 현수막 제작. 기자회견 연대발언자 모집 연락. 발언 순서 큐시트 정리. 사전보도자료 배포. 집회 진행. 현장보도자료 인쇄 및 배포. 구청장실 방면 피켓모드, 시위보도자료 배포. 연속 1인 시위 참가자 모집 및 일정 조정.

마포구 관내 도서·출판 관련 다른 이슈와 연대

[마포구 작은도서관 폐쇄 시도 반대하는 주민단체 1]과 연락. [마포구 관내 출판사 조직을 시도하는 출판인 1]과 연락.

조례 제정 준비

"[가칭] 마포구 출판문화 및 유관 산업 진흥에 관한 조례" 제정 준비 초동모임.

입주연장심사 및 신규입주사 선발 기한.
이 이후에도 문제가 지속될 가능성이 높음.

15 July 2023

요구가 기억될 수 있도록

*4/30 포스터 작품 출품 마감일
이후에도 업무가
추가될 수 있음.

Studio Half-bottle

13 February 2023

15 July 2023

플랫폼P 입주사협의회의 업무 목록 리스트 | 스튜디오 하프-보틀은 2023년 2월부터 '플랫폼P 입주사협의회'에 참여하고 있다. 서울 마포구청이 구립 마포출판문화진흥센터(플랫폼P) 운영을 파행시키는 것을 막고 센터를 지키기 위해 센터 전현직 입주사 46개가 모였다. 이들은 센터가 그동안 출판문화 및 지역사회 공동체에 기여한 바를 인정받고 지키고자 한다.

모든 사회운동은 자기 가치관을 사람들의 기억에 남기려 하고, 사람들은 이런 행위의 숭고함을 칭찬한다. 하지만 그 뒤편에는, 목표를 관철하기 위해 반드시 수행해야 하지만 사람들에게 주목받지는 못하는 수많은 업무가 있다. 전체 전략과 타임테이블을 짜는 것에서부터 집회용 앰프를 대여하는 자잘한 실무에 이르기까지.

이 작품은 2023년 2월부터 7월까지 협의회가 치른 업무를 12가지 종류로 분류하고 세부 사항을 나열했다. 한 사회의 인권과 민주주의를 지탱하기 위해 사회운동의 업무를 묵묵히 감당하는 모든 사람들의 공로를 기념하며, 협의회 활동을 통해 그 업무를 얕게나마 체험한 내용을 사람들에게 알리고자 한다.

List of Duties Performed by the Council of Tenant Companies at PLATFORM P | Studio Half-bottle has been a member of the Council of Tenant Companies at PLATFORM P since February 2023. Forty-six current and former tenant companies have united to form a council in the hopes of preventing the Mapo-gu Office in Seoul from shutting down PLATFORM P (the Mapo-gu Publishing Culture Promotion Center). They also aim to demand recognition of the platform's contributions to the publishing industry and local community.

All social movements attempt to imprint certain values in people's minds, and people praise the nobility of such activism. However, behind the active "frontlines" are countless, unrecognized duties that need to be performed to the goal's end. These duties range from coming up with the overall strategy and managing the timetable to petty chores like renting amplifiers for rallies.

This work divides the duties carried out by the council from February to July 2023 into 12 categories and lists them in detail. This work commemorates the contributions made by all social activists who silently undertake the work that goes into upholding human rights and democracy. Additionally, by sharing Studio Half-bottle's humble experience as a member, it seeks to inform people of the activities of the council.

플랫폼P 입주사협의회와 겹쳐진 날짜들 ㅣ 민주주의 사회 속에는 구성원이 기억하고 행동할 사안들이 많이 있다. 그들은 이에 대응하기 위해 자신의 시간, 자본, 업무 역량, 발언 기회, 관심 등 자원을 쓰곤 한다. 그러나 물리적인 한계가 있다 보니 사람들은 사안에 따라 자기 자원을 더 많이/적게 들이게 된다.

이 작품은 스튜디오 하프-보틀이 플랫폼P 입주사협의회 활동에 참여한 2023년 2월부터 7월 사이의 '날짜'들을 추려봤다. 첫째는 인권의 증진 또는 후퇴와 관련해서 기억할 날짜들이고, 둘째는 스튜디오의 본래 작업 활동을 위한 업무 관련 날짜들이다. 그러니까 이 작품은 스튜디오 하프-보틀이 협의회 업무에 바빠서 자원 투입에 소홀했던 '날짜'의 목록이다. 협의회 활동에 더 많은 시간과 자본과 발언 기회와 관심을 투입할 이유는 분명했다. 그러나 누군가에게 이 '날짜'들은 더욱 많은 자원을 투입해서 다뤄지고 기억되어야 마땅한 것이다. 여기서 도발적인 질문을 던진다. 민주주의 사회의 구성원으로서 당신은, '날짜'마다 어떤 기준에 따라 자원을 투입하는가? 그리고 다른 기준을 가지고 있는 구성원을 받아들일 수 있는가?

Important Dates Overlapped with Important Dates for the Council of Tenant Companies at PLATFORM P | In a democratic society, there are many issues that demand attention and action. Individuals invest resources such as time, money, work capacity, voices, and attention to their issues of interest. Yet, due to physical limitations, these resources are bound to be distributed unevenly amongst the various issues.

This work highlights important dates between February and July 2023, a period during which Studio Half-bottle took part in the Council of Tenant Companies at PLATFORM P. Some of the dates mark memorable moments in regard to the progress and retrograde of human rights, while others mark the days that Studio Half-bottle was invested in its own agenda. In a sense, this work indicates the dates on which Studio Half-bottle neglected to invest its resources into other social causes because of being tied up with its council duties. Surely, the council duties were reason enough to speak up on related issues or to invest more time, money, and attention. However, some might feel that those dates deserve increased attention and commemoration for alternate reasons. So, here is a provocative question: as a member of a democratic society, on what standard would you base your investment of resources for each date? Can you accept other members of society with different standards?

킴 알브레히트

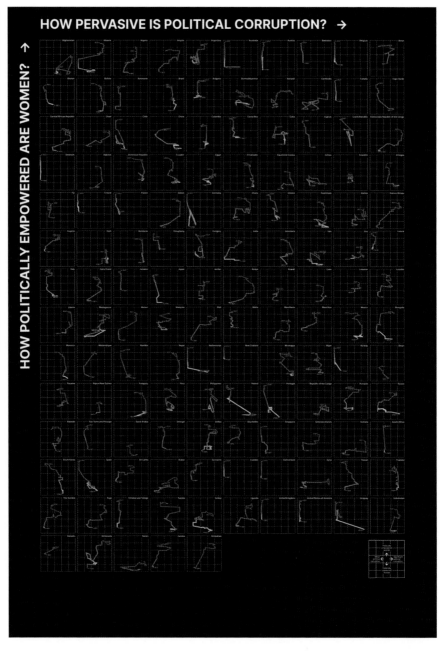

<여성의 역량 강화와 정치적 부패>, 2023. | Empowered Women and Political Corruption. 2023.

Kim Albrecht

<이동의 자유와 학문적 자유>, 2023. | *Freedom of Movement and Academic Freedom*, 2023.

여성의 역량 강화와 정치적 부패 · 이동의 자유와 학문적 자유 ㅣ 민주주의의 의미는 복잡하다. 그것은 다양한 사회적 조정을 수반하는 복잡미묘한 용어다. 민주주의 다양성 연구소(Varieties of Democracy, V-Dem)에서는 질문 형태를 띤 400개 이상의 구체적인 지표를 사용해 하나의 다차원적 데이터 세트로서 민주주의를 다룬다. 이를 시각화한 두 작품은 두 개의 지표를 택해 시간의 경과에 따른 국가별 추이를 보여준다. 그 결과, 시간 경과에 따른 국가별 발전을 추적하는 격자형 선 그래프가 나타난다. 민주주의 개념과 관련된 두 개의 질문은 시간을 따라가는 색깔 선의 형태로 처리된다. 그래픽 안에서 제시된 질문들은 고정적이지 않고 변화하는 불안정한 구성물로서 끊임없이 경합한다. 두 질문이 서로 연관성이 있어 보일 때도 있는데, 둘 중 하나를 중요하게 생각하면서 다른 하나를 무시하는 국가가 항상 존재한다. 10년, 100년 단위로 시간을 추적하는 선들은 민주주의의 특정 측면이 얼마나 불안정할 수 있는지 보여준다. 두 포스터는 각각 질문을 두 개씩 던진다. (각 질문에 대한) 아래 설명은 민주주의 다양성 연구소 웹사이트에서 가져온 것이다. (https://www.v-dem.net/static/website/img/refs/codebookv111.pdf)

정치적 부패가 얼마만큼 만연해 있는가?
부패 지수는 통치 조직의 다양한 영역 및 수준을 모두 다루는 부패의 6개 유형별 지표를 포함하며, 행정·입법·사법적 부패를 구분한다.

여성의 정치적 역량은 얼마나 강화되었는가?
여성의 정치적 역량 강화는 여성의 역량이 증가하는 과정이라고 정의되며, 이는 사회적 의사결정에 대한 여성의 더 많은 선택과 행위, 참여로 이어진다. 여성이 시민으로서 기본적 자유를 갖는지, 여성이 정치적 사안에 대한 공개적 담론 및 시민사회조직에 참여하는지,

Empowered Women and Political Corruption • **Freedom of Movement and Academic Freedom** | The meaning of democracy is a complex one. It is an intricate, tangled term involving manifolds of social arrangements. The Varieties of Democracy, V-Dem, research institute tackles democracy as a multidimensional dataset covering over 400 specific indicators in the form of questions. These visualizations place two of the indicators against one another spanning time and nations. The result is a gridded argument of lines tracing the development of countries over time. Two questions relevant to the notion of democracy are negotiated in the form of a colored line tracing time. Within the graphic, the presented questions are nothing static, but constantly in negotiation, a changing fragile construct. At times the two questions seem related but there are always countries respecting one question while neglecting another. The lines tracing decades and centuries indicate how fragile certain aspects of democracy can be. Each of the two posters places two questions toward one another. The descriptions below come from the Varieties of Democracy website: https://www.v-dem.net/static/website/img/refs/codebookv111.pdf

HOW PERVASIVE IS POLITICAL CORRUPTION?
The corruption index includes measures of six distinct types of corruption that cover both different areas and levels of the polity realm, distinguishing between executive, legislative and judicial corruption.

HOW POLITICALLY EMPOWERED ARE WOMEN?
Women's political empowerment is defined as a process of increasing capacity for women, leading to greater

공식적인 정치적 직위에 여성이 대표성을 갖고 진출하는지 등 세 가지
동등한 중요성을 지닌 측면들을 통합한 지수이다.

학문적 자유는 어느 범위까지 존중받는가?

학문적 자유는 교수 및 강사의 권리에 관한 것으로 이해되며 그들이
규정된 원칙의 제한 없이 가르치고 토론할 자유, 연구를 수행하고
그 결과를 유포 및 출판할 자유, 종사하는 기관 또는 시스템에 대해
자신의 의견을 자유롭게 표현할 자유, 제도적 검열을 받지 않을 자유,
전문적 또는 대표적 학술 기관에 참여할 자유로 이해할 수 있다.

시민들은 이동 및 거주의 자유를 누리는가?

이 지표는 시민이 낮과 밤 시간에 주요 공공 도로에서 자국 내 여러
지역을 넘나들며 자유롭게 이동하고 자신이 원하는 장소에 영구적인
거주지를 확보할 수 있는 정도를 명시한다.

choice, agency, and participation in societal decision-making. It is understood to incorporate three equally weighted dimensions: fundamental civil liberties, women's open discussion of political issues and participation in civil society organizations, and the descriptive representation of women in formal political positions.

TO WHAT EXTENT IS ACADEMIC FREEDOM RESPECTED?
Academic freedom is understood as the right of academics, without constriction by prescribed doctrine, to freedom of teaching and discussion, freedom in carrying out research and disseminating and publishing the results thereof, freedom to express freely their opinion about the institution or system in which they work, freedom from institutional censorship and freedom to participate in professional or representative academic bodies.

DO CITIZENS ENJOY FREEDOM OF MOVEMENT AND RESIDENCE?
This indicator specifies the extent to which citizens are able to move freely, in daytime and nighttime, in public thoroughfares, across regions within a country, and to establish permanent residency where they wish.

Studio Rejane Dal Bello

What are <u>your</u> first & second
priorities regarding human rights?

FIRST

SECOND

〈당신에게 첫 번째는 무엇이며, 두 번째는 무엇인가—인권과 관련하여〉, 2023. | *What Is Your First, What Is Your Second—Regarding Human Rights?*, 2023.

Seed Pods—Empathy and Solidarity

시민이 먼저, 디자이너는 그다음 ㅣ 헤잔느 달 벨로는 그래픽 디자이너가 되기 위해 공부하면서 빈곤선(poverty line) 아래 속한 브라질 어린이들을 위한 사회복지 일에도 참여했다. 이때 그녀는 창의력 및 그로 인한 긍정성이 발현되는 세계와 그 반대편에 있는 시민의 세계 간의 차이를 자각하게 되었다. 그 반대편의 세계는 형태와 색채 그리고 긍정성만으로 누군가의 현실을 변화시키기에는 충분치 않은 세계였다. 그녀는 이 경험을 바탕으로 자신만의 우선순위를 여기 적은 대로 정하고 디자인 작업과 사회복지 일을 병행하고 있다.

당신에게 첫 번째는 무엇이며, 두 번째는 무엇인가—인권과 관련하여 ㅣ 당신에게 첫 번째는 무엇이며, 두 번째는 무엇인가—인권과 관련하여? 이 질문을 한층 폭넓은 대중에게 던짐으로써 이 주제와 관련된 사람들의 우선순위, 그리고 이 주제 내에서 사람들에게 의미 있는 행동이 무엇인지 알아보고자 한다. 사람들이 포스터에 자기 생각을 쓰게 함으로써 다양한 목소리와 관점을 모으는 것을 목표로 한다.

Citizen First, Designer Second | While enrolling to become a graphic designer and also doing social work for kids living below the poverty line in Brazil, Rejane's encounter was a contrast between two worlds: creativity and its positivity against the poverty of the citizens, where shapes, colors, and positivity alone would not be enough to change anyone's reality. From that experience alone she has continued to maintain her social work in parallel with her design work, but with her priorities outlined here.

What Is Your First, What Is Your Second—Regarding Human Rights? | "What Is Your First, What Is Your Second—Regarding Human Rights?" By asking this question to the wider public, we gather their own priorities regarding the subject and having an understanding of what actions within the subject mean to them. The aim is to have them write on the poster and gather multiple voices and perspectives.

<민주의 씨앗 폭탄>, 2023. | Democracy Seed-Bombs, 2023.

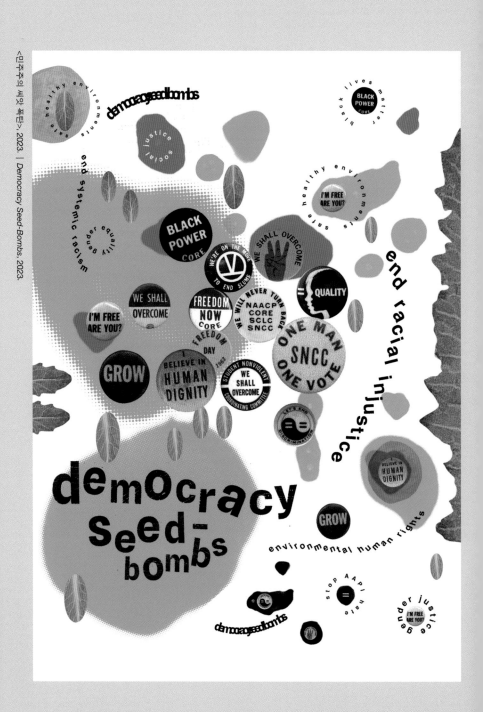

Moon Jung Jang

민주주의 씨앗 폭탄 | 이 포스터는 1960-1970년대 뉴욕에서 일어났던 해티 카던(Hattie Carthan)의 도시 환경 운동과 리즈 크리스티(Liz Christy)의 씨앗 폭탄을 통한 게릴라 가드닝에서 영감을 받았다. 시민권 운동의 역사와 그 의미를 검토하고, 현재 전 세계적으로 우리가 목도하고 있는 인권 관련 문제를 반영한 문구를 포함하는 작업이다. 과거 시민권 운동 당시 쓰였던 'Freedom Now', 'I Believe In Human Dignity', 'Black Power', 'Equality'('지금 자유를', '인간의 존엄성을 믿는다', '블랙 파워', '평등') 같은 기념비적인 버튼들■과 오늘날의 슬로건을 모아서 민주주의 씨앗 뭉치를 만들었다.

■ 버튼 이미지는 시민권 운동 아카이브(Civil Rights Movement Archive)에서 사용하였습니다.
https://www.crmvet.org/

Democracy Seed-Bombs | This poster is inspired by Hattie Carthan's urban environment movement and Liz Christy's guerrilla gardening through seed bombs in the 1960s and 1970s in New York City. In reviewing the history of the Civil Rights Movement and its meanings, I mapped out words and slogans that mirror relevant issues we witness now in the world and created democracy seed-bombs that included a collection of historical buttons■ saying "Freedom Now," "I Believe In Human Dignity," "Black Power," and "Equality," and current slogans to end discrimination.

■ The button images were from Civil Rights Movement Archive.
https://www.crmvet.org/

폭력과 이를 넘어서는
정의에 관하여

정근식 | 서울대학교 명예 교수

1. 폭력의 문제에 직면하여

길게는 1990년 제정된 '5·18민주화운동관련자보상등에관한법률'로부터
시작되고, 짧게는 2005년 제정된 '진실·화해를위한과거사정리기본법'에
의해 본격화된 이행기 정의 프로젝트들은 한국의 근현대사에서 경험한
거대한 폭력들에 관한 근본적 성찰의 계기가 되었다. 공안 기구의 밀실에서
자행된 수많은 고문과 인권유린, 시내 중심가에서 시민들을 향해 가해진
적나라한 국가폭력, 안보를 명분으로 진행된 '내부의 적' 만들기, 전쟁
중에 자행된 대규모 민간인 학살 등의 진실에 직면할수록, 우리는 폭력이
예외적인 것이 아니라 근대국가에 내재하는 보편적인 현상은 아닌지 의심할
수밖에 없고, 과연 이런 폭력들이 남긴 상처를 온전히 치유할 수 있을지,
또는 폭력과는 거리가 먼 평화사회를 건설할 수 있을지 회의적인 생각에
빠져들기도 한다. 그러나 이와는 달리, 한 단계 더 높은 민주인권국가로
성장하기 위한 노력도 부단히 지속되어 왔다는 점도 상기되어야
한다. 2001년에 출범한 국가인권위원회와 민주화운동기념사업회,
그리고 두 차례에 걸쳐 시도하고 있는 진실화해위원회의 성과는
한국을 아시아에서 손꼽히는 민주인권국가로 만들었다.

폭력의 문제를 정면으로 부각시킨 이행기 정의 프로젝트들은
탈식민, 탈전쟁, 탈권위주의 등 3가지 동심원을 그리면서 진행되었는데,
이들은 1894년 동학농민혁명으로부터 권위주의적 지배가 거의 종료된
1992년까지 약 100년간의 근현대사를 포괄하고 있다. 이들은 모두 폭력에
대한 진실규명에 기초하여 희생자들의 명예를 회복하거나 보상할 수 있는

기반을 마련하고, 때로는 폭력의 책임을 추궁하기도 하였다. 이를 통하여 우리는 폭력의 희생자들을 재인식하게 되었고, 이들의 고통에 공감하면서 피해를 회복하기 위한 방안을 강구하지 않을 수 없었다. 이 과정은 이행기 정의의 주요 원칙뿐만 아니라 이행기 정의의 모델들을 정립하는 과정이었고, 그 성과는 국제적 관심의 대상이 되기도 하였다. 여기에 더하여 2018년부터 시작된 민주화운동기념관 조성 사업은 한국의 민주화 운동 및 인권침해 사건들에 대한 기억과 그 역사적 교훈을 어떻게 표상화하고 이를 후세대들에게 전승할 것인가라는 새로운 과제를 던져주었다.

이 글은 민주화 운동뿐 아니라 인권운동 나아가 이행기 정의를 실현하는 과정에서 우리가 실질적으로 직면했던 폭력의 유형과 성격을 어떻게 개념화하고 이론화할 것인지, 나아가 이를 어떻게 재현할 것인지를 생각해 보려는 것이다. 폭력은 근대 계몽사상과 자유주의 이론으로 인하여 학술적 변두리에 위치했지만, 근래에 이를 사회의 중심에 놓고 사유하려는 이론가들이 많이 출현했다.[1] 특히 폭력이 초래한 고통을 효과적으로 재현하여 공감의 폭을 넓히는 것은 정의와 평화를 위한 연대의 기반이며, 우리가 당면하고 있는 중요한 과제라는 인식이 커지고 있기 때문이다.

2. 반식민주의와 저항폭력

진실과 정의, 또는 화해의 맥락에서 우리가 직면했던 폭력들은 매우 다양하고 복합적이다. 민주화 운동이 직면했던 폭력과 인권운동이 직면했던 폭력은 그 범위와 깊이가 상당히 다르지만, 여기에 식민주의나 전쟁이 더해지면, 그것은 더 말할 나위 없이 복잡해진다. 진실화해위원회의 경우, 일제의 지배에 대한 항일독립운동, 한국전쟁 발발 전후의 민간인 학살, 그리고 전후 권위주의 시기의 발생했던 대규모 인권침해 사건들의 진실을 규명하고 희생자들의 치유 또는 사회적 화해를 모색하는데, 여기에서 조사 대상이 되는 사건들을 초래한 폭력의 성격이나 의미는 동질적이지 않다. 예컨대, 1894년 동학농민군들이나 한말의 의병, 또는 안중근의 폭력적 저항을 우리는 무엇이라고 개념화해야 하는가?

1 　신진욱, 「근대와 폭력—다원적 복합성과 역사적 불확정성의 사회이론」, 『한국사회학』 38권 4호(2004): 1-31.

독일의 유명한 역사철학자 발터 벤야민(Walter Benjamin)은 1920년에 쓴
「폭력 비판을 위하여」에서 '신화적 폭력'과 '신적 폭력'을 언급하였다.[2] 신화적
폭력의 '신화'는 그리스 신화를 가리키고, 신적 폭력의 '신'은 유대교의 신,
곧 야훼를 가리킨다. 그는 "신화적 폭력이 법 정립적이라면, 신적 폭력은
법 파괴적이고, 신화적 폭력이 경계들을 설정한다면, 신적 폭력은 경계를
파괴한다."고 말했다. 곧, 신화적 폭력이 법을 정립하고 보존하는 폭력이라면,
신적 폭력은 그런 법을 파괴하고 해체하는 폭력이라고 말한다. 그의 설명에
따르면 안중근의 의거는 신적 폭력에 해당한다. 벤야민은 신적 폭력을 '순수한
폭력'이라고 옹호하였다. 그의 논의를 참고한다면, 식민지 상황에서 진행된
많은 항일운동과 독립운동은 사회의 질서를 바꾸려고 하는 신적 폭력에
해당한다. 우리는 이를 흔히 항일독립운동이라는 하나의 범주로 말하지만,
엄밀하게 말하면 항일운동과 독립운동이 동일한 외연과 내포를 갖는 것은
아니다. 독립운동 참여자들은 그것이 평화적이건 비평화적이건 관계없이
유공자로 인정되는데, 종종 항일운동 참여자들은 여기에서 배제된다.
식민지하의 조선인들을 옹호하는 인권운동의 존재를 인정하고 이를 보다
적극적으로 해석할 필요가 있다.

폭력의 역사에서 가장 미묘한 사례는 아마도 2차대전 종전 직전에
히로시마나 나가사키에 투하된 원자폭탄일 것이다. 벤야민의 신적 폭력에
가까운 이 사건은 전쟁의 승자인 미국의 헤게모니 또는 전후 질서에 의해
정당화되었지만, 일본인 피해자들은 이에 침묵하고 있거나 동의하지 않는
경향이 있다. 한국인들은 이 원폭 투하를 '전범국 일본에 내린 천벌'로
간주하는 경향이 있는데, 이는 식민지로부터의 해방이라는 역사적 인식과
함께 인과응보에 친화적인 문화가 결합된 소산이라고 할 수 있다. 그러나
만약 우리가 여기에서 '천'은 무엇인가를 묻거나 조선인 원폭 피해자는 왜
희생되어야 했는가를 묻는다면, 천벌론은 약간 단순하고 일방적인 것임을
깨닫게 된다. 권위나 헤게모니에 정당화된 폭력이 인권의 잣대로는 쉽게
용납되지 못하는 상황을 자주 목격하게 되는데, 바로 여기에서 전쟁사와
평화사의 공존의 딜레마가 시작된다.

3. 창법적 폭력과 전쟁

앞에서 벤야민이 다루고자 하는 것은 '법적 폭력'이었다. 그는 신화적 폭력을
언급하면서 법 정립적 폭력과 법 보존적 폭력을 구별했다. 법 정립적 폭력은
창법적 폭력(rechtsetzende Gewalt)이라고도 표현할 수 있는데, 여기에서 법은
세계의 질서를 의미하거나 국가 형성의 기초가 되는 헌법을 의미한다고 볼 수
있다. 세계질서의 변화하는 과정에서 국가 형성이 이루어진다면, 창법적 폭력은
하나의 현상으로 보이지만, 개념적으로 양자는 구별되어야 한다. 2차대전의
종전과 세계적 냉전의 형성기에 아시아의 국가 형성이 진행되었다는 사실을
염두에 두면서 창법적 폭력을 사유할 수밖에 없기 때문이다.

국가는 헌법을 기초로 이를 지키기 위한 폭력을 일상적으로 행사하지만,
종종 국가 스스로가 여기에서 이탈하면 불법적 국가폭력이 나타난다.
많은 사람들이 폭력을 이성의 한계로, 법은 이성의 정당한 출발점으로
인식한다. 그러나 벤야민은 "폭력은 정치의 근원이자 토대이고, 법은 정치의
종점"이라고 생각했다. 우리가 철학적 사유로부터 좀 더 현실적인 역사로
시야를 돌린다면, 오래전에 민족국가를 형성한 유럽이 세계대전을 거치면서
인권을 본격적으로 사유하기 시작했던 것에 비해, 아시아는 19세기 후반부터
근대 민족국가 형성을 위한 노력을 시작했고, 인권을 돌아볼 수 있는 기회가
없었다. 아시아에서는 민족국가 형성 또한 순탄하지 않았다. 오랫동안
서구의 식민주의를 경험하였고, 그 유산으로 인한 내전이 국가 형성기에
발생하거나 가혹한 군사독재가 이루어졌다. 따라서 인권의 원칙이나 법적
정의는 민주주의로의 이행을 경험한 후에 비로소 거론되기 시작했다. 사실상
군사독재로부터 민주주의로의 이행을 순탄하게 성취한 국가는 한국이나
타이완 등 소수에 불과하고, 대부분의 국가들은 여전히 이행의 과정에 있거나
이행기 정의가 지지부진하며, 오히려 일상적으로 인권침해를 경험하고
있다고 하는 편이 더 정확할 것이다.

한국은 일제로부터의 광복 이후 통일된 민족국가로 나아가지 못하고

2 여기에서 언급된 폭력은 독일어의 'Gewalt'인데, 이는 영어의 'violence'와는 달리 힘이나 권능과 같은 다양한
의미를 포괄한다. 벤야민이 다루는 폭력은 '윤리적 상황'과 관련된 폭력을 뜻한다. 발터 벤야민, 『폭력비판을
위하여』, 최성만 옮김(서울: 도서출판 길, 2008).

남북으로 분단된 채 별도의 국가 형성 과정을 겪었다. 3년간의 미군정기는
국가 형성을 위한 준비 기간이자 이를 제약하는 환경을 제공했다. 이 기간에
법과 국가는 존재했는가? 이 기간에 행사된 권력을 벤야민이 말했던 법
정립적 폭력이라고 불러도 되는가?

　　한국의 헌법은 1948년에 제정되었다. 제헌의회가 구성되고 여기에서
헌법이 제정되었는데, 그 초안은 제헌의회 구성 이전에 마련되었기 때문에
헌법제정의 실질적 주체가 누구인지를 질문할 수 있다. 헌법 제정 이후
정부가 수립되고, 곧이어 국가보안법이 제정되었는데, 주권과 더불어 국가
형성의 핵심 요소인 영토와 국민 규정에서 헌법과 국가보안법이 편차를
보이고 있다는 사실은 우리로 하여금 국가 형성의 문제를 설명하는데
어려움을 안겨준다. 한반도 전체를 영토로 하는 민족국가가 규범적인 헌법에
기초한다면, 분단의 경계 내부만을 실질적인 영토로 삼는 국민국가는
현실적인 국가보안법에 기초하고 있다. 여기에 더하여 북한 또한 헌법을
만들었다는 점은 국가 형성에 관한 설명을 더욱 곤혹스럽게 한다. 통일된
민족국가가 아닌 분단된 국민국가에 관한 이론이 필요하기 때문이다.

　　한국전쟁은 분명히 헌법 제정 이후에 발발했지만, 세계적 냉전의 중요한
전기였을 뿐 아니라 2차대전 이후 동아시아의 질서를 실질적으로 정초했다는
점에서 창법적 폭력이 행사되는 장이었다고 말할 수 있다. 한국전쟁은 국가
형성과 연관된 남북 간 내전과 국제적 냉전 질서에 종속되는 국지전이
결합되어 있다. 전쟁의 성격 또한 복합적인데, 이것은 남북한과 미국 그리고
중국에서 사용하는 전쟁의 명칭이 서로 다르다는 점에 잘 반영되어 있다.

　　전쟁포로는 조르조 아감벤(Giorgio Agamben)이 말했듯이 '벌거벗은 생명'
이다.[3] 이 표현은 은유적일 뿐 아니라 직설적이다. 전투 현장에서 포로가 되면,
두 손을 들고 저항할 의사가 없다는 것을 표현해야 할 뿐 아니라 소지하고
있는 무기가 없다는 것을 확인받기 위해 발가벗겨졌다. 포로수용소에서
정체성이 확인될 때까지 이들의 생명은 보장되지 않았다. 정체성은 소속과
국민됨을 분명히 표현하는 것으로 뼛속 깊이 이를 간직하고 있어야 한다는
점에서 문신을 새겼고, 그 문신은 낙인이 되었다. 포로 문제에서 또 한
가지 흥미로운 것은 주전선과 부전선의 의미가 확실히 다르다는 것이다.
부전선에서 포로가 된 사람들은 전쟁포로로 간주되지 않고, 민간인 억류자나

정치범으로 간주되었으며, 또한 출신자에 따라 포로의 신분이 달라졌다. 북한은 국군포로의 대부분을 전쟁포로로 간주하지 않고 송환 대상에서 제외하였다.

한국전쟁은 전투원뿐 아니라 수많은 민간인 희생을 낳았다. 전쟁 발발 직후 전국의 형무소에 수감되어 있던 정치범들이 대규모로 학살되었고, 수감되지 않았지만 좌익 경력이 있어서 보도연맹에 가입해야 했던 사람들은 국가 권력에 의해 희생되었다. 북한군 점령과 후퇴 국면에서는 지방 좌익들에 의해 우익 인사들이 대규모로 희생되었다. 우리는 흔히 전쟁기에 발생한 수많은 민간인 희생을 보면서 전쟁상태는 곧 무정부상태 또는 무법천지라고 생각하기 쉽지만, 그것은 오해이다. 전쟁 과정에서 발생한 민간인 학살은 대부분 국가보안법과 계엄법[4]뿐 아니라 '국방경비법', '비상사태하의범죄처벌에관한특별조치령'에 기초하고 있었다.[5]

한국전쟁 발발 전후의 민간인 희생에서 언급하지 않으면 안 되는 것이 폭력의 연쇄이다. 예방 학살은 보복 학살을 낳고 이는 다시 2차 보복 학살로 이어졌으며, 국가권력은 보복 학살의 후반기에 이를 통제하려고 시도했지만 실패했다. 학살의 연쇄를 끊는다는 것은 용서와 절제를 필요로 하는데, 전쟁 상황은 이를 불가능하게 만들었다. 또한 남북 관계는 관념적 적대가 아닌 현실적인 적대에 기초하게 되었다. 현실적인 적대는 남북관계뿐 아니라 한국 내부에서 소수자들이 차별과 사회적 타자화를 경험하도록 하는 원인이 되었다. 전쟁에서 희생된 민간인 문제는 1960년 유족회 활동이 5·16 쿠데타에 의해 무산된 후 약 40년간 침묵의 세계에 머물렀다.

3 조르조 아감벤, 『호모 사케르: 주권 권력과 벌거벗은 생명』, 박진우 옮김(서울: 새물결, 2008); 강선형, 「푸코의 생명관리정치와 아감벤의 생명정치」, 『철학논총』 78권 4호(2014): 129-148; 서용순, 「바디우와 아감벤의 예외의 주체이론」, 『비평과 이론』 22권 2호(2017): 63-84.

4 강성현, 「한국의 국가 형성기 '예외상태 상례'의 법적 구조─국가보안법(1948·1949·1950)과 계엄법(1949)을 중심으로」, 『사회와 역사』 94권(2012): 87-128.

5 김욱경, 「국방경비법과 재심─진실화해위원회의 활동을 중심으로」, 『서울법학』 25권 3호 (2017): 311-357; 김욱경, 「한국전쟁기 부역자 처벌과 재심: '비상사태하의 범죄처벌에 관한 특별조치령'을 중심으로」, 『공익과 인권』 18권(2018): 143-189.

4. 불법적 국가폭력과 인권

한국에서 국가폭력은 국가 형성기부터 존재해왔지만, 그런 표현은 2000년경에 널리 사용되기 시작했다. 그 이전까지 국가는 다양한 사회적 폭력을 통제하고 감시하는 주체로 인식되었지 불법적인 폭력의 주체로 인식되지는 않았다. 불법적 국가폭력은 1980년 5·18 항쟁과정에서 가시화되었다. 이는 "어떻게 국민의 생명과 안전을 지켜야 하는 국군이 국민에게 총부리를 겨눈단 말인가"라는 탄식에서 증명된다. 그러나 그것이 '국가폭력'이라는 개념으로 정립된 것은 약 20년 후이다. 그것은 5·18 20주년에서 트라우마와 함께 사용되었다.

5·18 진상규명운동의 이론적 성과는 '불법적 국가폭력'을 학문적 시민권이 있는 개념으로 만들었고, 이것이 연장되어 민주화 과정에서 '의문사'로 희생된 사람들의 문제에 적용되었다. 헌법정신에 대한 인권적 재인식과 함께 영장 없는 체포나 불법 구금, 고문은 인권침해의 중요한 기준이 되었으며 이것은 국가보안법이나 반공법, 기타 위헌적 요소가 있는 법률들을 구속했다. 이와 함께 민주화 운동 희생자로 인정된 사람들을 포함하여 불법적 법 집행에 의해 피해를 받은 사람들에게 소송을 통한 보상의 길이 열리기 시작했다. 2000년에 시작된 의문사진상규명위원회와 민주화운동보상심의위원회의 활동은 불법적인 국가폭력의 진실을 밝히는 데 크게 기여했다. 그러나 의문사의 경우, 이에 관한 기록 자체가 존재하는지 불분명하고, 있다고 하더라도 주요 권력기관에 소장되어 있어서 진실규명에 큰 장애로 작용하였고, 민주화운동보상심의위원회는 민주화 운동의 범위를 좁게 설정하여 생존권 확보 투쟁과 연관된 희생자들이 제외되는 결과를 낳았다. 이 때문에 미진하거나 조사 대상에서 제외된 많은 사건들이 2005년에 시작된 진실화해위원회에서 다시 조사될 수밖에 없었다.

불법적 국가폭력에 의한 인권침해는 첫째 남북분단과 연관되어 국가보안법이나 반공법이 적용된 사건, 둘째 권위주의적 독재에 저항하거나 생존권 투쟁으로 부당한 처벌을 받은 사건, 셋째 정부의 캠페인에 의해 집단적으로 수용된 사회적 약자 사건 등으로 구분된다. 첫째는 불분명한 월경 혐의로 납북되었다가 송환된 후 간첩 혐의가 씌워진 납북어부 사건이 대표적이며,[6] 둘째는 정부의 정치적 정당성에 도전하는 각종 민주화 운동

관련 사건이나 노동운동 또는 농민운동에 대한 부당한 탄압이 대표적이다. 셋째는 1기 진실화해위원회에서 간과되었지만 2기 진실화해위원회에서 본격적으로 다루어진 형제복지원이나 선감학원 사건 등 집단 수용소에서의 인권침해 사건이 대표적이다. 근래에 이에 관한 연구들이 많이 축적되었다.[7] 이들은 사회사업이나 복지라는 매우 긍정적인 정책적 이미지하에서 형성된 대규모 인권침해 사건으로 '선의'에 대한 재해석을 요구했다. 또한 이런 집단적 인권침해 사건들은 세 차례의 헌정 중단기, 즉 1961년 5·16 직후, 1972년 유신체제 선포 직후, 그리고 1980년 5·18 직후, 이른바 '사회악 일소'가 강조되던 시기에 집중적으로 발생했다. 또한 올림픽과 같은 국제적 이벤트를 앞두고 이루어진 '도시경관의 미화'에 수반된 과잉권력의 산물이었다. 이런 불법적 국가권력의 피해자는 사회적 약자들에게 집중되었다.

5. 공감과 연대를 향하여

한국에서 민주화 운동 기념을 포함한 이행기 정의의 역사는 폭력의 책임자에 대한 응보적 정의에 기초한 과거청산 모델로부터 점차 피해자들의 고통에 공감하고 이들의 권리를 복원하는 데 치중하는 회복적 정의모델로 옮겨갔다. 이 과정은 또한 한국뿐 아니라 유사한 경험을 가진 외국의 사례들에 대한 관심과 연대를 위한 노력이 이루어지는 것을 의미했다. 그런 점에서 정의의 실현은 정치적인 프로젝트일 뿐 아니라 예술적 상상력을 필요로 하는 문화적 프로젝트이기도 하다.

한국전쟁 이후 강력한 반공주의가 정착하면서 민주화 운동이나 인권운동은 강력한 탄압의 대상이었고, 표현의 자유는 극도로 제한되었다. 이 때문에 실제로 작동하고 있는 국가폭력은 어디에서도 재현되기 어려웠다. 1980년대 민주화 운동의 일부로 문화운동이 형성되기 전까지 불법적 인권침해를 시각적으로 표현한 작품은 거의 만들어지지 않았다. 1968년 동베를린 사건을 직접 경험한 이응노는 자신의 수감생활에서 매우 추웠던

6 김종군, 「구술을 통해 본 분단 트라우마의 실체」, 『통일인문학』 51권(2011): 37-65.

7 서울대학교 사회학과 형제복지원연구팀 엮음, 『절멸과 갱생 사이: 형제복지원의 사회학』(서울: 서울대학교출판문화원, 2021); 유해정, 「부랑인 수용소와 사회적 고통: 피해생존자들의 경험을 중심으로」, 『기억과 전망』 39권(2018): 387-436.

도판 1 | 이응노, <자화상>, 1968, 한지에 수묵, 34×38 cm. 이응노미술관 소장. ⓒ Lee Ungno / ADAGP, Paris - SACK, Seoul, 2023

Fig. 1 | Lee Ungno, *Self-portrait*, 1968, ink on paper, 34×38 cm. Leeungno Museum Collection. ⓒ Lee Ungno / ADAGP, Paris - SACK, Seoul, 2023

기억을 떠올려 자신의 자화상으로 표현하였다.(도판1) 1970년대 초반의
김지하 사건 및 서승 사건은 '한국의 양심수'라는 개념을 탄생시켰는데 이를
시각화한 도미야마 다에코의 작품들이 한국 인권화의 역사를 열었다고
해도 과언이 아니다.[8] 이 시기에 한국의 양심수 문제를 쟁점화한 앰네스티의
홍보활동은 불법적 국가폭력과 이에 대항하는 인권운동의 이미지를 '촛불'로
형상화했는데, 이것이 당시의 인권문제에 대한 주의를 환기시키는 데 크게
기여하였다.[9]

　한국에서 민주화 운동과 인권에 관한 이미지는 1980년 5·18로 인하여
근본적인 변화를 겪었다. 이른바 '민중미술'과 판화운동을 통해 만들어진
작품들이 이를 대변하였고, 이에 관한 이론적 고투가 '현실과 발언' 등의
전시회를 통해 진행되었다. 2000년을 전후한 시기에 4·3 특별법이 제정되고
이에 관련된 국가폭력과 희생자 이미지가 한라산과 '동백꽃'으로 수렴되어
갔다면, 한국의 인권운동은 다양한 소수자들의 목소리에 귀를 기울이면서
과거의 민주화 운동과는 다른 길을 걸었다.

　폭력과 인권을 시각화하는 데 있어서 판화나 걸개그림과 같은 매체 외에
포스터도 중요한 역할을 담당했다. 우리는 이런 사례를 서양미술사에서도
쉽게 찾을 수 있는데, 그 한 가지 사례로 스페인의 호안 미로(Joan Miró)를 들
수 있다. 그는 1937년 스페인 내전을 경험하면서 공화주의적 대의를 위하여
기금을 마련할 때, '스페인을 도와 달라'는 우표용 포스터를 그렸다. 그는
1940년대에 바르셀로나 시리즈라고 불리는 동판화 작품들을 만들었다. 그는
이때 익힌 판화 기법으로 1960-1970년대에 포스터 작품을 많이 만들었는데,
1968년 바르셀로나의 메이데이를 기념하는 포스터, 1974년 유네스코의

도판 2 | 호안 미로, <유네스코 인권 캠페인을 위한 포스터>, 1974, 종이에 채색 석판화, 80×60 cm. ⓒ Successió Miró / ADAGP, Paris - SACK, Seoul, 2023

Fig. 2 | Joan Miró, *Poster for UNESCO, Human Rights*, 1974, lithograph in colors on paper, 80×60 cm. ⓒ Successió Miró / ADAGP, Paris - SACK, Seoul, 2023

인권 캠페인을 위한 포스터**(도판 2)**, 1976년 앰네스티 인터내셔널의 기금 마련을 위한 포스터 등이 이에 해당한다. 이런 작품들은 모두 인권을 옹호하고 프란시스코 프랑코(Francisco Franco)의 독재를 종식시키기 위한 노력의 일환으로 제작된 것들이다. 미로는 포스터와 판화가 미술 세계에서 독특한 의미를 가지고 있다고 생각했다. 그는 대중들의 인권 감수성을 제고하고 보편적 가치를 확산시키는데 이들이 유용한 수단이라는 점을 잘 인식했다. 그는 예술이 사회적 책임을 전달하면서 일상생활의 일부가 되어야 한다고 생각했다. 또한 예술가는 다른 사람들이 침묵할 때 무엇인가 목소리를 내야 하며, 그가 말하는 것이 쓸모없는 것이 아니라는 것을 확신시킬 의무가 있다고 말했다.

민주주의나 인권을 옹호하는 시각적 작품들이 특정 양식에 사로잡혀 있을 수는 없다. 이 또한 새로운 문제의식으로 세계 시민들과 소통해야 하므로 형식과 내용의 측면에서 부단한 혁신이 필요한 것은 말할 것도 없다. 우리가 직면했던 창법적 폭력이나 불법적 국가폭력의 기억을 망각하지 않으면서도, 폭력의 세계화를 극복하기 위한 이론적 상상력으로 에티엔 발리바르(Étienne Balibar)가 말하는 시민인륜에 기대거나 슬라보예 지젝(Slavoj Žižek)이 말하는 신적 폭력에 기대거나 관계없이,[10] 매우 다양하게 분화된 인권의 현대적 쟁점들을 예리하게 포착할 수 있는 눈은 예술가의 역사적·정치적 감수성에 의존할 수밖에 없다.

8 정근식, 「5·18의 시각적 형상화와 역사공동체」, 『경계를 넘는 화가: 도미야마 다에코의 삶과 예술』 5·18기록관 도미야마 다에코 학술대회 발표 논문, 2020.

9 정근식, 「양심수에서 공동체적 연대로: 민주화운동기 이미지 전환」, 『인권연구』 3권 2호(2020): 1-33. 근래의 다양한 인권운동에 관해서는 국가인권위원회가 출간한 『대한민국 인권 근현대사 4권』을 볼 것.

10 김정한, 「폭력과 저항: 발리바르와 지젝」, 『사회와 철학』 21권(2011): 363-390.

On Violence and Its Transcendence through Justice

Jung Keun-Sik | Emeritus professor, Seoul National University

1. Confronting the issue of violence

Over a transitional period that dates broadly back to the 1990 enactment of the Act on the Compensation to Persons Related to May 18 Democratization Movements and more recently entered full swing with the 2005 enactment of the Framework Act on Settling the Past Affairs for Truth and Reconciliation, projects to achieve justice have been occasions for fundamental reflection on the extensive acts of violence experienced in South Korea's modern and contemporary history. The focuses have included the innumerable examples of torture and human rights violations committed in the back rooms of public security institutions; open acts of state violence perpetrated against members of the public in city centers; the use of "national security" as a pretext to brand individuals as "internal enemies"; and large-scale massacres of civilians during wartime. The more we confront these issues, the more we come to ask whether violence is not the exception but rather a universal phenomenon of the modern state. We skeptically wonder whether it is ever truly possible to heal the scars that this violence leaves behind or create a peaceful society that is not marred by violence. At the same time, it should be remembered that there have also been tireless efforts to usher South Korea to a higher plateau as a democratic state that respects human rights. The achievements following the 2001 launches of the National Human Rights Commission of Korea and the Korea Democracy Foundation, as well as two different periods of activity

by the Truth and Reconciliation Commission, Republic of Korea (TRCK), have helped to transform South Korea into an Asian nation widely recognized for its respect for democracy and human rights.

With their central emphasis on issues of violence, the transitional justice projects have represented three concentric circles with the shifts away from colonization, war, and authoritarianism. They encompass a modern and contemporary history extending over nearly a full century from the Donghak Peasant Revolution in 1894 to the year 1992, when authoritarian rule had more or less reached its end. All of them have laid a foundation for compensating the victims or restoring their good name based on investigations into acts of violence; on some occasions, they have pursued the question of responsibility for the violence. Through them, we have gained a new awareness of the victims of violence, sympathizing with their suffering and considering ways of making up for what they endured. It has been a process of formulating not only key principles for justice but also models of transitional justice, the results of which have on occasion drawn international attention. Meanwhile, the effort since 2018 to establish the National Museum of Korean Democracy has raised new questions in terms of how we should represent the memories and historical lessons associated with South Korea's democratization movement and past human rights violations, and how we should share those memories and lessons with future generations.

In this text, I consider how to conceptualize, theorize, and represent the forms and nature of violence that South Koreans have confronted in real terms not only during the democratization movement but also during their campaigns for human rights and the transitional justice process. Amid the influence of modern enlightenment thought and liberalism theory, violence has tended to occupy a peripheral place academically, but there have recently been many theorists who have centralized the issue in their contemplations of society.[1] There is a growing sense that representing the suffering associated with violence

1 Shin Jin-Wook, "Violence and Modernity," *Korean Journal of Sociology* 38, no. 4 (2004): 1–31.

in an effective way—one that broadens the scope of empathy—is a matter of laying a foundation of solidarity toward justice and peace, as well as an urgent project that confronts us all.

2. Anti-colonialism and the violence of resistance

In the contexts of truth, justice, and reconciliation, the forms of violence that Koreans have experienced have been quite diverse and complex. The forms of violence encountered by the democratization movement and human rights movement have differed substantially in scope and depth—a situation that becomes all the more complex when the examples of colonization and war are also taken into account. The TRCK has investigated the facts in connection with the independence movement against Japanese colonial rule, massacres of civilians around the time of the Korean War's outbreak, and large-scale human rights infringements during the postwar authoritarian era. In the process, it has sought healing for the victims and social reconciliation. The incidents under examination, however, involve acts of violence with different natures and meanings. For instance, how should we conceptualize the violent acts of resistance by the Donghak peasant army in 1894, the "righteous army" of the late Joseon era, or a person like An Junggeun?

In his 1920 essay "Critique of Violence," the eminent German philosopher of history Walter Benjamin referred to "mythic violence" and "divine violence."[2] The "myth" in "mythic violence" was a reference to Greek mythology, while the "divine" in "divine violence" was a reference to the god (Yahweh) of Judaism. "If mythic violence is lawmaking, divine violence is law-destroying; if the former sets boundaries, the latter boundlessly destroys them," he wrote. So if mythic violence was violence that served to establish and preserve the law, divine violence was violence that destroyed and dismantled the law. Based on his explanation, the acts of An Junggeun represented divine violence. Benjamin defended divine violence as a "pure" form of violence. By the standards that he discusses, much of the anti-Japan and pro-independence campaigning that took place in

colonial Korea corresponded to "divine violence" meant to change the social order. We often speak of these acts as falling within the single category of "anti-Japanese, pro-independence campaigns," but in stricter terms, the scopes of the anti-Japanese and pro-independence campaigns do not precisely overlap. Members of the pro-independence movement are recognized today as "persons of merit," regardless of whether their means were peaceful; often, members of the "anti-Japanese movement" are left out of this category. The presence of a human rights campaign to defend Koreans under colonial rule should be recognized and more actively interpreted.

Among the most curious examples in the history of violence is the dropping of atomic bombs on Hiroshima and Nagasaki just before the end of World War II. The incident, which approaches the realm of what Benjamin characterized as "divine violence," was subsequently legitimized by the hegemony or postwar order of the US as the war's victor, but the Japanese victims have tended to disagree or to remain quiet about this. Koreans have tended to view the atomic bombs dropped on Japan as "divine retribution against a country guilty of war crimes," a fact that can be attributed to a combination of historical perceptions (rooted in their liberation from colonial rule) and a culture with a particular affinity for concepts of karmic retribution. But if we pose the question of what "divine" agency is at work here, or why Koreans in Japan should also have been victimized by the atomic bombs, we realize that the "divine retribution" characterization is somewhat simplistic and one-sided. We often encounter situations where the sorts of violence that are legitimized by power or hegemony are not readily accepted by the standards of human rights. This is the starting point for the dilemma of coexistence between a history of war and a history of peace.

2 The "violence" referred to here is the kind described by the German word *Gewalt*, which unlike the English concept of "violence" encompasses different meanings such as those related to power and authority. The violence that Benjamin focuses on is related to an "ethical situation." Walter Benjamin, *Critique of Violence*, trans. Choe Seong-Man (Seoul: Gil Publishing, 2008).

3. "Lawmaking violence" and war

The topic that Benjamin was attempting to address was that of "legal violence." In his discussion of mythic violence, he distinguished between forms that "make" and "preserve" the law. When we speak of "lawmaking violence," we can see the law here as representing the global order or the constitution that serves as a foundation for the state. As countries are formed within a shifting global order, lawmaking violence may appear to represent one phenomenon, but two forms must be conceptually distinguished. In our consideration of lawmaking violence, we must bear in mind that Asian states were established during the period when World War II was ending and the Cold War was taking shape at the global level.

Constitutionally based states have routinely used violence to preserve that order, and when the state itself deviates from this framework, the result has often taken the form of illegal violence on the part of the state. Many perceive violence as representing the limits of reason, and the law as reason's legitimate starting point. But Benjamin viewed violence as the origin and foundation of politics and the law as its endpoint. Turning our attention from philosophical ideas to real-world history, we see that while Europe (where nation states had formed long ago) began deeply considering the issue of human rights over the course of the world wars, Asian countries launched their efforts to form modern nation states in the late 19th century and had no time to reflect on human rights. Moreover, the establishment of these Asian nation states was not a straightforward process. The countries in question had long experiences with Western colonialism, as a legacy of which they were plagued by civil war during their formation period or suffered under harsh military dictatorships. Accordingly, discussions of human rights principles and legal justice came about only after the transition to democracy. Indeed, South Korea and Taiwan are among the very few states to have achieved a relatively smooth transition from military dictatorship to democracy; in most countries, it would be more accurate to say that the process is still underway, that transitional justice has been slow in coming,

and that human rights violations remain a commonplace experience.

After liberation from Japanese rule, Korea did not immediately become a unified nation state. Instead, it was divided into North and South halves, each of which underwent its own formation process. The three years of US military government rule were a period of preparing for the state's establishment, but the resulting environment also placed constraints on that establishment. What "law" or "state" existed during this time? Can the authority wielded then be defined as the sort of "lawmaking violence" that Benjamin discussed?

The Republic of Korea's Constitution was enacted in 1948. A constituent assembly (the National Assembly) was created, and while the Constitution was enacted there, the draft version had been created before the assembly was formed. This raises questions about where the actual agency behind the Constitution's enactment lies. The government was formed shortly after the Constitution was enacted, and the National Security Act was created shortly after that. The fact that a discrepancy exists between the Constitution's and National Security Act's definition of the territory and people as key elements of the state's establishment (alongside sovereignty) presents us with difficulties in explaining the matter of the state's creation. If the nation state with a territory extending across the entire Korean Peninsula is a notion rooted in a normative Constitution, then the nation state of a nation whose actual territory consists only of what lies within their post-division borders is based on the practical dictates of the National Security Act. Further complicating the explanation of the nation's establishment is the fact that North Korea created its own Constitution. This necessitates a theory that relates not to a unified nation state but a divided nation.

The Korean War obviously erupted in 1950 after the Constitution was enacted, but it can be characterized as an example of the exercise of lawmaking violence not only in the sense of it representing an important turning point in the global Cold War but also in that of its practical creation of a post-WWII East Asian order. The Korean War combined a civil war (between North and South) in connection with the

formation of individual states with a local war that was subordinate
to the international Cold War order. The nature of warfare was itself
complex, a point clearly reflected in the fact that North and South
Korea, the US, and China use different names for the conflict.

Giorgio Agamben described the prisoner-of-war as a "bare
life."[3] The expression is both metaphorical and direct: after prisoners
were captured on the battlefield, they had to raise their hands
to indicate that they did not intend to resist, but they were also
stripped of clothing to confirm that they were not carrying weapons.
In the camps, their lives were not guaranteed until their identity
was confirmed. Identity was a clear expression of affiliation and
citizenship, something that must be sustained deep within, and so it
was tattooed onto them, with those tattoos becoming like stigmata.
Another interesting aspect of the POW matter is the clear difference
in significance between the primary and secondary fronts. Those
taken prisoner on secondary fronts were regarded not as prisoners-
of-war but as civilian detainees or political prisoners, and the
prisoners' status also varied with their origins. Most prisoners taken
from the Republic of Korea's military were not regarded as POWs by
North Korea, which did not treat them as subjects for repatriation.

The Korean War was responsible for a great many deaths not only
among combatants but also among civilians. Many political prisoners
who were detained in prisons throughout South Korea after the war's
outbreak were ultimately massacred. Others were not incarcerated
but were forced to join the Bodo League due to their history of left-
wing activities, only to end up killed by state authorities. During
the occupation by North Korean forces and their subsequent retreat,
many right-wing figures were killed by members of the left in the
provinces. When confronted with the countless civilian deaths
that occur in wartime, we often think of the state of war as being
anarchical or lawless, but this is a mischaracterization. Most of the
massacres of civilians that occurred during the war were grounded
in laws, including the National Security Act[4] and the Martial Law
Act as well as the National Defense Security Act and Special Decree

for the Punishment of Crimes during a State of Emergency.[5]

The chain of violence is a matter that must be mentioned in connection with the losses of civilian lives around the outbreak of the Korean War. Preventive massacres led to retaliatory massacres, which led in turn to other retaliatory massacres; while state authorities made efforts to control this during the later stages of the reprisals, they were unsuccessful. Breaking the chain of massacres would require forgiveness and restraints, but the wartime situation made that impossible. Moreover, the relationship between North and South Korea was rooted in practical hostilities rather than conceptual ones. Those practical hostilities are the factor that led to certain minorities being subjected to punishment and social other-ization not only within the context of inter-Korean relations but also within South Korea. The issue of civilian deaths during wartime would remain veiled in silence for the 40 years after the surviving family members' association activities in 1960 were suspended by the May 16 coup d'état in 1961.

4. Illegal state violence and human rights

"State violence" has existed in the Republic of Korea since its inception, but it was not until around 2000 that the term itself entered wide parlance. Before that, the state was perceived as an agent controlling and monitoring various forms of social violence, but not as an agent of illegal violence itself. This illegal state

3 Giorgio Agamben, *Homo Sacer: Sovereign Power and Bare Life*, trans. Park Jin-Woo (Seoul: Saemulgyeol, 2008); Kang Sun-Hyung, "Foucault and Agamben on Biopolitics," *Journal of the New Korean Philosophical Association* 78, no. 4 (2014): 129–148; Seo Yong-Soon, "A Research on Subjective Theory of Exception of Badiu and Agamben," *The Journal of Criticism and Theory* 22, no. 2 (2017): 63–84.

4 Kang Sung-Hyun, "A Study on Legal Structure of 'Usual State of Exception' in the Formative Period of South Korea: National Security Law (1948·1949·1950) and Martial Law (1949)," *Society and History* 94 (2012): 87–128.

5 Kim Youn-Kyeong, "The Articles for the Government of Korean Constabulary and the New Trial—Focusing on the Activities of the Truth and Reconciliation Commission," *Seoul Law Review* 25, no. 3 (2017): 311–357; Kim Youn-Kyeong, "The Need for the Retrial about the Collaborator's Punishment during the Korean War: Focusing on the Special Ordinance for Crime Punishment under the State of Emergency," *Public Interest and Human Rights* 18 (2018): 143–189.

violence became visible during the response to the May 1980 democratization movement. This is borne out by the laments of those questioning how "the same South Korean military that should be protecting the public's life and safety could instead be pointing gun barrels at that public." The characterization of this through the concept of "state violence" would not come for another 20 years, however. It emerged in conjunction with the concept of trauma around the 20th anniversary of the events of May 1980.

Theoretical achievements in connection with the campaign to learn the truth of May 1980 turned "illegal state violence" into a concept possessing academic civil rights. It was also extended to issues involving people who died suspiciously during the democratization movement. With the renewed understanding of the constitutional spirit in terms of human rights, matters such as warrantless arrests, illegal detentions, and torture became crucial standards for identifying human rights infringements, attaching to the National Security Act, Anti-Communism Act, and other laws containing unconstitutional elements. Meanwhile, avenues were created for people who had been victimized by illegal law enforcement—including those recognized as victims in the democratization movement—to sue for compensation. The activities of the Presidential Truth Commission on Suspicious Deaths and the Democratization Movement Compensation Review Committee, which began in 2000, contributed significantly to uncovering the truth about illegal acts of state violence. In cases of suspicious deaths, however, it was unclear whether the records in question actually existed; even when they did, the fact that they were in the possession of the major power institutions created a major obstacle to investigation. Meanwhile, the narrow scope of the Compensation Review Committee's definition of the "democratization movement" resulted in the exclusion of victims whose activities had to do with the battle for survival rights. Many incidents that were insufficiently investigated or not investigated at all would have to wait until the 2005 launch of the TRCK for re-examination.

Human rights violations through illegal state violence can be divided into three main categories: those involving the application of the National Security Act or Anti-Communism Act (a matter relating to the division of North and South Korea), those involving unfair punishments of those battling for survival rights or resisting an authoritarian dictatorship, and those involving socially vulnerable groups who were interned en masse through government campaigns. A representative example of the first kind can be found in the case of a fisher who was accused of "espionage" following repatriation by North Korea, which had abducted him on unclear charges of "border crossing."[6] Examples of the second kind include the unjust suppression of workers' and farmers' movements, as well as various democracy campaigns that challenged the administration's political legitimacy. The third category includes internment facility human rights infringements such as those associated with the "Brothers' Welfare Center" and Seongam Academy, which were overlooked by the first TRCK but received focused attention by the second. These cases have been the subject of a great deal of research recently.[7] As incidents involving large-scale human rights abuses masked by very positive policy images (social projects and welfare activities), they have demanded a reinterpretation of the concept of "Goodwill." Moreover, many of these incidents involving mass human rights infringements took place during three periods when the Constitution was effectively suspended and the "eradication of social ills" was being emphasized by the administration: after the May 1961 coup, after the promulgation of the Yushin regime in 1972, and after the events of May 1980. They also resulted from overzealous use of authority to "clean up the cities" ahead of major international events

6 Kim Jong-Kun, "A Study on the Substance of Division Trauma through Oral Survey," *The Journal of the Humanities for Unification* 51 (2011): 37–65.

7 *Between Annihilation and Renewal: The Sociology of the Brothers' Welfare Center*, eds. Seoul National University Department of Sociology "Brothers' Welfare Center" Research Team (Seoul: Seoul National University Press, 2021); Yu Hae-Jeong, "Vagabond Institution and Social Pains: Focusing on the Experiences of Victim Survivors," *Memory & Vision* 39 (2018): 387–436.

such as the Olympics. The victims of these illegal abuses by state authorities were predominantly the vulnerable members of society.

5. Toward empathy and solidarity

In South Korea, transitional justice—including commemoration of the democratization movement—has shifted over its history from a model of addressing past issues through "retributional justice" directed at those responsible for violence to a model of "restorative justice," which focuses on sympathizing with the suffering of victims and restoring their rights. This process has entailed efforts toward solidarity with and interest in not only South Korean cases but also overseas ones that have involved similar experiences. In that sense, the realization of justice is not only a political project but also a cultural one that necessitates an artistic imagination.

Amid the powerful anti-communist belief system that became established in South Korea after the Korean War, the campaigns for democracy and human rights were targets of intense suppression, and freedom of expression was severely restricted. As a result, it became difficult for the state violence that actually operated to be artistically represented in any context. Almost no works of art visually representing illegal infringements of human rights were created until the establishment of a cultural movement as part of the democratization campaign in the 1980s. Artist Lee Ungno, who personally experienced an instance of imprisonment in connection with overblown "espionage" accusations in 1968, created a self-portrait in which he summoned memories of the bitter cold that he endured while incarcerated. (Fig. 1, p. 314) During the early 1970s, the cases of the dissident poet Kim Chi-Ha and the writer Suh Sung gave rise to the concept of the "prisoner of conscience," and the visualizations of this in the works of Japanese artist Tomiyama Taeko could fairly be seen as having ushered in the era of "human rights painting" in South Korea.[8] Around this time, publicity activities by Amnesty International (which raised issues surrounding South Korea's prisoners of conscience) used the image of a candle to represent illegal state

violence and the human rights campaign against it, contributing greatly to calling attention to human rights issues at the time.[9]

The images associated with the democratization movement and human rights in South Korea would undergo fundamental changes in the wake of May 1980. This was represented by the artwork that emerged from the "Minjung (grassroots) art" and printmaking movement, while a related theoretical struggle unfolded through the exhibitions of groups such as "Reality and Utterance." Where images of state violence and victims in connection with the Jeju April 3 incident came to center around the symbols of Mount Halla and the camellia flower after the enactment of the Jeju April 3 special law around 2000, the South Korean human rights campaign adopted a different course from the democratization movement before it as it turned its attention to voices of different minority groups.

In addition to media such as printmaking and *geolgae geurim* (hanging paintings), posters served an important role in visually representing violence and human rights. Similar examples can be readily identified in Western art history, one of them being the work of Spanish artist Joan Miró. While living through the Spanish Civil War in 1937 and working to raise funds for the Republican cause, Miró painted a postage stamp poster image bearing the message "Help Spain." He also produced his *Barcelona Series* of copperplate works in the 1940s. He would go on to produce many posters in the 1960s and 1970s using the printmaking techniques that he learned at this time; examples include a 1968 poster commemorating May Day in Barcelona, a 1974 poster for a UNESCO human rights campaign **(Fig. 2, p. 315)**, and a 1976 poster to raise funds for

8 Jung Keun-Sik, "Visual Representation of May 1980 and the Historical Community," *A Painter Beyond Borders: The Life and Art of Tomiyama Taeko*, presented at Tomiyama Taeko conference (5/18 Archives), 2020.

9 Jung Keun-Sik, "From a Prisoner of Conscience to Communal Solidarity: The Transition of Human Rights Image in the Period of Democratic Movement," *Journal of Human Rights Studies* 3, no. 2 (2020): 1–33. For more on the various recent human rights movements, see *Modern and Contemporary History of Human Rights in the Republic of Korea Vol. 4* by the National Human Rights Commission of Korea.

Amnesty International. All of them were created as part of the artist's efforts to defend human rights and bring an end to the Francisco Franco dictatorship. Miró believed that posters and prints held a unique significance in the world of art. He understood well how useful they were in promoting universal values and sensitivity toward human rights among the greater public. He believed that art should be a part of daily life, expressing a message of social responsibility. He also said that the artist had the obligation to speak out where others are silent—and to convince others that the artist's statements were not "pointless."

When it comes to visual artwork that defends democracy and human rights, there can be no fixation on style. This work must connect with the citizens of the world through a new critical awareness; it goes without saying, then, that it necessitates constant innovation in terms of form and content. For the theoretical imagination to overcome the globalization of violence without losing sight of our memories of lawmaking violence or illegal state violence, we may rely on Étienne Balibar's concept of "citizenship" or Slavoj Žižek's notion of divine violence.[10] Either way, we must depend on the historical and political sensitivity of the artist for a perspective that incisively captures the diverse and differentiated contemporary issues of human rights.

Translated by Colin Mouat

10 Kim Jung-Han, "Violence and Resistance: Etienne Balibar and Slavoj Zizek," *Social Philosophy* 21 (2011): 363–390.

국가폭력의 역사에 대한 시각적 기념,
그 가능성과 한계

김상규 | 서울과학기술대학교 디자인학과 교수

벽화의 빈 곳

미국 애틀랜타의 국립민권인권센터가 2018년 10월 13일에 벽화 이미지를

페이스북에 올렸다.[1] (도판 1)

이 벽화는 디자인 전문회사

펜타그램(Pentagram)이

국립민권인권센터의 의뢰를 받아

폴라 셰어(Paula Scher)와 함께

진행한 프로젝트로 알려졌다.

펜타그램은 애틀랜타 민권

운동의 발상지라는 도시의

유산을 활용하여 박물관 로비에

인권 운동의 그래픽에 경의를

표하는 대형 벽화를 디자인했다.

도판 1 | 미국 애틀랜타 국립민권인권센터 페이스북 계정의 2018년
10월 13일 포스팅

Fig. 1 | Posted on the Facebook page of the National Center
for Civil and Human Rights on October 13, 2018.

저항을 표현하는 손을 중심으로 선들이 뻗어나가면서 여러 단어와 이미지를
담아내었는데 이 벽화는 다양한 운동을 연결하는 이미지를 전할 뿐 아니라
포스터, 플래카드 등 그래픽이 저항 운동과 지지를 모으는 데 중요한 역할을
했음을 부각시켰다.

1 국립민권인권센터 페이스북 계정의 2018년 10월 13일 포스팅. https://www.facebook.com/ctr4chr/
 photos/a.340865449319032/2295414207197470/?paipv=0&eav=AfZx00sRkTbSXK-79Cdr_RP
 2mDMGOy7Frjv3b13gAhB84FZV2JIqgxZeJOUFsxiEfyA&_rdr

벽화를 제작하기 위해 디자이너들이 역사적인 포스터를 조사하여 최종적으로 25개 이상의 포스터를 선정했고 포스터가 제작된 시기와 상태가 서로 달랐기 때문에 모두 디지털화하여 콜라주했다. 방문객들은 벽화에 그려진 손 모양을 따라 자신만의 '하이 파이브'(high fives) 이미지를 촬영하여 소셜 미디어에 공유하면서 벽화의 메시지에 연대를 표하기도 했다.

그런데 그날 페이스북에 올라온 사진을 자세히 보면 벽화 중 일부가 비어 있다. 훼손된 것이 아니라 박물관이 아웅산수지(Aung San Suu Kyi)의 얼굴을 떼어낸 것이다. 2017년 미얀마군이 로힝야족 주민을 상대로 벌인 폭력 사태가 일어났고 당시 미얀마 실권자인 아웅산수지 고문이 미온적으로 대응한 것에 대해 국립민권인권센터가 항의를 표한 사건이다. 아웅산수지는 2019년에 국제사법재판소에 출석해서도 로힝야 사태가 집단학살이 아니라고 발언하여 국제사회에 실망을 안겨주었다.

곧장 노벨평화상과 각종 인권상을 박탈해야 한다는 주장까지 나왔다. 국립민권인권센터가 아웅산수지 이미지를 벽화에서 떼어내기로 결정한 것에 대해서 폴라 셰어 역시 동의했다. "나는 이 상징을 보호하고, 벽화의 통합적이고 영감을 주는 의도에 반하는 이 이미지를 제거하는 것이 맞다고 생각한다."[2] 이 사례는 인권 운동의 시각적 기념물이 수정될 수 있다는 것을 보여준 이례적인 일이었다. 그리고 오늘날 시각적 기념에 대해 다시금 생각하게 하는 사건이기도 하다.

기억의 문제

기념은 기억에서 시작된다. 애틀랜타의 국립민권인권센터 벽화는 전 세계의 시위 포스터에 사용된 이미지로 구성되었다. 새롭게 디자인된 것이 아니라 과거의 것을 콜라주한 것이므로 기억들의 집합이라고 할 수 있다.

기억의 문제는 서구 지식사회에서 역사의 이념에 대해 회의가 일면서 시작되었고 활발하게 연구되고 있다. 한국 사회에서도 '기억 투쟁', '기억의 정치' 등으로 불리면서 기억 담론이 발전되었다. 역사학자 전진성에 따르면 기억 담론은 과거에 대한 비판과 향유 사이에서 갈등을 겪고 있다. 전자는 과거의 신화를 해체하려는 반면, 후자는 과거를 재신화화한다는 것이다.[3] 서울 남영동 근처의 민주인권기념관(2024년 민주화운동기념관으로 재개관

예정)은 국가폭력에 대한 강력한 기억과 기념의 장소다. 이 공간은 민주화 과정을 살아온 한국인들의 집단 기억 속에 깊이 자리 잡고 있다. 집단기억 문제를 연구해온 제프리 올릭(Jeffrey K. Olick)은 기억이 결코 통일적이지 않고 사회관계 속에서 기억의 기능과 위상, 형식이 변한다고 말한다.[4] 또 기억문화를 연구하는 임지현 교수는 기억을 산 자와 죽은 자의 대화라고 설명한 바 있다.[5] 이런 주장을 고려하면 민주인권기념관은 국가폭력의 흔적으로 잘 보존해야 하는 곳이면서도 현장에서 기억하고 말하는 대화가 이어지고 여전히 감춰진 부분을 밝혀내야 하는 곳이라고 할 수 있다. 이 관점을 반영하여 2019년에 민주인권기념관에서 처음 전시가 열렸다.[6]

참여 작가 중 진달래&박우혁이 민주인권기념관 본관에 설치한 작업 〈적색 사각형들〉(2019)(도판 2)은 국가폭력을 시각화한 의미 있는 사례다. 〈적색 사각형들〉은 대공분실의 조사실로 사용되었던 5층의 좁은 창문을 부각시킨다. 건물의 파사드에 빨간 세로 그래픽은 그 창문 안쪽의 붉은 빛 아래에서 고문과 취조를 당한 역사적 사실을 지시한다. 조사실 내부에 전시된 〈남영동 대공분실〉(2019)(도판 3)은 방 밖에 설치된 조명 스위치, 층수를 알 수 없는 나선 계단 등 비틀어진 일상의 사물에 부여된 악의를 신문형식으로 낱낱이 밝힌 작품이다.

아카이브의 현재성

국가폭력과 재난에 대한 연대의 핵심 의제는 잊지 않는다는 것이고 이것은 사회적 기억과 기록을 연결시켰다. 한국 사회에서 2014년부터 이어진 일련의 사건들을 통해서 아카이브에 대한 관심이 커졌고 개인들의 아카이빙 작업도 활발해졌다.

2 Bo Emerson, "Fallen from grace, her face to be removed from signature mural," *The Atlanta Journal-Constitution*, October 10, 2018. https://www.ajc.com/news/fallen-from-grace-her-image-removed/HhfN9qjjAZs0l2uvZMToOM/

3 전진성, 『역사가 기억을 말한다』(서울: 휴머니스트, 2005).

4 제프리 K. 올릭, 『국가와 기억: 국민국가적 관점에서 본 집단기억의 연속·갈등·변화』, 최호근 옮김(서울: 민주화운동기념사업회, 2006).

5 임지현, 『기억 전쟁: 가해자는 어떻게 희생자가 되었는가』(서울: 휴머니스트, 2019).

6 민주인권기념관 기획전《잠금해제(Unlock)》, 2019년 6월 10일-9월 29일.

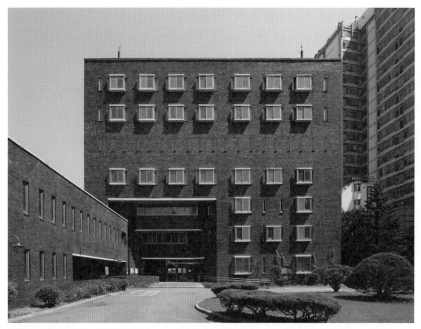

도판 2 | 진달래&박우혁, <적색 사각형들>, 2019, 창문에 적색판 설치, 각 130×30 cm.

Fig. 2 | Jin Dallae & Park Woohyuk, *Red Rectangles*, 2019, red plates attached to the windows, 130×130 cm each.

도판 3 | 진달래&박우혁, <남영동 대공분실>, 2019, 신문 인쇄, 530×390mm (20쪽).

Fig. 3 | Jin Dallae & Park Woohyuk, *Namyeong-dong Anti-Communist Branch*, 2019, newspaper prints, 530×390 mm (20 pages).

확실히 2014년 세월호 참사 이후 한국 사회는 달라졌다. 위험사회에 대한 인식, 참사에 대한 국가의 부실한 대응이 국가폭력에 대한 기억을 떠올리게 했다. 이후 2016년 강남역 살인 사건과 구의역 사망 사고, 그리고 2022년 10월 29일 이태원 참사까지 사회적 재난과 폭력이 국가의 책임과 연결되었다. 잊지 말자는 구호가 기록 전문가들과 시민단체의 아카이브 구축으로 이어졌고 '세월호 아카이브', '강남역 10번 출구 아카이브'가 만들어졌다.

사실 아카이브는 시각 예술에서 2000년대 이후 하나의 전략과 수사학으로 등장하기 시작했다. 할 포스터(Hal Foster)는 이 현상을 "아카이브 예술의 편집광적 관점은 예술과 문학 그리고 철학과 일상에서 실패한 비전을 사회관계의 대체적 종류로 다시 회복시키려는 의지를 보여 준다."고 평가한 바 있다.[7]

하지만 작가들에게 전쟁과 폭력에서 기억에 대한 문제는 아직도 이어지는 '현재성'을 띠고 있다. 즉, 아카이브는 죽은 과거의 예술을 증언하는 도큐먼트가 아니라 동시대성을 알려 주는 중요한 지표가 되는 것이다. 그런 점에서 시각적 기념은 과거의 사건들이 현재성을 띠게 하는 가능성을 분명히 담고 있다.

기억하기의 한계

그런데 아카이브의 현재성을 시각적 기념의 현재성, 동시대성으로 연결 짓는 것이 얼마나 현실적일까? 시각 이미지들로 포화된 환경 속에서 더 이상 기억할 의지나 능력이 우리에게 남아있는가? 미술사학자 안드레아스 후이센(Andreas Huyssen)이 기억의 과잉은 실제 기억의 사라짐과 망각에 대한 불안의 표현이라는 점에서 모순된다고 한 말을 떠올려 보면 기억할 의지가 이미 사라지고 있는 것 같다. '포스트 기억 세대'(Postmemory Generation)에 대한 주장, 그리고 '미디어-기억'(Media-Memory)이라는 작동방식도 존재한다.[8]

7　정연심, 「동시대 미술과 아카이브 전시」, 전승보 엮음, 『큐레이팅을 말하다: 전문가 29인이 바라본 동시대 미술의 현장』(파주: 미메시스, 2019)에서 재인용.

8　포스트 기억 개념은 문화이론가 마리안 허시(Marian Hirsch)가 홀로코스트 같은 트라우마적 사건의 사후기억 세대가 역사적 비극과 이중적인 관계를 취한다고 주장한 것이다. '미디어-기억'은 미디어로 포화된 사회에서 기억한다는 것이 미디어에 의해 결정되는 작동방식이다. 다음의 책을 참조하였음. 강경래, 『미디어와 문화기억』(서울: 커뮤니케이션북스, 2018).

결국 전시와 출판 등 다양한 매체에서 시각적 기념이 대중에게 전달될 때 그것이 한 사회 내 문화기억 아카이브로 증언의 기능을 가질 수 있는지 의문을 갖게 된다. 더군다나 과거에 머물러 현재성을 갖지 못한 행사와 창작이라면 더욱 기억과 기념으로부터 멀어질 수밖에 없다. 서동진은 과거라는 시간은 자신의 무게를 모두 박탈당하고 오늘의 시간 경험을 위한 재료로 이바지한다고 주장하면서 이를 '시간의 박물관화'(Musealization)라고 표현한다.[9] 기억하기의 즐거움에 탐닉하게 되면 결국에는 비판적인 기억을 통해 상대하고자 했던 나쁜 기억의 형식에 도전하는 것을 소홀히 하거나 잊어버리고 만다는 것이다. 삭제되거나 추방되었던 기억을 복원하고 발굴하는 것은 기억의 폭력에 대한 싸움이어야 한다. 즉, 기억에 대한 비판과 역사에 대한 비판이 모두 이뤄져야 한다. 그렇지 않으면 '대상화된 정신'으로서의 1980년대를 재현하고, 심미적인 양식화로 그 시기를 기억한다는 일반화 작업을 하게 된다.

기억을 일반화하는 것은 기억의 대상을 일종의 유산으로 간주하는 것이다. 역사학자이자 지리학자인 데이비드 로웬덜(David Lowenthal)은 유산을 중요하게 여기는 것은 과거에 대한 의식으로 고취하느라 미래에 대한 기대를 약화시킨다고 주장한 바 있다. 아울러 우리 것을 기념하고 타인의 것을 배제하는 것의 문제도 제기한다.[10] 말하자면 유산으로서 기념은 집단적 자부심을 형성하지만 한편으로는 선한 우리와 나쁜 그들을 구별하게 되는 것이다. 민주화 운동의 기념이든 국가폭력과 희생, 저항을 기념하는 것이든 자칫하면 도덕적 판단으로 세계 안에 있는 자들과 밖으로 쫓겨난 자들로 나누게 된다.

그래픽 디자인에서 이 현상은 9·11 테러 이후에 두드러졌다고 할 수 있다. 테러가 일어나기 바로 직전인 2001년 8월에 네덜란드 기반의 디자인 스튜디오 익스페리멘털 젯셋(Experimental Jetset)은 다음과 같은 선언문을 작성했다.

우리에게 필요한 그래픽디자인의 형태는 비도덕적이지도 도덕적이지도 않은 초도덕적인 것이다. 그것은 재생산이 아닌 생산적인 것, 기생적이 아닌 건설적인 것이다. 리얼리즘에서 벗어나 현실을 향한 움직임인 추상화가 궁극적인 참여 형태라고 믿는다.[11]

이 선언문은 2001년 9월말 워싱턴에서 개최될 미국그래픽아트협회
(American Institute of Graphic Arts, AIGA)의 컨퍼런스를 위해 준비된 것이었다.
하지만 테러가 발생하자 그 컨퍼런스는 열리지 못했다. 비평가 릭 포이너(Rick
Poynor)는 이 사건이 한창 전 세계의 사회적·정치적 관심을 논의하기 시작한
미국의 디자인계가 자신들의 문제로 시각을 맞추게 되었다는 아쉬움을
토로한 바 있다.

실제로 9·11 이후 국가에 대한 저항의 목소리는 잦아들었다. 미국발
금융위기 이후에 집을 빼앗긴 사람들이 2011년에 월가 점령운동(Occupy Wall
Street, OWS)을 벌인 이후로 블랙 라이브스 매터(Black Lives Matter, BLM)까지
당사자들이 목소리를 내는 운동이 촉발되었다.

미국의 문제가 아닌 미얀마를 생각해 보자. 미얀마에서는 2021년 2월
1일, 총선에서 다시 승리한 문민정부의 임기 첫날에 군부가 쿠데타를 일으키고
아웅산수지를 구속했다. 미얀마 사람들이 어메 수(엄마 수)라고 부르며
아웅산수지의 석방을 요구했다. 로힝야 학살의 책임자인 민아웅흘라잉(Min
Aung Hlaing) 사령관은 미얀마 집권자가 되었고 장기 집권을 다지고 있다.

그 사이에 미얀마에서 반군 시위뿐 아니라 '우리의 선거를 존중하라'는
소셜 미디어 캠페인 포스터, 시민불복종운동(CDM), 빨간 리본 캠페인 등 할
수 있는 모든 수단을 동원해서 시위를 벌였다. 시인이 불법 체포되어 사망하고
'Everything will be OK' 티셔츠를 입고 시위에 나선 태권도 소녀가 총탄에
희생되었다.[12] 국제사회가 개입하기를 바랐으나 몇 가지 제재 조치 이외에
지금까지 별다른 행동은 없다.

인권 센터의 벽화에서 떼어낸 이미지는 아웅산수지 개인의 얼굴 사진이
아니라 미얀마 인권 운동에 사용된 이미지였다. 어쩌면 그때 미얀마 운동의

9 서동진, 『동시대 이후: 시간-경험-이미지』(서울: 현실문화A, 2018).

10 David Lowenthal, *The Heritage Crusade and the Spoils of History* (London: Viking, 1997). 지그문트
바우만, 『레트로토피아: 실패한 낙원의 귀환』, 정일준 옮김(파주: 아르테, 2018)에서 재인용.

11 익스페리멘털 젯셋이 작성한 「Disrepresentation Now: On the social, political, and revolutionary role of
graphic design」의 일부. https://designmanifestos.org/experimental-jetset-disrepresentation-now/

12 미얀마 사태는 다음의 책들을 참고하였다. 판셀로, 『봄의 혁명: 미얀마, 사선을 넘나든 100일간의 기록』,
Nicholas C 옮김(부천: 모래알, 2022). 켓티 외, 『미얀마 혁명시집, 나의 투쟁 보고서』, 우탄툿우 옮김(서울:
들꽃, 2022).

이미지가 함께 사라진 것인지 모른다. 떼어낼 수는 있었지만 미얀마를 위한 또 다른 보탬은 없었다.

사회적 기억의 활성화

위의 두 사건을 생각해보면 적어도 디자인, 그래픽 디자인 분야에서 전 세계에 대한 관심은 이제 각자의 관심으로 돌아선 것 같다. 아니면 선택적인 태도를 보이는 것 같다.

9·11로 취소되었다가 2002년 3월에 치러진 AIGA 회의에서 밀턴 글레이저(Milton Glaser)는 "공적 책임감을 느낀 뉴욕 안팎의 많은 디자이너들이 9·11과 같은 전례 없는 사태를 이겨내고자 여러 이미지를 만들어 냈다."고 밝혔다.[13] 사실 '전례 없는 사태'는 미국에만 일어나지 않지만 뉴욕의 디자이너들에게는 전 세계를 생각하기 앞서서 9·11이 우선이었다. 애초에 기억문화(memory culture)란 개인이나 사회가 '자기' 과거와 지속적으로 대면하는 행위와 방식의 총체를 일컫는다. 국가든 도시든 자기 공동체의 과거와 대면하는 것 이상을 기대하기 어려운 것인가.

고려대학교 사학과 교수 최호근은 사회적 기억의 활성화를 위해서는 '살아있는 기념'이 필수적이라고 주장한다.[14] 오늘날은 '기념의 시대'라고 할 만큼 다양한 방식의 기념이 존재한다. 정부 인사, 정치인들이 참석하는 기념 의례가 있고 기념관이 세워지고 기념물이 제작된다. 이것은 '기념의 제도화'의 한 형태로 나타난다. 제도화는 사회적 기억을 인정한다는 점에서 의미가 있다. 그런데 이 기념이 기억을 잉태하지 못하면 존재할 이유가 없다. 최호근은 "새로운 가능성에 대한 탐색이 멈출 때 기념은 박제화되고 박제화된 기념이 지속될 때 기억은 질식"되고 만다고 설명한다.[15]

시각적 기념에서 고려할 것은 '누구를 위한 기억인가' '무엇을 기억할 것인가' 하는 것이다. 결국 기념했다는 사실, 시각적 기념의 질적 수준을 따지는 수준과는 별개로, 기념의 목적은 살아있는 기억을 만들어 내는 데 있다. 살아있는 기억이 사회적 기억의 활성화를 담보하고 시각적 기념에 의미를 부여하기 때문이다.

향수, 애도

시각적 기념의 또 다른 한계는 특정한 시기에 대한 각별한 기억으로 고착될 수 있다는 것이다. 폭압의 시대이면서 저항의 운동성이 존재했던 시기에 대한 향수로 남게 된다. 스베틀라나 보임(Svetlana Boym)은 "20세기는 미래의 유토피아로 시작해 향수로 끝났다."고 한 바 있으며 오늘날을 '집단 기억을 지닌 공동체를 정서적으로 동경하며, 분열된 세상에서 지속성을 열망하는, 향수라는 세계적인 유행병의 시대'로 진단한다.[16]

이것은 체 게바라(Che Guevara)의 이미지가 머그잔과 티셔츠에 인쇄되어 팔리는 것과 다르지 않다. 물론 체 게바라 티셔츠를 입었다는 것 자체가 정치적인 논란을 일으키기도 한다.(2013년 광복절 기념행사에 광주시립소년소녀합창단이 입은 티셔츠가 보수언론과 보수단체로부터 비난을 받았다.) 이렇듯 정치적 사건이나 인물이 대중의 지속적인 관심의 대상이 되는 것의 의미가 있으나 혁명이 추억거리에 머물 수 있다.

베를린 시내의 보도에 설치된 슈톨퍼슈타인(Stolperstein, 걸림돌)을 생각해 보자. 걷다 보면 회색빛 보도 중간 중간에 금빛으로 눈에 띄는 황동 판들이 보인다. 가로세로 10센티미터의 이 블록은 독일 예술가 군터 뎀니히(Gunter Demnig)가 진행해 온 '걸림돌' 프로젝트의 결과물이다. 1933년부터 1945년까지 박해받은 유대인, 사회주의자, 집시, 동성애자의 이름이 새겨져 있고 독일 전역에 5만 개 이상이 설치되었다. 이것은 향수로 남지 않는다. 오랫동안, 앞으로도 계속해서 불편한 걸림돌로 일상 공간에 존재한다. 사회적 기억, 집단기억으로 남은 폭력을 기억하고 시각적으로 기념하는 것은 자연스러울 수가 없다. 마주하기 부담스럽고 누군가에게는 몹시 불편할 것이다. 그것이 정상이다. 진정한 기념은 불편한 걸림돌이라는 점을 인정해야 할 것이다.

13 Rick Poynor, *Designing Pornotopia: Travels in Visual Cultures* (New York: Princeton Architectural Press, 2006), 59.

14 최호근, 『기념의 미래: 기억의 정치 끝에서 기념문화를 이야기하다』(서울: 고려대학교출판문화원, 2019).

15 위의 책, 37.

16 스베틀라나 보임, 『공통의 장소: 러시아, 일상의 신화들』, 김민아 옮김(서울: 그린비, 2019).

2022년에 발생한 10.29 이태원 참사 이후에 애도가 중요한 쟁점으로 부각되었다. 정부가 서둘러 추모 기간을 설정하면서 애도를 제도화했다는 비난이 일었다. 이 사건만 해당되는 것이 아니다. 최성용이 주장하듯이 한국 사회에서 지난 수십 년간 일어난 모든 폭력과 죽음의 경험들이 사회적으로 적절히 애도되지 못했다.[17] 폭력과 죽음이 국가에 의한 것임을 강조하는 시각적 기념 방식은 사회적 기억을 환기시키는 의미가 있지만 어찌 보면 사건을 쉽게 봉합하는 것일 수 있다. 사건의 원인을 규명하고 그 사건을 대하는 기관과 대중의 태도와 인식에서 생겨난 문제를 직시하는 것이 필요하다. 그 속에서 가해의 시스템, 폭력의 작동방식을 확인해야 한다. 시각적 기념에서 봐야 할 것은 국가폭력의 문제 제기 정도가 아니라 그러한 적극적인 가공일 것이다.

17 최성용, 「사회적 참사가 일깨워준 감각: 건국신화 없는 나라와 반복되는 국가폭력」, 『문화과학』 113호, 2023.

Visual Commemoration
of the History of State Violence:
The Limits and Possibilities

Kim Sang-kyu | Professor, Department of Design,
Seoul National University of Science & Technology

A white-out spot in the mural

On October 13, 2018, the National Center for Civil and Human Rights in Atlanta, Georgia, USA, posted an image of a mural on their Facebook page.[1] **(Fig. 1, p. 329)** The center had commissioned the design company Pentagram to create the mural in the lobby of the museum; Pentagram partner Paula Scher worked on the project. Drawing on the city's heritage as the birthplace of the civil rights movement, Pentagram designed the large mural, which pays homage to the graphics of the movement. The mural contains various words and images, and lines expressing resistance extend from a hand at the center. This not only conveys images connecting various movements, but also highlights the important role that graphics such as posters and placards have played in resistance movements and in gathering support for them.

To create the mural, designers researched historical posters and ultimately selected more than 25 posters; because they were produced at different times and in different conditions, the posters were all digitized and collaged. Visitors showed solidarity with the mural's message by making the hand gesture drawn on the mural, taking their own "high-five" photos, and sharing them on social media.

1 Posted on the Facebook page of the National Center for Civil and Human Rights on October 13, 2018. https://www.facebook.com/ctr4chr/photos/a.340865449319032/2295414207197 470/?paipv=0&eav=AfZx00sRkTbSXK79Cdr_RP2mDMGOy7Frjv3b13gAhB84FZV2JIqgxZe JOUFsxiEfyA&_rdr

However, if one looked closely at the photos posted on Facebook that day, one would have found that one spot in the mural was empty. No, the mural had not been vandalized. The museum removed the face of Aung San Suu Kyi from the mural in protest against the 2017 violence against the Rohingya people by the Myanmar military and the lukewarm response of Aung San Suu Kyi, who was in power at the time. She disappointed the international community again in 2019 when she appeared before the International Court of Justice and stated that the Rohingya crisis was not a genocide.

Promptly, there were calls for revocation of her Nobel Peace Prize and various human rights awards. Paula Scher agreed with the museum's decision, saying "I feel compelled to help protect this symbol, removing this image, which now feels counter to the mural's unifying and inspirational intent."[2] This case was an anomaly that showed that a visual monument to human rights movements could be modified. It is also an incident that makes us think again about visual commemoration today.

The discourse on memory

Commemoration begins with memory. The mural at the museum in Atlanta is composed of images of protest posters from around the world. It is not a new design, but a collage of the past. In this sense, one can call it a collection of memories.

The ongoing discourse on memory began in the West with skepticism about the ideology of history. In South Korea, too, the discourse developed as part of the struggle for memory as well as its politics. According to the historian Jin-sung Jeon, the conflict in the memory discourse arises from the conflict between criticism and sharing. The former seeks to dismantle the myths of the past, while the latter remythologizes it.[3] The Democracy and Human Rights Memorial Hall (scheduled to reopen as the National Museum of Korean Democracy in 2024) near Namyeong-dong in Seoul, is a place for commemorating strong memories of state violence. The space is deeply rooted in the collective memory of the many South Koreans who have lived

through the country's democratization process. Jeffrey K. Olick, who has studied collective memory issues, says that memories are never homogeneous, and that their function, status, and form change with evolving social relations.[4] In addition, Professor Jie-Hyun Lim, who studies memory culture, has explained that memory is a dialogue between the living and the dead.[5] Taking these statements into consideration, one can conclude that the mandates for the Namyeong-dong memorial hall are as follows: Preserve the traces of state violence; make sure the conversations that the space itself remembers and speaks of continue; and bring into light what is still in darkness. With these mandates in mind, *Unlock*, the first exhibition of the Democracy and Human Rights Memorial Hall, was held in 2019.[6]

Among the works shown, *Red Rectangles* (2019) **(Fig. 2, p. 332)**, installed at the main building by artists Jin Dallae and Park Woohyuk, stands out in particular in terms of visualizing state violence. The work highlights the narrow windows on the fifth floor of the infamous Anti-Communist Investigation Office, where the national police force used the rooms to interrogate political activists. The vertical red graphic on the facade of the building is a reference to the historical fact of torture and interrogation that took place under the red light inside the windows. *Namyeong-dong Anti-Communist Branch* (2019) **(Fig. 3, p. 332)** was another work, which borrows a newspaper style to meticulously reveal the various details of the design of the building, such as the light switch intentionally installed outside the interrogation room or the metal spiral staircase designed to spatially disorient the blindfolded victims.

2 Bo Emerson, "Fallen from Grace, Her Face to Be Removed from Signature Mural," *The Atlanta Journal-Constitution*, October 10, 2018. https://www.ajc.com/news/fallen-from-grace-her-image-removed/HhfN9qjjAZs0I2uvZMToOM/

3 Jin-sung Jeon, *History Speaks of Memory* (Seoul: Humanist, 2005).

4 Jeffrey K. Olick, *States of Memory: Continuities, Conflicts*, and *Transformations in National Retrospection*, trans. Ho-Keun Choi (Seoul: Korea Democracy Foundation, 2006).

5 Jie-Hyun Lim, *Memory War: How Perpetrators Became Victims* (Seoul: Humanist, 2019).

6 *Unlock*, a special exhibition of the Democracy and Human Rights Memorial Hall, June 10-September 29, 2019.

Archive as part of the present

The core agenda of solidarity movements in the face of state violence or disasters is to not forget, and this is the connection of social memory to archiving. In South Korea, in the wake of a series of events that have occurred since 2014, interest in archiving has grown, and projects involving archiving by individuals have become more common.

Certainly, civil society has changed since the Sewol Ferry Disaster of 2014. Consciousness about "risk society" and the state's poor response to the disaster brought back memories of state violence. Since then other events have also shaken South Korean society. In 2016, a brutal murder took place at the Gangnam Subway Station, and a young contract worker at the Guui Subway Station died of a workplace accident. On October 29, 2022, the Itaewon disaster occurred. In each of these cases, the public demanded that the state take responsibility for the disasters, the violence, and the deadly accident. The call to not forget led to the establishment of archives by professional archivists and civic groups. That is how the "Sewol Ferry Archive" and the "Gangnam Station Exit 10 Archive" were created.

In fact, archiving began emerging as a strategy and rhetoric in the visual arts in the 2000s. Hal Foster commented on this phenomenon, saying that "the paranoid dimension of archival art is the other side of its utopian ambition—its desire to turn belatedness into becomingness, to recoup failed visions in art, literature, philosophy, and everyday life into possible scenarios of alternative kinds of social relations."[7]

However, for artists dealing with war and violence, memory is an ongoing present. In other words, an archive is not a document that is a testimony to the dead art of the past, but an important index by which we learn about our contemporary world. In this respect, visual commemoration clearly has the possibility to make past events take on contemporary significance.

Limits of remembrance

But how realistic is it to connect the nowness of archives with the nowness, the contemporaneity of visual commemoration? In an

environment that is inundated with visual images, is there any will or ability left in us to remember? If we recall the words of the art historian Andreas Huyssen that excess of memory is a "paradox" in that it is actually an expression of anxiety about the disappearance of memory and oblivion, it seems that the will to remember is already disappearing. There is also the argument of the "postmemory generation," and the modus operandi of "media memory."[8]

Ultimately, when visual commemoration is delivered to the public through various media such as exhibitions and publications, it raises the question as to whether it can serve the function of a cultural memory archive in society. Furthermore, if an event or an art work stays in the past and is devoid of any contemporary significance, it would become even further distant from remembrance and commemoration. Dongjin Seo has pointed out that the past is deprived of all its weight as time and serves as fodder for experiencing today's time. He calls this process the "musealization of time."[9] In other words, what he is arguing is that if we indulge in the pleasure of remembering, we will eventually neglect or forget to challenge the bad forms of memory, the challenge that we set out to achieve in the first place through critical memory. Restoring and excavating memories that have been erased or banished must constitute opposition to violence against memory. In other words, both the critique of memory and the critique of history must be present. Otherwise, the 1980s will be represented as an "objectified spirit," and we will fall into the pitfall of generalization by remembering the era through aesthetic stylization.

7 Quoated in Yeon Shim Chung, "Contemporary Art and Archive Exhibitions," in *Speaking of Curating: Contemporary Art Scenes as Seen by 29 Professionals*, ed. Jeon Seung-bo (Paju: Mimesis, 2019). [Original text is also available from Hal Foster, "An Archival Impulse," https://monoskop.org/images/6/6b/Foster_Hal_2004_An_Archival_Impulse.pdf—Trans.]

8 "Postmemory" refers to the term coined by the cultural theorist Marian Hirsch. She argued that "postmemory" generations, or generations that come after those who have witnessed traumatic events such as the Holocaust first-hand, have a dual relationship with these historical tragedies. "Media memory" refers to the mode of operation determined by the media to remember in a society saturated with media. See Kyoung-Lae Kang, *Media and Cultural Memory* (Seoul: Communication Books, 2018).

9 Dongjin Seo, *Post-Contemporary: Time-Experience-Image* (Seoul: Hyusnsilmunhwa A, 2018).

To generalize memory is to regard the object of remembrance as a kind of heritage. Historian and geographer David Lowenthal has argued that attaching importance to heritage undermines an outlook toward the future by raising awareness of the past. In addition, it raises the issue of celebrating what is considered "our own" and excluding what is considered belonging to "others."[10] In other words, while commemoration as heritage builds collective pride, it also separates "us" from "others," or the good ones from the bad ones, respectively. Whether it is a commemoration of the democratization movement or a commemoration of state violence and subsequent sacrifice and resistance, a moral judgment would easily lead to the division of those within the world and those who are expelled from it.

In graphic design, this phenomenon became prominent after the 9/11 attacks. In August 2001, just before the terror attacks, a Dutch-based design studio, Experimental Jetset, wrote the following manifesto:

What we need is a form of graphic design that is neither immoral nor moral, but amoral; that is productive, not reproductive; that is constructive, not parasitic. We believe that abstraction, a movement away from realism but towards reality, is the ultimate form of engagement.[11]

This manifesto was prepared for the conference of the American Institute of Graphic Arts (AIGA) to be held in Washington in late September 2001. However, the conference was postponed after the attacks. Critic Rick Poynor expressed regret, pointing out that the American design world had begun to discuss social and political concerns from around the world, but that after the incident it came back to focus on its own problems.

Indeed, after 9/11 the voices of resistance against the state died down. Instead, from the Occupy Wall Street (OWS) movement in 2011, carried out by people who had their homes stolen after the subprime mortgage crisis, to the Black Lives Matter movement, resistance movements were sparked by the victims themselves.

Let us now move away from the U.S. and visit Myanmar. On February 1, 2021, on the first day of the civil government, which took back power by winning the general election, the military staged a coup and arrested Aung San Suu Kyi. The people of Myanmar demanded her release, calling her *Ame Su* (Mother Su). However, Commander Min Aung Hlaing, who was responsible for the Rohingya massacre, became the ruler of Myanmar and is currently consolidating power for long-term rule.

In the meantime, people in Myanmar carried out antimilitary protests using all means available to them; they posted "Respect Our Election" signs on social network services, launched a civil disobedience movement, and carried out the red ribbon campaign. A poet was illegally arrested and died in the custody of the state authorities, and a "Taekwondo girl" wearing a T-shirt with the writing "Everything will be OK" was killed by a bullet.[12] It was hoped that the international community would intervene, but so far, except for imposing a few sanctions, nothing has been done.

What was removed from the mural in Atlanta was not the face of Aung San Suu Kyi the individual but the face of the Myanmar human rights movement. With the removal of the image from the mural at the museum, perhaps the concern for this movement also disappeared. It might have been justifiable to remove the image of Aung San Suu Kyi, but the problem was that there was no additional support for the human rights struggles in Myanmar.

Activating social remembrance

Considering the above two incidents, at least in the design and

10 David Lowenthal, *The Heritage Crusade and the Spoils of History* (London: Viking, 1997). Quoted in Zygmunt Bauman, *Retrotopia*, trans. Chung Il Joon (Paju: Arte, 2019).

11 Experimental Jetset, "Disrepresentation Now: On the Social, Political, and Revolutionary Role of Graphic Design." https://designmanifestos.org/experimental-jetset-disrepresentation-now/

12 For other details on the situation in Myanmar, see Ei Pencilo, *Burma Spring Revolution: 100 Days of Darkness*, trans. Nicholas C. (Bucheon: Publication Morae-al, 2022); Khet Thi, et al., *Collection of Poems on Myanmar Revolution: My Struggle Report*, trans. Thunt Htut Oo (Seoul: Deulkkot, 2022).

graphic design field, it seems that interests in issues from around the world are now retrieved and turned inward. At the very least, the attitudes seem to be selective.

At the AIGA conference held in March 2002 in the aftermath of 9/11, Milton Glaser said, "Many designers in and out of New York, feeling they had a public responsibility, produced images and words to help us deal with this unprecedented event."[13] In fact, "unprecedented events" do not take place in the U.S. alone, but for the designers in New York, 9/11 came first before the rest of the world. Memory culture, by definition, refers to the totality of behaviors and ways in which individuals or societies continuously confront "their own" past. Shall we then give up any expectation from either nations or cities to go beyond confronting their own past?

Ho-Keun Choi, a professor of history at Korea University, argues that "living commemoration" is essential to vitalize social memory.[14] Today, commemoration takes place in such diverse ways that one can say we live in an "era of commemoration." There are commemorative ceremonies attended by government officials and politicians; memorial halls are constructed, and monuments are erected. They constitute a form of the institutionalization of commemoration. Institutionalization is meaningful in that it recognizes social memory; however, if such commemoration is not pregnant with memories, there is no reason for it to exist. Choi explains that "commemoration becomes taxidermized when the search for new possibilities ceases, and when the taxidermized commemoration continues, memory suffocates."[15]

There are two questions that are important to consider in visual commemoration. They are, "In whose interest do we commemorate?" and "What are we to remember?" In the end, apart from the fact that a commemoration took place, and apart from whether it was well executed or not from the technical point of view of visual commemoration, the purpose of commemoration is to create living memories. This is because living memory guarantees the vitality of social memory and gives meaning to visual commemoration.

Nostalgia, mourning

Another limitation of visual commemoration is that it can be fixated on as a special memory of a specific period. Such a memory becomes a nostalgia for the tyrannical era and the resistance movement. Svetlana Boym said, "The 20th century began with a futuristic utopia and ended with nostalgia." She also diagnosed the current era as experiencing a global epidemic of nostalgia, emotionally yearning for a community with collective memory and longing for continuity in a fractured world.[16]

The phenomenon of selling Che Guevara images printed on mugs and T-shirts fits this diagnosis. Of course, wearing a Che Guevara T-shirt itself can cause political controversy. (For example, the T-shirt worn by the Gwangju Municipal Boys and Girls Choir at the Liberation Day celebrations in 2013 was criticized by conservative media and conservative groups.) As this example shows, it can be meaningful for a political event or figure to be the subject of continued public interest, but it also entails the danger of turning revolution into fodder for nostalgia.

Consider the *Stolperstein* ("stumbling stone") installed on sidewalks in Berlin. As one walks, striking golden brass plates appear in the middle of the gray sidewalk surfaces. These square plates measuring 10 cm along the sides are the result of the "stumbling stone" project by German artist Gunter Demnig. The names of Jews, socialists, gypsies, and homosexuals persecuted from 1933 to 1945 are inscribed, and more than 50,000 such plates are installed

13 Rick Poynor, *Designing Pornotopia: Travels in Visual Cultures* (New York: Princeton Architectural Press, 2006), 59. [For the citation of the original text here, see also, Milton Glaser, "This Is What I Have Learned," a PDF file of the text of the speech delivered by Milton Glaser at the AIGA Voice Conference on March 23, 2002. https://www.macacos.com.uy/material/pdf/glaser_aiga_2002.pdf–Trans.]

14 Ho-Keun Choi, *The Future of Commemoration: Speaking of Memory Culture at the End of the Politics of Memory* (Seoul: Korea University Press, 2019).

15 Ibid., 37.

16 Svetlana Boym, *Common Places: Mythologies of Everyday Life in Russia*, trans. Kim Min-ah (Seoul: Greenbee, 2019).). [For English text quoted here, see also Svetlana Boym, "Nostalgia" on the website for the publication of *Atlas of Transformation* (2010) http://monumenttotransformation.org/atlas-of-transformation/html/n/nostalgia/nostalgia-svetlana-boym.html–Trans.]

throughout Germany. Such commemoration does not turn memory into nostalgia. They exist in everyday space as uncomfortable stumbling stones, and they will continue to remain so for a long time to come. There is no "casual" way to remember or to visually commemorate the violence etched in social and collective memory. The memory is burdensome to face, and—for some people— excruciating. The discomfort is normal. We must recognize that true commemoration is like the stumbling stone; it is uncomfortable.

In South Korea, after the 10.29 Itaewon disaster in 2022, mourning emerged as an important issue. Accusations arose that the government institutionalized mourning by hastily establishing a memorial period. The accusation applies not only to this case: As Choi Sung-yong argues, the violence and deaths that South Korean society has witnessed in the past decades have not been properly mourned in a social context.[17] As a method of visual commemoration, highlighting the state's responsibility can be meaningful in arousing social memory, but it can also result in prematurely closing the book on the cases. An act of commemoration must identify the cause of the incident and point out the problems arising from the attitudes and perceptions of institutions and the public in dealing with it. In this process, the system of perpetration and the mechanism of violence must be identified. What we need to see in a visual commemoration is not simply the raising of the issue of state violence, but more active processing.

Translated by Kyunghee Lee

17 Choi Sung-yong, "A Sensation Awakened by a Social Disaster: A Nation without a Birth Myth and Repeated State Violence" in *Munhwa/Gwahak* [Culture/Science], no. 113, 2023.

군부와 청소년 행동주의:
태국의 경우

게이코 세이 ┃ 작가, 기획자, 미디어 활동가

태국 총선 다음 날인 2023년 5월 15일, 우리는 이 나라에서 누구도 들을 수 있을 것으로 기대하지 않았던 소식을 들었다. 진보적 의제, 청년층의 인기, 후보자들의 다양한 배경으로 알려진 전진당(Move Forward Party)이 이번에 가장 많은 하원 의석수를 확보한 것이다. 전진당의 캠페인은 군대 개혁, 징병제 폐지, 형법 112조(왕실 모독죄, the lèse-majesté law)[1] 개정을 포함한다. 태국은 어떤 곳인가? 1932년 혁명 이래 19번의 쿠데타를 거치면서 전통적 지배계층이 군사 쿠데타를 이용해 선거 결과를 바꾸는 행위가 거의 제도화된 나라다. 또한 권위를 향해 이의를 제기하는 목소리 대부분을 범죄시하는 형법 112조, 컴퓨터 범죄법, 항시적 '비상사태 포고령'을 자주 행사해 유형으로 확립된 나라다. 전진당은 이 모든 것을 종식하겠다고 공약했다. 즉 기득권층 자체의 개혁을 제안한다.

이 획기적인 결과는 절대로 기적도 아니고 일회성 유행도 아니었다. 민주주의 활동가들과 다양한 시민권 단체가 수년간 고심하며 노력한 결과였다. 그렇기는 하지만 전진당 승리의 결정적 요소 중 하나는 정당 캠페인을 위한 제트(Z)세대의 적극적 지지와 동원력이었다. 이들 중 다수는 아직 선거권조차 없는데도 말이다. 전진당 자체적으로도 2020년 청년층이 주도한 대규모의 연속 시위(이 글에서 '2020년 시위' 혹은 '시위'로 지칭)에서[2] 이익을

[1] 태국 형법 112조는 군주제 비판을 법으로 금지한다. 공식 법률 문서에는 다음과 같이 적혀 있다. "국왕, 왕비, 왕세자나 섭정자를 비방, 모욕하거나 위협하는 자는 누구든 3년에서 15년의 감옥형으로 처벌한다."

[2] 시위는 처음에 신미래당 해산에서 촉발되었는데, 2020년 2월 헌법재판소는 전진당의 전신인 신미래당의 핵심 구성원들에게 정계 진출 금지령을 내렸다.

봤다고 전해진다.

'블랙 라이브스 매터'(Black Lives Matter)부터, '미래를 위한 금요일'(Fridays for Future), '세 손가락 경례'(three-finger salute)까지 세계 곳곳에서 제트세대가 주도한 신선한 행동주의는 널리 보도되고 분석되었다. 이 글에서 나는 전진당의 승리에 때맞춘 반응으로서 어떻게 태국 청소년들이 행동주의 동력원이 되었는지에 관한 통찰을 공유하고자 한다. 우리는 주로 그래픽 디자인에 초점을 두고 태국 청소년들의 창의적 형성, 궤적, 전술은 물론 그들이 구세대의 창의적 활동가들에게 받은 지지와 영향과 영감도 살펴볼 것이다. 나는 미얀마의 2021년 2월 쿠데타 이후 그곳의 청년들이 태국 청년들의 몇몇 전술을 어떻게 활용해 왔는지를 목격했다. 그래서 본보기가 되는 태국 사례가 전체주의 체제 아래에서 싸우고 있는, 특히 세계 곳곳에서 군사 쿠데타가 재유행하고 있는 이때[3] 행동주의자들에게 영감을 불러일으키기를 희망하면서 이 글을 쓴다.

2020년까지의 상황

태국 활동가들은 엄격한 왕실 모독죄 아래에 살고 있기에 지속해서 창의적이어야만 했다. 많은 경우, 그들은 당국을 비판할 때 미묘한 차이와 풍자를 사용하기로 선택했다. 전통적으로 만화, 코미디, 지역의 극장 연극, 모람(Mor Lam) 노래와 같은 일부 음악 장르는 정치 풍자를 제공해 왔다. 오늘날 이런 전통은 사이버공간의 플랫폼으로 확장되어 여전히 지속되고 있다.[4] 그래픽 디자인 분야에서는 2000년대 상반기 재계 거물인 탁신 친나왓(Thaksin Shinawatra) 정부 시절, 그리고 그가 쿠데타로 축출된 2006년 후부터 디자인 행동주의의 물결이 등장했다. 좌파 경향의 급진적 출판사인 파디유 칸(Fah Diew Kan, '같은 하늘')과 그래픽 디자이너 프라챠 수비라논트(Pracha Suveeranont)는 함께 책과 잡지의 표지 디자인, 그리고 도발적이고 쟁점이 되는 정치적 전시를 제작했다.(도판 1) 사회와 디자인 이론가인 프라챠는 또한 태국의 옛 교과서를 비평적 형태로 재상상하기, 미술 담론을 시각 매체로 융합하기, 위계 구조 해체를 위해 타이포그래피 해체하기, 그리고 '버내큘러 타이'(vernacular Thai)라는[5] 개념을 포함하여 자신이 구상한 여러 가지의 디자인 개념과 전술에 관한 글을 썼다. 그때는 웹 1.0에서 웹 2.0으로 디지털 전환이

Ceci n'est pas une pipe.

This is not a pipe.

NEPTUNE

PLUTO

Ceci n'est pas un planète.

This is not a planet.

Ceci n'est pas un coup d'État.

This is not a coup.

2006 the Year in Denial

도판 1 | 프라챠 수비라논트, 『국왕이 국가의 수장인 민주주의 체제를 위한 쿠데타: 2006년 9월 19일 쿠데타 관련 원고』 책 표지 디자인, 파 디유 칸 출판사, 2007.

Fig. 1 | Pracha Suveeranont, Cover of the book *The Coup for the Democratic System with the King as Head of State: Articles on the September 19th, 2006 Coup d'état*, Fah Diew Kan (Same Sky) Publishing, 2007.

이루어지는 시기였고, 태국 사람들은 자신들의 디자인 작업을 블로그와 웹 게시판에 올리기 시작했다. 이런 방식으로 파 디유 칸과 프라챠의 작업은 정치 디자인 분야에서 엄청난 영향력을 끼쳤고, 그 증거는 새로운 세대의 민주주의 활동가 그래픽 디자이너들의 작업에서 볼 수 있다.

2006년 쿠데타 이후 태국 사회는 '레드 셔츠'(Red Shirts)와 '옐로 셔츠'(Yellow Shirts)라는 두 진영으로[6] 선명하게 나뉘었다. 두 진영 사이에 갈등이 계속 진행 중인 이유로 많은 이들이 이 시기를 '잃어버린 10년'으로 부른다. 역설적으로 이 시기에 두 진영이 각각 자신만의

3 2010년 이후 일어난 쿠데타와 쿠데타 시도는 아프리카에서 50번, 아시아에서 6번, 유럽에서 4번, 라틴아메리카에서 4번이다. 국제연합(UN) 사무총장 안토니오 구테흐스(António Guterres)는 세계정세에 관한 연설에서 이 같은 동향을 확인하고 "군사 쿠데타가 돌아왔다."라고 말했다.

4 밀크티 동맹은 아시아의 제트세대 민주주의 활동가들의 연합체로 널리 알려졌다. 원래 태국 누리꾼들이 홍콩이 독립국으로서의 자격을 지니고 있는지를 놓고 밤새도록 중국 민족주의자들과 [태국 주재 중국 대사관 페이스북 계정에서] 온라인 대결을 벌인 결과 승리자로 여겨졌을 때 결성됐다. 2020년 당시 태국 누리꾼들은 어떤 공격적 댓글도 지혜롭고 우스운 밈(meme)으로 대응하는 기술을 보여 줬는데, 이는 지침서를 따르는 것으로 보이는 중국 온라인 사무관들이 대적할 수 없는 것이었다. 이에 깊은 인상을 받은 홍콩과 타이완의 누리꾼들은 태국 누리꾼들에게 연합체를 만들자고 제안했고, 밀크티를 좋아하는 나라의 활동가들과 단체를 만들었다(나중에 인도와 미얀마를 포함하여 확장되었다).

5 '버내큘러 타이'는 보통 사람들의 자생적 민속 문화, 즉 '포크 타이'(folk Thai)의 적용을 말한다. 이것은 (예를 들어 영화 포스터에서처럼) 엔터테인먼트 목적에 사용하기 위한 상업주의에서 나왔기 때문에 속성상 뿌리 없는 것이고 그러므로 '태국적'이라고 하기에는 충분히 '국가적'이지 못한 것으로 여겨진다고 주장한다. 미술에서 이 개념은 다른 미술 및 문화 형식에 그대로 적용할 수 있는 포크 타이에 대해 관객이 가지고 있는 인식의 문제이다. 즉, 서양에서 키치가 작동하는 방식과 비슷하다. 이런 전술은 특히 사회적 위계 구조를 인지적으로 해체하고 시골 혹은 주변부 문화를 예찬하는 데 유용한 것으로 입증되었다.

6 옐로셔츠파의 주요 구성원은 탁신과 그의 협력자들에 반대하는 사람들이다. 레드셔츠파는 탁신 지지층을 포함하는데, 그들은 주로 태국 북부 및 북동부의 시골 출신이며, 일부는 도시에 살고 있으나 시골에 사는 저소득층 노동자 및 농부들과 공감대를 가진 사람들, 그리고 지배계층과 군부에 의한 정치 개입이 반복되는 걸 반대하는 사람들이다.

주목할 만한 행동주의 방식으로 경쟁하면서 창의적 행동주의가 만발했다. 2014년 탁신 정당의 세 번째 재탄생인 프아타이당(Pheu Thai Party)이 군사 쿠데타에 의해 축출되었고, 이때 처음으로 정치 시위에 반대 의견의 즉흥적 표명으로서 세 손가락 경례가 등장한다. 당시 태국에서는 이미 소셜 네트워크 사이트가 뿌리를 내리고 있었고, 세 손가락 경례는 들불처럼 번져 나갔다. 그 배경에는 부분적으로 이 행위가 셀카 사진에 적합하고 사진은 인스타그램에 올릴 만한(instagrammable) 것으로 여겨진다는 이유도 있다.

밀레니얼(Y세대) 활동가들은 반쿠데타 시위가 진행되는 동안 최대한 창의적으로 되기 위해 그들이 할 수 있는 모든 것을 했다. 예컨대 조지 오웰의 소설 『1984』를 공공장소에서 낭독하고 샌드위치 먹기 파티를 열었다(다섯 명 이상의 어떠한 집합도 금지하는 이유로 그저 다섯 명 이상이 모이기 위해 가장 순진해 보이는 행사를 조직했다). 그러나 군부는 하나부터 열까지 모든 행동을 금지했다. 악의 없는 행동이 하나씩 연달아 금지되는 방식은 우스꽝스럽고 부조리하기까지 했다. 어떤 경찰 간부에 따르면, "샌드위치를 먹는 행위 자체는 위법이 아니지만 의도를 가지고 먹는다면 그럴 수 있다."라고 주장하기도 했고, 이 경험은 감수성이 예민한 청년들에게 집단 기억이 되었다. 그리고 이 집단 기억은 차세대 젊은 활동가들이 자신들만의 전략을 숙달하는 데 필요한 동기를 부여했다.

제트세대 반격하다: 부조리한 사회를 향한 부조리한 행동

2020년 7월 어느 날 방콕, 젊은이 수만 명이 〈방가방가 햄토리〉(Trotting Hamtaro)의 노래 가사를 정치 풍자로 바꿔 "어서 달리자, 달려, 달려, 햄토리. 가장 맛난 건 … 세금이지"라고 부르며 민주 기념탑 주위를 뛰어다녔다. 그전에는 2020년 1월 어떤 공원에서 13,000여 명이 참가한 '반독재 달리기'라는[7] 규모가 큰 마라톤이 열렸다. 이들 두 행사는 몇 가지 요소를 공유한다. 운동 행사를 가장해 금지를 피하고, 태국 정치의 부조리함을 드러내기 위해 부조리한 일을 벌이고, 또한 귀여운 캐릭터를 사용해 비정치적인 청년들을 끌어들이는 동시에 행사를 위험성이 없고 순진해 보이도록 했다. '반독재 달리기'를 위해 선택된 마스코트는 카이 매오(Khai Meow, '고양이 달걀'이라는 뜻)가 만든 풍자 만화 연작에 등장하는

농 타 사이(Nong Ta Sai, '천진난만한 소년')라는 이름의 꼬마다. 순수하고 호기심이 넘치며, 사회에서 일어나는 모든 일을 가까이 목격하고 있는 꼬마는 태국 정치의 부조리함이 너무 혼란스러워 가끔 눈이 뱅글뱅글 돈다. 이 마스코트는 수년간의 정치적 소용돌이와 사회적 불평등으로부터 고통을 받아온 대다수 10대와 어린이들[8]을 대변했고, 그래서 마치 꼬마가 실제로 살아 있는 듯이 2020년 여러 시위 현장과 장소에 나타났다.(도판 2)

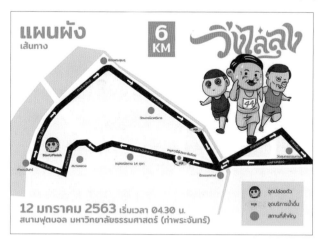

도판 2 | 카이 매오가 제작한 포스터와 여러 시각 자료들은 방콕 중산층을 끌어들였고, 이들이 대규모로 행사에 참여하게 만들었다.

Fig. 2 | The poster and other visual materials created by Khai Meow attracted middle-class Bangkokians, so that they participated in the event in mass.

미적 위계 구조의 민주주의

이 모든 걸 그저 10대들의 공상으로 무시하기란 쉽다. 나는 그렇게 하기 보다는 귀여운 캐릭터 사용에 숨겨진 깊은 속뜻을 살펴보고자 한다. 태국 지배계층에 속한 사람들은 종종 자신들의 신분을 정당화하기 위해 불교의 업보 개념을 동원하곤 한다. 예컨대 그들은 전생에서 선행을 했기 때문에 그들이 가진 것 (부, 뽀얀 피부의 아름다움, 높은 사회적 신분)을 갖고 있다는 논리이다. 같은 논리에 의하면, 가난한 사람들은 전생에서 좋지 않은 행동을 했기 때문에 가난하고 그렇기 때문에 계층 이동 사다리 오르기를 꿈꿔서는 안 된다. 이 뒤틀린 논리는 또한 국가를 위해 '좋은' 게 무엇인지 오직 자신들만이 결정할 수 있다고 굳게 믿는다는 점에서 참정권으로까지 관점을 확장한다.

7 마라톤 대회명은 '랩 어게인스트 딕테이터쉽'(Rap Against Dictatorship)이라는 상당히 인기 높은 태국 랩 그룹에서 빌어왔다.

8 흥미롭게도, 카이 매오의 만화는 당시 옐로셔츠파를 지지하던 중산층 성인 방콕인들을 끌어들이기도 했다.

태국 활동가들은 지배계층의 논리적 허점에 빠지지 않기 위해 위계 구조의 가상적 반전이 일어날 수 있는 작동원리를 발명해야만 했다. 귀여운 캐릭터 사용은 그중 한 가지 시도다. 이런 행동을 뒷받침하는 생각은 사회적 신분, 피부색, 인종, 성별에 상관없이 누구든 귀여움을 주장할 수 있다는 것이다. 역으로, 활동가들은 독재자를 귀여운 캐릭터로 바꿀 수 있는데, 일부 나이 든 활동가들은 물의를 일으키는 방법이라고 보기는 하지만 독재자의 권위적 아우라를 줄일 수 있다.

캐릭터 창조는 복잡하고 어려운 일이며, 상업 분야에서는 엄청난 양의 자원과 마케팅 조사 연구를 투여한다. 그러나 풀뿌리 정치 행동주의 분야에서 디자이너들은 캐릭터 디자인 역시 예외 없이 포스터와 로고를 디자인하기 위해 시위에 가담하고, 대화에 참여하면서 발전 과정을 따라간다. 성공적인 캐릭터는 생명력을 갖게 되며, 고개를 들고 걷기 시작하고, 결국은 사회를 변화시킨다. 가치 체계를 위계 구조, 질서, 훈육에[9] 기대고 있는 군부는 귀여움 영역에서 실패할 확률이 높기 때문에 이쪽에서는 활동가들이 확실한 이점을 가지고 있다.

영웅 민주화

같은 개념으로, 제트세대 활동가들은 새로운 영웅을 창조하는 작업도 익히고 숙달했다. 2022년 5월의 방콕 주지사 선거와 2023년 5월의 태국 총선 등 선거를 연속으로 두 차례 치르는 동안, 어느 익명의 그래픽 디자이너는 민주적 후보자들을 위해 만화 영웅 그림체로 영웅적인 캐릭터를 창조했다. 방콕 주지사 후보인 차드차트 시트푼트(Chadchart Sittipunt)[10] 캐릭터는 DC 코믹스에서 나온 것처럼 생겼고, **(도판 3)** 전진당의 주요 후보자들은 일본 만화『조조의 이상한 모험』그림체로 그려졌다. 미국 만화와 일본

도판 3 | 방콕 주지사 후보 차드차트 시트푼트의 캠페인 비주얼.

Fig. 3 | Bangkok gubernatorial candidate Chadchart Sittipunt's campaign visuals.

만화를 꿰뚫고 있는 젊은 유권자들은 이들 새로운 영웅의 외형과 군부가
숭배하는 전통적 유형의 영웅들, 즉 국왕들, 선택된 자들의 그것 사이의
차이를 즉각 알아차렸다. 젊은 행동가들에게는 2014년 쿠데타 직후
태국 왕실 군대가 과거의 태국 국왕들을[11] 기념하기 위해 건설한 라차팍
공원(Rajabhakti Park)을 둘러싼 논란이 아직도 생생한 기억으로 존재했다.

공원 대지에 세워진 거대한 국왕 동상들은 구식이고, 자아도취에 빠져
있으며, 제작비가 지나치게 높다는 비판을 받았다. 이들 동상이 우리에게
보여주는 바는 무엇보다도 '영웅주의'라는 개념과 특징이 어떻게 진화하고
있는지 군부가 이해하지 못하고 (혹은 무시하고) 있다는 점이다. 영웅을 다룬
재현은 위에서 언급한 캐릭터와 마스코트의 경우처럼 시대를 반영한다.
고대의 강력한 전사에서부터 최근의 반영웅적 영웅, 그리고 더 다양하고
복잡하고 취약한 특질을 지닌 영웅까지.[12] 위에서 언급한 익명의 디자이너는
정치 후보를 막강한 슈퍼 영웅으로 묘사하는 대신 더 나은 사회를 건설하기
위해 매일 지역 사회와 함께 일하고자 하는, 좀 더 미묘한 차이를 담은 매력
있는 영웅 이미지를 그렸다.

같은 맥락에서 흥미로운 디자인 행동주의의 선례는 스스로를
프라챠티파타입(PrachathipaType)으로 부르는 디자인 그룹의 작업이다.
프리챠티파타이(prachathipatai), 즉 프라챠('democracy') + 타이포그래피의 단어
유희인 명칭이 말해주듯이 이 그룹은 타이포그래피를 민주주의 행동주의를
위한 매개체로 택했다. 이들의 작업 중 잘 알려진 것은 시위 현장의 거대
그라피티 작품에 사용된 폰트와 차드차트 시티푼트의 주지사 후보 번호와
그의 이름을 결합한 캠페인 로고다. 또 다른 작업에서 프라챠티파타입은

9 2004년 일본의 반다이 캐릭터 연구소는 사람들에게 캐릭터에서 어떤 종류의 영향을 받는지 물었다. 답변
중 1위는 "마음을 편하게 해준다.(55.9%)"였고 2위는 "좀 더 신사적이고 친절한 사람이 되게 해준다."는
것이었다. 이 답변 두 개는 10위 안에 드는데, 답변 열 개 모두 치유적 효과와 관련이 있다. 일본에서
유류캬라(Yuru-Kyara, '느슨한'과 캐릭터의 합성어)로 부르는 지역 마스코트는 이런 경향에서 비롯했다. 이
설문조사로 명백해진 것은 귀여운 캐릭터와 군부 사이에는 공생 관계가 성립될 수 없다는 것이다.

10 138만 표 이상을 획득한 차드차트 시트푼트는 방콕 주지사 선거 기록을 깨고, 두 번째로 표를 많이 얻은
후보다 100만 이상의 표 차로 이겼다.

11 라차팍 공원과 동상들은 인기가 없었을 뿐 아니라 공원 건설 사업은 공사를 위한 뇌물성 환불과 연루해
이어진 추문에 어려움을 겪었다.

12 영웅의 진화는 주류 문화인 DC 코믹스와 마블 코믹스, 그리고 <원펀맨>, <나의 히어로 아카데미아>와 같은
일본 만화에 반영되었다.

1966년 죽임을 당한 후 활동가들이
대대로 존경해 온 태국 혁명가이자 좌파
저술가이며 언어학자인 칫 푸미삭(Chit
Phumisak)의 손 글씨를 따서 폰트를
만들었다.**(도판4)** 이 디자인 그룹은 이런
방식으로 언어학자에서 혁명가가 된

도판 4 | 프라챠티파타입, 칫 푸미삭 손글씨 폰트.
Fig. 4 | PrachathipaType, Chit Phumisak Handwriting fonts

영웅을 살아나게 했다. 그뿐만 아니라,

그들이 만든 폰트는 사람들에게 영웅 이야기는 전통적으로 한 세대에서 다음
세대로 전설, 신화, 민담과 같이 말을 통해 전승되었으며, 지금은 자신들만의
영웅적 행동에 관한 이야기를 써 나갈 때라는 것을 상기시켜 준다.[13]

도판 5 | 프라챠티파타입, 코로나19 기간 왕실과 군대에 편성된
국고를 재현한 파이 차트.

Fig. 5 | PrachathipaType, pie charts representing the
national budget being allocated to the monarchy and the
army during COVID-19.

호르몬 카오스(hormonal chaos)를 축하하라

2020년 태국 시위는 엄청난 군중을 끌어들였다. 레즈비언 게이 양성애자
트랜스젠더 퀴어 (LGBTQ+)부터 소수 민족 집단까지 모든 종류의 소수
집단이 초대되고, 오타쿠들이 대거 밖으로 나오고, 심지어 비정치적인
태국인들까지 젊은 행동가들이 내놓은 즐겁고 신선한 활동에 매료되었다.
그중에 정치 풍자로 가득 찬 퀴어 쇼, 한국 팝에서 영감을 받은 새로운
정치 노래에 맞춰 춤추기, 별똥별 공으로 공룡[14] 퇴치하기 등이 있다.
가장 예리한 발상 제공자는 '나쁜 학생들'(Bad Students)이라는 고등학생

그룹이었다. 학생들은 학교의 엄격한 두발 규칙에[15] 반대하는 1인 가좌
퍼포먼스로 시작해, 교육부 건물에 교복을 걸고, 정부 관리에게 토론하자고
도전하는[16] 등의 상식을 깨는 다양한 행동을 조직하는 방향으로 나아갔다.

그래픽 디자이너 파르챠 차이몽콜섭(Pharcha Chaimongkolsub [PHAR])은
전례 없이 나이가 어린 활동가들을 위한 디자인을 구상하기 위해 고등학생
집단이 [사회에서] 듣는 형용사를
수집해 왔다.[17] 부정적으로 들릴 수 있는
단어('혼란스럽고', '변덕스럽고', '말썽을 일으키고',
'중2병 같은')부터, '반항적', '급진적' 등의
중립적인 것, 그리고 '용기 있는', '의식이
높은', '진실한', '열정적인' 등의 '긍정적'인
단어까지 범위가 넓다. 파르챠는 이 모든
걸 혼합하기로 결정한 것으로 보인다.
왜냐하면 파르챠가 청소년 활동가들을
위해 디자인한 시각 자료는 아무 때나
불쑥 터져 나오는, 신기하게도 예측할
수 없는 특성을 엮어 짠 태피스트리처럼
보이기 때문이다. 나는 그의 작업을 '호르몬
카오스'의 축하로 묘사하고 싶다.(도판 6)

도판 6 | 파르챠 차이몽콜섭, '나쁜 학생들 학교 생존 가이드' 표지 디자인.

Fig. 6 | Pharcha Chaimongkolsub, Cover of The Bad Student School Survival Guide.

13 대조적인 의미에서 프라챠티파타입의 또 다른 흥미로운 작업은 그래픽 데이터를 기반으로 제작한 폰트이다.
 이 디자인 그룹은 코로나19와 싸우던 기간에 왕실과 군대에 편성된 국고를 재현한 파이 차트를 사용해
 폰트를 만들고, 또한 정부의 우선순위와 왕실을 향한 제스처를 의문시하는 그래픽 상징을 디자인했다.
 이 경우, 이 디자인 그룹이 만든 폰트를 사용하는 저자들은 객관적·과학적 데이터가 주관적 글쓰기를
 좌우한다는 점을 떠올릴 것이다. (도판 5)

14 대체로 공룡은 절대 사라지지 않는 군 장성의 상징으로 쓰이며, 별똥별은 그들을 없애고자 노력하는
 청소년들과 관련이 있다. 별똥별은 신미래당/전진당과도 관련이 있다.

15 2020년 6월, '나쁜 학생들'의 공동 창립자이면서 열다섯 살 여학생인 벤자마폰 니바스(Benjamaporn
 Nivas)는 공공장소에서 무릎에 가위를 놓고 앉아 있었다. 학생은 자기 목에 학교의 두발 규칙을 어긴 상징적
 벌칙으로 자기 머리를 잘라 줄 것을 행인에게 요청하는 표지판을 걸었다.

16 2020년 8월 19일, '나쁜 학생들'은 교육부 청사에서 벌인 시위에서 장관의 사임을 요구했다. 장관이
 학생들을 만나러 나오자, 그들 앞에서 발언하려면 차례를 기다려야 한다는 말을 들었다.

17 프라챠티파타입은 그들 역시 자신의 디자인이 소셜 네트워킹 사이트에서 이루어지는 대화와 토론을
 받아들이고 반영한 결과라고 말한 바 있다.

우리는 태국의 젊은 활동가들이 어떻게 군부에 결핍된 곳을 파고들어 지혜롭게 이익을 얻는지 살펴봤다. 그러나 인공지능(AI) 기술이 급속도로 발전하는 이때 군부는 기술의 도움을 받아 창의성 영역에서 개선될 기회가 많다. 그런 날이 도래하더라도 청소년 활동가들이 창작 과정에서 호르몬의 혼돈을 자유로이 펼친다면 여전히 우위를 점할 수 있다. 왜냐하면 결국 그것은 인공지능이 심층 학습하여 모사하지 못하는 인간의 진정한 특질 중 하나이기 때문이다. 그렇게 이 같은 방법으로 창조한 작업과 프로젝트는 속임수와 진실한 것 사이의 반정립(안티테제)을 드러낼 수 있다.

부름의 기록

『아리엘 도프먼: 희망의 미학』의 저자인 소피아 매클레넨(Sophia A. McClennen)은 쿠데타 생존자이기도 한 도프먼과 같이 인권 문제를 재현하는 저자의 사명감을 다음과 같이 묘사한다. "그것은 그들이 거절할 수 없는 부름이며 이상주의, 회의주의, 인내심을 요구하는 과정이다."[18] 젊은 활동가들은 '부름'이 어디서 비롯하는지 아직은 알 수 없을 것이다. 그러나 그들은 그것을 거절할 수 없고, 거절하지 않았고, 거절하지 않을 것임을 이해하고 있을지도 모른다.

태국 활동가들은 크게 발전해 왔고, 그들이 가야 할 길은 여전히 많이 남아 있다.[19] 이렇게 길고 험난한 길에서 그래픽 디자인은 활동가들이 내적 부름에 답한 반응의 중요한 기록으로 기여할 것이다.

<div align="right">번역: 길예경</div>

18 Sophia A. McClennen, *Ariel Dorfman: An Aesthetics of Hope* (Durham: Duke University Press, 2010).

19 민주주의 진영의 승리는 그들이 정부를 구성할 수 있다는 가능성을 보장하지 않는다. 군부가 그런 만일의 사태를 방지하기 위해 다양한 사전 대책 조치를 마련해 놓았기 때문이다. 그중 가장 주목할 만한 것은 오직 군부만이 임명할 수 있는 250명 구성의 상원이다.

Military and Youth Activism:
The Case of Thailand

Keiko Sei | Writer, Curator, and Media Activist

On May 15, a day after the general election in Thailand, we received news that none of us in this country had ever expected to hear. The Move Forward Party (hereinafter the "MFP"), known for their progressive agenda, popularity among the youth, and candidates from diverse backgrounds, had won the highest number of seats. Their campaign pledges included reforming the army, abolishing conscription, and amendment of Article 112 (the lèse-majesté law).[1] This is a country where the use of military coups by traditional elites to alter election results has been almost institutionalized, with 19 coups since the revolution in 1932. This is also a country where for the most part, a pattern of criminalizing voices of dissent against authority has been established, with frequent use of Article 112, the Computer Crime Act, and ubiquitous "Emergency Decrees." The MFP pledges to end all of these; they have proposed the reform of the establishment itself.

This astonishing result was by no means a miracle or a one-time fad: it was the result of years of painstaking efforts by democracy activists and various civil rights organizations. One of the decisive factors for the victory of the MFP, however, was the overwhelming support and mobilization power of Generation Z for the party's campaign, even though many of them hadn't

[1] Section 112 of the Thai Criminal Code prohibits anybody from criticizing the monarchy. The official text reads as follows: "Whoever defames, insults or threatens the King, the Queen, the Heir-apparent or the Regent, shall be punished with imprisonment of three to fifteen years."

even reached voting age. The MFP itself was said to have cashed in on the series of massive youth-led protests that took place in 2020[2] (here I refer to these as the "2020 Protests" or "Protests").

Fresh activism by Gen Z around the world has been widely reported on and analyzed, from Black Lives Matter to Fridays for Future to the three-finger salute. Here, as a timely response to the victory of the MFP, I would like to share some insights into how Thai teenagers have become an activist powerhouse: mainly focusing on the area of graphic design, we will take a look at their creative formation, trajectory, and tactics, as well as assistance, influence, and inspiration that they have received from older generations of creative activists. Having watched how some of the tactics of the Thai youth have been adopted by youth activists in Myanmar after the coup in February 2021, I write this article with the hope that the Thailand model will inspire activists that are still fighting under totalitarian regimes, especially in this time of the revival of military coups around the world.[3]

Up until 2020

Living under the draconian lèse-majesté law, Thai activists have constantly had to be creative—in many cases, they have opted to use nuance and satire when criticizing the authorities. Traditionally, cartoons, comedies, local theater plays, and some musical genres (such as Mor Lam) have provided political satire. This tradition still continues today with expanded platforms in cyberspace.[4] In the area of graphic design, during the government of business tycoon Thaksin Shinawatra in the first half of the 2000s and after he was deposed by a coup in 2006, a wave of design activism emerged. A left-leaning radical publishing house called Fah Diew Kan ("Same Sky"), together with graphic designer Pracha Suveeranont, created numerous designs for book/magazine covers as well as political exhibitions that were provocative and controversial. **(Fig. 1, p. 351)** As a theorist of society and design, Pracha has also written about various design concepts and tactics that he conceived, including reimagining old Thai textbooks

in a critical style, incorporation of artistic discourse into visual media, deconstruction of typography to deconstruct hierarchy, and the concept of "Vernacular Thai."[5] It was a time of digital transformation from Web 1.0 to Web 2.0, when people in Thailand started to discuss their design works on blogs and web boards. In this way, the works of Same Sky and Pracha Suveeranont have had a tremendous impact in the area of political design, evidence of which can be seen in the works of the new generation of democracy activist graphic designers.

After the 2006 coup, Thai society became sharply divided between two camps: red shirts and yellow shirts.[6] This period is called "the lost decade" by many because of the ongoing conflicts between the two. Ironically, it was also a time when creative activism flourished as the two camps competed against each other with their own noticeable styles of activism. In 2014, the third incarnation of Thaksin's party, the Pheu Thai Party, was ousted by a military coup. It was the first time the three-finger salute had appeared

2 The protests were initially triggered by the dissolution of the Future Forward Party, the predecessor of the MFP, and the banning of its key members from politics by the Constitutional Court in February 2020.

3 Since 2010, there have been 50 coups and coup attempts in Africa, 6 in Asia, 4 in Europe, and 4 in Latin America. UN Secretary-General António Guterres, in a speech he made about the state of the world in September 2021, confirmed the trend, saying that "military coups are back."

4 The Milk Tea Alliance, a well-known democratic alliance of Asian Gen Z activists, was originally founded when Thai netizens were seen as the clear winner of an all-night online battle against Chinese nationalists over Hong Kong's status as an independent country. Chinese online officers, who mostly seemed to have been following a manual, were seen as being no match for Thai netizens' skill in countering any offensive comments with clever and funny memes. Netizens from Hong Kong and Taiwan were impressed, and thus proposed an alliance with Thai netizens, creating a group of activists from countries who love milk teas (this later expanded to more countries, including India and Myanmar).

5 "Vernacular Thai" is the application of the indigenous folk culture of laypeople ("folk Thai"). It is claimed that since it was born out of commercialism to be used for entertainment purposes (such as in movie posters), its commercial nature makes it rootless and hence not considered "national" enough to be "Thai". In art, this becomes a matter of the viewer's perception of folk Thai that can be readily applied to other forms of art and culture, similar to how kitsch works in the West. This tactic has proved to be particularly useful in perceptionally deconstructing the social hierarchy while celebrating rural or periphery cultures.

6 The yellow shirts mainly consist of people who oppose Thaksin Shinawatra and his allies. The red shirts include supporters of Thaksin, many of which come from the north and rural northeastern parts of Thailand, and some from urban areas who are sympathetic to low-income workers and farmers in rural areas, as well as those who oppose repeated political interventions by elites and the military.

in political protests as a spontaneous demonstration of people's dissent. By that time, social networking sites had already taken root in Thailand, and the three-finger salute spread like wildfire, partly because it worked well in selfies and was instagrammable.

The Millennial activists did all they could to be creative during anti-coup protests: examples include reading *1984* in public and organizing sandwich-eating parties (due to a ban of any assemblies of more than five people, the most innocent-looking events were organized simply to gather more than five people). Every single action, however, was banned by the military. The way each of these harmless actions was banned one after another became so ridiculous and absurd—according to a senior police chief, "eating sandwiches is not illegal per se, but eating them with intent would be"—that for the sensitive youth who witnessed it, the experience became a collective memory. And this memory became a motive for the subsequent generation of young activists to master their own strategies.

Gen Z hits back: Absurd actions against an absurd society

One day in July 2020 in Bangkok, hundreds of young people were running around Democracy Monument while singing a song from *Trotting Hamtaro*: "Come out and run, run, run, Hamtaro. The most delicious thing is the … people's tax!"—changing the original lyrics to political satire. The event was preceded by a larger marathon event entitled Run Against Dictatorship[7] that took place in January 2020 at a park and was attended by 13,000 participants. The two events have several elements in common: avoiding a ban by pretending to be a sporting event, doing absurd things to highlight the absurdity of Thai politics, and the use of cute characters in order to attract non-political youth while making the events look harmless and innocent. The mascot chosen for Run Against Dictatorship was a little boy called Nong Ta Sai ("Innocent boy") that appears in a series of satirical cartoons created by Khai Meow ("Cat Egg"). Innocent and curious, keenly witnessing all that is happening in society, the boy is so confused of the absurdity of Thai politics that his eyes often

spin around. The character represented the vast majority of teenagers and children[8] who have suffered years of political turmoil and social inequality, and thus the boy appeared in many scenes and sites throughout 2020's protests, as if he were actually alive. **(Fig. 2, p. 353)**

Democratization of esthetic hierarchy

It is easy to dismiss all these as a mere teenagers' fancy. Instead, I would like to look at a hidden and deeper implication in the use of cute characters. Thai elites often use the Buddhist concept of karma in order to justify their status, that they have what they have (wealth, fair-skinned beauty, high social status) because of their good deeds in a previous life. By the same logic, poor people are poor because of bad actions in their previous lives, so they should not even dream of climbing the ladder. This twisted logic also extends to their view on suffrage in the sense that they firmly believe that they are the only ones to decide what is "good" for the country.

In order not to fall into the elites' logical trap, Thai activists have had to invent a mechanism by which a virtual reversal of the hierarchy can occur. Using cute characters is one of these attempts. The idea behind this is that anybody can claim cuteness regardless of social status, skin color, ethnicity, and gender. Conversely, activists can turn a dictator into a cute character—a practice seen as controversial by some older activists—so that the authoritative aura of the dictator can be diminished.

Character creation is a complex undertaking and in the commercial field, extensive resources and marketing research are poured into such endeavors. In the field of grassroots political activism, however, designers mostly rely on field experience of attending protests, joining conversations, and constantly following developments in order for them to design posters and logos, with character design

7 The title was taken from a hugely popular political rap group called "Rap Against Dictatorship."

8 Interestingly, Khai Meow's cartoons even attracted middle-class adult Bangkokians, who had been supporting the yellow shirts at the time.

being no exception. A successful character will be given a life of its own and start walking with its head up, and may eventually change society. The military, whose value system relies on hierarchy, order, and discipline[9], tends to fail miserably in this area, so that democratic activists have a clear advantage in the realm of cuteness.

Democratization of heroes

With the same concept, Gen Z activists have also mastered the creation of new types of heroes. During political campaigns for two successive elections—the Bangkok gubernatorial election in May 2022 and the Thai general election in May 2023—an anonymous graphic designer created heroic characters for democratic candidates in the style of cartoon heroes: Bangkok gubernatorial candidate Chadchart Sittipunt's[10] character looked like he'd come out of DC Comics, **(Fig. 3, p. 354)** and key candidates from the MFP were drawn in the style of the manga *Jojo's Bizarre Adventure*. Young voters who were versed in comics and manga immediately recognized the difference between the profile of these heroes and the traditional style of heroes that the military worships: kings, the chosen ones. For young activists, memory of the controversy surrounding Rajabhakti Park, which the Royal Thai Army built soon after the 2014 coup to commemorate the past Thai kings,[11] was still fresh.

The giant statues of the kings that were built on the park grounds have been criticized by many for being antiquated, self-complacent, and overly costly. What these statues show us, most of all, is the military's unawareness of (or disregard for) the evolution of "heroism" in its concept and characteristics. Heroic representation is a reflection of the times, as in the case of the characters and mascots discussed above. From ancient powerful warriors to the more recent anti-hero heroes, to heroes whose traits are more diverse, complex, and fragile.[12] Instead of depicting a political candidate as a mighty superhero, the anonymous designer chose to draw images of more nuanced, charming heroes who would work together with the community every day to build a better society.

An interesting example of design activism in this context is the work by a design group calling themselves PrachathipaType (wordplay from prachathipatai ("democracy") + typography). As the name suggests, the group takes typography as medium for democracy activism, and their better-known works include a font used on large graffiti artworks at protest sites and the logo for Chadchart Sittipunt's campaign, which combined his candidate number with his name. In one of their works, the group has made fonts out of the handwriting of a Thai revolutionary, leftist writer and philologist Chit Phumisak, who has been looked up to by generations of activists since he was killed in 1966. **(Fig. 4, p. 356)** Not only has the design group brought the philologist-turned-revolutionary hero back to life in this way, but also, the fonts remind people that traditionally heroes' tales have been passed down from generation to generation through words as legends, myths, and folktales, and now is the time for them to write their own tales of heroic deeds.[13]

Celebrate hormonal chaos

The 2020 Protests drew huge crowds. Minorities of all kinds were invited, from LGBTQ+ to ethnic minorities, otakus came out en

9 The Bandai Character Research Institute, during their research in Japan in 2004, asked people what kind of effect they feel from characters. The No. 1 answer was "Make me feel at ease and at peace" (55.9%), and the 2nd was "Make me a gentler and kinder person." With these two answers at the top, the top 10 answers were all about characters' therapeutic/healing effects. The trend of laid-back local mascots in Japan called Yuru-Kyara has arisen from this tendency. What is obvious from this survey is that there can be no symbiosis between cute characters and the military.

10 Chadchart Sittipunt gained over 1.38 million votes, breaking the record for Bangkok gubernatorial elections, and he won over 1 million votes more than the next leading candidate.

11 Not only were Rajabhakti Park and the statues not popular, but the park project has also been beset by a series of scandals involving kickbacks for its construction.

12 The evolution of heroes has been reflected in mainstream culture such as DC Comics, Marvel, and manga such as *One-Punch Man* and *My Hero Academia*.

13 Another interesting work by PrachathipaType in an almost contrasting sense is a font created out of graphic data. The group used pie charts representing the national budget being allocated to the monarchy and the army during the country's struggle with COVID-19 to make a font, together with graphic symbols questioning the government's priorities and its gestures towards the monarchy. In this case, writers using these fonts will remind themselves that objective and scientific data is dictating their subjective writing. **(Fig. 5, p. 356)**

masse, and even non-political Thais were drawn to the fun and fresh activities that young activists had come up with: queer shows full of political satire, dances with new, K-Pop-inspired political songs, and a party of exterminating dinosaurs with meteor balls,[14] among others. One of the keenest providers of ideas was a high school student group calling themselves Bad Students. They started from a solo sit-in performance against the strict school rules on haircuts[15] and went on to organize various provocative actions such as hanging school uniforms at the Education Ministry and challenging government officials to debates.[16]

Graphic designer Pharcha Chaimongkolsub (PHAR) had been collecting all the adjectives that the high school student group had been called, from those that might be taken as negative—*chaotic, whimsical, troublemaking, chuunibyo-like,* etc.—to more neutral ones such as *rebellious* or *radical,* as well as "positive" words such as *courageous, high-consciousness, truthful, passionate,* etc., and thus she was able to conceive a design for the unprecedentedly young activists.[17] She must have decided to combine all of these, since the visual materials that PHAR has designed for youth activists resemble a tapestry of these wonderfully unpredictable qualities of teenagers that may pop out at any time. I would like to describe her works as a celebration of "hormonal chaos." **(Fig. 6, p. 357)**

We have looked at how Thai youth activists have been ingeniously taking advantage of the shortcomings of the military. With the rapid development of AI technology, however, the military now has much better chances of improving in the area of creativity with the help of technology. Even if such a day comes, teenage activists will still be able to keep their advantage if they let their hormonal chaos run free in their creative process—because, after all, it is one of the few genuine traits of humans that AI cannot deep-learn and imitate. As such, works and projects that are created in this way will highlight the antithesis between trickery and truthful.

Record of calling

Sophia A. McClennen, the author of *Ariel Dorfman: An Aesthetics of Hope*, describes the sense of commitment felt by writers representing human rights issues such as Dorfman, himself a coup survivor, as "a calling they can't refuse and a process that requires idealism, skepticism, and perseverance."[18] The young activists may not yet know where the "calling" comes from, what exactly it is, or what it will do to them. Perhaps they are aware, however, that they cannot, did not, and will not refuse it.

Thai activists have come a long way, and much of their path still remains ahead of them.[19] On such a long and winding road, graphic design will serve as a critical record of activists' response to their inner calling.

14 Dinosaurs are often used as a symbol of army generals that never go away, and meteors are associated with the youth that try to eradicate them. Meteors are often associated with the Future Forward/Move Forward Party as well.

15 In June 2020, 15-year-old student and co-founder of Bad Students Benjamaporn Nivas sat in a public place with scissors on her lap and a sign around her neck inviting passersby to cut her hair as a symbolic punishment for violating the school's haircut rule.

16 On August 19, 2020, Bad Students organized student protests at the Education Ministry to call for its Minister to quit. When the Minister came out to meet the students, he was told that he would have to wait his turn to address them.

17 PrachathipaType also states that their design is a result of absorbing and reflecting on conversations and debates on social networking sites.

18 Sophia A. McClennen, *Ariel Dorfman: An Aesthetics of Hope* (Durham: Duke University Press, 2010).

19 The victory of the democracy camp does not guarantee that they can form a government, due to various proactive measures by the military to prevent such an eventuality. The most noticeable measures include the 250 members of the Senate that can only be appointed by the military.

프로젝트 중심 민주주의:
민주주의 실험을 위한 디자인

에치오 만치니 | 밀라노공과대학 명예 교수, 데시스네트워크[1] 대표

"우리는 어렵고 위험한 시기에 처해 있다. 우리가 사는 세상이
비록 완벽하지 않아도 오랫동안 인권과 기본적 자유와 개인 성장
기회의 증대라는 민주주의 원칙에 충실했다면, 오늘날의 상황은
완전히 달라졌다. 민주주의에 대한 공격은 각국에서 벌어지고
있다. 민주주의가 결코 흔들릴 것 같지 않던 곳에서조차 말이다.
이 같은 전개에 직면한 우리는 디자인 공동체 즉 실무자, 연구자,
이론가, 학생, 언론인, 출판인, 큐레이터 등 디자인에 관련된 활동을
하는 모두가 단호한 태도로 발언하고 행동해야 한다고 믿는다."

위 글은 6년 전, 2017년 3월에 빅터 마골린(Victor Margolin)과 내가 함께 쓴
디자인 공동체를 향한 공개서한의 도입부다.[2] 직접 행동을 촉구하는 이
서한에서는 민주주의와 디자인 사이의 작동 관계에 대한 우리의 이해를
간략히 제시했다. 이 관계는 네 가지 영역으로 표현된다. (1) 민주주의의
디자인: 민주적 절차와 민주주의의 토대가 되는 제도를 개선하기. (2)
민주주의를 위한 디자인: 더 많은 사람들이 민주적 절차에 참여할 수 있도록,
특히 기술을 활용하여 역량을 강화하기. (3) 민주주의에서의 디자인:
민주주의 제도에 접근성, 개방성, 투명성을 부여하여 평등과 정의를 담보하기.
(4) 민주주의로서의 디자인: 참여적 디자인을 실천하여, 다양한 행위자들이
공정하고 포용적인 방식으로 현재와 미래의 세계를 만들어 갈 수 있도록 하기.
　공개서한의 주장은 위 모든 영역에서 실천이 필요하다는 것이지만,
거기서 그치지 않고 더 나아가야 한다는 의미를 담고 있기도 하다. 눈앞의

위기에 맞서는 대책으로서의 저항뿐만 아니라, 민주주의를 위한 새로운 발달 노선을 상상하고 발전시킬 필요가 있다는 뜻이다.

그때 이후로 우리가 직면한 위기는 더욱 심각해졌고, 많은 토론과 성찰이 이루어졌다. 이 같은 방향으로 함께 나아가는 데 보탬이 되고자 이 글을 쓴다. 여기서는 민주주의 재생의 문제를 전부 다루는 대신, 위에서 언급한 네 번째 영역 즉 참여적 민주주의에 집중한다.

위기의 근원

오늘날 세계 각지에서 득세하고 있는 권위주의 정권들과, 더 놀랍게도 유럽과 미국에서 벌어지고 있는 윤리적·문화적 역행은 민주주의가 처한 위기를 잘 보여준다. 하지만 이러한 현상은 비록 극적이기는 하나 위기의 원인보다는 결과인 듯하다. 위기의 근원은 더 과거로 거슬러 올라간다.

내 생각에 문제의 핵심은 다음과 같다. 사회가 초중앙화 시스템으로 진화함에 따라 의사결정 방식은 점점 불투명해졌고, 민주적으로 대표성을 부여받은 적 없는 기관 및 경제적 행위자들에 의해 의사결정이 이루어지게 되었다. 결과적으로 사람들은 민주적 논의가 무용지물이라는 인식을 갖게 되었는데, 최종적인 결정은 다른 곳에 있는 다른 이들이 내리기 때문이다. 선택할 대안이 없다면 토론하고 숙의하는 일 또한 무의미한 것이다. 그리고 (사실은 엘리트 특권층의 이해관계를 다수에게 강요하는 파렴치한 행위에 불과한) 경제 시스템의 시장 자동조절이라는 명목으로 사람들의 행동 범위가 축소 내지 소거된다면, 민주주의 또한 존재할 수 없다. 따라서 나는 민주주의의 재생이, 바로 '민주주의는 "민중에게 권력을" 더 많이 주어야 한다'는 급진적 선언에서 시작되어야 한다고 믿는다. 이를 위해서는 자유와 평등, 인권과 사회적 형평성을 창의적인 방식으로 융합해야 한다. 즉 사회혁신과 기술이 제공하는 기회를 최대한 활용하는 민주주의 실험을 추진하여 위기를 극복해나가야 한다. 디자인은 이 실험에서 중요한 역할을 할 수 있다.

1 역주: DESIS Network. 사회적 혁신과 지속가능성을 위한 디자인 네트워크

2 역주: Ezio Manzini and Victor Margolin, "Open Letter to the Design Community: Stand Up For Democracy," Democracy and Design Platform, March 5, 2017. http://democracy-design.designpolicy.eu/open-letter-stand-up-democracy/

사람들이 권력을 가지려면, 그들이 진정한 의미에서 결정을 내릴 수 있는 문제와 그러한 결정이 이루어질 수 있는 장이 존재해야 한다. 즉 다양한 문제에 대한 의사 결정권이 실질적으로 관련 공동체에 주어져야 한다는 뜻이다. 그런데 이를 위해서는 의논과 결정의 대상이 되는 문제 자체에 지역적 차원이 존재해야 하고, 어떤 선택을 하는지에 따라 직접적인 영향이 발생해야 한다.

다시 말해 지역적 층위에서 논의를 진행한 뒤 정작 결정과 실행을 중앙 조직에 맡겨서는 안 된다. 대신 생산 및 서비스 시스템의 지역적 작동이 바로 지역적 하위 시스템에 주로 의존하도록 하는 설계가 필요하다. 이때 지역적 하위 시스템은 자율성을 가져야 하며, 지역에서 결정하고 실행한 선택에 따라야 한다. 이는 곧 오늘날 만연한 중앙화된 계층적 시스템으로부터 '분산형 시스템'으로 전환해야 함을 뜻한다. 분산형 시스템은 상호연결되어 있으면서도 상대적으로 자율적이며 지역 공동체에 의해 결정될 수 있는 요소들로 구성된 사회기술 시스템을 말한다.

로빈 머리(Robin Murray)는 분산형 시스템을 다음과 같이 설명한다. "분산형 시스템은 복잡성을 다룰 때 중앙 중심의 균일화나 단순화의 방법이 아니라 시스템 말단(각 세대와 서비스 사용자, 그리고 직장의 경우 지역 매니저와 근로자)까지 복잡성을 분산시키는 방법으로 해결한다. 시스템의 말단에 위치한 사람들은 시스템 중앙에서는 파악할 수 없는 구체적인 지식(예를 들면 시간, 장소, 어떤 사항의 특수성, 소비자 혹은 시민의 경우에는 그들의 필요와 바람의 특수성)을 확보하고 있다. 이론적으로는 이런 잠재력이 존재하지만, 이를 실현하기 위해서는 새로운 종류의 사용자 참여, 새로운 관계 정립, 새로운 형태의 고용과 보상이 필요하다."[3]

나는 그동안 이 새로운 패러다임과 그로부터 파생되는 [작고(Small) 지역적이며(Local) 열려 있고(Open) 연결된(Connected)의 앞 글자를 따서 SLOC 시나리오[4]라고 불러왔으며, 이런저런 이유로 지금은 근접성(Proximity) 시나리오[5]라고 부르고 있는] 시나리오에 관해 꾸준히 이야기해 왔다. 이 시나리오에서 사회기술 시스템은 머리가 설명하듯이 복잡성을 네트워크의 노드(node)에 재분배하기 때문에 복잡성을 감당할 수 있다. 그럼으로써 이들 시스템은 지역의 가용 자원을 최대한 활용하고 경험으로부터 학습할 수

있다. 바로 이러한 이유로 분산형 시스템은 회복력을 가지며 지속 가능하다
(반면 중앙화된 계층적 시스템은 본질적으로 취약하고 지속 가능하지 못하다). 이 같은
긍정적 측면에 더해 나는 분산형 시스템이 민주주의에 더 적합한 맥락으로
작동한다고 덧붙이겠다. 분산형 시스템은 활동과 권력을 네트워크의 노드에
분산시킴으로써 공공의 이해관계에 관한 토론의 장을 가능케 하고 그것에
접근하기 쉽게 만들며, 그 토론의 장에서는 이해당사자 공동체들이 논의할 수
있는 규모의 문제가 제기된다.

결론적으로, 일정 수준의 권력을 지역 공동체에 돌려주는 분산형 시스템
시나리오를 통해서만 민주주의가 처한 위기를 근본적으로 해결할 수 있다.
이러한 시나리오가 실현될 수 있을지, 그리고 어떤 방식으로 실현될지는 여러
요소에 달려 있다. 그중 한 가지는 디지털 기술, 뉴미디어, 그리고 근미래에
다가올 인공지능의 확산이다.

민주주의, 디지털 기술, 뉴미디어

디지털 기술과 뉴미디어의 확산은 민주적 절차의 배경이 되는 커뮤니케이션
환경을 통째로 뒤바꾸어 놓았다. 그에 따라 새로운 가능성이 열리기도 했지만
지난 세기 민주주의가 자리 잡게 해준 실천들이 도전받기도 했다. 이십 년 전
브뤼노 라투르(Bruno Latour)는 이 같은 가능성을 일컬어 새로운 "민주주의의
기운"(democratic atmosphere)이라고 부른 바 있다.[6] 이 용어를 통해 라투르가
묘사한, 물리 세계와 가상 세계의 하이브리드 공간은 장소, 네트워크, 플랫폼,
디지털 매체 등의 구성요소가 서로 맞물려 다양한 공공의 장을 만들어 내는
곳이다. 그 안에서 사람들은 공통의 문제를 토론하고 의사결정을 하고 그
결정을 작동시킨다는 것이다. 하지만 우리가 잘 알고 있듯이, 실제 역사는

3 Robin Murray, "Danger and Opportunity: Crisis and the New Social Economy," NESTA-
Provocations, September 2009. https://www.nesta.org.uk/report/danger-and-opportunity-
crisis-and-the-new-social-economy/ 에치오 만치니, 『모두가 디자인하는 시대』, 조은지 옮김(파주:
안그라픽스, 2016), 50 번역 참조.

4 Ezio Manzini, "Small, Local, Open and Connected: Design Research Topics in the Age of
Networks and Sustainability," *Journal of Design Strategies* 4, no. 1 (Spring 2010).

5 Ezio Manzini, *Livable Proximity: Ideas for the City that Cares* (Milano: Egea, 2022).

6 Bruno Latour and Peter Weibel, *Making Things Public: Atmospheres of Democracy* (Cambridge,
MA: MIT, 2005), 14–43.

이렇게 흘러가지 않았다.

그로부터 십여 년 후 핀란드의 주요 연구소인 시트라(SITRA)는 "이론적으로는 기술 덕택에 서로와의 연결이 더욱 깊어질 수 있는 시대임에도, 실제로 우리가 목격하는 것은 분리, 필터 버블, 균질화 현상의 대유행"이라고 지적한 바 있다.[7]

그 말대로 디지털 기술과 뉴미디어의 확산은 전통적인 형태의 민주주의, 특히 여태껏 복잡한 사회의 기틀 역할을 해온 대의 민주주의에 엄청난 손상을 가하고 있다. 이는 잘 알려진 문제로 많이 다루어진 바 있다. 디지털 기술과 연결성은 탈지역화, 비동기화, 탈매개화된 사회적 형태의 구성을 가능케 한다. 간단히 말하자면 사람들은 이제 중재자 없이, 그리고 장소나 시점과도 무관하게 상호작용할 수 있는 것이다. 전통적인 정치 조직과 대의 민주주의가 처한 위기는 여기서 비롯된다. 더구나 이러한 연결성은 전례 없는 탈매개화의 가능성과 전통적인 직접 민주주의 관념을 위험하게 결합하고 말았다.

그러나 현재의 상황을 더 자세히 관찰하면 또 다른 무언가 있음을 알 수 있다. 이것을 일컬어 디지털 민주주의를 주제로 하는 실험 노선이라고 부를 수 있을 것이다. 영국의 싱크탱크 네스타(NESTA)는 이러한 실험 노선에 관한 연구의 결론부에서, 사람들이 민주적 절차에 참여하는 노력을 촉진하는 수백 가지의 도구와 플랫폼이 오늘날 사용되고 있다고 관찰한다. 하지만 동 연구에서 또한 지적하듯이 이것으로 충분한 것은 아니다. "일련의 난관들이, 조사한 사례 전부 혹은 대부분에서 공통적으로 발견되었고 디지털 민주주의 분야 자체에도 공백이 존재한다. 디지털 민주주의가 우리 민주주의 제도와 절차에 대한 공공의 신뢰를 회복하려면 이들 난관과 공백을 고민하고 해소해야 한다."[8]

여기에 나는 이런 일을 실현하기 위해 상당한 디자인 역량을 발휘할 필요가 있다고 덧붙이겠다. 창의적이고 정치적인 노력을 기울여, 디지털 기술 및 뉴미디어의 잠재력과 사회혁신 실천 사이의 융합을 이끌어내야 할 것이다.

참여적 민주주의의 새로운 형태

위와 같은 논의에 기여하기 위해 여기서는 '프로젝트 중심 민주주의 시나리오'를 제안하고자 한다. 핵심은 민주주의의 '디자인' 차원을

고려함으로써 민주주의 개념의 정의를 확장하는 것이다. 이 시나리오에서 민주주의는 물리적 환경과 디지털 환경이 혼합된 하이브리드 공간으로, 사람들이 만남을 가지고 대화에 임하고 각자의 프로젝트를 고안하고 협력을 통해 개선할 수 있는 가능성을 더 많이 제공하는 곳이다. 즉 프로젝트 중심 민주주의는 사람들이 만나 협력을 통해 각자의 삶과 세계를 디자인할 자유를 제공할 뿐만 아니라, 이러한 대화와 공동 디자인 과정에서 구체적인 결과가 발생할 가능성 또한 향상된 공간이다.[9]

요컨대 여기서 말하는 '프로젝트 중심 민주주의'는 참여적 역량 부여 생태계(participatory enabling ecosystem)로, 그 안에서는 다른 사람들의 활동을 방해하지 않는 한 누구나 자신의 프로젝트를 발전시키고 결과를 달성할 수 있다. 한편 디자인이나 생산 작업은 혼자 할 수 있는 것이 아니라는 점에서 이는 협업으로부터 만들어지는 민주주의이기도, 협업을 만들어 내는 민주주의이기도 하다.

그러므로 이 시나리오에서 프로젝트 중심 민주주의는 모든 사람에게 만남과 협업의 가능성을 제공하려는 환경이다. 이를 통해 사람들은 개인적이면서도 공동체적인 이해관계를 추구하며 목표를 달성할 가능성을 얻는다. 다시 말해 참여적 민주주의가 활성화될 수 있는 시나리오다.

프로젝트 중심 민주주의의 실현 가능성을 높이는 조건을 어떻게 조성할 수 있을까? 어떻게 하면 활발하게 활동하는 시민 집단과 대의 민주주의적 실천을 한데 모아 서로가 서로를 지탱하게 할 수 있을까? 프로젝트 중심 민주주의를 위한 '민주주의 인프라'는 어떻게 생산할 수 있을까?

사회혁신을 위한 디자인의 경험에서 이에 대한 해답을 찾을 수 있다. 프로젝트 중심 민주주의의 인프라는 역량 부여 생태계, 즉 다양한 프로젝트가 등장하고 성공할 수 있는 인프라를 갖춘 환경에 해당한다.[10]

7 Elina Kiiski Kataja, *From the Trials of Democracy towards the Future Participation*, SITRA Memorandum, March 21, 2017. https://www.sitra.fi/en/publications/trials-democracy-towards-future-participation/

8 Julie Simon, Theo Bass, Victoria Boelman, and Geoff Mulgan, *Digital Democracy. The Tools Transforming Political Engagement* (London: Nesta, 2017), 87.

9 이 내용은 다음 책에 더 자세히 서술되어 있다. Ezio Manzini, *Politics of the Everyday* (London: Bloomsbury Publishing, 2019).

이러한 역할을 수행하기 위해 역량 부여 생태계는 다양한 요소를 포함해야 한다. 이들 요소는 민주주의에서의 게임의 규칙(이는 모든 프로젝트가 성공 가능성을 동등하게 갖고 서로의 권리를 존중하며 공존할 수 있도록 한다), 물리 공간과 가상 공간에 존재하는 실험의 장(이곳에서 사람들은 만나서 목표가 무엇인지와 그것을 어떻게 달성할지를 결정할 수 있다), 온라인 서비스와 오프라인 지원(이를 통해 공동 디자인 및 공동 생산 활동의 접근성과 효율성이 증가한다), 사회적 공유재(모든 협업의 필요 조건인 신뢰와 공유가치 같은 것들이다) 등이다. 물론 이 모든 것들은 누군가 디자인해야 한다. 아니, 디자이너, 시민, 그리고 관련된 다른 사회적 행위자의 연합체가 공동 디자인하는 편이 더 좋을 것이다.

번역: 고아침

10 역량 부여 생태계에 관해서는 Ezio Manzini, *Design, When Everybody Designs. An Introduction to Design for Social Innovation* (Cambridge, MA: MIT Press, 2015)를 참고할 것.

Project-centered Democracies:
Designing for Democratic Experimentation

Ezio Manzini | Honorary Professor at Politecnico di Milano, President of DESIS Network

"We are in difficult and dangerous times. For many years, we lived in a world that, despite its problems, was nevertheless committed to principles of democracy in which human rights, fundamental freedoms, and opportunities for personal development were increasing. Today, this picture has changed profoundly. There are attacks on democracy in several countries—including those where democracy had seemed to be unshakable. Faced by these developments, we believe the design community should take a stand, speak out, and act: practitioners, researchers, theorists, students, journalists, publishers, and curators—all who are professionally involved in design-related activities."

This is the incipit of an Open Letter to the Design Community that Victor Margolin and I wrote 6 years ago, in March 2017. Beyond this call for direct mobilization, the letter also summarized what we saw as the operational relationship between democracy and design. A relationship that could be expressed on 4 terrains: (1) design of democracy—improving democratic processes and the institutions on which democracy is built; (2) design for democracy—enabling more people to participate in the democratic process, especially through the use of technology; (3) design in democracy—building access, openness, and transparency into institutions in ways that ensure equality and justice; and (4) design as democracy—the

practice of participatory design so that diverse actors can shape our present and future worlds in fair and inclusive ways.

The intent of the letter was to say that all these terrains had to be practiced, but that in the face of the current crisis, it was necessary to imagine and develop not only a proactive resistance, but look for new lines of development for democracy.

Since then, in the face of ever greater crisis, several discussions have taken place and several reflections have been made. The following notes are a contribution moving in this same direction. It doesn't deal with the whole issue of democracy regeneration, but it focuses on the fourth of the terrains indicated above: that of participatory democracy.

The roots of the crisis

Today, the crisis of democracy is made evident by the success of democratic–authoritarian regimes in many parts of the world and, even more surprisingly, by the ethical and cultural involution underway in Europe and the United States. However, dramatic as they are, these phenomena appear to be the effect rather than the cause of the crisis, which has deep roots reaching further back in history.

In my opinion, the deepest of these roots is as follows: it has happened that, in the evolution toward ultra-centralized systems, decisions are made in an increasingly opaque way and by institutions and economic actors that lack any democratic investiture to do so otherwise. As a consequence, people have the impression that democratic discussion is useless because, at the end of the day, decisions are made by others in other places. But if there are no alternatives to choose from, there is no point in discussing and deliberating. And if, in the name of automatisms in the economic systems (which are really only the shameless imposition of the interests of a privileged elite on the majority), the field of action is reduced to little or nothing, there can be no democracy. Consequently, I believe that the regeneration of democracy must start from here: from the radical affirmation that democracy must give more "power to the people." In order to do this, it must put liberty and equality,

human rights and social equity, together in a creative manner. This means tackling the crisis of democracy by promoting a great season of experimentation: democratic experimentation that makes best use of the opportunities that social innovation and technology can offer. In this experimentation, design can play a big role.

The need for democratic experimentation

If people must have power, there must be questions on which they can really make decisions and arenas in which they can do so. In practice, this means that decision-making power on various questions must be given to the communities involved. However, to do this, the questions to be discussed and decided must themselves have a local dimension on which choices can have a direct impact.

In other words, it is not only a case of discussing questions on a local level that will then be decided and put into action by central organisms. Instead, production and service systems need to be developed whose local functioning depends mainly on local subsystems, endowed with autonomy and determined by choices made and carried out locally. This means shifting from the centralized hierarchical systems prevailing today to *distributed systems*: socio-technical systems consisting of a network of interconnected but relatively autonomous elements over which the local communities have the real possibility of deciding.

Robin Murray describes distributed systems as follows: "distributed systems handle complexity not by standardization and simplification imposed from the center, but by distributing complexity to the margins—to households and service users, and in the workplace to local managers and workers. Those at the margins have what those at the center can never have—a knowledge of detail— the specificity of time, of place, of particular events, and in the consumer's and citizen's case, of need and desire. This is the potential. But to realize it requires new terms of engagement with users, new relations at work, new terms of employment and compensation."[1]

For my part, on other occasions, I have talked amply about this

new paradigm and the scenario deriving from it (which I have called the SLOC scenario, where SLOC stands for Small, Local, Open, Connected[2] and which I now, for various reasons, call the Scenario of Proximity[3]): a scenario in which the socio-technical systems are capable of tackling complexity because, as Murray writes, they redistribute it to the network nodes. By doing this, it is possible for them to make the best use of locally available resources and to learn by experience. Precisely because of this, distributed systems are resilient and sustainable (as opposed to centralized, hierarchical systems that, by their very nature, are intrinsically fragile and unsustainable). To these favorable considerations, I can now add that distributed systems are also a favorable context for democracy: by distributing activities and power to the network nodes, they make arenas possible and accessible for discussion about questions of public interest, and they do so proposing questions on a scale such that they can be debated by the communities immediately interested.

In conclusion, in returning a certain quota of power to local communities, the scenario of distributed systems is the only one that allows the crisis of democracy to be tackled at its deepest roots. Whether and how this will actually be put into practice will depend on a combination of factors. Among them, there is also the spread of digital technologies, new media, and, in the near future, artificial intelligence.

Democracy, digital technologies, and new media

The diffusion of digital technologies and new media has transformed the entire communicative environment in which democratic processes take place, opening new possibilities on this terrain, too, but also challenging the practices that shaped the democracy of the last century. Twenty years ago, Bruno Latour called this possibility the new "democratic atmosphere,"[4] describing it as a hybrid physical and virtual space made of places, networks, platforms, and digital media, which together create a wide variety of public arenas in which to discuss questions of common interest, make decisions, and make them operative. But, as we know, this is not how things have gone.

Ten years later, SITRA, an important Finnish research center, wrote: "In an age where technology allows us in theory to connect with one another much more deeply, we are in fact witnessing a huge trend in segregation, filter bubbles and homogenization."[5]

Indeed, the diffusion of digital technology and new media is having a devastating effect on traditional forms of democracy and, above all, on the representative democracy that until now has been the fundamental pillar of complex societies. The question is well known and amply debated: digital technology and connectivity allow the construction of delocalized, de-synchronized, and disintermediated social forms. To put it more simply, people can now interact without mediators, independently of the places they are in and the moment in which they choose to do so, whence the crisis of traditional political organizations and representative democracy. Moreover, this connectivity has also led to a short circuit between these unprecedented possibilities for disintermediation and the traditional idea of direct democracy.

But, upon closer inspection of the contemporary situation, it emerges that there is also something else, something that we could refer to as lines of experimentation on the theme of digital democracy. Research into these, conducted by the English think tank NESTA, concludes by saying that today there are hundreds of tools and platforms in use to facilitate people's commitment to democratic processes. But it also says that there is still a long way to go, and that "there are a number of challenges, common to all or most of our case

1 Robin Murray, "Danger and Opportunity: Crisis and the New Social Economy," NESTA-Provocations, September 2009. https://www.nesta.org.uk/report/danger-and-opportunity-crisis-and-the-new-social-economy/

2 Ezio Manzini, "Small, Local, Open and Connected: Design Research Topics in the Age of Networks and Sustainability," *Journal of Design Strategies* 4, no. 1 (Spring 2010).

3 Ezio Manzini, *Livable Proximity: Ideas for the City that Cares* (Milano: Egea, 2022).

4 Bruno Latour and Peter Weibel, *Making Things Public: Atmospheres of Democracy* (Cambridge, MA: MIT, 2005), 14–43.

5 Elina Kiiski Kataja, *From the Trials of Democracy towards the Future Participation*, SITRA Memorandum, March 21, 2017. https://www.sitra.fi/en/publications/trials-democracy-towards-future-participation/

studies, and a number of gaps in the field, which need to be addressed or resolved before digital democracy can reinvigorate and restore the public's trust in our democratic institutions and processes."[6]

For my part I would add that for this to happen, it is necessary to bring considerable design capability into play: a creative and political effort that should lead to convergence between the potential of digital technology and new media, and the practices of social innovation.

A new form of participatory democracy

In order to contribute to this discussion a scenario is proposed, i.e. a *scenario of a project-centered democracy*. The idea is to extend the definition of democracy by considering its "designing" dimension: democracy as a hybrid physical and digital space, equipped to offer people increased possibilities to meet, to start conversations, to conceive and collaboratively enhance their projects. That is, a democracy that not only gives people the freedom to meet and collaboratively design their lives and their world, but that also has to be seen as a space equipped to give these conversations and co-design processes a better chance of concrete results.[7]

In short, the *project-centered democracy* I am referring to here is a participatory enabling ecosystem in which everybody can develop their projects and achieve their results, insofar as they do not reduce the possibilities of other people doing the same. On the other hand, since we cannot design and produce alone, it is also a democracy that is born out of collaboration and produces collaboration.

In this scenario, project-centered democracy is therefore an environment that tends to give everybody the possibility of meeting and collaborating and, in so doing, to achieve objectives in pursuing interests that are both individual and collective. That is, it is a scenario in which participatory democracy can flourish.

How can we create the conditions that make the existence of project-centered democracy more probable? How can we bring the groups of active citizens and the practices of representative democracy together so they support each other? How can a *democratic*

infrastructure be produced for project–centered democracy?

The experience in design for social innovation permits us to answer these questions. In fact, the infrastructure of project–centered democracy corresponds to the existence of an enabling ecosystem[8]: an infrastructured environment where a variety of projects can emerge and thrive.

To play this role, this enabling ecosystem must include such various elements as: the rules of the democratic game (which ensure that every project respects the right of each other project to exist with equal possibility of succeeding), the physical and virtual arenas (where people can meet and decide on their aims and how to achieve them), the online services and offline support (which make the co–designing and co–production activities more accessible and effective), and the social commons (such as trust and shared values, which are the preconditions for all forms of collaboration). All of these, of course, have to be designed. Or better: co–designed by coalitions of designers, citizens, and other social actors involved.

6 Julie Simon, Theo Bass, Victoria Boelman, and Geoff Mulgan, *Digital Democracy. The Tools Transforming Political Engagement* (London: Nesta, 2017), 87.

7 This paper's contents are presented in a more extended way in the book: Ezio Manzini, *The Politics of Everyday* (London: Bloomsbury Publishing, 2019).

8 On enabling ecosystems, see Ezio Manzini, *Design, When Everybody Designs. An Introduction to Design for Social Innovation* (Cambridge, MA: MIT Press, 2015).

민주인권 디자인 워크숍

강연: 게이코 세이, 장문정
멘토: 김경원, 이동훈, 강유미
참여: 동서대학교 디자인대학 재학생
　　　김민지, 김예슬, 김채현, 문동엽, 박규리, 박세인, 박상하,
　　　양은희, 이예슬, 이지영, 최지은, 황지원

일자: 2023년 6월 29일-30일
장소: 동서대학교 디자인대학
주최 및 주관: 동서대학교 SDGs 센터
후원: 아시아미래디자인연구소, 이은콘텐츠
도움 주신 분들: 이명희(SDGs 센터장), 자오이웨이(촬영), 정무현(진행)

민주주의 포스터 프로젝트를 기획하고 진행하면서 우리에게 던져진 많은
숙제 중 하나는 실천적 디자인 교육이었다. 젊은 미래의 디자이너들은
민주주의를 어떻게 마주하고 있을까. 인권을 생각할 때, 디자이너는
어디서부터 무엇을 시작해야 할까. 이러한 질문과 함께 민주인권 관련
디자인의 실천적 모델은 어떤 것들이 있을까에 대한 탐구를 위해서 민주인권
디자인 워크숍을 준비하게 되었다. 부산에 있는 동서대학교 SDGs 센터와
아시아미래디자인연구소, 그리고 이은콘텐츠의 지원과 협업이 이루어졌고,
동서대학교의 디자인대학 재학생들의 참여로 워크숍을 진행할 수 있었다.
　　우선, 참여자들이 살고 있는 부산과 관련한 민주주의 역사 읽기를
이 워크숍의 시작점으로 삼고, 사전모임 날 부산 앞바다가 내려다보이는
민주공원길에서 만났다. 참여자들은 부산민주공원 입구의 장승터에서
넋기림마당(추념의 장)을 거쳐 민주항쟁기념관까지 함께 걸으며, 부마민주항쟁
(1979)을 중심으로 한국 민주화 운동에 관한 역사를 보고, 읽었다. 과거로의
시간 여행을 하면서, 다른 시대를 살았던 사람들의 경험과 정보를 각자의
방식으로 느끼고, 기록하였다.

첫째 날, 참여자들은 특별 강연을 통해서 민주주의와 디자인의 관계를 바라보는 새로운 시각들을 접하였다. 미디어 활동가이자 큐레이터인 게이코 세이는 "충동: 내면의 창조적 힘(URGE: the creative power from within)"이라는 강연에서 내면의 목소리와 어떤 강한 '충동'(urge)은 디자이너에게 중요한 힘이라고 말했다. 또한 디자이너는 인간이기 때문에 부당한 것에 맞서고 싶은 감정, '충동'을 가질 수 있으며 이러한 감정을 무시하지 않고 창조적이고 효과적인 행동으로 전환한다면 보다 민주적인 사회에 가까워질 수 있다고 강조했다. '충동'을 '창조적인 행동'으로 옮기려는 과정에서 많은 디자이너들이 즉각적 효과(urgent effect)와 불변하는 가치(permanent value) 사이에서, 혹은 지역적 효과(local effect)와 보편적 가치(universal value) 사이에서 갈등하게 되지만, 이러한 가치들은 서로 다른 것이 아니라 동시에 이루어진다고 설명했다. 예를 들어 2021년 미얀마 쿠데타에 대한 저항 시위에서 시민, 디자이너, 예술가들이 저항이라는 감정, '충동'을 '창조적 행동'으로 옮겨낸 결과로, 쿠데타 발생 후 3일간의 긴 침묵에 이어 일어난 비조직적이고 지역적인 소규모 시위(Pots and Pans)가 점차 조직적·전문적 대규모 시위로 확대되어 간 사례를 소개했다.

이어서 민주주의 포스터 프로젝트 감독 장문정은 "민주인권, 그래픽 상상과 행동"이라는 강연을 통해 물리적으로 무언가를 본다는 것이 상당히 제한적이며, 그렇게 본 것을 시각화하는 과정에서 많은 정보와 의미들이 의도적 혹은 비의도적으로 누락되거나 배제될 수 있다고 설명했다. 이러한 맥락에서 민주인권을 대하는 자세로 사회적·문화적·역사적 편견을 성찰하고 의도적으로 배제된 것을 보려는 '적극적 보기'가 필요함을 주장했다. 그 적극적 보기의 예시로 디자인 탈식민지화 담론과 실천 방향, 즉 지배 디자인에 대해 인식하기, 비유럽 중심 디자인에 대해 상상하기, 익숙한 것에서 벗어나기, 소수 발언 경청하기, 다양한 디자인 역사·미학·정체성 발견하기 등의 사례들을 소개하였다. 예를 들면 동학혁명(1894)을 역사 학습의 새로운 패러다임으로 구축하고 실험했던 〈디자이너, 역사를 읽다〉 프로젝트(2002), 미국 학생 비폭력 조정 위원회(Student Nonviolent Coordinating Committee, SNCC)와 시민권 운동(1960년대)을 재맥락화한 시각디자인과 서체디자인, 최근 미국 디자인 교육계에서 활발히 논의되고 있는 블랙디자인 역사 리서치, 다양한

디자인 정체성을 향한 블랙 디자이너들의 연대와 실천 등이다. 덧붙여 같은 맥락에서 이 워크숍의 계기가 된 민주주의 포스터 프로젝트에 참여한 작가들과의 포스터 작업을 공유했다.

강연 후 참여자들은 세 팀을 이루어 부산민주공원에서 기록했던 생각의 조각들, 1979년 부마민주항쟁 및 부산 민주화 운동의 역사에 대한 이해, 그리고 특별 강연에서 배운 새로운 시각과 디자인 사례 등을 정리하는 인식의 지도 그리기를 통해 민주인권과 관련한 개념어를 공유하였다.

둘째 날, 참여자들은 인식의 지도를 리뷰하면서 개념어들을 분석하고 재배치하여, 부산이라는 공간과 평등을 상징하는 공통 개념어 '수평선'을 도출해 내었다. 각 팀은 공통 개념어 '수평선'을 바탕으로 다양한 문장과 시각적 구성으로 발전시켰고, 이를 짧은 모션 그래픽으로 시각화하였다. 첫 번째 팀은 미얀마 저항문화의 '소리'에서 글자 '평등'으로, 또 수평선으로 변환되는 소리의 시각화를 제시해 주었다. 두 번째 팀은 반복되는 차별과 혐오의 역사를 상자에 갇혀 풀리지 않은 채 무한 반복되는 뫼비우스의 띠에 비유하고, 그러한 역사를 극복하는 과정을 무한한 수평선으로 표현하였다. 부마민주항쟁에서 영감을 받았던 세 번째 팀의 작업은 민주화 운동에서 희생된 사람들의 용기를 기념한다는 것은 지금 '연대의 힘, 촛불의 의미'를 지속하는 것임을 표현해 주었다. 참여자들은 평소에 접하지 못했던 주제를 갖고 이야기 나누는 것에 대한 새로움, 역사 읽기와 인식의 중요성, 사회문화적 디자인에 대한 진실한 관심, 디자인 행동에 대한 소감 등을 밝혔다. 참여자들의 작업을 동서대학교 미디어아트갤러리에서 상영하는 것으로 워크숍은 마무리되었다. 이 워크숍을 통해서 역사를 기념하고 시각적으로 말하는 것이란 익숙하지 않은 것들을 인식하고 이해하고 공감하는 것이며, 우리가 가진 감각·지각·직관을 창의적인 디자인 행동으로 전환하는 것임을 확인할 수 있었다.

Design Workshop
for Democracy and Human Rights

Lecturers
Keiko Sei, Moon Jung Jang

Mentors
Kyungwon Kim, Lee Dong Hun, Yumi Kang

Participants
Students at College of Design, Dongseo University
Kim Min Ji, Kim Yeseul, Kim Chaehyun, Moon Dong Yeop, Gyuri Park, Sein Park,
Park SangHa, Yang Eunhee, Lee Yeseul, Lee Jiyoung, Choe JiEun, Hwang Jiwon

Date
June 29-30, 2023

Venue
College of Design, Dongseo University

Hosted and organized by
DSU SDGs Center

Sponsored by
Asia Design Center for Future (ADCF), eeuncontents

Thanks to
Myunghee Lee (director, DSU SDGs Center), Zhao Yiwei (videographer),
Moo Hyun Jung (coordinator)

While developing and executing the Democracy Poster Project, one of the many tasks thrown our way was providing praxis-based design education. How are young designers of the future confronting democracy? What should designers do and where should they start when considering human rights issues? To build on such questions, we prepared a workshop to explore praxis-based models for design related to democracy and human rights. Our workshop was made possible thanks to the participation of students from Dongseo University's (DSU) College of Design, and the support from and collaboration with DSU's Sustainable Development Goals Center (SDGs), Asia Design Center for Future, and eeuncontents.

The workshop began with reading centered around the history of democracy in Busan, where many of the participants live. One

day prior to the workshop, we met at Democracy Park, which overlooks the Busan coastline. Participants learned about South Korea's democratization movement, with a focus on the 1979 Busan–Masan Uprising, as we walked from Jangseung yard, past the Memorial Sculpture, and into the Democratic Struggle Memorial Building. This opportunity to travel to the past allowed each person to feel and document, in their own way, the experiences and details of those that lived in an era different from ours.

On the first day of the workshop, two special lectures introduced participants to perspectives on the relationship between democracy and design. Keiko Sei, a media activist and curator, discussed how our inner voice and certain strong "urges" are an important source of power for designers in her lecture "URGE: the creative power from within." She also emphasized that designers are humans who experience the feelings of "urges" that motivate them to confront certain injustices. If they can keep from ignoring such feelings and channel them into creative and effective action, humankind can draw closer to a more democratic society. In the process of moving towards "urges" and "creative action," many designers find themselves conflicted between immediate effect and permanent value, or local effect and universal value, but Sei explained how these values are not all that different from one another. Per her example, in the protests over the 2021 Myanmar coup d'état when citizens, designers, and artists shifted their urges—or feelings of resistance—towards "creative action." There was a long, three–day silence after the coup d'état, followed by unorganized, regional small–scale pots–and–pans protests, which gradually developed into organized, specialized large–scale protests.

In the second lecture, "Democracy and Human Rights: Graphic Imagination and Action," Moon Jung Jang, director of the Democracy Poster Project, said that there are limitations to physically looking at something. Jang explained that viewing things can lead to the omission and exclusion—whether intentional or not—of a great deal of information and meaning. In this context, she argued for "active viewing" when dealing with democracy and human rights

issues. We need to reflect on social, cultural, and historical biases to see that which has been intentionally excluded. To illustrate the idea of active viewing, she spoke about design decolonization discourse and practice, namely, recognizing oppressive designs, imagining non-Eurocentric design, breaking out of the familiar, actively listening to what minorities have to say, discovering diverse design history, aesthetics, identity, and more. Examples include the 2002 project Designer: Reader of History, which constructed and tested a new paradigm of learning history with the Donghak Peasant Revolution of 1894; the re-contextualized visual and font design of the 1960s US Civil Rights Movement and Student Nonviolent Coordinating Committee (SNCC); research on Black design history, which is actively being discussed in current US design education; and the solidarity and practices of Black designers working towards diverse design identities. From this same context, Jang went on to share the poster designs of artists who participated the Democracy Poster Project.

After the lectures, participants separated into three groups to share concepts related to democracy and human rights through a cognitive mapping activity. Here, they organized the thoughts they recorded in Democracy Park, their understanding of the history of the 1979 Busan-Masan Uprising and the Busan Democratic Movement, as well as new perspectives and design examples from the lectures.

On the second day, participants analyzed and rearranged their concepts together while reviewing the cognitive maps, and eventually settled on the common concept of "horizon" to symbolize both equality and Busan. Based on this idea, each group developed a variety of textual and visual compositions which were then turned into short motion graphics. The first group presented a visualization of sounds in which the "sound" of Myanmar's culture of resistance was converted into letters of "equality," and once more into a horizon line. The second group compared a history of repeated discrimination and hate to a Möbius strip locked inside a box, and used infinite horizon lines to express the process of overcoming history. The third group, inspired by the Busan-Masan Uprising, shared work that expressed

how celebrating the courage of those killed in the pro-democracy movement helps the "power of solidarity and the significance of revolutionary desire" to persist into the present day. Participants expressed feelings of newness regarding the discussion of a subject they hadn't broached before, of the importance of reading and recognizing history, of a sincere interest in socio-cultural design, and the action inspired by design activism. The workshop concluded with a display of the participants' work at DSU's Media Art Gallery. Through this workshop, we were able to identify that celebrating history and sharing visual messages entails recognizing, understanding, and empathizing with the unfamiliar, and that our senses, perceptions, and intuitions can be converted into effective action through creative design.

작가 약력

가스 워커

1957년 남아프리카공화국 출생. 남아프리카공화국 거주 및 활동.

가스 워커의 스튜디오인 미스터 워커(Mister Walker)는 다수의 남아프리카공화국 저명 기업 및 브랜드의 디자인을 진행했다. 그러나 가스 워커 개인의 관심은 '무엇이 나를 아프리카인으로 만드는가, 그리고 그것은 어떤 모습인가?'에 있다. 1994년 남아프리카공화국 최초의 민주주의 선거 이후 『아이 주시』(ijusi) 1호가 출간됐고 세계적인 호평을 받았다(www.ijusi.com). 그의 작품은 주요 미술관에서 전시되었고 수많은 책과 잡지에 실렸다. 가스 워커는 국제그래픽연맹(Alliance Graphique Internationale, AGI) 및 영국 디자인 & 아트 디렉션(D&AD) 회원이며 타이프 디렉터스 클럽(뉴욕) 종신회원이다.

게릴라 걸즈

1985년 결성. 미국 기반.

게릴라 걸즈는 익명의 예술가·활동가 그룹이다. 예술, 영화, 정치, 대중문화에 깃든 젠더와 인종에 대한 편견과 부패를 폭로하기 위해 노골적인 헤드라인, 눈에 띄는 시각효과, 허를 찌르는 통계를 사용한다. 모두를 위한 인권을 위해 싸우는 상호교차성 페미니즘(intersectional feminism)을 실천하며 하층부, 행간, 간과된 것, 누가 봐도 부당한 것을 드러냄으로써 주류적 서사를 허물어뜨리는 작품을 내놓는다. 전 세계 여러 미술관 전시 작품뿐 아니라 거리 포스터, 현수막, 활동, 책, 영상 등 수백 편에 이르는 작품을 창작했다. '한 가지 일을 하라. 그것이 효과를 발휘하면 또 다른 일을 하라. 효과가 없어도 어쨌든 또 다른 일을 하라. 계속해서 야금야금 침투하라. 창의적 항의는 효과가 있다!' 이것이 게릴라 걸즈의 모토다.

골든 코스모스
(도리스 프라이고파스, 다니엘 돌즈)

1983년 독일 출생. 독일 거주 및 활동.

골든 코스모스는 도리스 프라이고파스와 다니엘 돌즈가 결성한 2인조 팀이다. 예술가이자 일러스트레이터인 골든 코스모스는 독일 베를린에서 활동하고 있다. 두 사람은 각각 드레스덴과 에르푸르트에서 출생했다. 도리스 프라이고파스는 베를린 바이센제 예술학교에서 공부했고, 다니엘 돌즈는 베를린 HTW에서 공부한 뒤 바이센제 예술학교에서 예술 석사 학위를 받았다. 골든 코스모스는 매주 『뉴요커』, 『뉴욕타임스』, 『워싱턴포스트』, 『디 차이트』(Die Zeit) 등 세계 유수의 언론 매체와 작업하고 있다.

국지은

1991년 대한민국 출생. 대한민국 거주 및 활동.

인간과 인간, 사회, 생태 등 다양한 대상 사이의 관계적 가치를 고민하며, 타이포그래피와 그래픽을 기반으로 하는 시각 예술의 영역에서 디자이너가 할 수 있는 '실천'의 방식을 탐구하고 있다.

굿퀘스천(우유니, 신선아)

1991년 대한민국 출생. 1993년 대한민국 출생. 대한민국 거주 및 활동.

대전과 서울을 기반으로 활동하는 디자인 스튜디오로, 다양한 분야의 구성원들과 함께 좋은 질문을 발굴하고 새로운 질서를 만들기 위해 노력한다. 최첨단 변화구파 신선아는 대전 페미니스트 문화기획자 그룹 'BOSHU'와 비혼 여성 커뮤니티 '비혼후갬' 운영을 병행하고 있다. 대담무쌍 강속구파 우유니는 페미니즘 출판사 '봄알람' 운영을 병행하고 있다. '페미니스트 디자이너 소셜 클럽(FDSC)' 열심회원들이다.

권민호

1979년 대한민국 출생. 대한민국 거주 및 활동.

드로어, 일러스트레이터. 영국 센트럴 세인트 마틴스와 왕립예술대학원(RCA)에서 비주얼 커뮤니케이션을 공부했다. 드로잉과 뉴미디어를 기반으로 일러스트레이션과 순수 회화의 경계를 넘나들며 작업하고 있다. 도면의 형식을 빌린 흑백의 그림에 빛으로 움직임과 색을 입히고 구조물 만들어 공간에 세운다. 특정한 장소를 시간과 사회적 사건의 연속된 흐름 위에서 보려고 노력한다. 그 장소가

가지는 역사적 사실, 사회 정치적 맥락(context)을
모아 직관과 상상으로 엮어 시각화한다. 런던 팩툼
아르테(Factum-Arte), 봄파스 앤 파르(Bompas
& Parr), 조타 스튜디오(Jotta Studio), RA
등과 일했고 저우드 드로잉 프라이즈, V&A
일러스트레이션 어워즈, 런던 디자인 페스티벌
서스테인 RCA 등에서 수상했다. 국립현대미술관
덕수궁 야외프로젝트, 타이포잔치 2017 등에서
작업을 선보이고 전시를 기획했다. 《새벽종은
울렸고 새아침도 밝았네》(문화비축기지, 2020),
《권민호: 회색 숨》(국립현대미술관 청주, 2020) 등의
개인전을 열었다. PaTI 일러스트레이션 스튜디오의
마루로 재직 중이다.

다이애나 에자이타

1985년 이탈리아/나이지리아 출생. 독일 거주 및 활동.
다이애나 에자이타는 베를린에서 활동하는
일러스트레이터이자 직물 디자이너다. 그녀의
일러스트는 부드러운 패턴 및 질감과 이에 대조되는
흑백의 영역이 극적 대비를 이루며, 여성의
힘을 드러내는 이미지를 만들어 낸다. 이탈리아
크레모나에서 출생했고 나이지리아 혈통을 지닌
에자이타는 예술 활동을 통해 자신의 혈통에 대해
경의를 표한다.
"나는 대체로 중앙아프리카 문화에 깊이 몰두하며,
문학과 예술, 전통 직물을 사랑한다. 인종적 배경이
다른 부모님 사이에서 태어나 이민을 경험하면서
식민/탈식민 사회의 영향, 인종 및 젠더 차별, 정체성
탐구 같은 문제에 깊은 관심을 갖게 되었다."

디스 애인트 로큰롤
(찰리 워터하우스, 클라이브 러셀)

2009년 결성. 영국 기반.
디스 애인트 로큰롤은 클라이브 러셀과 찰리
워터하우스의 스튜디오이다. 그들의 작품은 변화를
촉구한다. 가장 유명한 작업으로는 환경단체
'멸종저항'(Extinction Rebellion)과의 협업과
지역화폐인 브릭스턴 파운드(Brixton Pound)
디자인이 있다. 디스 애인트 로큰롤의 작품은
빅토리아 앤 알버트 뮤지엄, 뉴욕현대미술관,

영국박물관, 스미스소니언 등 여러 기관에 전시 및
소장되었다.

디자인 & 피플

2003년 결성. 인도 기반.
디자인 & 피플은 전쟁, 장애, 정치적·환경적 이유로
불이익을 받는 사람들의 삶을 개선하기 위한
오늘날의 노력에 디자인이 기여할 수 있는 방법을
모색한다. 인도에 기반을 둔 이 비영리 기관은 그래픽
디자이너, 산업 디자이너, 건축 디자이너가 사회적·
인도적 프로젝트에 자신들의 경험과 기술을 적용할
수 있도록 결속시키고 격려한다.

레이븐

레이븐은 2012년 미얀마 양곤의 국립경영대학을
졸업하고 광고회사 카피라이터로 일했다. 어린
시절부터 주요 관심사는 그림이었으며, 그래픽
디자이너 동료를 통해 디지털 아트를 접하게
되었다. 이후 미술을 배우기로 결심하고, 2017년
그래픽 노블 전공으로 싱가포르 라셀 예술대학교에
입학해 2020년 졸업했다. 현재 프리랜서
일러스트레이터이자 전업 예술가로 일하고 있다.
2019년 《Word Therapy》와 《Building Bridges》,
2022년 4월 《MidSummer》 등의 전시에
참여했으며, 2022년 9월 첫 개인전 《18/29》를
열었다.

로시 루즈베하니

1985년 이란 출생. 영국 거주 및 활동.
로시 루즈베하니는 이란의 프리랜서 일러스트레이터로,
이란 테헤란에서 태어나 자랐으며, 현재는 영국
런던을 기반으로 활동하고 있다. 『뉴요커』, 『가디언』,
『워싱턴 포스트』, 국제앰네스티와 협업하여 사회적
문제에 대한 논설 및 인물의 일러스트를 제작한다.
성평등과 여권 신장에 깊은 관심을 갖고 있으며 이런
주제들을 작품의 중심에 둔다. 유럽, 미국, 이란에서
개최한 그룹전에 여러 차례 참여했고 그녀의 작품은
『크리에이티브 붐』(Creative Boom), 『디자인
위크』(Design Week), 『미들 이스트 아이』(Middle
East Eye) 등에 수록되었다. 『영감을 주는 이란

여성 50인』(50 Inspiring Iranian Women)의
일러스트레이터이자 저자이다.

루이스 마존

1986년 스페인 출생. 스페인 거주 및 활동.
루이스 마존은 일러스트레이터이자
애니메이터이다. 그는 손이나 디지털 브러시를
이용하여 일러스트를 채색 또는 스케치하고 거기에
반복되는 움직임으로 활기를 불어넣는다. 마존의
작품은 『뉴요커』, 『워싱턴포스트』, 『가디언』,
『뉴욕타임스』에 실렸다.

루카 손치니

1980년 이탈리아 출생. 이탈리아 거주 및 활동.
루카 손치니는 1980년 파르마 출생으로
밀라노 미술 아카데미를 졸업하고, 이탈리아의
일러스트레이터이자 디자이너로 활동하고 있다.
오랜 기간 회화 작업을 해왔으며, 현재는 출판 및
광고 분야에서 개념적 일러스트와 시각적 소통에
중점을 두고 있다.

마크 고잉

1970년 오스트레일리아 출생. 오스트레일리아
거주 및 활동.
마크 고잉은 오스트레일리아 시드니에서 작업하는
예술가이자 타이포그래퍼이다. 그는 예술 및
디자인 서적 출판사 '포미스트 에디션'(Formist
Editions)과 표현적(expressive) 폰트 및
커스텀 타이포그래피 전문 스튜디오 '포미스트
파운드리'(Formist Foundry)의 설립자로 35년
이상 활동하고 있다. 고잉은 수많은 서체 및 출판
프로젝트를 진행했으며, 그가 개발한 서체 중에는
보울더 모노(Boulder Mono), 세로스(Serous),
실험적인 성격의 논(NON) 서체 등이 있다. 가장
최근에는 카피톨(Kapitol) 서체 시리즈와 함께
한정판 박스 세트를 제작했다. 최근 '포미스트'에서
출간된 『Inside the Oblong』에 고잉이 제작한
포스터들이 수록되어 있다. 고잉은 폴란드 바르샤바
제22회 국제포스터비엔날레, 이탈리아 토리노의
디비에토 다피시오네(Divieto d'Affissione),

오스트레일리아 멜버른 모나시대학교에서 개인전을
열었고, 시드니 컨템포러리 아트 페어에서 작품을
선보이기도 했다. 고잉은 AGI 회원으로, 그의 작품은
미국 뉴욕의 쿠퍼 휴잇 스미소니언 디자인미술관 등
다수의 기관 컬렉션에 포함되어 있다.

멜린다 베크

1966년 미국 출생. 미국 거주 및 활동.
멜린다 베크는 브루클린을 기반으로 25년 이상
일러스트레이터, 애니메이터, 그래픽 디자이너로서
활동했다. 베크는 두 차례 에미상 후보로 지명되고
일러스트레이터 협회에서 메달을 받았으며,
그 밖에도 수많은 상을 받았다. 베크가 작업한
정치적 일러스트 연작은 미국 국회도서관에 영구
소장되었다. 최근 프로젝트로는 연방법 타이틀
나인(TITLE IX, 교내 성차별 금지법안) 통과와 50주년
기념우표 연작, 24m 길이의 필라델피아 벽화
프로젝트, 42번가 5번 애비뉴에 리모델링한 뉴욕
공립도서관 청소년 센터를 위한 벽화 연작, 직접
쓰고 그린 그림책 『우리에겐 형태가 있어요』(We
Are Shapes) 등이 있다.

문상현

1986년 대한민국 출생. 대한민국 거주 및 활동.
문상현은 로드아일랜드 디자인스쿨 학사, 서울
대학교 시각디자인 석사 학위를 받았다. 그는
워커아트센터, 한화그룹, 현대자동차 크리에이티브
웍스에서 일했다. 그의 작품은 구글 디자인, CNN,
WIRED에 소개되었다. 2012년 그는 PRINT의 '30세
이하의 신진 비주얼 아티스트 20인'에 선정되었다.
문상현의 작품은 샌프란시스코 현대미술관,
필라델피아 미술관, 파리 장식미술관에 영구
소장되었다. 현재 그는 서울에서 디자인 컨설턴트
회사 '그리드'(Grid)를 운영하고 있다.

미콜라 코발렌코

1973년 우크라이나 출생. 슬로바키아 거주 및 활동.
미콜라 코발렌코는 우크라이나 출신의 그래픽
디자이너이다. 그는 키이우의 미하일로 보이추크
장식·응용미술디자인 국립 아카데미에서 수학했다.

디자인 분야에서 20년간 경력을 쌓았으며, 자신의 이름을 딴 '미콜라 코발렌코 스튜디오'를 운영하고 있다. 그는 우크라이나 아트 디렉터 클럽 명예 회원이자 슬로바키아 아트 디렉터 클럽 회원이며, 우크라이나 그래픽 디자이너 협회 'The 4-th Block'과 체코 브루노비엔날레 디자이너 협회 회원이다. 레드닷 디자인 어워드(독일), 골든 드럼(슬로베니아), 유러피언 디자인 어워드(그리스), 그라피스(미국) 등 국제 디자인 공모전 및 페스티벌에서 150여 개의 상을 받았다. 그는 우크라이나, 스페인, 벨라루스 등 여러 나라에서 개최한 국제 디자인 페스티벌에서 심사위원단으로 활약했으며, 국제 전시회에 정기적으로 참여한다. 또한 우크라이나, 슬로바키아, 폴란드 등지에서 포스터 개인전을 열고, 그래픽 디자인에 대한 강연과 워크숍을 진행하기도 한다. 그의 작품들은 세계 여러 잡지와 도록에 수록되었으며, 다수의 문화적·사회적 국제 프로젝트를 만들고 있다.

박새한

1989년 대한민국 출생. 프랑스 거주 및 활동.
1989년 2월 4일 한국 출생으로 현재 프랑스 스트라스부르에 거주하며 활동 중이다. 만화의 도시 부천에서 자란 박새한은 한국, 일본, 유럽 등 여러 나라의 만화에서 다양한 영감을 얻었다. 한국과 프랑스에서 공부했고, 특히 프랑스 루인 고등미술학교(HEAR)에서 일러스트를 공부하면서 자신만의 목소리를 찾았다. 현재 박새한의 작품은 『뉴욕타임스』, 『블룸버그 비즈니스위크』 등의 신문과 주간지에 실리고 있다. 첫 번째 동화책 『아빠 풍선』(Papa Ballon)으로 2021년 ADAGP 그림책상을 받았다. 호기심이 많고, 그림 그리는 것과 그림을 그리고 싶게 만드는 것을 좋아하며, 그러면서도 자신에게 중요한 가치를 잊지 않는다. 또한 한국의 여성 시각예술인 네트워크 '루이즈 더 우먼'(Louise the Women)의 멤버이기도 하다.

베른하르트 렝거

1991년 오스트리아 출생. 네덜란드 거주 및 활동.
베른하르트 렝거는 네덜란드를 기반으로 활동하는 오스트리아 출신의 디자이너다. 렝거는 연구와 디자인을 통해 사회의 난제를 다루는 기관 및 회사들을 지지하는 작업을 하는 것으로 유명하다. 렝거는 환경, 기술, 사회적 의제에 집중하면서 사회적 문제를 새롭게 조명하고 사람들이 사회적 변화에 일조하도록 도와 그 능력을 폭넓게 인정받았다. 그는 양적 연구와 질적 연구의 독특한 조합, 전략적 디자인, 사회 변화를 촉진하는 이해 당사자들과의 협업 등을 통해 작업한다. 렝거는 베른하르트 렝거 스튜디오와 창의적인 혁신 기관 '왓츠더매터'(What's the Matter)를 설립했고 '파운데이션 위아'(Foundation We Are)에서 크리에이티브 디렉터로 일하고 있다.

빅토리아 치혼

1990년 독일 출생. 독일 거주 및 활동.
빅토리아 치혼은 2014년 뉘른베르크 게오르크 시몬 옴 대학교에서 일러스트레이션 전공으로 학사 학위를 받았다. 디자인 에이전시 안슐레게.데(anschlaege.de)에서 인턴으로 근무했고 예술가 컬렉티브 클룹지벤(Klub7)과 협업했다. 2019년에는 다섯 명의 창작자와 함께 베를린 노이쾰른에 디자인 컬렉티브 더 보이스 클럽(The Boys Club)을 설립했다. 베를린 노이쾰른에서 거주하면서 프리랜서 디자이너로 활동 중이다. 인쇄물, 온라인, 애니메이션으로 손 글씨 디자인이 결합된 다양한 종류의 일러스트 작품을 창작하며, 창문이나 벽 같은 대형 평면에도 그림을 그린다. 사람의 별난 행동, 페미니즘 운동, 우스운 것들 등에서 영감을 얻어 재미있는 캐릭터와 정곡을 찌르는 대사로 변환시킨다.

사키 호

1985년 홍콩 출생. 독일 거주 및 활동.
사키 호는 독일 함부르크를 기반으로 활동하는 독립 그래픽 디자이너이자 연구자다. 홍콩에서 성장하고 그 외 다양한 문화적 맥락을 지닌 도시에서 생활한 경험에서 영감을 얻어 타이포그래피 작품을 통해 언어와 문화적 차이의 모호성을 탐구한다. 세계적인 예술·문화 프로젝트에 참여했으며 홍콩, 일본,

네덜란드, 독일 등지에서 작품을 선보였다. 브랜딩과 협업을 위한 창의적인 전략에 특성화된 '리서치 스튜디오'(Research Studio)의 창립자이기도 하다. 독창적인 관점과 전문 지식을 갖추고 여러 프로젝트에 기여하며 좋은 평판을 받고 있다.

세바스티안 큐리

1986년 아르헨티나 출생. 미국 거주 및 활동.

세바스티안 큐리는 로스앤젤레스를 기반으로 활동하는 아르헨티나 일러스트레이터이자 애니메이터이다. 그는 크고 대담한 형태와 진한 선을 사용해 다채로운 캐릭터를 창조한다. 원래 애니메이터인 세바스티안은 약 10년간 애니메이션 산업에 종사했고 이후 노선을 변경해 일러스트레이션 작업에 집중하고 있다. 그는 자신의 경험을 바탕으로 자신만의 강렬한 세계 속에서 사는 특이한 인물들을 중심으로 하는 독특한 스타일의 일러스트레이션을 개발했다.

스튜디오 하프-보틀

2019년 결성. 대한민국 기반.

스튜디오 하프-보틀은 그래픽디자인과 저널리즘·출판 컨텐츠를 제작한다. 인쇄물, 브랜딩, 웹페이지, 전시 작업을 통해 의뢰인의 입장과 스튜디오가 가진 관점을 드러낸다. 스튜디오 하프-보틀은 "물이 (겨우 반 병/반 병이나) 남았다."며 엇갈리는 사람들의 생각과 감정에 주목하고, 이들이 서로 연대하고 경쟁하여 세계가 진보하도록 이끄는 작업을 추구한다.

스튜디오 헤잔느 달 벨로

2014년 결성. 영국 기반.

스튜디오 헤잔느 달 벨로는 의미 있고, 참여를 유도하며, 지속적인 작품을 창작하는 디자인 스튜디오이다. (새로운 브랜드, 디지털 경험, 책 등을 비롯한) 모든 작업에서 중점이 되는 것이 무엇인지 찾아내려 애쓴다.

강력하고, 감동적이고, 효율적인 방식으로 사람들의 믿음을 명확하게 전달하는 것을 목표로 삼아, 디자인의 힘에 열광하는 이들과 기꺼이 함께 일한다.

빠른 이동, 직접적인 협업, 대담한 작업을 위해 의도적으로 스튜디오를 소규모로 운영한다. 런던에 기반을 두고 적합한 전문가를 적재적소에 배치해 전 세계 사람들과 함께 일한다.

스튜디오 설립자 헤잔느 달 벨로는 대표적인 작품들로 다양한 상을 받은 이력이 있는 디자이너다. 20년의 그래픽 디자인 및 브랜딩 경력을 지닌 그녀는 울프 올린스(Wolff Olins, 영국), 스튜디오 둠바(Studio Dumbar, 네덜란드) 등에서 작업했으며, 최근에 카운터-프린트(Counter-Print)에서 출간한 『시민이 먼저, 디자이너는 그다음』(Citizen First, Designer Second)을 집필했다. 브랜드 아이덴티티, 그래픽 디자인, 브랜드 전략, 모션 디자인, 디지털 및 소셜 디자인, 편집 디자인, 패키지, 일러스트, 환경 디자인 작업을 주로 하고 있다.

시멘트(박용훈, 양효정)

2019년 결성. 대한민국 기반.

스튜디오 시멘트는 서울과 울산을 기점으로 활동하는 디자이너 그룹이다. 2명의 그래픽 디자이너를 주축으로 다양한 분야의 사람들이 유연하게 모이고 다시 각자의 자리로 돌아간다. 우리는 서로 다른 대상, 영역, 문화, 사람이 만나는 경계에 있으며, 관계의 가치를 중요하게 생각한다. 물질과 물질을 접착하는 물질이라는 의미를 가진 시멘트는 우리가 추구하는 디자인과 닮아있다. 우리는 다양한 모습으로 변화하며, 유연하고 실험적인 태도로 디자인을 마주한다. 앞으로도 우리는 깊이 있는 호흡으로 다양한 분야의 사람들과 관계를 맺고 협업할 방법을 찾고자 한다.

신인아

1985년 대한민국 출생. 대한민국 거주 및 활동.

그래픽 디자이너 신인아는 서울에서 디자인 스튜디오 '오늘의 풍경'을 운영한다. 디자이너에게는 사회적 책임이 있다고 배웠고, 논리적이고 맥락이 드러난 디자인만이 책임을 질 수 있다고 생각하기에 설명할 수 있는 작업을 한다. '카카오임팩트', '청년허브', '여성예술인연대' 등 주로 변화를 꾀하는

개인 및 조직과 함께해 왔다. '페미니스트 디자이너 소셜클럽'에서 활발히 활동 중이다.

안마노

1982년 대한민국 출생. 대한민국 거주 및 활동.
안그라픽스 크리에이티브 디렉터.
홍익대학교 시각디자인과와 스위스
바젤디자인학교(Hochschule für Gestaltung und Kunst)에서 그래픽 디자인을 전공했다.
서울국제타이포그래피비엔날레, 스위스
벨트포르마트포스터페스티벌, 시와 타이포그라피 잔치 등에 참여했으며 도쿄 타입디렉터스 클럽(TDC Tokyo), Output 어워드, 서울국제실험영화제, APD(Asia Pacific Design) 등에 작업이 소개되었다. 현재 파주타이포그라피배곳에 출강하고 있다.

애니나 테케프

1990년 독일/불가리아 출생. 독일 거주 및 활동.
애니나 테케프는 베를린을 기반으로 하는 일러스트레이터이자 그래픽 디자이너이다.
유엔여성기구, 『디 차이트』, 『베니티페어』(Vanity Fair)와 작업했다. 그래픽 디자인을 전공했고 독일과 스위스의 여러 디자인 회사와 광고 회사에서 일했으며, 2014년부터는 일러스트에 집중하고 있다. 인권, 평등, 기후변화 같은 주제들을 작품에 주로 다루고 있다.

에런 니에

1977년 타이완 출생. 타이완 거주 및 활동.
타이완의 선구적 그래픽 디자이너인 에런 니에는 2012년 타이완의 첫 번째 AGI 회원이 되었다.
미묘하면서도 도발적인 디자인으로 알려져 있으며, 중국어계 그래픽 디자인을 재정립하고 있다.
현재 타이페이와 가오슝에 있는 그의 스튜디오 '에런 니에 워크숍'(Aaron Nieh Workshop)은 심상(imagery), 상징, 재료를 섬세하게 사용하여 그래픽디자인에 새로운 관점을 도입한 것으로 명성이 높다.

엘리엇 스톡스

1988년 미국 출생. 미국 거주 및 활동.
엘리엇 스톡스는 로스앤젤레스를 기반으로 활동하는 예술가, 일러스트레이터, 아트 디렉터이다.
그는 드로잉을 바탕으로 하여 복수의 매체를 통해 탐구한다. 전반적으로 도전적인 정신이 담긴 그의 작품은 다수의 출판물에 실렸다. 엘리엇은 아시아계 미국인이자 퀴어인 자신의 정체성과 경험을 바탕으로 포스터 작업의 주제를 설정했다.

엘머 소사

1978년 멕시코 출생. 멕시코 거주 및 활동.
엘머 소사는 마케팅 석사를 이수한 그래픽 디자이너이자 일러스트레이터, 교수이다. 그는 2015년, 2019년, 2021년에 예술 창작 및 개발 장려 프로그램의 지원을 받았으며 아르헨티나 팔레르모 대학교 라틴 디자인 앰배서더였다. 2022년 픽토라인(Pictoline) 주관 라틴 아메리카 제3회 일러스트 비엔날레 우수상, 2020년 모스크바 그래픽디자인 국제비엔날레 골든비 상, 2019년 멕시코 오악사카 제4회 국제포스터 비엔날레 1위, 2017년 러시아 골든터틀 2위, 2017, 2012, 2011년 독일 무트 추어 부트상, 2014-2018년 포스터·일러스트 부문 디자인 상 및 2015, 2016년 소책자·포스터 부문 은상, 2016년 러시아 후쿠다 국제포스터대회 1위, 2016년 프라하 버추얼 비엔날레 우수상, 2013년 쿼룸 상, 2013년 쿠바 제18회 국제 그래픽 유머 비엔날레 우수상 등을 수상했다. 그의 작품은 폴란드, 이탈리아, 페루, 볼리비아, 베네수엘라, 쿠바, 프랑스, 우크라이나, 스페인, 미국, 러시아, 체코, 일본, 중국 등지에 전시되었다. '요미요미 스튜디오'(Yomi Yomi Studio) 아트 디렉터 그는 다수의 출판사를 위해 일러스트를 작업하며 여러 대학교에서 강의를 하고 있다.

오사와 유다이

1984년 일본 출생. 일본 거주 및 활동.
1984년생으로, 2006년 타마 예술대학교를 졸업하고, 광고회사에서 근무하다가 독립했다.
2010년대 중반부터 사회적 문제를 다루는

프로젝트를 위해 그래픽 작업을 만들기 시작했다. 그는 그래픽 디자인이 사회에 기여할 수 있는 방안을 지속적으로 모색하고 있다. 유다이는 또한 앰비언트 음악 그룹 언노운 미(UNKNOWN ME)와 아토리스(Atoris)의 멤버이기도 하다.

윤예지

1983년 대한민국 출생. 대한민국 거주 및 활동. 일상을 상상으로 엮어 그림을 그리는 일러스트레이터이다. 출판, 포스터, 광고 등 다양한 분야에서 여러 국적의 클라이언트들과 작업하고 있다. 기후위기, 동물권, 인권 등 좀 더 나은 세상을 위한 실천에도 관심이 많아 그림으로 메시지를 전하는 방법을 탐구 중이다. 동물권 행동 카라와 매년 서울동물영화제 포스터 작업을 하고 있고, 국제앰네스티 한국 지부와도 작업하고 있다. '세계인권선언'을 다시 읽는 『존엄을 외쳐요』라는 그림책을 작업했다.

이경민 (플락플락)

1986년 대한민국 출생. 대한민국 거주 및 활동. 그래픽 디자이너. 2012년부터 민음사 미술부에서 북디자이너로 3년간 근무했으며, 이후 그래픽 디자인 스튜디오 플락플락을 운영 중이다. 특히 퀴어 주제를 시각 언어로 바라보는 것에 관심이 많아 소수자·퀴어 단위들과 협업을 이어가고 있다. 관련 논문 「한국의 퀴어 연속간행물 아카이브 확장하기」(2023)로 서울시립대학교 디자인전문대학원 석사 과정을 졸업했다. 『민간인 통제구역』으로 2022년 '한국에서 가장 아름다운 책'을 수상했다.

이재영 (6699프레스)

1983년 대한민국 출생. 대한민국 거주 및 활동. 6699프레스는 이재영이 운영하는 그래픽 디자인 스튜디오이자 출판사다. 디자인 및 기획한 『New Normal』, 『1-14』로 2020년과 2023년 '한국에서 가장 아름다운 책'에 선정되었으며, 『한국, 여성, 그래픽 디자이너 11』, 『서울의 목욕탕』, 『너의 뒤에서』 등을 기획 및 출판했다. 2015년부터 2018년까지 한국타이포그라피학회에서 출판 국장을 역임하며 『글짜씨』를 만들었다. 현재 대학에서 타이포그래피와 북 디자인을 강의하고 있다.

이지원 (아키타입)

1987년 대한민국 출생. 대한민국 거주 및 활동. 이지원은 오늘날 비주류로 분류되는 담론에 관심을 두고, 이를 비판적으로 검토해 실천하는 작업을 한다. 출판사 아키타입(archetypes)을 운영하며 저술과 출판 활동 등을 통해 책과 기록물을 만들고 있다. 디자인문화연구서 『새시각』의 발행인이며, 자율디자인랩의 연구원, 페미니스트 디자이너 소셜 클럽의 회원으로 활동한다.

일레인 L

1993년 중국 출생. 미국 거주 및 활동. 일레인 L은 중국 상하이에서 태어나 자랐다. 일러스트레이션 전공으로 예술 석사 학위를 받은 일레인 L은 현재 미국 중서부에 거주하며 프리랜서 일러스트레이터로 활동 중이다.

일레인 로페즈

1984년 미국 출생. 미국 거주 및 활동. 일레인 로페즈는 쿠바계 미국인 디자이너이자 연구자, 예술가, 교육자이다. 그녀의 작품은 디자인계 내에서 문화, 정체성, 평등, 리소그라프(Risograph) 인쇄의 교차점을 탐구한다. 일레인 로페즈는 그래픽 디자인 전공으로 2007년 플로리다대학교에서 학사, 2019년 로드아일랜드 디자인스쿨에서 석사 학위를 받았다. 2019년부터 2021년까지 메릴랜드 예술대학교에서 AICAD 특별 연구생 장학금을 받고 그래픽 디자인 프로그램에서 학부생과 대학원생을 가르쳤다. 현재 파슨스 디자인 스쿨의 커뮤니케이션 디자인 조교수이다. 또한 AIGA 시카고, 타입 디렉터스 클럽 등 다양한 디자인 기관에서 위원으로 활동했다. 그녀의 작품은 STA:100, 《흑인 디자이너는 어디에 있는가?》 전시, 인/비저블 컨퍼런스 등 다양한 전시회, 출판물, 컨퍼런스에 소개되었다. 일레인 로페즈는 포괄적이고 평등한 디자인 공간 창출에

열성적이며 그녀의 작품 활동은 현존하는 디자인 패러다임에 이의를 제기한다.

일상의실천

2013년 결성. 대한민국 기반.

일상의실천은 권준호, 김경철, 김어진이 운영하는 그래픽디자인 스튜디오이다. 일상의실천은 오늘날 우리가 살아가는 현실에서 디자인이 어떤 역할을 해야 하며, 또한 무엇을 할 수 있는가를 고민하는 소규모 공동체이다. 그래픽디자인을 기반으로 하고 있지만, 평면 작업에만 머무르지 않는 다양한 디자인의 방법론을 탐구하고 있다.

조나단 반브룩

1966년 영국 출생. 영국 거주 및 활동.

조나단 반브룩과 그의 스튜디오는 영국에서 가장 잘 알려진 그래픽디자인 그룹 중 하나다. 반브룩 스튜디오는 데이비드 보위(David Bowie)의 주요 앨범 커버 디자인을 담당했고 보위의 마지막 앨범 〈블랙스타〉(Blackstar) 디자인으로 그래미상을 받았다. 반브룩 스튜디오는 또한 점령 운동(Occupy Movement), 뱅크시(Banksy), 애드버스터스(Adbusters) 등과의 협업으로 유명하다. 2005년 도쿄 긴자 그래픽갤러리와 2007년 런던 디자인미술관에서는 반브룩 스튜디오의 그래픽디자인 회고전이 열렸다. 2004년 한국에서 열린 《내일의 진실》(Tomorrow's Truth) 전에서는 북한 관련 프로젝트를 포함, 정치적 성격을 띠는 기존 그래픽 작품과 새로운 작품을 선보였다.

카로 악포키에르

1981년 나이지리아 출생. 독일 거주 및 활동.

카로 악포키에르는 전통적인 회화 기법과 디지털 기법을 융합하여, 그가 거주하는 도시에서 예리하게 인지해 낸 사회적·개인적·정치적 현실을 담은 대담한 작품들을 제작한다. 악포키에르의 작품에는 텍스트와 이미지의 밀접한 결합이 특징적으로 자주 나타나는데, 그는 이런 기법을 사용해 광범위한 가상의 담화와 비가상의 담화를 창출한다. 그는 제56회 베니스비엔날레, 제4회 몬테비데오비엔날레, 제20회 상파울루 세스크 비디오브라질 비엔날레 등 여러 비엔날레에 참여했다. 그의 작품은 잘츠부르크 현대미술관, 비트라 디자인미술관, 애틀랜타 하이 미술관, 함부르크 예술협회 등지에 전시되었다.

카테리나 코롤레프체바

1989년 우크라이나 출생. 우크라이나, 서유럽 거주 및 활동.

카테리나 코롤레프체바는 우크라이나 출신의 독립 브랜드 디자이너, 아트 디렉터, 서체 디자이너이다. 창의적 전략을 기반으로 타이포그래피에 집중하는 브랜딩 프로젝트에 열의를 갖고 있다. 그녀의 개인 프로젝트 중 하나로 잘 알려진 서체 미스토(Misto)는 체르노빌 원전 폭발 사고 이후 건설된 도시이자 자신의 고향인 슬라부티치에 대한 오마주 작업이다. 카테리나 코롤레프체바는 디자인 컨퍼런스(타이포그래픽스 NYC, ATypl 파리 등)에서 공개 강연을 하고 『Design Week』(디자인 위크), 『Alphabettes』(알파벳츠) 등의 잡지에 글을 기고한다. 타이프 디렉터스 클럽(Type Directors Club, TDC69) 공모전 서체 디자인 부문 심사위원이기도 하다. 우크라이나 디자인과 문화, 서체 디자인 유산에 대한 지식을 공유함으로써 세계 디자인 지도에 우크라이나를 새겨 넣기 위해 노력하고 있다.

크리스 리(이정민)

1981년 캐나다 출생. 미국 거주 및 활동.

크리스 리(이정민)는 레나페호킹(뉴욕 브루클린)을 기반으로 활동하는 그래픽 디자이너이자 교육자로, 프랫 인스티튜트 커뮤니케이션·디자인학부 부교수이다. 그는 오캐드대학교(토론토)와 샌드버그 인스티튜트(암스테르담)에서 수학하였으며 『월러스 매거진』(The Walrus Magazine), 메타헤븐 스튜디오, 브루스 마우 디자인에서 일했다. 그는 또한 『스케이프고트』(Scapegoat) 저널의 디자이너이자 편집위원이었다. 오노마토페이(Onomatopee/Library Stack)에서 출간한 저서 『불변: 디자인 역사』(Immutable:

Designing History)는 그래픽 디자인이
자본주의와 식민주의의 개발 및 영속화와 어떤
연관이 있는지 탐구한다.

크리스 버넷

1991년 미국 출생. 미국 거주 및 활동.
크리스 버넷은 로스앤젤레스에서 다방면으로
활동하는 작가이다. 버넷은 대단히 풍부한 표현력을
갖추고 다양한 창작 산업에서 10년 가까이 조용히
자신의 족적을 남겨 왔다. 추상적인 콜라주부터 논설
삽화, 앨범 및 제품 디자인, 캠페인 그래픽, 최근에는
패션 디자인 분야에 이르기까지 그는 진정한
팔방미인으로서 최대한 많은 창의적인 분야에
왕성하게 뛰어들었다. 진보적인 발상과 실험적인
접근법을 유지하는 버넷의 작품에는 추상적인
활기와 젊은 에너지가 약동한다.

크리스티나 다우라

1988년 스페인 출생. 스페인 거주 및 활동.
크리스티나 다우라는 라 마사나 예술학교에서
일러스트레이션을 공부하고 미국 볼티모어의
메릴랜드 예술대학교(MICA)에서 학업을 마쳤다.
졸업 후 다우라는 수년간 예술계와 관련이 없는
일을 했으나 결국은 항상 바랐던 대로 자신만의
일러스트레이션과 만화를 창작하는 데 전념하기로
결심한다. 놀랍게도 일이 잘 풀려 그 일을 지속할 수
있게 되었다. 최근에는 『뉴욕타임스』,『뉴요커』,『디
제니트』(Die Zenit),『SZ 매거진』(Süddeutsche
Magazine),『엘 파이스』(El País), 펭귄북스,
블래키북스, 플라네타(Planeta), 나이키,
모그(Moog), 라즈마타즈(Razzmatazz), 마드리드
시청, 도미노 레코드 등 다양한 고객을 상대하는
전업 일러스트레이터로 활동 중이다. 다우라는
바르셀로나, 빌바오, 파리, 리옹, 마르세유, 함부르크,
멕시코시티, 로사리오 등지에서 전시를 열었다.
다우라의 작품은 어린아이 같은 순수한 미학과
초현실주의적인 내러티브 사이를 넘나들고 있는
것으로 여겨진다. 다우라는 만화와 야수파 예술에서
가장 큰 영향을 받았고, TV와 인터넷에서도 영감을
얻는다.

킴 알브레히트

1987년 독일 출생. 독일 거주 및 활동.
킴 알브레히트는 문화적 · 기술적 · 과학적
형태의 지식을 시각화한다. 그의 작품은 재현의
구조를 전개하고 문제를 제기하며 기술과 사회의
미학을 탐구한다. 알브레히트는 바벨스베르크
콘라드 볼프 영화대학교 교수이며, 하버드대학교
메타랩(metaLAB) 책임연구원, 베를린 자유대학교
메타랩 디렉터, 하버드대학교 버크만 클라인 인터넷
및 사회 센터의 연구원이다. 포츠담대학교에서
미디어이론 박사 학위를 받았으며 하버드 미술관,
포 돔 파빌리온 브로츠와프, 아르스 일렉트로니카
센터, 쿠퍼 휴잇, 큐브 디자인 박물관, 카를스루에
예술미디어 센터(ZKM), 케스트너 게젤샤프트,
롱 비엔날레, 이스탄불 현대미술관, 쿤스트하우스
그라츠 등 여러 기관에서 전시를 했다.

파흐미 레자

1977년 말레이시아 출생. 말레이시아 거주 및 활동.
파흐미 레자는 말레이시아 쿠알라룸푸르에서
활동하는 적극적이고 정치적인 그래픽
디자이너이자 사회활동가이다. 파흐미 레자는
20년이 넘게 그의 작품과 사회활동을 통해
말레이시아 정부를 거침없이 비판해 왔고, 이 때문에
구속, 벌금, 규제, 징역 등 수많은 탄압을 받았다.
그는 적극적으로 예술과 사회활동, 정치를 혼합하며,
정치적 담화와 사회변화를 일으키는 매개체인
예술의 힘을 탐구하고자 불굴의 노력을 기울이며
왕성하게 활동하고 있다.

프라챠 수비라논트

1957년 태국 출생. 태국 거주 및 활동.
프라챠 수비라논트는 뉴욕 파슨스 디자인스쿨을
졸업했다. 그는 디자이너로서 SC 매치박스에서
1993년부터 2010년까지 일했다. 저서로는
『태국: 예술과 디자인 속 본연의 태국』(Thai: The
Vernacular Thai in Art & Design, Samesky
출판사, 2012),『디자인 + 문화 1-3』(Design +
Culture 1-3, Samesky 출판사, 2009-2011),
『레이-누 파냐디 1-3』(Rey-Noo Panyadee 1-3,

Samesky 출판사, 2011), 『태국 활자와 국가
태국의 10가지 얼굴(꼴)』(10 Faces of Thai Type
and the Nation, SC 매치박스, 2002), 『라에 누에
투에 낭』(Lae Nue Tue Nang, Matichon 출판사,
2001) 등이 있다.

프란체스카 산나
1991년 이탈리아 출생. 스위스 거주 및 활동.
프란체스카 산나는 이탈리아 그림책 작가로
시각적 스토리텔링과 서사적 일러스트레이션에
관심을 갖고 있다. 첫 번째 그림책 『긴 여행』(The
Journey)은 2017년 케이트 그리너웨이 메달 최종
후보에 올랐고, 클라우스 플루게 상을 수상했으며,
20개 이상의 언어로 번역 출간되었다. 최근작으로는
『쿵쿵이와 나』(Me and My Fear), 『내 친구
지구』(My Friend Earth), 『The More You Give』,
『If You Were a City』 등이 있다. 현재 취리히에
거주하며 활동하고 있으며 지중해의 조그만 섬인
고향과 바다, 고양이를 계속 그리워하고 있다.

하이 온 타입
(한스 슈텐벨드, 이보 브라우어, 줄리안 프리에,
귀도 드 보어, 빈센트 드 보어)
2014년 결성. 네덜란드, 프랑스 기반.
하이 온 타입은 서체에 대한 열정을 공유하는
(그래픽) 아티스트 5인으로 구성된 콜렉티브이다.
이들은 개별적으로 자신의 시각적 언어를
탐구하고, 협업을 통해 그 언어를 확장해 나간다.
직접적인 표현 방식인 쓰기(writing)를 통해 형태를
만들어 내는 이들의 작품은 남겨진 흔적으로서의
행위이기도 하다. 집단적이고 퍼포먼스적인 실험
작업을 통해 시각적 어휘의 경계를 확장하고 있으며,
쓰기를 통해 표현의 새로운 가능성을 찾고자 한다.

Artist Biographies

Karo Akpokiere

b. 1981, Nigeria. Lives and works in Germany. Karo Akpokiere's bold works combine traditional and digital drawing techniques to tell stories informed by his acute perception of social, personal, and political realities in the cities he inhabits. Akpokiere's work is often characterized by a close combination of text and image which he uses to create expansive fictional and non-fictional narratives. Akpokiere has participated in biennials including the 56th Venice Biennale, the 4th Montevideo Biennale, and the 20th Biennial Sesc_Videobrasil, Sao Paulo, and his work has been displayed in Museum der Moderne, Salzburg, Vitra Design Museum, High Museum of Art, Atlanta, and Kunstverein in Hamburg, among others.

Kim Albrecht

b. 1987, Germany. Lives and works in Germany.

Kim Albrecht visualizes cultural, technological, and scientific forms of knowledge. His diagrams unfold and question the structures of representation and explore the aesthetics of technology and society. Kim is a Professor at the Film University Babelsberg Konrad Wolf, principal at metaLAB at Harvard, director of metaLAB at FU Berlin, and a fellow at Berkman Klein Center for Internet & Society Harvard. Kim holds a Ph.D. from the University of Potsdam in media theory and exhibited, among others, at Harvard Art Museums, Four Domes Pavilion Wrocław, Ars Electronica Center, Cooper Hewitt, Cube design museum, ZKM Center for Art and Media Karlsruhe, Kestner Gesellschaft, The Wrong Biennial, Istanbul Contemporary Art Museum, and Kunsthaus Graz.

An Mano

b. 1982, South Korea. Lives and works in South Korea.

An Mano, creative director at Ahn Graphics (AG), majored in visual design at Hongik University in Korea and graphic design at Hochschule für Gestaltung und Kunst in Switzerland. He participated in the Seoul International Typography Biennale and the Poetry & Typography Festival in Korea, and the Weltformat Graphic Design Festival in Switzerland, and his works were presented at TDC Tokyo, the Output Award, the Experimental Film & Video Festival in Seoul, and Asia Pacific Design. He currently gives lectures at the Paju Typography Institute.

Jonathan Barnbrook

b. 1966, UK. Lives and works in the UK. Jonathan Barnbrook and his studio are one of the most well-known graphic design groups in Britain. They were David Bowie's main record cover designers, winning a Grammy for their design of his final album *Blackstar*. The studio is also known for their activist collaborations with the Occupy movement, Banksy, and Adbusters. Their contribution to graphic design was recognized by a retrospective at Ginza Graphic Gallery in Tokyo in 2005 and the Design Museum in London in 2007. In 2004 they had a major exhibition in South Korea entitled *Tomorrow's Truth* which featured existing and new political graphics works, including projects about North Korea.

Melinda Beck

b. 1966, USA. Lives and works in the USA. Based in Brooklyn, Melinda Beck has been working as an illustrator, animator, and graphic designer for over a quarter century. Her artwork has received numerous awards including two Emmy nominations and medals from the Society of Illustrators. A series of her political illustrations has been acquired by the Library of Congress for their permanent collection. Recent projects

include a series of stamps for the US Postal Service commemorating the 50th anniversary of the passage of TITLE IX, an eighty foot mural for Mural Arts Philadelphia, a series of murals for the teen center of the newly renovated Mid-Manhattan New York Public Library on 42nd St. and 5th Ave., and the children's book *We Are Shapes*, which she wrote and illustrated.

Chris Burnett

b. 1991, USA. Lives and works in the USA. Chris Burnett is a multi-disciplinary artist from Los Angeles, CA. With an unmistakably expressive style, Burnett has quietly been leaving his mark on various creative industries for almost a decade. From abstract collages to editorial illustrations, album art and merchandise, campaign graphics, and most recently a foray into fashion design, Burnett is a true polymath with aims of indulging in as many creative fields as possible. His work pulsates with abstract vibrancy and youthful energy, while maintaining a forward-thinking and experimental approach.

cement
(Yonghoon Park and Hyojung Yang)

Founded in 2019. Based in South Korea. Studio cement is a group of designers based in Seoul and Ulsan with two graphic designers at the group's center. Here, professionals from diverse fields gather organically to collaborate, later returning to their usual practices. The group values relationships and positions itself on the boundaries that lie between disparate subjects, areas, cultures, and people. Cement, which affixes one substance to another, symbolizes the kind of design pursued. The transformative group approaches design with a flexible and experimental attitude, and seeks to continue to find ways to relate to, collaborate with, and deeply resonate with people in a variety of fields.

Viktoria Cichoń

b. 1990, Germany. Lives and works in Germany.
Viktoria graduated in 2014 from Georg-Simon-Ohm University of Applied Science in Nuremberg with a bachelor's degree in illustration. She interned at anschlaege.de and worked together with Klub7 artist collective. In 2019 she founded the design collective The Boys Club in Berlin Neukölln together with five creatives. She has been freelancing ever since, lives and works in Berlin Neukölln, Germany. She creates all sorts of illustrative artworks combined with hand-lettered designs for print, online, and animation, and also paints on large surfaces like windows or walls. Her inspiration is peculiar human behavior, feminist rage, and silly things which she transforms into fun characters and taglines.

Sebastian Curi

b. 1986, Argentina. Lives and works in the USA.
Sebastian Curi is an Argentinian illustrator and animator based in Los Angeles. He creates colorful characters using big, bold shapes and strong lines. Originally an animator, Seb spent around ten years in the animation industry before switching disciplines to focus on illustrative work. His experience allowed him to develop a unique style of illustration, centering around quirky figures who live in their own super-stylized universe.

Cristina Daura

b. 1988, Spain. Lives and works in Spain. After studying illustration at La Massana school and completing her studies at the Maryland Institute College of Art (Baltimore,

Maryland, USA), years passed when Cristina only found jobs with no connection with the art world, but one day she decided to send everything to hell and only concentrate on what she'd always wanted: to illustrate and draw comics her own way. Surprisingly, things started to get better, and she could even pay her rent. These days she works full-time as an illustrator with clients such as *The New York Times*, *The New Yorker*, *Die Zenit*, *Süddeutsche Magazine*, *El País*, Penguin Books, Blackie Books, Planeta, Nike, Moog, Razzmatazz, Ayuntamiento de Madrid, Domino Records, etc. Her work has been exhibited in Barcelona, Bilbao, Paris, Lyon, Marseille, Hamburg, Mexico City, and Rosario (AR). Her illustrations have been considered to play between childlike esthetics and uncanny surrealistic narratives. Comic and fauvist art are two of her greatest influences, along with a lot of television and the Internet.

Design & People
Founded in 2003. Based in India.
Design & People identify how design can intervene to make a contribution to the ongoing efforts to improve the lives of people disadvantaged by war, disability, and political and environmental conditions. The India-based non-profit organization unites and encourages graphic, industrial, and architectural designers to apply their experience and skills to social and humanitarian projects.

Diana Ejaita
b. 1985, Italy/Nigeria. Lives and works in Germany.
Diana Ejaita works as an illustrator and textile designer in Berlin. What sets her illustrations apart is a combination of dramatically contrasting areas of black and white with soft patterns and textures that create images

that betray the strength of femininity. Born in Cremona from Nigerian origins, her aesthetic pays homage to her lineage.
"I am mostly into central African culture; I love its literature, arts, and textile traditions. But as a child of migration and of interracial parents I am very driven by the issues of colonial/post-colonial effects, racial and gender discrimination, and identity research."

Everyday Practice
Founded in 2013. Based in South Korea.
Everyday Practice is a graphic design studio founded by Joonho Kwon, Kyungchul Kim, and Eojin Kim. It is a small community of designers who think about the role of design in the current reality of the world we live in. Though their work is based on graphic design, they do not restrict themselves to two-dimensional design. They constantly experiment with various design methods and try to apply the lessons to future works.

Golden Cosmos
(duo Doris Freigofas and Daniel Dolz)
b. 1983, Germany. Live and work in Germany.
Golden Cosmos is the working name for Doris Freigofas and Daniel Dolz. The freelance artist-and-illustrator duo live in Berlin, Germany. They were born in Dresden and Erfurt, respectively. Doris studied at the Weißensee Kunsthochschule Berlin, and Daniel studied at the HTW in Berlin and earned a master of arts degree from the Weißensee Kunsthochschule Berlin. Golden Cosmos illustrates weekly for *The New Yorker*, *The New York Times*, *The Washington Post*, *Die Zeit*, and other media worldwide.

Good Question
(Yuni Ooh and Sun-ah Shin)
b. 1991, South Korea. b. 1993, South Korea. Live and work in South Korea.
Good Question is a multi-disciplinary design

studio based in Seoul and Daejeon, South Korea. They explore good questions with people searching for new answers. Sun-ah Shin is a feminist graphic designer based in Daejeon, South Korea. She is a member of the Daejeon feminist artist collective BOSHU and runs an anti-marriage women's community, Behonhoogam. Yuni Ooh runs a feminist publishing company Baume à L'âme, with two co-founders. They are passionate members of the Feminist Designer Social Club (FDSC), building a supportive network and a fair culture for women in the creative scene.

Mark Gowing

b. 1970, Australia. Lives and works in Australia.

Mark Gowing is an artist and typographer working in Sydney, Australia. With a practice spanning more than 35 years, he is the founder of Formist Editions, a publisher of art and design books, and Formist Foundry, a type foundry specializing in expressive fonts and custom typography. Gowing has produced numerous type and publishing projects, including his *Boulder Mono* and *Serous* typefaces, the experimental *NON* type series, and most recently the *Kapitol* type family accompanied by a limited edition companion box set. Gowing's poster works were recently documented in the book *Inside the Oblong*, published by Formist Editions. He has been honored with solo exhibitions at the 22nd International Poster Biennale in Warsaw, Poland, the Divieto d'Affissione in Turin, Italy, and Monash University in Melbourne, Australia, while his artworks have been exhibited at the Sydney Contemporary art fair. Gowing is a member of the Alliance Graphique Internationale (AGI) and his work is held in numerous institutional collections including the Cooper Hewitt Smithsonian Design Museum in New York, USA.

Guerrilla Girls

Founded in 1985. Based in the USA.

The Guerrilla Girls are anonymous artist activists using disruptive headlines, outrageous visuals, and killer statistics to expose gender and ethnic bias and corruption in art, film, politics, and pop culture. We practice an intersectional feminism that fights for human rights for all. Our work undermines the mainstream narrative by revealing the understory, the subtext, the overlooked, and the downright unfair. We have created hundreds of street posters, banners, actions, books, and videos as well as museum exhibitions all over the world. Our motto: Do one thing. If it works, do another. If it doesn't, do another anyway. Keep chipping away! Creative complaining works!

Jieun Guk

b. 1991, South Korea. Lives and works in South Korea.

Jieun Guk contemplates the value of relationships among humans, society, and the ecosystem as she explores modes of typography and graphics-based design that can be practiced in the realm of visual art.

High on Type
(Hans Schuttenbeld, Ivo Brouwer, Julien Priez, Guido de Boer, Vincent de Boer)

Founded in 2014. Based in the Netherlands and France.

High on Type is a collective of five (graphic) artists that share a passion for the letterform. As individuals they explore their own visual language, through collaboration this language is amplified. Forms are made by writing, a very direct way of expression. The work is both the act as the trace left behind. Through collective performative experiments, they stretch boundaries of the visual vocabulary. The collective goal resonates,

finding new possibilities for expression through writing.

Saki Ho

b. 1985, Hong Kong. Lives and works in Germany.

Saki Ho is an independent graphic designer and researcher based in Hamburg, Germany. Her typographic work explores the ambiguity of language and cultural differences, inspired by her upbringing in Hong Kong and her experiences living in cities with multiple cultural contexts. Saki has participated in artistic and cultural projects worldwide, showcasing her work in Hong Kong, Japan, the Netherlands, and Germany, among others. She is the founder of Research Studio, specializing in creative strategies for branding and collaboration. Saki's unique perspective and expertise make her a valuable contributor to any project, with a reputation for excellence in the industry.

Kateryna Korolevtseva

b. 1989, Ukraine. Lives and works in Ukraine and Western Europe.

Kateryna Korolevtseva is an independent brand designer, art director, and type designer from Ukraine. With a background in creative strategies, Kateryna is passionate about branding projects that have a deep focus on typography. One of her personal projects is a well-known Misto font, which is an homage to her hometown of Slavutych, a city that was born after the Chornobyl explosion. Kateryna gives public speeches at design conferences (e.g. Typographics NYC and ATypl Paris) and writes for *Design Week*, *Alphabettes*, etc. She is also a judge in the Type Directors Club (TDC69) Competition in the Type Design category. By sharing her knowledge about Ukrainian design, culture, and type design heritage, Kateryna strives to put Ukraine on the map in the design world.

Mykola Kovalenko

b. 1973, Ukraine. Lives and works in Slovakia.

Mykola Kovalenko is a famous Ukrainian graphic designer. He studied at the Kyiv State Academy of Decorative and Applied Art and Design named after Mykhailo Boychuk. Mykola Kovalenko has 20 years of experience in design. He runs his own design studio Mykola Kovalenko Studio. Mykola Kovalenko is an honorary member of the Ukrainian Art Directors Club, a member of the Slovakian Art directors Club, a member of the Ukrainian Graphic Designers Association "The 4-th Block" and the Czech Brno Biennale Designers Association. He has won more than 150 awards at international design contests and festivals, including the Red Dot Design Award (Germany), the Golden Drum (Slovenia), the European Design Awards (Greece), Graphis (USA), and others. He has often served as a member of juries at international design festivals in Ukraine, Spain, Belarus, and other countries. Mykola Kovalenko regularly participates in international exhibitions. He also holds solo poster exhibitions in Ukraine, Slovakia, Poland, and other countries. Mykola gives lectures and runs workshops on graphic design. His works have been featured in magazines and catalogues all over the world. Mykola Kovalenko is a creator of many international cultural and social projects.

Minho Kwon

b. 1979, South Korea. Lives and works in South Korea.

Minho Kwon is an illustrator. He studied visual communication at Central Saint Martins and Royal College of Art (RCA) in London. Using drawing and new media, he works across the boundary separating illustration from fine art. Kwon skillfully blends black and white drawings, utilizing the format of blueprints, while infusing

them with movement and color through light. This innovative approach results in the creation of structures within exhibition spaces. His art deeply explores specific locales, viewed through the lens of time's progression and social events. Kwon meticulously gathers information related to the historical and socio-political contexts of these places, transforming them into compelling visual narratives that merge intuition and imagination. He went on to collaborate with Factum-Arte, Bompas & Parr, Jotta Studio and RA, and won awards at Jerwood Drawing Prize, V & A Illustration Awards, and London Design Festival (Sustain RCA). His artistry has been displayed and acclaimed at various events, including the Deoksugung Outdoor Project of the National Museum of Modern and Contemporary Art, Korea (MMCA) and Typojanchi 2017: The 5th International Typography Biennale. Notable solo exhibitions, such as *The Dawn Bell Rang and the New Morning Came Too* at the Oil Tank Culture Park in 2020, and *Kwon Minho: Clouded Breath* at MMCA Cheongju, 2020, have earned significant recognition. Currently, Kwon holds the position of "maru," meaning director, at Paju Typography Institute's (PaTI) Illustration Studio.

Elaine L

b. 1993, China. Lives and works in the USA. Elaine L was born and raised in Shanghai, China. After acquiring an MFA in illustration, she now lives in the American Midwest and works as a freelance illustrator.

Chris Lee

b. 1981, Canada. Lives and works in the USA. Chris Lee is a graphic designer and educator based in Lenapehoking (Brooklyn, NY), where he is an Assistant Professor at the Pratt Institute in the Undergraduate Communications Design Department. He graduated from OCADU (Toronto) and the Sandberg Instituut (Amsterdam) and has worked for *The Walrus Magazine*, Metahaven, and Bruce Mau Design. He was also the designer and an editorial board member of the journal *Scapegoat: Achitecture/Landscape/Political Economy*. Chris is the author of the book, *Immutable: Designing History*, which explores the entanglement of graphic design with the development and perpetuation of capitalism and colonialism. It is published by Onomatopee/Library Stack.

Jaeyoung Lee (6699press)

b. 1983, South Korea. Lives and works in South Korea.

6699Press is a graphic design studio and publisher run by Jaeyoung Lee. Publications ideated and designed by the studio include *New Normal* and *1-14* which was selected as the Best Book Design from Korea in 2020 and 2023; *11 Korean, Women, Graphic Designers*; *Bathhouses in Seoul*; and *Staring at Your Back*. Lee published the typography journal *LetterSeed* as the head of the publication department at the Korean Society of Typography from 2015 to 2018 and currently gives typography and book design lectures at universities.

Jiwon Lee (archetypes)

b. 1987, South Korea. Lives and works in South Korea.

Jiwon Lee produces works that critically assess and practice discourses deemed minor in today's world. She runs the publisher archetypes, writes, and produces books and documentations. Lee currently publishes the design and culture sourcebook *New Time New View* and serves as a member of the Jayul Design Lab and the Feminist Designer Social Club.

Kyungmin Lee (flagflag)

b. 1986, South Korea. Lives and works in South Korea.

Graphic designer Kyungmin Lee designed books at Minumsa for three years from 2012 to 2015 and currently runs the graphic design studio flagflag. Lee's interest lies in interpreting queer culture through visual language, and he continues to collaborate with minority and queer groups. He earned his master's degree from the Graduate School of Design, University of Seoul, with the thesis "Expanding the Archives of Queer Serial Publications in South Korea" (2023). Designed by Lee, *Civilian Restricted Area* was selected as the Best Book Design from Korea in 2022.

Bernhard Lenger

b. 1991, Austria. Lives and works in the Netherlands.

Bernhard Lenger is an award-winning Austrian social designer based in the Netherlands. He is renowned for his work in supporting organizations and companies in addressing societal challenges through research and design. Lenger's focus on environmental, technological, and social issues has earned him widespread recognition for his ability to shed new light on social challenges and enable people to be part of social transitions. His methodology involves a unique combination of quantitative and qualitative research, strategic design, and collaboration with stakeholders to facilitate social change. He founded Studio Bernhard Lenger and the creative innovation agency What's the Matter, and is working as Creative Director at Foundation We Are.

Elaine Lopez

b. 1984, USA. Lives and works in the USA.

Elaine Lopez is a Cuban-American designer, researcher, artist, and educator whose work explores the intersection of culture, identity, equity, and Risograph printing within the design field. She acquired her BFA from the University of Florida (2007) and her MFA from the Rhode Island School of Design (2019), both in graphic design. She was awarded the AICAD Post-Graduate Teaching Fellowship in 2019–2021 at the Maryland Institute College of Art, where she taught in the undergraduate and graduate graphic design programs. She is currently an Assistant Professor of Communication Design at Parsons School of Design. Additionally, she has served on the boards of various design organizations, including AIGA Chicago and the Type Director's Club. Her work has been featured in various exhibitions, publications, and conferences, such as the *STA:100*, *Where Are The Black Designers?*, and the In/Visible Conference. Elaine is passionate about creating inclusive and equitable design spaces, and her practice challenges existing design paradigms.

Luis Mazón

b. 1986, Spain. Lives and works in Spain

Luis Mazón is an illustrator and animator. His illustrations are painted or sketched by hand or using digital brushes before being brought to life with looping movements. His work has appeared in *The New Yorker*, *The Washington Post*, *The Guardian*, and *The New York Times*.

Sang Mun

b. 1986, South Korea. Lives and works in South Korea.

Mun holds a BFA in Graphic Design from the Rhode Island School of Design and an MFA in Visual Communication from Seoul National University. He worked at the Walker Art Center as well as Hanwha and Hyundai Motor's Creative Works team. His works have been published on Google Design, CNN,

and *WIRED*. In 2012, he was selected as "20 Under 30: New Visual Artists" by *PRINT*. His work has been added to the permanent collections of the San Francisco Museum of Modern Art and the Philadelphia Museum of Art in the US and the Musée des Arts décoratifs in Paris. Currently, he runs the creative consultancy Grid based in Seoul.

Aaron Nieh

b. 1977, Taiwan. Lives and works in Taiwan.
Aaron Nieh, a trailblazing graphic designer in Taiwan, joined AGI in 2012 as its first Taiwanese member. Known for his subtle yet provocative designs, Nieh has redefined graphic design in the Chinese-speaking world. His studio, Aaron Nieh Workshop, now based in both Taipei and Kaohsiung, is acclaimed for its refined use of imagery, symbols, and materials, introducing a novel perspective in graphic design.

Yudai Osawa

b. 1984, Japan. Lives and works in Japan.
Born in 1984, Osawa graduated from Tama Art University in 2006. After working for an advertising production company, he became independent. Since the mid-2010s, he has started to provide graphics for projects dealing with social issues. He is constantly searching for ways in which graphic design can contribute to society. He is also active as a member of the ambient unit UNKNOWN ME and Atoris.

Saehan Parc

b. 1989, South Korea. Lives and works in France.
Born on February 4, 1989 in South Korea, she lives and works in Strasbourg, France. Growing up in Bucheon, a city of comics, she was immersed in various inspirations such as manhwa, manga, comics, and European comics. Then, by following her studies in Korea and France, especially at HEAR (Haute école des arts du Rhin) in the illustration section, she found her own voice. Today, her artwork can be found in newspapers such as *The New York Times* or *Bloomberg Businessweek*, and in exhibitions or book fairs. Her first children's book *Papa Ballon* published by Éditions 2024 won the prize Révélation livre jeunesse 2021 of ADAGP. Curious, she likes to draw and make people want to draw, without forgetting the values that are important to her. She is also a member of Louise the Women, a women's visual artist collective in Korea.

Raven

Raven graduated from National Management College in Yangon, Myanmar specializing in English for Professional Purposes in 2012 and worked as a copywriter in advertising agencies. Although drawing has been a major interest since a young age, digital art was introduced to her by her graphic designer colleagues. She then decided to learn fine arts and started going to LASALLE College of the Arts, Singapore, specializing in Fine Arts (Graphic Novel) in 2017 and graduated in 2020. She is now working as a freelance illustrator and full-time artist. She participated in the two group exhibitions *Word Therapy* and *Building Bridges* in 2019 and another called *MidSummer* in April 2022. She exhibited her first solo show *18/29* in September 2022.

Fahmi Reza

b. 1977, Malaysia. Lives and works in Malaysia.
Fahmi Reza is an outspoken political graphic designer and activist hailing from Kuala Lumpur, Malaysia. With over two decades of experience, Fahmi has fearlessly used his art and activism to critique the Malaysian government, and as a result, he has faced

numerous repercussions including arrests, charges, bans, and even a jail sentence. His passion for merging art, activism, and politics is evident in his unyielding efforts to use his creative work as a means of exploring the power of art as a vehicle for promoting political discourse and igniting social change.

Roshi Rouzbehani

b. 1985, Iran. Lives and works in the UK. Roshi Rouzbehani is an Iranian freelance illustrator, born and raised in Tehran, Iran, and now based in London, UK. Collaborating with clients such as *The New Yorker*, *The Guardian*, *The Washington Post*, and Amnesty International, Roshi creates editorial and portrait illustrations about social issues. She is passionate about gender equality, and women's empowerment is at the center of her work. Roshi has participated in many group exhibitions in Europe, the USA, and Iran, and her works have been featured in *Creative Boom*, *Design Week*, *Middle East Eye*, and more. She is the illustrator and author of the book *50 Inspiring Iranian Women*.

Frenci (Francesca) Sanna

b. 1991, Italy. Lives and works in Switzerland. Frenci (Francesca) Sanna is an Italian picture book illustrator and author whose main interest lies in visual storytelling and narrative illustration. Their first book *The Journey* (Nobrow/Flying Eye) won, among others, the 2017 Kate Greenway Amnesty Honour (UK), the Klaus Flugge Prize (UK), and has been translated into over 20 languages. Their most recent publications include *Me And My Fear* (Nobrow/Flying Eye), *My Friend Earth* (by Patricia MacLachlan, Chronicle Books), *The More You Give* (by Marcy Campbell, Knopf BFYR), and *If You Were A City* (by Kyo Maclear, Chronicle Books). They are currently based in Zurich where they work, constantly missing the small Mediterranean island they come from, the sea, and their cat.

Shin In-ah

b. 1985, South Korea. Lives and works in South Korea.
Graphic designer Shin In-ah runs the design studio Scenery of Today in Seoul. Having been taught that designers must be socially responsible, Shin believes that responsible designs should embody logic and context. She therefore only produces works that she can explain. Shin has mostly worked with individuals and organizations that seek to make a difference, including Kakao!mpact, the Seoul Youth Hub, and the Association of Women Artists (AWA). She is also an active member of the Feminist Designer Social Club (FDSC).

Luca Soncini

b. 1980, Italy. Lives and works in Italy.
Luca Soncini, born in Parma in 1980, is an Italian illustrator and designer who graduated from the Academy of Fine Arts in Milan. After a long training in painting, his work today focuses on conceptual illustration and visual communication in editorial and commercial fields.

Elmer Sosa

b. 1978, Mexico. Lives and works in Mexico. Holding a graduate degree in Marketing, Elmer Sosa is a graphic designer, illustrator, and professor, and he was a beneficiary of the Programa de Estímulo a la Creación y el Desarrollo Artistico 2021, 2019, and 2015 (Puebla), as well as a Latin Design Ambassador for the Universidad de Palermo Argentina. His accolades include Honorable Mention in the Third Biennial of Illustration / Latin America by Pictoline 2022, the Golden Bee Award at the Moscow Global Biennale of Graphic Design 2020, First place in the

4th International Poster Biennial in Oaxaca 2019, Mexico, and 2nd place in the Golden Turtle 2017, Russia, winner of "Mut Zur Wut" in Germany 2017, 2012, and 2011, the Design Award for the Poster and Illustration Category 2014–2018 and Silver Mention of the same award for the brochure and poster category 2015 and 2016, First place in the International Poster Competition FUKUDA Russia 2016, Honorable Mention at the Virtual Biennial in Prague 2016, Award Quórum 2013, and Honorable Mention at the 18th International Graphic Humor Biennial in Cuba 2013. His work has been exhibited in Poland, Italy, Peru, Bolivia, Venezuela, Cuba, France, Ukraine, Spain, the United States, Russia, the Czech Republic, Japan, and China. He is Art Director of the Yomi Yomi Studio, an illustrator for different publishing houses, and a teacher at several universities.

Elliot Stokes

b. 1988, USA. Lives and works in USA.
Elliot Stokes is an artist, illustrator, and art director based in Los Angeles. His art practice is grounded in drawing and explored through multiple mediums. Typically irreverent in spirit, his work has been featured in numerous publications. He has drawn upon his identity and experience as Asian-American and queer in establishing the themes of his posters.

Studio Half-bottle

Founded in 2019. Based in South Korea.
Studio Half-bottle organizes content production for the graphic design, journalism, and publishing fields. The name "Half-bottle" symbolizes the varied thoughts and emotions of individuals—a bottle half full to some appears half empty to others. In each endeavor, Studio Half-bottle adeptly balances the viewpoints of their clients with their own unique perspective. It aims to promote solidarity and competition of different perspectives which lead to create a progressive society.

Studio Rejane Dal Bello

Founded in 2014. Based in the UK.
We are a design studio creating work that is meaningful, engaging, and lasting. Everything we work on—a new brand, a digital experience, a book, or something else—we get to the heart to find what matters.
Our job is to clearly communicate your beliefs in a striking, moving, and effective way. If you're passionate about the power of design, then we'd love to work together. We are an intentionally small studio, so we can move fast, collaborate directly, and create brave work. We're based in London and we work with people from all over the world, pulling in the right expert at the right moment.
Founded by Rejane Dal Bello, an award-winning designer with a history of iconic work. She has 20 years of experience in graphic design and branding, including stints at renowned agencies such as Wolff Olins (UK) and Studio Dumbar (NL), and recently she wrote the book *Citizen First, Designer Second*, published by Counter-Print. Our services are brand identity, graphic design, brand strategy, motion design, digital & social design, editorial design, packaging, illustration, and environmental design.

Pracha Suveeranont

b. 1957, Thailand. Lives and works in Thailand.
Pracha Suveeranont graduated from Parsons School of Design, New York. As a designer, he worked at SC Matchbox from 1993 to 2010. His published works include *Thai: The Vernacular Thai in Art & Design* (Samesky Publishing, 2012), *Design + Culture 1-3* (Samesky Publishing, 2009–2011), *Rey-Noo Panyadee 1-3* (Samesky Publishing, 2011),

10 Faces of Thai Type and the Nation (SC Matchbox, 2002), and Lae Nue Tue Nang (Matichon Publishing, 2001).

Anina Takeff
b. 1990, Germany/Bulgaria. Lives and works in Germany.

Anina Takeff is an illustrator and graphic designer based in Berlin. She worked for clients like United Nations Women, *Die Zeit*, and *Vanity Fair*. After graduating with a degree in graphic design and working with several design and ad agencies in Germany and Switzerland, in 2014 she started focusing on illustration. Her work often revolves around the themes of human rights, equality, and climate change.

This Ain't Rock'n'Roll
(Charlie Waterhouse and Clive Russell)
Founded in 2009. Based in the UK.

This Ain't Rock'n'Roll is the studio of Clive Russell and Charlie Waterhouse. Their work inspires change, most famously in the look and feel of Extinction Rebellion and the Brixton Pound. This Ain't Rock'n'Roll's work has been exhibited and collected by the V&A, MoMA, British Museum, and Smithsonian, among others.

Garth Walker
b. 1957, South Africa. Lives and works in South Africa.

Garth Walker's studio Mister Walker has designed for most of South Africa's best known corporate and consumer brands. However, his personal interest lies in the idea of "what makes me African—and what does that look like?" In 1994, following South Africa's first democratic elections, issue #1 of *ijusi* was published to worldwide acclaim. See more at www.ijusi.com. His work has been widely exhibited in major museum collections, and published works

in books and magazines number in the hundreds. Garth is a member of Alliance Graphique Internationale, British Design & Art Direction (D&AD), and a Life Member of The Type Directors Club (NY).

Yeji Yun
b. 1983, South Korea. Lives and works in South Korea.

Yeji Yun is an illustrator who weaves her images out of imagination. She works with clients of diverse nationalities across to create publications, posters, and advertisements and more. With interests in climate change as well as animal and human rights, Yun explores ways through which illustrations can contribute to a better world. She produced posters for the annual Seoul Animal Film Festival in cooperation with Kara (Korea Animal Right Advocates) and also worked with the Korean branch of Amnesty International. Among her major publications is the picture book *Let's Shout Out "Dignity,"* which reinterprets the Universal Declaration of Human Rights.

필자 약력

강유미

아트선재센터와 아라리오갤러리에서 근무했으며, 한국문화예술위원회 인사미술공간에서 IASmedia 프로그램과 저널 『볼』 편집을 담당(2007-2008)했다. 아트 스페이스 풀, 아뜰리에 에르메스, 4회 안양공공예술프로젝트, SeMA 비엔날레 미디어시티서울 2016, 서울미디어시티비엔날레 2018, 서울시립미술관 등의 출판 작업에 참여했다.

게이코 세이

게이코 세이는 저술가이자 큐레이터로 사회 변화와 창의적 미디어 행동주의에 초점을 두고 활동하고 있다. 일본에서 비디오 큐레이터로 일한 후, 1988년 동유럽의 독립 미디어 및 행동주의를 연구하기 위해 그 지역으로 이주했다. 2002년에는 미얀마에서 영화 교육 프로그램과 와탄 영화제(Wathann Film Festival)를 새롭게 만드는 등, 작업과 연구를 더 먼 동쪽으로 확장하기 위해 동남아시아로 활동 기반을 옮겼다. 기획한 주요 프로젝트로는 <매체는 우리와 함께한다! 루마니아 혁명에서 텔레비전의 역할>(The Media Are With Us! The Role of Television in the Romanian Revolution, 부다페스트, 1990), <니콜라 테슬라의 시대>(The Age of Nikola Tesla, 오스나브뤼크, 1991), <엑스-오리엔테-럭스—루마니아 비디오 주간>(EX-ORIENTE-LUX—Romanian Video Week, 부쿠레슈티, 1993), <동유럽 텔레비전과 정치>(Eastern Europe TV & Politics, 버펄로, 1993), 《마술 환등》(Lanterne magique, 스트라스부르, 1998), 《폴리틱-움/새로운 참여》(POLITIK-UM/new Engagement, 프라하, 2002), 《동방을 재디자인한다》(Re-Designing East, 슈투트가르트, 그단스크, 2010; 부다페스트, 2011), SeMA 비엔날레 미디어시티서울 2016의 『그런가요 2호: 하이스쿨 스페셜』(서울, 2016), <정치 무관심에 반대한다>(Against Apathy to Politics, 방콕, 2018) 등이 있다. 출판물로는 『관료 정치에서 TV 정치로』(Von der Bürokratie zur Telekratie, 편집, 독일, 1990)와 『말기의 풍경』(Terminal Landscape, 체코, 2004)이 있으며, 『도큐멘타 12 매거진』에서 편집자로, <도큐멘타 12 매거진스 프로젝트>에서 지역 코디네이터로 일했다. 사회 변화를 기록한 작업이 대부분인 그의 비디오 컬렉션은 오스트리아에 위치한 제네랄리 파운데이션(Generali Foundation)에서 소장하고 있다.

김경원

김경원은 그래픽디자이너, 디자인 교육자다. 홍익대학교와 킹스턴대학교(영국)에서 커뮤니케이션디자인을 공부했으며 지난 10여 년간 다양한 매체를 기반으로 타이포그래피, 편집, 아이덴티티 디자인 프로젝트를 수행했다. 현재 동서대학교의 디지털미디어디자인전공 교수로 재직 중이다. 역서로는 『디자이너 주인이 되어라』(2014), 『비주얼 그래머』(2015) 등이 있다.

김상규

서울대학교와 국민대학교 대학원에서 산업디자인을 전공한 후, 예술의전당 디자인미술관 큐레이터로 일하는 동안 《droog design》, 《한국의 디자인》, 《모호이너지의 새로운 시각》, 《잠금해제》 등의 전시를 기획했다. 한국디자인문화재단(KDF)의 사무국장을 역임했으며 현재는 서울과학기술대학교 디자인학과 교수로 있다. 「디자인 아카이브 연구」로 박사 학위를 받고 디자인뮤지엄과 디자인아카이브 관련 연구를 지속해왔으며 현재는 생태전환 디자인과 사변적 디자인을 아우르는 사물 연구, 20세기 사회주의 체제의 디자인에도 관심을 갖고 있다. 역서로는 『사회를 위한 디자인』(2004), 『파워 오브 디스플레이』(2007), 『뉴 큐레이터: 건축과 디자인을 전시하기』(2023), 저서로는 『관내분실: 1999년 이후의 디자인전시』(2021), 『디자인과 도덕』(2018) 등이 있다.

에치오 만치니

에치오 만치니는 지속가능성을 위한 디자인 분야에서 30년 이상 활동해 왔다. 최근에는 지속가능한 변화의 주요 동인으로 여겨지는

사회적 혁신에 주목하고 있다. 이와 같은 관점에서 지속가능성을 위한 사회 혁신 디자인 분야에서 활동하는 디자인 대학들의 국제 네트워크인 DESIS를 설립했다. 현재 DESIS 네트워크의 대표이자 밀라노 공과대학교의 명예 교수이다. (지난 10년 동안) 엘리사바디자인공학스쿨(바르셀로나), 퉁지대학교(상하이), 장난대학교(우시), 런던예술대학교(런던), 케이프페닌슐라기술대학교(케이프타운), 파슨스디자인스쿨(뉴욕) 등 전 세계 여러 디자인 학교에서 객원 교수로 재직했다. 저서로는 『Design, When Everybody Designs』(MIT 출판, 2015), 『Politics of the Everyday』(Bloomsbury, 2019), 『Livable Proximity』(Egea, 2021), 『Plug-Ins: Design for City Making in Barcelona』(Albert Fuster 및 Roger Paez 공저, Elisava and Actar, 2023) 등이 있다.

장문정

장문정은 그래픽 디자이너, 비주얼 아티스트, 크리에이티브 디렉터, 디자인 교육자로 활동하고 있다. 주요 연구 분야는 시각적 내러티브 시스템, 시각적 개념으로서의 다중성, 타이포그래피의 은유적 모듈, 순차적 색상에 관한 연구이다. 연구 작품으로는 <시각적 형태의 다중 내러티브>, <다중 내러티브로서의 다면체>, <시공간에서의 색상도>, <삼각표면을 구르는 하이퍼볼러블 문자>(Hyperbolable Types Across a Triangulated Surface) 등이 있다. 또한 사회문화적 디자인, 미술/디자인 전시를 위한 시각아이덴티티, 편집/미디어디자인 분야에서 활동하면서 SeMA 비엔날레 미디어시티서울 2016 출판물 『그런가요』(2016)와 미국공예협회 출판물 『American Craft Inquiry』(2016-2018)를 디자인 디렉션하였고, 《수퍼서피스》(SuperSurfaces, 2017), 《타이포-헤테로크로니아: 서울-아틀란타》(Typo-Heterochronia: Seoul-Atlanta, 2021) 등의 전시를 기획했다. 장문정의 작품은 트라나바 포스터 트리엔날레(슬로바키아), 국제 포스터 트리엔날레(일본), 쇼몽 국제 포스터 및 그래픽 아트 페스티벌(프랑스), 골든비 모스크바

국제 그래픽 디자인 비엔날레, 프린트 연례 공모전(미국), 365: AIGA(미국 뉴욕), AIGA SEED Award GALA(미국 애틀랜타) 등에 수상/초대 및 전시된 바 있다. 최근 엘렌 럽튼(Ellen Lupton)의 저서 『Thinking with Type』(2024)에 필자로서 참여하였다. 현재 미국 조지아주립대학교 라마 도드 예술대학의 그래픽 디자인 교수로 재직 중이다.

정근식

서울대학교 사회학과를 졸업하고 동 대학원에서 박사 학위를 받았으며, 전남대학교 교수를 거쳐 서울대학교 사회학과 교수로 재직했다. 하버드·옌칭연구소, 교토대학, 시카고대학, 타이완 중앙연구원, 베를린자유대학 등에서 방문교수로 활동했다. 한국사회사학회, 비판사회학회, 한국냉전학회, 한국구술사학회 회장을 지냈으며 진실·화해를위한과거사정리위원회 위원장, 대통령 소속 친일반민족행위 진상규명위원회 위원, 민주화운동기념사업회 한국민주주의연구소 소장을 역임했다. 『소련형 대학의 형성과 해체』(2018), 『북한의 대학: 역사, 현실, 전망』(2017), 『냉전의 섬, 금문도의 재탄생』(2016), 『전쟁 기억과 기념의 문화정치: 남북한과 미국·중국의 전쟁기념관 연구』(2016) 등의 저서와 「On the Ruins: Forgetting and Awakening Korean War Memories at Cheorwon」(2017) 등의 논문이 있다.

Contributor Biographies

Moon Jung Jang

Moon Jung Jang is a graphic designer, visual artist, creative director, and design educator. Her research interests include visual narrative systems, multiplicity as a visual concept, metaphorical modules in typography, and sequential color. Her research includes *Multiple Narratives in Visual Forms*, *Polyhedralness as Multiple Narratives*, *Color Value in Space-Time*, and *Hyperbolable Types Across a Triangulated Surface*. She has designed in the fields of visual identity and editorial/media design for socio-cultural events and art/design exhibitions such as the non-periodical publication for SeMA Biennale Mediacity Seoul 2016, *Could Be* (2016) and the American Craft Council publication, *American Craft Inquiry* (2016-2018). She directed exhibitions, *SuperSurfaces* (2017) and *Typo-Heterochronia: Seoul-Atlanta* (2021). Jang's work has appeared internationally and nationally in many exhibitions, such as The Tranava Poster Triennial (Slovakia); The International Poster Triennial (Japan); The International Poster and Graphic Arts Festival of Chaumont (France); The Golden Bee Moscow International Biennale of Graphic Design; Print Regional Annual Competition (USA); 365: AIGA (New York, USA); AIGA SEED Award GALA (Atlanta, USA). She recently contributed to Ellen Lupton's book, *Thinking with Type* (2024). Jang is an Associate Professor of Graphic Design at the University of Georgia, Lamar Dodd School of Art in Athens, Georgia (USA).

Jung Keun-Sik

Jung Keun-Sik graduated in sociology from Seoul National University and earned a doctoral degree at the same institution. He worked as a professor at Chonnam National University before becoming a sociology professor at SNU. He has also been a visiting professor at the Harvard-Yenching Institute, Kyoto University, the University of Chicago, the Academia Sinica in Taiwan, and the Freie Universität Berlin. He has been president of the Korean Social History Association, the Critical Sociological Association of Korea, the Korean Association of the Cold War Studies, and the Korean Oral History Association, and he has also served as chairperson of the Truth and Reconciliation Committee, a member of the Presidential Committee for the Inspection of Collaborations for Japanese Imperialism, and director of the Korea Democracy Foundation's Institute for Korean Democracy. His books include *Formation and Collapse of the Soviet Type Universities* (2018), *Universities in North Korea: History, Reality, and Prospects* (2017), *Rebirth of a Cold War Island, Jinmen* (2016), and *Politics of Korean War Memory and Commemoration* (2016). His academic publications include "On the Ruins: Forgetting and Awakening Korean War Memories at Cheorwon" (2017).

Yumi Kang

Yumi Kang worked at the Artsonje Center and Arario Gallery. From 2007 to 2008, she was in charge of the IASmedia program and edited Journal *Bol* at Insa Art Space of the Arts Council Korea. Since then, she participated in publishing work for Art Space Pool, Atelier Hermès, the 4th Anyang Public Art Project, SeMA Biennale Media City Seoul 2016, Seoul Mediacity Biennale 2018, and Seoul Museum of Art.

Kyungwon Kim

Kyungwon Kim is a graphic designer and design educator. He studied Communication Design at Hongik University (KR) and Kingston University (UK) and has been working on typography, editorial, and identity design projects in diverse media over the

past 10 years. He is currently a professor of Digital Media Design at Dongseo University. His translations include *The Designer as...* (2014) and *Visual Grammar* (2015).

Kim Sang-kyu

Prior to joining the Seoul National University of Science & Technology, Kim Sang-kyu served as curator of the Hangaram Design Museum. He has curated several exhibitions on historical and contemporary design, including *New Vision from László Moholy-Nagy* (Seoul Arts Center, 2005), *Reset: Korean New Wave Design* (ARCO, Madrid, 2007), *Futures of the Past* (Gwangju Design Biennale, 2017) and *Unlock* (The Democracy and Human Rights Memorial Hall, 2019). He also contributed to *&Fork* (Phaidon, 2007) and *Encyclopedia of East Asian Design* (Bloomsbury, 2019) and translated *Design For Society*, *The Power of Display* and *New Curator: Exhibiting Architecture and Design* into Korean. His books include *Design and Morality* (2018) and *Design Exhibitions after 1999* (2021).

Ezio Manzini

For over three decades, Ezio Manzini has been working in the field of design for sustainability. Most recently, his interests have focused on social innovation, considered as a major driver of sustainable changes. In this perspective, he started DESIS: an international network of schools of design, active in the field of design for social innovation for sustainability. Presently, he is president of DESIS Network and an honorary professor at the Politecnico di Milano. He has been a guest professor in several design schools world-wide, as (in the past decade): Elisava Barcelona School of Design and Engineering (Barcelona), Tongji University (Shanghai), Jiangnan University (Wuxi), University of the Arts London (London), Cape Peninsula University of Technology (Cape Town), Parsons The New School for Design (NYC). His most recent books are: *Design, When Everybody Designs* (MIT Press, 2015), *Politics of the Everyday* (Bloomsbury, 2019), *Livable Proximity* (Egea, 2021), and *Plug-Ins: Design for City Making in Barcelona* (with Albert Fuster and Roger Paez, Elisava and Actar Publishers, 2023).

Keiko Sei

Keiko Sei is a writer and curator whose focus is on social change and creative and media activism. After working as a video curator in Japan, she moved to Eastern Europe in 1988 to research independent media and activism in the region. In 2002, she moved to Southeast Asia to extend her work and research further east, including the launch of film education programs and the Wathann Film Festival in Myanmar. Her curatorial projects include: *The Media Are With Us! The Role of Television in the Romanian Revolution* (Budapest, 1990), *The Age of Nikola Tesla* (Osnabrück, 1991), *EX-ORIENTE-LUX—Romanian Video Week* (Bucharest, 1993), *Eastern Europe TV & Politics* (Buffalo, 1993), *Lanterne magique* (Strasbourg, 1998), *POLITIK-UM/new Engagement* (Prague, 2002), *Re-Designing East* (Stuttgart and Gdansk, 2010; Budapest, 2011), *Could Be: High School Special* for SeMA Biennale Mediacity Seoul 2016 (Seoul, 2016), *Against Apathy to Politics* (Bangkok, 2018). Her publications include *Von der Bürokratie zur Telekratie* (ed., Germany, 1990) and *Terminal Landscape* (Czech Republic, 2004). She worked as an editor of *documenta 12 magazine* and curator for *documenta 12 magazines project*. Her video collection, which mostly consists of documents of social change, is included in the video collection of the Generali Foundation in Austria.

민주화운동기념사업회

민주화운동기념사업회는 한국 민주주의 발전의 핵심 동력이었던 민주화운동 정신을 계승·발전시키기 위해 2001년 국회에서 제정된 민주화운동기념사업회법에 의해 설립된 행정안전부 산하 공공기관이다. 주요 사업으로는 6·10민주항쟁 기념식 개최를 포함하여 민주화운동 정신 계승사업, 민주화운동 관련 사료 수집사업, 민주주의 발전을 위한 연구사업과 교육사업 등이 있다. 또한 사업회는 옛 남영동 대공분실을 민주화운동과 민주주의의 역사를 기억하는 공간인 민주화운동기념관으로 조성하고 있다.

Korea Democracy Foundation

The Korea Democracy Foundation is a public institution under the Department of Public Administration and Security, established following the Korea Democracy Foundation Act enacted in the National Assembly in 2001 to inherit the spirit of the democratization movement that propelled the development of Korean democracy. The foundation's main projects include holding the ceremony for the June Democratic Uprising, inheriting the spirit of the democratization movement, collecting historical records related to the movement, and researching and educating on the development of democracy. Furthermore, the foundation is turning the former Namyeong-dong Anti-communist Investigation Office into the National Museum of Korean Democracy as a space to remember the democratization movement and the history of democracy.

민주주의 포스터 프로젝트

기획
민주화운동기념사업회

진행
한국디자인사학회, 이은콘텐츠

감독
장문정

큐레이터
김경원, 강유미

참여 작가
가스 워커, 게릴라 걸즈, 골든 코스모스(도리스 프라이고파스, 다니엘 돌즈), 국지은, 굿퀘스천(우유니, 신선아), 권민호, 다이애나 에자이타, 디스 애인트 로큰롤(찰리 워터하우스, 클라이브 러셀), 디자인 & 피플, 레이븐, 로시 루즈베하니, 루이스 마존, 루카 손치니, 마크 고잉, 멜린다 벡, 문상현, 미콜라 코발렌코, 박새한, 베른하르트 렝거, 빅토리아 치혼, 사키 호, 세바스티안 큐리, 스튜디오 하프-보틀, 스튜디오 헤잔느 달 벨로, 시멘트(박용훈, 양효정), 신인아, 안마노, 애니나 테케프, 에런 니에, 엘리엇 스톡스, 엘마 소사, 오사와 유다이, 윤예지, 이경민(플락플락), 이재영(6699press), 이지원(아키타입), 일레인 L, 일레인 로페즈, 일상의실천, 장문정, 조나단 반브룩, 카로 악포키에르, 카테리나 코롤레프체바, 크리스 리(이정민), 크리스 버넷, 크리스티나 다우라, 킴 알브레히트, 파흐미 레자, 프라챠 수비라논트, 프란체스카 산나, 하이 온 타입

Democracy Poster Project

Organized by
Korea Democracy Foundation

Coordinated by
The Design History Society of Korea
eeuncontents

Director
Moon Jung Jang

Curators
Kyungwon Kim, Yumi Kang

Participating Artists
Karo Akpokiere, Kim Albrecht, An Mano, Jonathan Barnbrook, Melinda Beck, Chris Burnett, cement (Yonghoon Park and Hyojung Yang), Viktoria Cichoń, Sebastian Curi, Cristina Daura, Design & People, Diana Ejaita, Everyday Practice, Golden Cosmos (duo Doris Freigofas and Daniel Dolz), Good Question (Yuni Ooh and Sun-ah Shin), Mark Gowing, Guerrilla Girls, Jieun Guk, High on Type, Saki Ho, Moon Jung Jang, Kateryna Korolevtseva, Mykola Kovalenko, Minho Kwon, Elaine L, Chris Lee, Jaeyoung Lee (6699press), Jiwon Lee (archetypes), Kyungmin Lee (flagflag), Bernhard Lenger, Elaine Lopez, Luis Mazón, Sang Mun, Aaron Nieh, Yudai Osawa, Saehan Parc, Raven, Fahmi Reza, Roshi Rouzbehani, Frenci (Francesca) Sanna, Shin In-ah, Luca Soncini, Elmer Sosa, Elliot Stokes, Studio Half-bottle, Studio Rejane Dal Bello, Pracha Suveeranont, Anina Takeff, This Ain't Rock'n'Roll (Charlie Waterhouse and Clive Russell), Garth Walker, Yeji Yun

민주주의
씨앗뭉치

이 책은 민주화운동기념사업회의 민주화운동기념관
개관을 기념하여 제작되었습니다.

기획
민주화운동기념사업회

편집
장문정, 김경원, 강유미

원고
정근식, 김상규, 게이코 세이, 에치오 만치니

번역
콜린 모엣, 이경희, 길예경, 고아침, 서울셀렉션

교정 교열
길예경, 라이언 허버트 카스텐

자문
마크 캘러핸

디자인
213ho

펴낸날
초판 1쇄 2024년 6월 10일

펴낸곳
이은북
(04029) 서울특별시 마포구 동교로12안길 16,
삼성빌딩 4층, 5층
T. 02 338 1201 | ask@eeuncontents.com
eeuncontents.com

ISBN
979-11-91053-40-1 (03650)

값
30,000원

Seed Pods of
Democracy

This book is published to accompany the
Democracy Poster Project, one of the programs
for the opening of the National Museum of
Korean Democracy.

Conceived by
Korea Democracy Foundation

Editors
Moon Jung Jang, Kyungwon Kim, Yumi Kang

Contributors
Jung Keun-Sik, Kim Sang-kyu, Keiko Sei,
Ezio Manzini

Translators
Colin Mouat, Kyunghee Lee, Yekyung Kil,
Achim Koh, Seoul Selection

Proofreading
Yekyung Kil, Ryan Herbert Karsten

Project Consultant
Mark Callahan

Design
213ho

Publication Date
June 10, 2024

Publisher
eeunbook
Samsung Building, 4th and 5th Floors,
(04029) 16 Donggyo-ro 12an-gil, Mapo-gu,
Seoul, Korea
T. +82 2 338 1201 | ask@eeuncontents.com
eeuncontents.com

ISBN
979-11-91053-40-1 (03650)

Price
30,000 KRW